MIND AND ART

an essay on the varieties
of expression

By Guy Sircello

Mind&Art

Princeton University Press

Contents

Preface

This book originated in my puzzlement at the theory of expression as it was "classically" elaborated by Benedetto Croce, R. G. Collingwood, John Dewey, and Susanne K. Langer. These philosophers seemed to me not only to be at cross-purposes but also to be given to outlandish statements about expression which were outrageously false, outrageously obscure, or both; and I became curious about the source of such outlandishness and outrageousness. I soon discovered that, rather than relying on expression theorists for an understanding of expression, I must probably gain the latter in order to understand the former. I therefore began systematically to canvass the various uses and senses of "expression" and its cognates.

It soon became evident that a great part of the chaos in expression theory was due to the fact that "expression" denotes, not a single concept, but a mass of concepts, all of which apparently are only tenuously related and each of which has a significance and fascination independent of the others. The more I poked and prodded the mass the more it began to reveal an unexpected structure which, moreover, seemed to support ideas about subjects in the very center of philosophy's domain. Instead of leading merely to the philosophy of art and aesthetics, which are normally considered to be on the periphery of philosophy, the concepts of expression took me to the inner sanctum of modern philosophy, the philosophy of mind. Ironically, they also led me to a theory of mind—or a theory of some aspects of mind—which I confess to finding somewhat outlandish and outrageous, though neither false nor obscure. And yet

I am still not sure that I understand classical expression theorists.

This brief history of the present book explains something of its structure. On the one hand, it is a series of explorations of several, but not all, varieties of expression. On the other hand, it contains a single thesis or theme, namely the justification of a certain model of mentality which I call "Romantic." In the book, therefore, this theme is not played in a single grand crescendo, to use a musical analogy. Rather, in the early chapters it is heard only distantly and in a muffled way. But by Chapter Six it appears as a dominating, soaring melody which "peaks" in Chapter Nine and recedes again in the last chapter.

A couple of methodological points should be noted here, too. Much of what I say depends upon certain ways of talking about art and other verbal works. To illustrate these ways, I sometimes quote critics and sometimes use critical statements of my own. But none of my conclusions depend upon assuming that any of these illustrative statements are either true or totally adequate as critical statements about the works in question. The statements are meant to illustrate *categories* of critical talk. If a reader disagrees with an illustrative statement, therefore, I invite him to substitute his own choice in its place. My point concerning categories of critical talk will, I predict, be undamaged. I have chosen my illustrative statements, by the way, from a rather wide range of critics. My point was to avoid biasing the data by selecting critics of only certain ideological persuasions. For I believe that the categories of critical talk which I discuss do not depend merely upon this or that aesthetic and/or critical theory but are embedded in the language that we all find natural and indispensable in talking about art and other cultural productions.

The reader who survives as far as Chapter Ten will notice that the texture of argument there is significantly coarser than in the other chapters. The reason is that there exists virtually no philosophical literature on the subject of self-expression. This means that the subject has not been very finely harrowed, as it were. Indeed, it has not even been ploughed. But unturned ground demands a rough tool. If the soil then seems worth cultivating, subtler machinery can and no doubt will be brought to the job.

THIS book has been long in the making, and I have collected many debts along the way. I owe a fundamental debt of gratitude to my first philosophy teachers, Edwin Garlan and Marvin Levich of Reed College, even though neither of them directly affected the writing of this book. The respective philosophical virtues of these two men are quite diverse, yet I believe that I can recognize the influence of both of them in this book. I hope they too are able to.

I am also thankful for conversations, carried on when the book was in its earliest stages, with William Davie, now of the University of Oregon, and Brian Grant, now of the University of Calgary. Those discussions concerning the nature of philosophy enabled me to put into this study whatever integrity it possesses.

I owe a monumental debt to my present and former colleagues of the philosophy department at UC Irvine: Gordon Brittan, Daniel Dennett, Eike-Henner Kluge, Karel Lambert, A. I. Melden, Stanley Munsat, Nelson Pike, Gerasimos Santas, and Peter Woodruff. Although each of these men has helped me with advice, information, criticism, and/or encouragement, I owe my debt to them more collectively than singly. For the intellectual and imaginative qualities, the dedication to philosophical discipline, and the geniality

and generosity which each individually possesses have worked together to provide the best possible atmosphere of intellectual and moral support for philosophical work. I sincerely believe that I could not have written this book in any other situation. Indeed, the departmental situation here has been so superlatively beneficial as to make it all the more clear to me that the defects of this book must be due to my own deficiencies.

I am grateful, also, for funds to support the research and preparation of this book provided by grants from the University of California Humanities Institute and the UC Irvine School of Humanities Research and Travel Committee and by a University of California Faculty Scholarship. An earlier version of Chapter One was published as "Expressive Predicates of Art" in *Artistic Expression*, edited by John Hospers (copyright © 1971 by Appleton-Century-Crofts, Educational Division, Meredith Corporation). It is included here, in revised form, by permission of the publishers. I would also like to thank Edward Allen, formerly with Instructional Media Services at the University of California, Irvine, for the photograph of the Watts Towers used on the dust jacket.

A special debt is owed my wife, Sharon. She has not only contributed her technical skills to the preparation of this book but has forced me to reconsider matters of substance in it as well. Much more important to me, however, has been her unquestioning confidence not only that I would complete my project, but that it would be significant. I hope the latter confidence will prove to be as greatly effective as the former has been.

I must fondly discharge one last debt. Everyone knows that books, like higher organisms, are likely to be sounder and more perfect if their gestation period is not curtailed.

PREFACE

It is important that one not publish prematurely. I therefore owe thanks to my children Billy, Alexander, Constantine, Deborah, Pier, Anne-Marie, and Christopher for helping to insure that this book was not shorter in the preparation.

Irvine, California
January 1972

G. S.

MIND AND ART

Introduction

❧

Expression is a characteristically Romantic idea, and understandably so. A notion held by many of the artists, critics, and philosophers of the Romantic Period is that the mind is an original source of human action and its products and perhaps even of Nature itself.[1] This idea contrasts with the typical seventeenth- or eighteenth-century view of the mind and its workings, of human acts and their products, as being derived, in a variety of ways, from non-mental Nature. According to the latter view, for example, ideas are copies of things, the intellect is a reflection of the world, art is an imitation of reality, language itself is merely a verbal image of our ideas and their relations, mental acts are simply a special kind of occurrence and/or process, and human activity in general is due, in the last analysis, to the operation of "external" causes upon the human organism. The favorite models of the mind during the pre-Romantic modern period were the theater, the tablet, the wax, and the mirror, which wait upon an external Nature to supply, respectively, its shows, its markings, its impressions, its images. The Romantics, however, preferred to think of the mind as a stream, a fountain, a candle, or a lamp. While

[1] I am quite aware of the "perils" of historical periodization and of other kinds of large-scale historical generalization. Needless to say, I do not intend this introduction as a contribution to Intellectual History. That is not to imply, however, that my historical remarks are not meant seriously. Philosophers should recognize in these pages a kind of "rhetorical history" used, and thereby sanctified, by a string of philosophers from Aristotle to Gilbert Ryle. An excellent scholarly exploration of some of the themes sketched in the following paragraphs is M. H. Abrams, *The Mirror and the Lamp: Romantic Theory and the Critical Tradition* (New York: Oxford University Press, 1953).

3

for Locke the mind is like a *camera obscura*, for the Romantics it is more like the sun. The radical difference in these sets of metaphors is obvious. The Romantic metaphors make of the mind a dynamic agency, a source of energy, while the pre-Romantic figures project the mind as a passive receiver, affected by alien agents and external sources.

The Romantic picture of the mind thus reverses the direction of the influence between Mind and Non-mind which was presumed in the best thought of the early modern period and as far back as Aristotle and Plato. But it is even more radical than that. When the Romantics thought of the human mind as an original source, the term "original" bore the connotation of "unique" as well as of "primary." To the Romantic, not only are the mind and things mental not "derived" from a non-mental Nature in the sense of being the *effects* of extra-mental factors, but they are also not derivative in the sense of being merely *special cases* of the sorts of objects, occurrences, processes, and/or events belonging to the non-mental universe. The mind thus "transcends" Nature in a Romantic view which shows a great deal of its Kantian ancestry. Even representations of the mind in terms of streams, fountains, candles, and lamps, therefore, are doomed to be metaphorical for they attempt to grasp mind and the mental in terms which cannot possibly be adequate. It is simply that fountains and lamps seemed to the Romantics to be apter metaphors of mind than tablets and mirrors.

The concept of expression suits this image of the mind, and the Romantics were pleased to have discovered it. "Expression," after all, immediately contrasts with "impression" as "pressing out" to "pressing in." It is of the utmost significance that "impression" was a favorite metaphor in pre-Romantic theories of mind, a metaphor which Hume raised to the status of a technical term. "Expression" was,

and is still, used in the literal sense of "pressing out"; juice is expressed from the grape, and oil from the olive. Here the picture of something inside coming out is direct and accurate, but it is carried over in our talk about expressing ideas and emotions as well, as the following story shows.

Peter expresses his feelings, but his brother Paul keeps his to himself. In fact, he keeps them bottled up too much; Peter is much the healthier for letting his emotions come out into the open. However, Paul is much more outspoken when it is a question of standing by principle. Both brothers are offended by the reactionary tirades on social and political matters by their rich grandfather, but Paul will often express his disagreement with his grandfather. Peter, the prudent one in these cases, counsels his brother to keep his opinions to himself lest Grandfather change his will.

Even Peter, however, was moved to outrage once by an especially stunning pronouncement from the old man. Unfortunately he was so dumbfounded that he could only stand there and sputter helplessly. "Oh, come out with it, boy," said Grandfather contemptuously. But Peter, completely unable to express himself, charged out of the room.

The incident with his grandfather had a profoundly disturbing effect on Peter. Waves of dissatisfaction and confusion—inchoate feelings—which he could neither analyze nor suppress welled up within him. He felt he had to get them out, purge them, but he did not know how until one day, as he was seated dully trying to write a routine essay for his freshman composition course, words seemed to flow from him. He found himself portraying a boy much like himself with strong feelings and opinions but overly cautious, ignobly prudent, and fatally

ineffectual when it counted. His portrait was cruel, but not pessimistic, for it depicted inner strengths which might outweigh and counteract the defects of the boy's character. When the burst of energy was expended, the essay completed, Peter knew that it was a good job. And, surprisingly, he found that his former frustrations and anxieties were drained from him. In carrying out that simple course assignment he had managed finally to express his feelings and attitudes towards himself, which in their dumb and confused state had disturbed him for so many days.

People who know the brothers Peter and Paul often comment on how different they are. Peter is the more impulsive, emotional, active one; Paul is more aloof, intellectual, and reserved. These fundamental traits come out in many different ways, even in their respective walking styles. Peter's brisk, loose, and swinging gait contrasts strikingly with Paul's slow, sedate, rigid and "contained" march. So we are not surprised, years later, when the boys own their own houses and join the suburban cult of gardening, to notice how even their gardens express their different personalities. Paul's is fenced, formal, and symmetrical, with neat paths and shaped trees and bushes. Peter's, though, consists of randomly scattered bulbs and annuals amidst a profusion of thickly growing trees and shrubs, the whole garden merging imperceptibly with the wooded area behind the house.

The absence of literary merit in the above story is really its virtue. For the use of clichés to describe cases of expressions (or the failure of expression) points out the image associated in the vulgar imagination with the concept of expression. It is an image of something internal coming out and affecting that which is "outside" the mind, such as bod-

ily movement, speech, and even one's "natural" surroundings. The language of the story shows, in short, how well-matched the common notion of expression is to the Romantic picture of the mind.

But if the term "expression" and its cognates suggest the originality of mind in the sense of its being an internal source, the characteristic uses of these terms also reinforce the idea that this internal source is a unique sort of thing. For despite the fact that etymologically "expression" denotes the purely mechanical act of pressing out, we do not imagine that the notion of pressing out gives us more than a metaphorical grasp of the expression of mental "things." There is a real difference here in the *sense* of "expression." We have only to think of ourselves jumping up and down in a tubful of grapes expressing both rage and juice in order to see that this is so. Therefore, except when it means "pressing out," "expression" and its relatives are used primarily where mind is at work. Thus there are linguistic expressions, artistic expressions, scientific and technical expressions; there are expressions of temperament, moods, and feelings, of ideas, opinions, and judgments.

We do, of course, talk of the expression of feelings in animals; but it is significant that such talk is more appropriate with respect to animals which are "psychologically" closer to man. When Darwin wrote of the expression of emotion in animals, he had the higher mammals in mind. The great apes, monkeys, horses, cats, and dogs express feelings; but earthworms, polyps, and jellyfish do not. And even then, monkeys can express more than sheep, dogs more than rabbits; in general, the more intelligent an animal is (or seems to us) the more does talk about its "expressions" seem apt. Furthermore, we all feel that attributing expressions or even "expressive properties" like anger or austerity to dumb nature, i.e. to earth, air, fire, or water, is

7

in some degree remarkable. Some of us even think that such attribution is primitive, childish, bizarre, or superstitious; and any thinker who takes such attributions too seriously is called names, like "anthropomorphist" or "panpsychist." For so close is the connection felt to be between "expression" and the human mind that to find expression in what is or appears to be non-mental seems at once to relocate the realm of mentality. Thus the Romantic intuition that the mind is "original" in the sense of being unique and radically different from the merely natural is reflected in the ways that we use the family of "expression" terms.

It is perfectly understandable, therefore, that a philosopher like, say, Gilbert Ryle, in his *The Concept of Mind* has nothing to say about the concept of expression. For this concept appears, on the face of it, to justify at least some of what Ryle ridicules, namely, that the mind is somehow a unique and "internal source" of what is "external" to the mind. But Ryle explains away the tendency to think of the mind as a special and inner source of the "outer." According to him, the tendency derives ultimately from a "philosopher's myth"; and the myth has its source in an intellectual dilemma. On the one hand, early modern philosophers were overly impressed by their mechanical model of the world and thus were led to think of everything, including the mind and its functions, in mechanical terms. But, on the other hand, since this picture of the mind appeared to conflict with religious and moral doctrines regarding the specialness of man, these thinkers were compelled to locate the workings of the mind in a hidden "internal" realm, quite distinct from the natural realm, but still understood in natural, that is, mechanical categories. Ryle might be correct in this explanation, of course, even if there were adequate *grounds* for thinking of the mind as a special, inner source of "external" acts and objects. Yet it is clear from Ryle's dis-

cussion that he excogitates this explanation—he certainly offers no historical *evidence* for it—precisely because he believes there are no adequate grounds for so thinking about the mind. But, as I have tried to show, taking the notion of expression seriously appears to present such a ground.

The concept of expression does not, however, offer a reason for holding that more specific opinion against which Ryle battles, namely that the mind operates in a paramechanical way from out of a secret and ultimately mysterious "place." The latter opinion was at least implicitly rejected by Romanticism also, even though it snatched at the idea of expression to represent its view that the mind is an original "inner" source of "external" things. From a Romantic point of view, Ryle has discarded the baby with the bath water; and he has done so because he has failed to see the importance of the concept of expression. For that concept apparently justifies the notion that the mind is "original" (in both senses) and "internal" as well, while it implicitly denies the validity of a mechanical, or any other *natural* model of mind, which might imply that mental things were *spatially* internal.

We might well ask, though, how it is, if the concept of expression does provide a ground for the originality and internality of the mind, that theorists of mind from Aristotle to Ryle could have been blind to the fact and have ignored the concept altogether. The answer lies in an ambivalence in the concept of expression itself. While on the one hand the concept carries those suggestions concerning the mind which the Romantics discovered in it, on the other hand it appears to bear no such theoretical freight. Indeed in many of their uses "expression" and its cognate terms seem to be eliminable in favor of expressions which do not at all suggest the originality of the mind at work, nor any drama of the inner becoming outer. The following are cases in point.

INTRODUCTION

(a) You tell me that Jacob was quite annoyed with me
for bringing up, during lunch, the story of his being cheated
by the television repairman. I am puzzled that that should
annoy anyone, especially Jacob, so I ask, in order to assess
your reading of his behavior, "Just how did Jacob express
those feelings?" Here, I want to know what *signs* of his feel-
ing he evinced or what *evidence* you have for your judg-
ment about Jacob. In this context there is no focus on
something "inside" pushing itself "outside," but rather on
an inference from one fact to another.

(b) When the newspaper article reports that the real es-
tate lobbyist expressed confidence that the sale of Yosemite
to private speculators would win Senate approval, this
would usually mean only that the lobbyist *said*, "We are con-
fident that the sale of Yosemite to private speculators will
win Senate approval," or made some other statement clearly
indicating his confidence.

(c) When I tell my aged mother that I will be on the first
pleasure flight to the moon, an expression of surprise and
dismay contorts her face and she cries, "Will I ever see you
again!" Clearly in this case what happens to Mother's face
is that a look of surprise and dismay comes over it; surprise
and dismay are "in" her face. Of course Mother's face looks
that way *because* she is surprised and dismayed; but the
use of "expression" here conveys not a drama of Mother's
emotions externalizing themselves in her face, but rather
the "look" of Mother's face.

(d) It has often been noticed that a characteristic of
Greek sculpture from early times to the fourth century B.C.
is that the faces are devoid of expression. This use of the
term "expression," however, does not suggest that Greek
sculptors portrayed human beings who "held back" or "held
in" their feelings. As in the preceding cases, "expression"
here apparently has no reference to psychophysical dynam-

10

ics. It is used rather to point out that the faces of Greek statues are neither happy nor sad, angry nor pleased, mean nor kind. "Expression" here quite simply refers to facial characteristics (or the lack of them).

(e) A similar use can be shown for the term "expressive." Thus we might say of Leonardo's Virgin of the Annunciation that her posture is as much expressive of dignity and restraint as of humility and subservience. But in this case there is not at all an issue of the Virgin's attitudes coming out or not coming out into the open, but simply a matter of describing her attitude. The term "expressive" might well be eliminated as a slightly wordy way of saying simply that the Virgin's posture is as dignified and restrained as it is humble and subservient.

(f) When a person is said to have, in general, expressive eyes or hands, we are to understand that the mentioned parts are especially animated or have a more than ordinary ability to *convey* ideas and feelings.

(g) Similarly, if art, language, science, and religion are spoken of as "forms of expression," nothing more need be meant by this phrase than that human ideas, feelings, and attitudes can be *conveyed* by these activities.

(h) Again, if an art critic were to turn from a discussion of the formal and stylistic properties of, say, Michelangelo's *Last Judgment* to a description of its expressive properties, he would simply go on to talk about the anguish, violence, and awful power visible in that work. He would not, in other words, have to discuss the *painter's* feelings of anguish, violence, or awful power, much less how these feelings of the artist got out onto the chapel wall.

(i) If, however, the same critic alleges that by making Christ's body thick and powerful and the Virgin cringing and relatively small, Michelangelo expressed the terribleness of a just God, the critic's use of "express" apparently

11

can be comfortably glossed as "depict," or "represent," or "portray." That is, in this sort of case the term "express" evidently does not designate a relation between a mental phenomenon and an externalized product of it but rather a relation between an art object and its subject matter.

(j) Finally, there is a very common use of the term "expression" in which it is prefixed by some linguistic or quasi-linguistic designation. Thus, there are slang, colloquial, or algebraic expressions. When the teacher of French asks her students to list as many French expressions as they can which serve as a greeting, they know she merely wants a list of words and phrases. This use of "expression" seems to be as far away as possible from the suggestion that something "inner" and "mental" is effecting something "outer" and non-mental.

The preceding list shows, above all, that "expression" and its cognates have a large variety of uses and/or senses with no apparent connection among them. And this fact is enough to put in question that "the" concept of expression could offer support for *any* theory of mind. Even more importantly, however, it shows that in a large number of their uses expression-terms do not carry even a hint of the Romantic picture of the mind. In fact, many of the meanings of "expression" and its relatives catalogued above suggest a picture of what is going on when expression occurs which is quite the opposite of the Romantic picture. They suggest not the mind's "originality" but its dependency upon the non-mental world. They invoke a number of models which either are based on non-mental phenomena or which present a direction of influence *from* the world *to* the mind. Thus the use of "expressions" in (j) above appears to designate a class of *objects*, albeit artifactual ones. And, although words and phrases may be more "abstract" than such artifacts as hammers and hoes (because they are "types" and

not merely "tokens"), this fact, it is commonly held, only makes them special *kinds* of objects. In (c), (d), (e), and (h), an obvious model for understanding what is going in these sorts of expression is the object-property relation. These uses of expression appear to involve nothing more than ascribing a certain property to Mother's face, the Virgin's posture, the gods' faces, or Michelangelo's fresco. In (f) the term "expressive" appears to denote nothing more noteworthy than a type of physical ability as do "agile," "flexible," or "swift." In (a) "expression" seems to involve signs and what they signify. But these signs appear to be not at all like billboards and traffic signals and rather a lot like the signs of spring or the signs of rain. The uses of "expression" and its cognates in (a), (b), (g), and (f), on the other hand, seem all to center around being informed. The "motion" involved here is either *from* the facts *to* a recipient mind or it is a motion easily seen in physical terms such as "conveyance" or "transmission." Finally, in (i) we have nothing but depiction, that is, the reproduction in paint of something quite "external" to Michelangelo and to us. And the natural presumption is that it is the external subject matter which controls the "expression" of it.

It is quite understandable, then, that to many philosophers the concept of expression would appear quite uninteresting and unremarkable and certainly no threat to any "naturalistic" theory of mind. But where then does the concept of expression lead us? "Nowhere" is one answer; "In two directions at once" is another. Either the notion is theoretically inert as far as the philosophy of mind is concerned, or it appears in itself to embody the opposition between two ways of considering the mind—between the idea of the mind as an original but non-natural "source" and the idea of the mind as a derivative part of a greater world.

The following study vindicates the concept of expression

13

as a topic of deep interest and of ultimate philosophical significance. It justifies the Romantic intuition that expressive phenomena overturn ancient, naturalistic models of the mind. "Expression" is indeed ambiguous; there are many more varieties of expressive phenomena than have usually been recognized. But I shall argue that many of the most interesting of these varieties presuppose a single, central sort of expression. I shall also argue that, despite superficial appearances, none of these varieties of expression can be understood on models like those suggested above in (a) through (j). I shall further argue that, much vulgar and philosophical opinion to the contrary, the "central" sort of expression can only be understood finally as upholding the Romantic view of the radical originality and irreducible internality of the mind.

Of course much depends on the outcome of the struggle, as I have interpreted it, between Romanticism and its enemies. A decision for the Romantic view is a decision for spontaneity and autonomy, for creativity and human freedom. We know this as well as did the Romantics, who were champions of freedom on many fronts. Why then is there such hostility, especially among philosophers, to a view of the human mind which would ground this freedom? (To see that there is such hostility one needs only consult one's own soul.) The theme of freedom is a theme of light. But, to many, the Romantics were harbingers of darkness. Characteristically defenders of freedom, the Romantics were also characteristically (though not universally) defenders of emotionalism, mythicism, and obscurantism. And it is not at all hard to discern these themes of darkness in the Romantic picture of the mind. A theory of mind resting on the notion of expression must heavily emphasize the emotions, since it is emotions which are most characteristically expressed. But, even more, a theory of mind which insists that the

EXPRESSIVE PROPERTIES OF ART

John Hospers, writing in the *Encyclopedia of Philosophy*, in effect, canonized the view.[2] Accordingly, I shall refer to it henceforth as the Canonical Position. Now despite the fact that it has illuminated the concept of expression in art, the Canonical Position is false in some respects and inadequate in others. In this chapter and the next two I shall argue (1) that attributions of "characters," or "anthropomorphic qualities," to works of art come in a number of different varieties, (2) that the simple thing-property relation is not an adequate model for understanding any of those varieties, (3) that there are far better reasons for calling art "expressive" than are allowed by the Canonical interpretation of Expression Theory, (4) that the presence of "anthropomorphic qualities" in works of art is not the only fact about art which makes it expressive, and (5) that the features of art which make it expressive have precise parallels in non-artistic areas of culture such as philosophy, historiography and science.

The Canonical Position has two incorrect presuppositions. The first is that works of art are very much like such natural objects as roses and apples as well as, I suppose, such natural quasi- and non-objects as hills, brooks, winds, and skies. The second is that the anthropomorphic predicates of art are not essentially different from simple color terms like "red" and "yellow." No one has seriously argued, as far as I know, that any art work is *just* like some natural "object." Everyone admits that there are basic differences between art and nature, most of them related to the fact that art is made by human beings and natural things are not. What the first presupposition of the Canonical Position amounts to, therefore, is that as far as the anthropomorphic predi-

[The] Encyclopedia of Philosophy, ed. Paul Edwards (New York: [Macmil]lan and The Free Press, 1967), I, 47.

mind is like nothing in Nature, even though it is a kind of "source" which is effectual in Nature, and which insists that the mind is an "inner" realm, even though it is in no way spatial, is incomprehensible. But, more perversely and invidiously, it appears to imply that an appeal to the obscure and paradoxical is itself illuminating and virtuous. A decision for the Romantic notion of mind, therefore, is apparently a decision for darkness over light.

The reader will probably have noticed that my characterization of "the Romantic theory of mind" is outrageously vague, brazenly metaphorical, and obnoxiously "literary." To admit, in addition to these sins, that I espouse a version of that theory, is to put myself, it seems, on Lucifer's side. Yet what I attempt in this book may seem even yet more brash. For in it I strive, in doggedly unromantic style, to eliminate precisely the metaphorical, paradoxical, and obscure elements in the Romantic notion as I have characterized it. I insist that we can have freedom *and* clarity. Such insistence may very well outrage both the defenders of darkness and the champions of light. At very least, the former may feel betrayed and the latter may remain suspicious. Possibly they will both be justified; perhaps this is the beginning merely of a long walk in the twilight.

Expressive Properties of Art

❧

Romantic ideas about mind and its relation to art did not receive their clearest expression until the twentieth century. Then philosophers like Croce, Collingwood, Cassirer, Dewey, and Langer tried to spell out exactly how it is that art can be expressive. But to many other twentieth-century philosophers, especially to those working in the various "analytical" styles whose intellectual ancestry was anything but Romantic, those philosophical discussions of expression in art were puzzling. This puzzlement can best be seen in the work of Monroe Beardsley and O. K. Bouwsma, philosophers who represent two distinct strains in recent analytical philosophy.

I think it is fair to understand the puzzlement of both Beardsley and Bouwsma in the following way. We understand relatively well what it is for a *person* to express such things as feelings, emotions, attitudes, moods, etc. But if we say that sonatas, poems, or paintings also express those sorts of things either we are saying something patently false or we are saying something true in an uninformative, misleading, and therefore pointless way. For to say of works of art that they express those sorts of things seems to imply that they are very much like persons. Therefore, unless we believe that philosophers who think of art as expression believe the unbelievable, that is, that art has feelings, attitudes, and moods and can express them, we must believe that such philosophers are trying, however inadequately, to come to grips with genuine truths about art.

16

Furthermore, there is such an obvious disparity b the nature of art and the thesis that art can express t' sorts of things that people do that we cannot un that thesis as simply a clumsy and inept way some truths about art. We must understand it, a kind of *theoretical* statement, that is, as a d contrived and elaborated way of construing s facts about art. Both Beardsley and Bouwsma of the "Expression *Theory*" of art.

What are the facts which the Expression Th to interpret? Although Beardsley and Bo slightly in the way they put the point, they ag of art have "anthropomorphic" properties. T often properly characterize works of art a gay, sad, witty, pompous, austere, aloof, in mental, etc. A "theory" of art as expressic say no more than that art works have prop by the same words which designate feelin tudes, moods, and personal characteristic

The nature of these properties has no deeply by analytical critics of the Expres ley calls them "qualities." Bouwsma "characters," pointing out their affinity of a number of things like sounds, faces. In case this suggestion is unhe invites us to conceive the relation art work in terms of the relation o a red apple. At this point he is exac who mentions a red rose instead

The Bouwsma-Beardsley posit pression in art is currently rathe

[1] Cf. Monroe Beardsley, *Aesthetic Criticism* (New York: Harcourt, Bra Bouwsma, "The Expression Theory ed. Max Black (Ithaca: Cornell Ú

cates are concerned works of art are not different from natural objects.[3]

It is fairly easy to show that this presupposition is false by the following strategy. Anthropomorphic predicates are applied to natural things in virtue of certain non-anthropomorphic properties of those things. Of course these properties vary, depending on the particular predicate as well as on the thing to which it applied. Hills, for example, may be austere in virtue of their color, their vegetation (or lack of it), or their contours; an ocean may be angry in virtue of its sound and the force and size of its waves; a tree may be sad in virtue of the droop and shape of its branches. With respect to a number of art works to which anthropomorphic predicates are applied, I shall inquire what it is about those works in virtue of which the predicates are applicable. This strategy will yield categorial features of art which do not belong to natural things.

(1) Like most of Raphael's Madonna paintings, the one called *La Belle Jardinière* can be described as calm and serene. It is fairly clear what there is about this painting which makes it calm and serene: the regular composition based on an equilateral triangle, the gentle and loving expressions on the faces of the Mother, the Child, and the infant John the Baptist, the placid landscape, the delicate trees, the soft blue of the sky, the gentle ripples in the Mother's garments blown by a slight breeze, and, finally, the equanimity and quiet with which the artist views his subject and records the details of the scene.

(2) We might reasonably describe Hans Hofmann's *The Golden Wall* as an aggressive abstract painting. But in this painting there is no representational content in the usual

[3] I hope it is clear that throughout this discussion the emphasis is on "natural," not on "object." But I will, for convenience, use the terms "object" and "thing" to cover non-objects and non-things as well.

sense and therefore nothing aggressive is depicted. What is aggressive is the color scheme, which is predominantly red and yellow. Blue and green are also used as contrasting colors, but even these colors, especially the blue, are made to look aggressive because of their intensity. Furthermore, by the way they are juxtaposed, the patches of color are made to appear as though they were rushing out towards the observer and even as though they were competing with one another in this rush towards the observer.

(3) We might say of Poussin's *The Rape of the Sabine Women* (either version, but especially the one in the Metropolitan Museum of Art in New York City) that it is calm and aloof. Yet it is quite clear that the depicted scene is *not* calm and that no one in it, with the possible exception of Romulus, who is directing the attack, is aloof. It is rather, as we say, that *Poussin* calmly observes the scene and paints it in an aloof, detached way.

(4) Breughel's painting called *Wedding Dance in the Open Air* can be aptly if superficially described as gay and happy. In this case however it is surely the occasion and the activities of the depicted peasants which are happy. Perhaps the prominent red used throughout the painting can be called "gay." The faces of the peasants however are neither happy nor gay. They are bland, stupid, and even brutal. It is this fact which makes the painting ironic rather than gay or happy. Yet there is certainly nothing about a peasant wedding, the dull peasants, or their heavy dance which is ironic. The irony lies in the fact that the painter "views," "observes," or depicts the happy scene ironically.

(5) John Milton's "L'Allegro" is not only "about" high spirits, but it is surely a high-spirited, i.e. gay and joyful, poem. The gaiety and joy are evident in several ways. First, the scenes and images are gay and joyful: Zephir playing with Aurora, maids and youths dancing and dallying, the

poet himself living a life of "unreproved" pleasure with Mirth. Second, the diction and rhythms are light-hearted: "Haste thee nymphs and bring with thee / Jest and youthful Jollity, / Quips and Cranks, and wanton Wiles, / Nods, and Becks and Wreathed Smiles."

(6) Another sort of example entirely is William Wordsworth's sentimental poem "We Are Seven." This poem is quite obviously not *about* sentimentality. It purports simply to record the conversation between the poet and a child. Neither the child nor the poet (that is, the "character" in the poem), moreover, is sentimental. The child matter-of-factly reports her firm conviction there are still seven members of her family despite the fact that two of them are dead. The poet is trying, in a rather obtuse and hard-headed sort of way, to get her to admit that there are only five. But the little girl is made to win the point by having the last word in the poem. She is thus made to seem "right" even though no explicit authorization is given to her point of view. By presenting the little girl's case so sympathetically, Wordsworth (the poet who wrote the poem, not the "character" in the poem) treats the attitude of the little girl, as well as the death of her siblings, sentimentally.

(7) The case of "The Dungeon" by Coleridge is different again. At least the first half of this poem is angry. But it is not about anger or angry persons. It is a diatribe in verse (and certainly not a poor poem on that account) against the cruelty, injustice, and wasteful ineffectiveness of prisons.

(8) T. S. Eliot's "The Lovesong of J. Alfred Prufrock" can, with considerable justice, be called a compassionate poem. In this case it is quite clear that the compassion exists in the way in which the character Prufrock is portrayed as a gentle and sensitive, if weak, victim of ugly and sordid surroundings.

(9) Suppose that we say that the second movement of

21

Beethoven's "Eroica" symphony is sad with a dignified and noble sadness characteristic of Beethoven. In this case the sadness is in the slowness of the tempo, and the special quality of the sadness comes from the stateliness of the march rhythm, from the use of "heavy" instruments like horns and tympani and from the sheer length of the movement.

(10) A somewhat different case is presented by Mozart's music for Papageno, which is gay, carefree, light-headed and light-hearted like Papageno himself. What differentiates this case from (9), of course, is that the Mozart music is intended to suit a certain kind of character, whereas the Beethoven has no clear and explicit "representational" content. Despite this difference, however, the "anthropomorphic qualities" of the Mozart music are, like those of the Beethoven, audible in properties of the sound: in the simple harmonies, tripping rhythms, and lilting melodies of Papageno songs.

(11) A slightly different case from either (9) or (10) is that presented by the first movement of Vivaldi's "Spring" Concerto. The first lilting, happy theme represents the joyful advent of spring. This is followed by the gentle music of the winds and waters of spring. Next, this pleasantness is interrupted by the angry music representing a thunder shower, after which the happy, gentle music returns. In this music the "programmatic" content is clear and explicit because we know the poetry from which Vivaldi composed the music.

(12) Quite different from the three cases immediately preceding is the witty Grandfather theme from Prokoviev's *Peter and the Wolf*. Grandfather's music, played by a bassoon, is large, lumbering, and pompous like Grandfather himself. But what makes it witty is that it portrays a dignified old man as just a bit ridiculous. Through the music

Prokoviev pokes gentle fun at the old man, fun which is well-motivated by the story itself. For in the end Peter turns out to be more than equal to the danger which Grandfather has ordered him to avoid.

(13) Finally, there is music like the utterly impersonal and detached music of John Cage, exemplified in *Variations II* played by David Tudor on (with) the piano. But where can we locate the "qualities" of impersonality and detachment in Cage's music? They do not seem to be "properties" of the sounds and sound-sequences in the way that gaiety is a property of Papageno's music or sadness is a property of Beethoven's. Indeed, we feel that these "anthropomorphic qualities" of Cage's music depend on the very fact that the sounds themselves are completely lacking in "human" properties. They are as characterless as any of a thousand random noises we hear every day. In fact, *Variations II* does have the apparent randomness and disorganization of mere noise. But we would not be inclined to call *any* random sequences of noises "impersonal" and "detached," even if they sounded very much like the sounds of *Variations II*. The predicates "impersonal" and "detached" are not applied to Cage's music simply in virtue of some features of its sounds. These "qualities" of *Variations II* arise rather from the fact that the composer presents what sounds like mere noise as music. Cage offers this "noise" for us to attend to and concentrate upon. Moreover, he offers it to us without "comment," and with no intention that it evoke, represent, or suggest anything beyond itself. That is to say, Cage offers these noise-like sounds in a totally uninvolved, detached, impersonal way, seeking in no way to touch our emotional life.

From the preceding examples we can see that there are some respects in which anthropomorphic predicates are applied to works of art in virtue of features of those works

which they share or could share with some natural things. In the Raphael it is the composition of the painting which accounts in part for the "calm" of the painting. But "composition" here refers simply to the configuration of lines and shapes, which sorts of features can of course be shared by natural objects. Similarly, the aggressiveness of Hofmann's painting is due to its colors and their arrangement. In the Beethoven and Mozart examples the anthropomorphic qualities are traceable to features of sound which can be present in natural phenomena. The ocean crashing on the shore, a twig tapping against a windowpane, the gurgle of a stream—all of these can have "tempi," "rhythms," and even "tone color." Natural "melodies" are present in the rustle of trees and the howl of winds as well as in the songs of birds. Even the anthropomorphic qualities of verbal art can be like properties of natural things. For, as the example of "L'Allegro" shows, such qualities can be attributed to poetry at least partly in virtue of the tempo and rhythm of its verses.

Some of the above examples of anthropomorphic qualities applied to art, however, show that such qualities sometimes belong to works of art in virtue of what those works represent, describe, depict, or portray. Thus the calm and serenity of the Raphael is due in part to the countryside, the sky, the garments, and the faces depicted; the gaiety of the Breughel comes from the gaiety of the depicted scene, and the high spirits of Milton's poem are due to the gay, happy scenes and images described and presented. In cases of this sort, neither paintings nor poems are comparable to natural things with respect to the way they bear their anthropomorphic qualities. And the situation is similar with respect to all other forms of representational art, whether prose fiction, drama, ballet, opera, or sculpture. Only architecture and music are generally incapable of bearing an-

thropomorphic qualities in this way. This is true, moreover, even for music with a sort of representational content such as the Mozart music mentioned in (10) above. For it is not due to the fact that Mozart's songs are written for a gay, lighthearted character that they are properly described as gay and lighthearted. It is rather that the songs suit Papageno precisely in virtue of the gaiety and lightheartedness of their "sound" and are thereby capable of portraying him musically.

There is a second way in which anthropomorphic predicates may be applied to art works which is unlike the ways in which such predicates apply to natural things. In the discussion of (1) through (13) above we discovered the following:

(a) *La Belle Jardinière* is calm and serene partly because Raphael *views* his subject calmly and quietly.

(b) *The Rape of the Sabine Women* is aloof and detached because Poussin calmly *observes* the violent scene and *paints* it in an aloof, detached way.

(c) *Wedding Dance in the Open Air* is an ironic painting because Breughel *treats* the gaiety of the wedding scene ironically.

(d) "We Are Seven" is a sentimental poem because Wordsworth *treats* his subject matter sentimentally.

(e) "The Dungeon" is an angry poem because in it the poet angrily *inveighs* against the institution of imprisonment.

(f) "The Lovesong of J. Alfred Prufrock" is a compassionate poem because the poet compassionately *portrays* the plight of his "hero."

(g) Prokoviev's Grandfather theme is witty because the composer wittily *comments* on the character in his ballet.

(h) Cage's *Variations II* is impersonal because the com-

25

poser *presents* his noise-like sounds in an impersonal, un-involved way.

I have italicized the verbs in the above in order to point up the fact that the respective anthropomorphic predicate is applied to the work of art in virtue of what the artist *does* in that work. In order to have a convenient way of referring to this class of anthropomorphic predicates, I shall henceforth refer to what verbs of the sort italicized above designate as "artistic acts." I do not intend this bit of nomenclature to have any metaphysical import. That is, I do not mean that the viewings, observings, paintings, presentings, portrayings, and treatings covered by the term "artistic acts" all belong to a category properly called "acts." Nor do I mean that all activities properly called "artistic" are covered by my term "artistic act." As shall come out later, many artistic activities are neither identical with, constituents of, nor constituted by "artistic acts." Furthermore, I do not want to suggest that "artistic acts" have anything more in common than what I have already pointed out and what I shall go on to specify. To do a complete metaphysics of artistic acts might be an interesting philosophical job but one which would distract me from my main purposes in this book.

WHAT the preceding discussion has shown is that the view of art presupposed by the Canonical Position ignores complexities in works of art which are essential in understanding how they can bear anthropomorphic predicates. Even more significant is the discovery that anthropomorphic predicates apply to art works in virtue of "artistic acts" in these works. For, as I shall argue presently at length, it is precisely this feature of art works which enables them to be *expressions* and which thereby shows that the Canonical Position has missed a great deal of truth in classical Expression Theory.

26

As far as I know, no adherent of the Canonical Position, with one exception to be noted below, has recognized the existence of what I call "artistic acts," much less seen their relevance to expression in art. But it is not difficult to anticipate the first defensive move a proponent of the Canonical Position would likely make against the threat posed by "artistic acts." It would go somewhat as follows. What the "discovery" of "artistic acts" shows is merely that not all applications of anthropomorphic predicates to art works attribute qualities to those works. They merely *seem* to do so because of their grammatical form. But in fact statements of this sort say nothing at all about the art work; they describe the artist. After all, "artistic acts" are acts of the artists, and they cannot possibly be acts of (i.e. performed by) the art works themselves.

However superficially plausible this objection is, it can be shown to have little force. First, the objection presupposes a false dichotomy: a statement must be descriptive either of a work of art *or* of its artist. On the contrary, there seems to be no reason why when we talk in the above examples of the painting's aloofness, the poem's sentimentality, etc., we cannot be talking *both* about the painting or poem and about how Poussin painted or how Wordsworth treated his subject. And it is in fact the case that we are talking about both. The best proof of this is that the *grounds* for the truth of the descriptions of artistic acts in (a) through (g) above can come from the art work in question. One knows by looking at Poussin's painting that he has painted the scene in an aloof, detached way. The cold light, the statuesque poses, the painstaking linearity are all visible in the work. Similarly, we recognize by reading Wordsworth's poem that he treats his subject sentimentally. That is just what it is to give the child, who believes that the dead are present among the living, the advantage over the

matter-of-fact adult. We can also recognize the impersonality of *Variations II* by listening to its neutral, noise-like sounds. A test for statements describing art in anthropomorphic terms is always and quite naturally a scrutiny of the art, even when the terms are applied in virtue of "artistic acts."

Moreover it is not as if this sort of attention to the work of art were merely a second-best way of testing such statements. One does not look, listen, or read in order to *infer* something about the aloof way Poussin painted, the compassionate way Eliot portrayed his hero, etc. We must not imagine that had we actually been with the artist at work, we could *really*, i.e. immediately and indubitably, have seen his aloofness, compassion, sentimentality, etc. How absurd to think that when Poussin's way of painting is described as aloof, what is meant is that Poussin arched his eyebrows slightly, maintained an impassive expression on his face, and moved his arms slowly and deliberately while he painted the picture. Or that because Eliot portrays Prufrock compassionately, he penned the manuscript of his poem with tears in his eyes. Not only would such facts not be needed to support statements about Poussin's aloofness or Eliot's compassion, but they are totally irrelevant to such statements. For even if we knew the way Poussin looked and moved when he was painting the Sabine picture or the way Eliot's face looked when he penned "Prufrock," we could not infer that the painting and poem were, respectively, aloof and compassionate in the ways we are discussing.

The foregoing considerations do not mean that the "artistic acts" in question are not truly acts of the artists, that is, are not truly something which the artists have done. Nor do they imply that these artistic acts are phantom acts, airy nothings existing mysteriously in works of art and disem-

bodied from any agents.[4] They simply mean that these acts are not identifiable or describable independently of the works "in" which they are done. Probably nothing makes this point clearer than the fact that descriptions of artistic acts of this sort can be known to be true even when little or nothing is known about the author, much less what he looked like and what his behavior was like at the precise time that he was making his art. It can be truly said, for example, that Homer describes with some sentimentality the meeting of the returned Odysseus and aged dog Argos. And yet it would be absurd to say that the truth of that statement waits upon some detailed knowledge about Homer, even the existence of whom is a matter of considerable dispute.

Artistic acts are peculiar in that descriptions of them are at once and necessarily descriptions of art works. They are in this way distinguishable from other sorts of acts of artists which contribute to the production of works of art, e.g. looking at the canvas, chiseling marble, penning words, applying paint, revising a manuscript, thinking to oneself, etc. But artistic acts, for all their peculiarity, are not entirely alone in the universe; there are other sorts of things which people do which are analogous to artistic acts in significant ways. Note the following: A person may scowl angrily, and thereby have an angry scowl on his face; he may smile sadly and thereby have a sad smile on his face; he may gesture impatiently and thus make an impatient gesture; he may shout defiantly and produce thereby a defiant shout;

[4] Nor are they "virtual," i.e. unreal, acts, as I have maintained in another place. Cf. my "Perceptual Acts and Pictorial Art: A Defense of Expression Theory," *Journal of Philosophy*, LXII (1965), 669-677. Giving these acts a separate and unusual metaphysical status not only complicates the universe needlessly, it is unfaithful to the common-sense facts of the situation. There are no good reasons to deny what our ways of talking implicitly affirm, namely, that "artistic acts," perceptual and otherwise, are "acts" of the artist.

he may pout sullenly and a sullen pout will appear on his face; his eyes may gleam happily and there will be a happy gleam in his eyes; he may tug at his forelock shyly or give a shy tug at this forelock. What is interesting about these clauses is that they show how an anthropomorphic term can be applied either adverbially to "acts" or adjectivally to "things" without a difference in the sense of the term or of the sentences in which it is used. This sort of shift in the grammatical category of a term is clearly analogous to what is possible with respect to those anthropomorphic predicates applied to works of art in virtue of their artistic acts. Thus one may, without change of meaning, say either that Eliot's "Prufrock" is a compassionate poem or that Eliot portrays Prufrock compassionately in his poem; that Poussin paints his violent scene in an aloof, detached way or that the Sabine picture is an aloof, detached painting.[5]

This grammatical shift is possible in both sorts of cases because of the inseparability of the "act" and the "thing." One does not *infer* from a smile on a person's face that he is smiling any more than one *infers* that Eliot portrayed Prufrock compassionately from his compassionate poem, and for analogous reasons. The "acts" of smiling, pouting, shouting, tugging are not even describable without also and at once describing the smile, pout, shout, or tug. Smiling, after all, is not an act which produces or results in a smile so that something could interfere to prevent the smiling from bringing off the smile. "Smiling" and "smile," we are

[5] Of course it is true that sometimes when anthropomorphic terms are predicated of art works, they apply to subject matters and to "material" aspects of the work such as lines, colors, sounds, masses, etc., as well as to "artistic acts." My point above is only that anthropomorphic adjectives may be applied to a work only in virtue of an artistic act, in which case it is, without change of meaning, immediately applicable in adverbial form to that act.

inclined to say, are simply two grammatically different ways of referring to the same "thing."[6]

Now the parallel I want to point out is not between smile-smiling, pout-pouting, tug-tugging, on the one hand, and poem-portraying, picture-(act of) painting, music-presenting, on the other. For clearly Poussin's Sabine painting is more than (is not simply identical with) Poussin's aloof way of painting the violent scene; Eliot's poem is more than his compassionate way of portraying its title character; Cage's music is more than his impersonal presentation of noise-like sounds. When we have described these artistic acts we have not by any means completely described the respective art works. The analogy rather is between smile-smiling and portrayal-portraying, presentation-presenting, treatment-treating, view-viewing, etc. Therefore, when we designate artistic acts by a noun term, those acts seem to be "parts" or "moments" of the works of art to which they pertain. We may then more properly understand the way in which an anthropomorphic adjective applies to an art work in virtue of such a "part" in something like the way in which a person's whole face is called sad in virtue merely of his sad smile or his sad gaze, or in which a person's behavior is generally angry in virtue (merely) of his quick movements and angry tone of voice. In these cases, too, it is not as if the terms "sad" and "angry" *completely* described the face or the behavior or even all parts and aspects of the face and behavior even though they can *generally* characterize the face and the behavior.

[6] It is no objection to this assertion that in virtue of the natural lay of their faces some people have perpetual "smiles," "smirks," "pouts," etc., on their faces even when they do not smile, smirk, or pout. Of course a "smile" of this sort is different from a smile; that is what the scare quotes signify. But even though a person with such a "smile" on his face is not thereby smiling, he is, significantly, "smiling."

The foregoing comparison points out that not only is it the case that anthropomorphic predicates do not always apply to art works the way predicates, anthropomorphic or not, apply to natural objects, but that sometimes anthropomorphic predicates apply to works of art rather like the way that they apply to verbal, gestural, and facial *expressions*. For sad smiles are characteristic expressions of sadness in a person; angry scowls, of anger; shy tugs at forelocks, of diffidence; sullen pouts, of petulance. And this is an all-important point which the Canonical Position has missed in its interpretation of the Expression Theory of Art. Had proponents of the Canonical Position pursued their inquiry into anthropomorphic predicates further, they would have been forced to question whether such predicates apply to art in the way they apply to objects or in the way they apply to common human expressions.

Instead of pursuing this line of questioning, however, they were misled by the noun-adjective form of their favorite example—sad music—into their object-quality interpretation of Expression Theory, an interpretation which of course makes that "theory" seem very far removed indeed from the "facts" which were alleged to have motivated it. Small wonder that Beardsley's final judgment on Expression Theory is that it "renders itself obsolete" after it has reminded us that anthropomorphic predicates may reasonably be applied to art works. Even O. K. Bouwsma, who of all the proponents of the Canonical Position comes closest to the point I am maintaining, was not able to see quite where his comparison between sad music and sad faces leads. For instead of making a transition from sad faces to sad *expressions* on faces, he takes the (rather longer) way from sad faces to red apples.

There is more to the comparison between artistic acts and facial, vocal, and gestural expressions than the formal

32

or grammatical similarities just noted. Even more important are the parallels between the "significance" of things like sad smiles and angry scowls and the "significance" of aloofness or irony in paintings, sentimentality or compassion in poems, and impersonality or wittiness in music. For there are parallels between what facial, gestural and vocal expressions, on the one hand, and artistic acts, on the other, can tell us about the persons responsible for them. In order to draw out these parallels explicitly I shall use the cases of an angry scowl and a compassionate portrayal in the mode of Eliot's "Prufrock."

First, it is obvious that an angry scowl on a person's face might well mean that the person is angry. It might be more than simply an expression of anger; it might be an expression of *his* anger. Now it should need very little argument to show that a compassionate poem like "Prufrock" might be an expression of the poet's own compassion. He might be a person with a generally sympathetic and pitying attitude towards modern man and his situation. In that case, a poem like "Prufrock," at least a poem with "Prufrock's" kind of compassion is precisely what one could expect from the poet, just as one could expect an angry man to scowl angrily. But just as we cannot reasonably expect that *every* time a person is angry he scowls angrily, we cannot expect that every man who is a poet and who has compassion towards his fellows will produce poetry with the compassion of "Prufrock." If a man can keep his anger from showing in his face, a poet can, with whatever greater difficulties and whatever more interesting implications for himself and his poetry, keep his compassion from showing in his poetry.

Moreover, just as there is no necessity that a man's anger show in his face, there is no necessity that an angry scowl betoken anger in the scowler. There is a looseness of connection between anger and angry expressions which is

33

matched by a looseness between compassion and compassionate poems. One reason that a man might have an angry scowl on his face is that he is *affecting* anger, for any of a number of reasons. Now although the range of reasons for affecting compassion in his poetry might be different from the range of reasons for affecting anger in his face, it is nevertheless possible that a corpus of poetry with "Prufrock's" sort of compassion might betoken nothing more than an affectation of compassion. This might be the case if, for example, the poet is extremely "hard" and sarcastic but thinks of these traits as defects. He might then quite deliberately write "compassionate" poetry in order to mask his true self and present himself to the world as the man he believes he should be.

On the other hand, both angry scowls and compassionate poetry might be the result simply of a desire to imitate. Children especially will often imitate expressions on people's faces, but even adults sometimes have occasion to imitate such expressions, e.g. in relating an anecdote. A poet might write poems with Eliot's sort of compassion in them in imitation of Eliot's early attitude. This imitation might be executed by a clever teacher in order to show more vividly than by merely pointing them out the means Eliot used to convey his special sympathy in "Prufrock." Or Eliot might be imitated because his techniques and style, together with the attitudes they imply, have become fashionable among serious poets or because these attitudes strike a responsive chord among serious poets. The latter sorts of imitation are rather like the imitations which a child might make of a person whom he regards as a model. It is not unusual for a girl who admires a female teacher, say, to practice smiling in that teacher's kind, gentle way or for a very young boy at play to "get angry" in the same way he has seen his father get angry.

A poet might write poems with the compassion of "Prufrock," not because he is either affecting or imitating the attitude of that poem, but because he is *practicing* writing poetry in different styles and different "moods." This may be just something like a technical exercise for him, or it may be part of a search for a characteristic attitude or stance which seems to be truly "his own." He thus "tries on" a number of different poetic "masks," so to speak, to see how they fit him. In a similar way, an adolescent girl grimacing before her mirror might "try on" various facial expressions to see how they "look on her" and to discover which is her "best," or perhaps her most characteristic face: innocent, sullen, sultry, haughty, or even angry.

Finally, an angry scowl on a face might be there when the person is portraying an angry person on the stage. There is a similar sort of situation in which compassionate poetry might be written not as betokening a characteristic of the poem's real author but as betokening the traits of a *character* in a play or novel who is *represented* as having written the poem. No actual examples of such a character come immediately to mind; but we surely have no trouble imagining a master of stylistic imitation writing a novelized account of modern literature in which he exhibits examples of the "Prufrock"-like poetry of an Eliot-like figure.

What I have argued so far is not that all art is expression, nor even that all art works with artistic acts anthropomorphically qualified are expressions. My argument shows only that artistic acts in works of art are remarkably like common facial, vocal, and gestural expressions. It also demonstrates that precisely in virtue of their artistic acts and of the similarity they bear to common kinds of expressions, works of art may serve as expressions of those feelings, emotions, attitudes, moods, and/or personal characteristics of their creators which are designated by the anthropomorphic pred-

icates applicable to the art works themselves. And it thereby demonstrates that one presupposition of the Canonical Position is clearly wrong: namely, that art works, insofar as they allow of anthropomorphic predicates, are essentially like natural things untouched by man.

BUT the second presupposition of the Canonical Position, to wit, that anthropomorphic predicates of art are like simple color words, is also false. It is false with respect to all of the three ways, distinguished earlier, that anthropomorphic predicates can be applied to works of art. And it is *a fortiori* false with respect to those predicates which are applied to art in two or three ways at once, as most of them are. The falsity of the presupposition can be brought out in an interesting way by showing how the three ways of applying anthropomorphic predicates to art bear a certain resemblance to color attributions which are rather unlike simply calling a (clearly) red rose red or an (indubitably) green hill green.

Suppose that a sign painter is painting a sign in three colors: yellow, red, and blue. Since the sign is large, he is required to move his equipment several times during the job. Suppose that he employs an assistant to attend to this business. Now we can imagine that the painter will have occasion to give directions to his assistant. He might say, "Bring me the red bucket, but leave the blue and yellow ones there, since I'll need them on that side later." Now if we suppose that the color of all the paint containers is black, when the painter calls for the "red bucket," he must mean "the bucket of red paint," and would surely be so understood by his assistant. In the context the phrase "red bucket" only *appears* to have the same grammatical form as "red rose." I suggest that to the extent that a painting or other representational work of art is called "gay" or "sad" solely

in virtue of its subject matter or parts thereof, the latter terms function *more* like "red" in "red bucket" than in "red rose."

It is a common opinion that "sad" in "sad smile" and "gay" in "gay laughter" function metaphorically.[7] There may well be a use of "metaphor" such that the opinion is true. Whether there is such a use will not be determined until there exists a thorough philosophical study of metaphor; and I do not intend to offer one here. But even if it turns out to be true that such uses of anthropomorphic words are metaphorical, it cannot be very useful simply to say it. For such uses *appear* not to be metaphorical at all. After all, it is not as if calling a smile sad were representing the smile as, as it were, feeling sad, acting sad, weeping and dragging its feet. To see a smile's sadness is not to discern the tenuous and subtle "likeness" between the smile and a sad person. It is much more straightforward to think that a smile is sad because it is a smile *characteristic* of a sad person who smiles; that laughter is gay because such laughter is *characteristic* laughter of persons who are gay. In this respect "sad smile" is rather like "six-year-old behavior" or "Slavic cheekbones." These phrases do not indirectly point to unexpected similarities between a sort of behavior and six-year-old children or between cheekbones and persons. They designate, respectively, behavior which is *characteristic* of six-year-old children and cheekbones *characteristic* of Slavs. And there is no inclination at all to call these phrases "metaphorical."

[7] Nelson Goodman's recent theory of expression seems to depend rather heavily on the opinion that such uses of anthropomorphic predicates are metaphorical. As far as I can tell, however, Goodman merely asserts and does not argue for this opinion. Nor does he offer anything more than the briefest sketch of a theory of metaphor, which could be used to support his assertion. See his *Languages of Art: An Approach to a Theory of Symbols* (Indianapolis: Bobbs-Merrill, 1968), pp. 50-51, 80-95.

Yet to say that a sad smile is a smile characteristic of sad people is not to deny what the Canonical Position affirms, namely, that "sad" designates a "property" or "character" of the smile. Surely there is something about the smile which marks it as sad: its droopiness, its weakness, its wanness. But the term "sad" still has a different import from "droopy," "weak," or "wan" when applied to smiles, even though all the latter terms are also characteristic smiles of sad persons. The difference is that the term "sad" *explicitly* relates the character of the smile to sadness of persons. A comparable sort of color term might be "cherry red." "Cherry red" is like the term "bright red with bluish undertones" in that they both designate roughly the same shade of red, which is characteristic of cherries. But the former term is unlike the latter in that it *explicitly* relates the color to cherries.

It might seem that the Canonical Position would be correct in its interpretation of anthropomorphic terms as they apply to those features of works of art which they can share with natural things. For the term "sad" applied to the second movement of the "Eroica" and to a weeping willow must surely denote some properties of the music and of the tree. And they do: drooping branches in the tree; slow rhythm and "heavy" sound in the Beethoven. But "sad" differs from "drooping," "slow," and "heavy" as in the preceding case; it immediately relates the properties of the sounds and the branches to properties of other things which are sad. In these cases "sad" does function metaphorically, harboring, as it were, a comparison within itself. To find an analogy among color words, this use of "sad" is like "reddish." Like "reddish," which quite self-consciously does not denote true redness, "sad" in "sad tree" does not denote true sadness but only a kind of likeness of it. This use of "sad" is also arguably analogous to the use of "red" in "His face turned red with shame." But whether "sad tree" and "sad rhythm" are closer to "reddish clay" or to "red face" is, if determinable

at all, unimportant for my point. For "reddish clay" and "red face" are equally unlike "red rose" and "red apple" when the latter refer to a full-blown American Beauty and a ripe Washington Delicious.

In this section I have argued that anthropomorphic terms, when applied to art, are *more* like "red" in "red bucket (of paint)," "cherry red" in "cherry red silk," or "reddish" in "reddish clay" than like "red" in "red rose." But, in truth, anthropomorphic predicates of art are not *very* much like any of these. The reason is that what all anthropomorphic predicates ultimately relate to are human emotions, feelings, attitudes, moods, and personal traits, none of which are very much at all like colors. But there is point in drawing out the comparison between anthropomorphic predicates and color-terms more complicated than "red" in "red rose." The point is that "red" as applied to bucket, "cherry red," and "reddish" are all in some way relational terms in ways that "red" said of a rose is not. "Red bucket" means "bucket *of* red paint"; "cherry red" means "the red *characteristic of* cherries"; and "reddish" means "of a color *rather like* red." Had proponents of the Canonical Position troubled to refine their comparison between anthropomorphic predicates and color predicates, they might have been forced to recognize the relational aspects of the former. Eventually they might have been led to see that anthropomorphic terms finally relate to various forms of the "inner lives" of human beings. And *that* is where Expression Theory begins. The Canonical model of the red rose (or apple) ultimately fails to help us understand how anthropomorphic predicates apply to art because such predicates are not very much like simple quality-words and what they apply to are not very much like natural objects.

In spite of all of the above arguments, the Canonical Position is not left utterly defenseless. Although it is the notion

of "artistic acts" which is most threatening to the Canonical Position, proponents of that position have been almost totally unaware of this threat. Not totally unaware, however. There is a brief passage in Monroe Beardsley's book *Aesthetics: Problems in the Philosophy of Criticism* in which he mentions an artist's "treatment" and "handling," two examples of what I have called "artistic acts." Beardsley does not relate them, however, to the analysis of anthropomorphic terms. He discusses them under the rubric "misleading idioms," and he suggests that all talk about art concerning "handling" and "treatment" not only can be but should be translated into talk which makes no mention of these sorts of acts.[8]

These are meager clues, but from them it is possible to excogitate an objection to my notion of "artistic arts" which a defender of the Canonical Position might raise. We should first note a remark which Beardsley makes elsewhere in his book when he is concluding his interpretation of Expression Theory. He states that all remarks about the expressiveness of an art work can be "translated" into statements about the anthropomorphic qualities either of the subject matter or of the "design," i.e. roughly the properties which the work could share with natural things.[9] A defense against the notion of "artistic acts" might thus run as follows: Any statement which describes an artistic act anthropomorphically can be "translated" into a statement which describes features of the work of art other than its artistic acts. So stated, however, the defense is ambiguous; it has two plausible and interesting interpretations. First, it might mean that any anthropomorphic description of an artistic act in a work can be replaced, without loss of meaning, by a description of the subject matter and/or design of the work in terms of the same anthropomorphic predicate. Or it might mean

[8] Beardsley, *Aesthetics*, pp. 80 ff. [9] *Ibid.*, p. 332.

that there are descriptions, of whatever sort, of the subject matter and/or design of a work which, given any true anthropomorphic description of an artistic act in that work, entail that description.

The first interpretation of the objection is easily shown to be false. All that is required is that some examples of art be adduced in which anthropomorphic predicates are applicable with some plausibility to an "artistic act" but which are in no other way plausibly attributable to the work. Let us look again at the works of Poussin, Eliot, and Prokoviev discussed earlier in this chapter.

In the Poussin painting of the rape of the Sabines there is nothing about the violent subject matter which could be called "aloof." Certainly the attackers and the attacked are not aloof. Romulus, the general in charge, is a relatively *calm* surveyor of the melee, but he cannot be called aloof, partly because we cannot see him well enough to tell what his attitude is. "Aloof" does not apply with regard to the formal elements of the Poussin painting either. It is difficult even to imagine what "aloof" lines, masses, colors, or an "aloof" arrangement thereof might be. The light in the painting is rather cold, and that feature does indeed contribute to the aloofness of the work. "Cold light" is not, however, the same as "aloof light," which does not even appear to be a sensible combination of words.

A similar analysis is possible with respect to Eliot's "Prufrock." If we consider first the "material" elements of the poem—its rhythm, meter, sound qualities, etc.—we realize that "compassionate" simply cannot apply to those features meaningfully. Moreover, there is nothing about the subject matter of "Prufrock" which is compassionate. Certainly Prufrock himself is not compassionate; he is simply confused, a victim of his own fears and anxieties, and of the meanness and triviality of his routinized life and soulless companions.

41

Finally, the wittiness of Prokoviev's Grandfather theme cannot be supposed to be a "property" of the music the way its comic qualities are. The music is amusing, or comic, because the wheeziness of the bassoon is funny and because the melody imitates the "structure" of a funny movement (one *must* move in an amusing way to that melody). Moreover, although Grandfather himself is funny, he is definitely not witty. What is comical, amusing, or funny is not always witty. To be witty is generally to make, say, or do something comical, amusing, or funny "on purpose." That is why Prokoviev's musical *portrayal* of a comical grandfather is witty. Similar analyses of the Breughel painting, the Wordsworth poem and the Cage music mentioned previously could obviously be carried out. But the point, I take it, is already sufficiently well made.

The second interpretation of the hypothetical attack on the importance of artistic acts borrows any initial plausibility it possesses from the fact that anthropomorphic descriptions of artistic acts can be "explained" or "justified" in terms which neither mention artistic acts nor use any of the terms which describe them. For example, one might point out the irony in the Breughel painting discussed above by noting the combination of the gay scene and the dull faces of its participants. Or one might justify the "aloofness" he sees in the Poussin by remarking on the cold light, clear lines, and statuesque poses in a scene of violence and turmoil. And in discussing the impersonality of *Variations II* it is necessary to mention that the Cage work sounds like accidentally produced noise, which is senseless and emotionally neutral, but that this noise-like sound is to all *other* appearances music, i.e. it is scored, it is performed on a musical instrument, it is even reproduced on recordings. From these facts about the way in which anthropomorphic descriptions are justified, it might seem plausible that the statements which

figure in the justification *entail* the original description. But such is not the case, as the following will show.

It has been suggested that the reason that Breughel's peasant faces are dull and stupid-looking is that the painter was simply unable to paint faces which were happy. Whether the suggestion is true or well supported by the evidence is not an issue here. What is important is that were there any reason for believing Breughel to have been incompetent in that way, then there might be (not necessarily "would be") that much less reason for believing that there is irony in Breughel's *Wedding Dance.* That is because Breughel's incompetence and Breughel's irony *can* in this case function as mutually exclusive ways of accounting for a "discrepancy" in the picture. Of course, there are ways of admitting both the incompetence and the irony. It is possible to suppose, for example, that Breughel used his particular incompetence in making an ironic "statement" about peasant existence. Such a supposition would imply that Breughel was aware of his limitation and made use of it in his work. However, were it *known* that the *only* reason for the discrepancy in the painting was Breughel's incompetence, the "irony" would disappear. It makes no difference, incidentally, that such a thing could probably *never* be known. I am making a logical point regarding the way an attribution of a certain sort to an "artistic act" relates to other aspects of a painting like the Breughel. In short, certain facts about the painting's subject matter do indeed "ground" the attribution but by no means logically entail that attribution. And that is so for the good reason that the same facts about the subject matter are consistent with a supposition about Breughel which might be incompatible with the description of the painting as ironic.

A similar point can be illustrated in Poussin's Sabine painting. In that work there is a discrepancy between the

43

violent scene, on the one hand, and the "still," clear figures, on the other. Two persons might agree about the character of the figures and the character of the depicted scene, however, and yet disagree whether these facts entail that Poussin painted the rape of the Sabines in an aloof, reserved way. One viewer might think simply that the work is incoherent, that Poussin's coldly classical means are not suited to the end he had in mind, namely, to depict the violence of the event. In this quite reasonable view, the discrepancy makes the painting "fall apart" rather than "add up" to an aloof and reserved point of view. Here then are two incompatible descriptions of a work which are equally well grounded on facts which allegedly "entail" one of the descriptions. I am mindful that it might be objected that there are other features of the Sabine painting than the ones mentioned which preclude the judgment of "incoherence" and necessitate the judgment of "aloofness." The best I can say is that there seem to me to be no such additional features contributing to the "aloofness" of the painting and that the burden of proof is upon those who disagree.[10]

Finally, let us suppose that a devoted listener of traditional Western music scoffs at the description of Cage's *Variations II* as "impersonal music." He insists that it is nothing but what it sounds like—meaningless noise. He charges that Cage is a fraud whose "music" is a gigantic hoax, a put-on, and that Cage is laughing up his sleeve at those who take him seriously, perform his "scores," record the performances, and listen gravely to his nonsense. He has, the traditional listener says, read some of Cage's "ideological" material relating to his "music" but he has noted

[10] These statements commit me to the position that a positive judgment about the Poussin cannot be deduced from any descriptions of the painting of the sort which "ground" its aloofness. For arguments in favor of this general position see my "Subjectivity and Justification in Aesthetic Judgments," *Journal of Aesthetics and Art Criticism*, xxvii (1968), 3-12.

how laden with irony it is. To him that shows that Cage is not to be taken seriously because he does not take himself seriously. Now such a doubter does not disagree with the description of *Variations II* which is used to justify calling it "impersonal." The disagreement concerns rather the way we are to assess John Cage. Are we to judge him to be a responsible and serious, albeit radically innovative, composer of music or not? It is only when Cage's seriousness is assumed that the term "impersonality" applies to his music. Otherwise, the aforementioned justification for calling it impersonal is equally justification for calling it nonsense.

What the above three cases demonstrate is that a true anthropomorphic description of an artistic act might presuppose conditions having nothing necessarily to do with the way the formal elements and/or subject matter are describable. The conditions mentioned are (1) the competence of the artist, (2) the coherence of the work, (3) the seriousness of the artist. But there are surely other examples which would bring light to other conditions of this sort. With sufficient ingenuity one could likely discover and/or construct examples of art in which anthropomorphic descriptions of artistic acts would or would not be applicable depending upon how one assessed the artist with respect to, say, his maturity, his sanity, his self-consciousness, his sensitivity, or his intelligence.

Now it is probably too rigid to regard "competence," "coherence," "seriousness," "maturity," "sanity," and the rest as denoting necessary *conditions* for the legitimate description of all artistic arts. It is probably not true that the artist *must* be serious, competent, sane, etc., and that the work *must* be coherent in order for any anthropomorphic description (of an artistic act) to apply to any work. What these terms should be taken as denoting are "parameters" according to which an artist or a work can be measured in whatever respect is relevant in a particular case. To do so would

45

be to admit that there is probably not a single set of particular conditions of these sorts presupposed in *all* descriptions of artistic acts. Naming these parameters simply points out the *sorts* of considerations which *might* be relevant in particular descriptions of artistic acts, leaving it an open question which of these parameters are relevant, and to what degree, in particular cases.

In any event, what the recognition of such parameters means is that any attempt to save the Canonical Position by "eliminating" descriptions of artistic acts in favor of "logically equivalent" descriptions of formal elements and/or represented subject matter is doomed to fail. For the description of artistic acts in anthropomorphic terms does presuppose something about the artist which cannot be known *simply* by attending to his art. A similar point holds with respect to common expressions. The look of a sullen pout on a person's face does not mean that the person is pouting sullenly if we discover that the look results from the natural lay of his face. And thus it is that no description simply of the configuration of the person's face can *entail* the statement that the person is pouting sullenly.

But it is equally true that the assertion that a person is pouting sullenly is incompatible with the claim that the person's face has the same configuration as it does when he is not pouting sullenly. The sullen pout *must* make a difference visible on the face. Analogously, for an anthropomorphic predicate of an artistic act to be applicable to a work of art there *must* be *some* features of the material elements and/or the subject of the work which *justify* the attribution of the term, even though they do not *entail* that attribution. One thing, however, is never presupposed or implied when an anthropomorphic predicate is truly applied to a work, namely, that the predicate is truly applicable to the *artist*. In this, too, works of art are like expressions.

46

chapter two

The Mind in Art

❧

The Canonical Position implies that the range of phe-
nomena which the Expression Theory could reasonably seek
to accommodate is no more extensive than the range of
cases in which anthropomorphic predicates are applicable
to works of art. In the present chapter I shall argue that that
assumption is wrong. In particular I shall show that there
are what I shall call "subjective factors" in works of art,
which, like artistic acts, are not describable independently
of the work but which, unlike artistic acts, are not describa-
ble in terms predicated of the work. "Subjective factors" is
an ugly phrase that I shall consistently use as a short-hand
designation for an extremely diverse set of phenomena. The
term is deliberately vague because the nature of the phe-
nomena it covers is quite complicated and impossible to cap-
ture in a word or two. It is a major task of this chapter to
clarify the nature of these subjective factors.

The following statements by critics of the arts will serve
to indicate the variety of facts covered by the term "subjec-
tive factors." In these statements it is important to note that
the respective subjective factor is not designated by an ad-
jective applied to the work in question. I shall argue, more-
over, that in none of the cases could the sense of the state-
ment even be *translated* in such a way that an appropriate
anthropomorphic predicate is applied to the work in ques-
tion.

In *Greek Painting* by Pierre Devambez the author finds
"love of nature" in the paintings of Crete and a "delight in
nature" in a vase painting from Chios.

(1) We have already seen how nature—both animal and vegetable—was one of the main sources of inspiration for Cretan painting; even in the otherwise rather stiffly conceived frieze which adorns a building near the palace of Knossos, the pheasants and other crested birds are endowed with life and individuality. Even more remarkable, however, is the painting of a cat recently discovered at Hagia Triada. Hiding behind a bush, with its claws scrubbing the soil, its eyes dilated, its back arched, the animal is stalking a pheasant which struts innocently about, all unaware. Nothing could be more lifelike than this little scene. Even the bush is drawn with sensitive subtlety—as it sways in the wind it recalls the decorative purity of a Japanese drawing. The great charm of Cretan art lies in that suppleness and sense of movement which is shared by animate and inanimate creatures alike.[1]

Devambez then proceeds to substantiate his idea by discussing Cretan murals and Cretan vase paintings. He concludes:

Both are imbued with the same love of nature, but the mural artists depict it for itself alone, trying to convey to the onlooker something of the impressions which they would experience in contact with a living scene, in its natural setting. The vase-painters on the other hand use nature merely as an element, the sole purpose of which is to beautify the vase made by the potter for whom they work. . . .[2]

Can we say the same about a most unusual cup, now in the Louvre, the background of which is taken up

[1] Pierre Devambez, *Greek Painting* (New York: The Viking Press, 1962), p. 6.
[2] *Ibid.*, p. 8.

by what we could hardly call a landscape, but which is, at any rate, one of those rare pictures which Greek artists of the pre-Hellenic period seem to have painted with no other object than that of expressing their delight in the nature which surrounded them? The composition may seem a little odd. The painter wanted to depict a man in a forest: to show his happiness he has made him wave his arms and open his mouth as though he were singing as he runs about. But to adapt the composition to the circular frame of the medallion the artist has arranged his trees not vertically but horizontally, so that they are perpendicular to the human figure; the branches curve over, following the circumference. To complete the landscape there are nests at the top of the tree-trunks with birds fluttering towards their young ones. The difficulty of enclosing within a circle a picture of this sort (designed to be displayed breadthwise), the clumsiness of the artist who was only able to solve the problem by flattening out his trees, prove that this must be an adaptation, since the subject could not have been designed for its present form. It is thus tempting to conclude that a picture must have served as model for the decorator of the cup, and this picture may well have been Ionian, since in the world of Greece only the Ionians seem to have appreciated natural beauty.[3]

Now in the above two statements the only plausible result of putting "love of nature" into an adjectival form is "nature-loving." "Delight in nature" can take the gerundive form "delighting in nature." But neither of these adjectival phrases could be applied to paintings and mean what Devambez means. The supposition that Devambez means that certain paintings either love nature or take delight in nature

[3] *Ibid.*, p. 18.

is patently ridiculous. The terms "love of nature" and "delight in nature" clearly operate differently in discourse about art from simple anthropomorphic predicates like "sad" and "gay" applied to art works.

Much the same points can be made about the following two passages from Lionel Trilling's *The Opposing Self*, in each of which the author claims to have found "love" in a body of fiction. The first passages are by Henry James about William Dean Howells, and they are quoted with approval by Trilling.

(2) "He is animated by a love of the common, the immediate, the familiar, and the vulgar elements of life, and holds that in proportion as we move into the rare and strange we become vague and arbitrary; that truth of representation, in a word, can be achieved only so long as it is in our power to test and measure it.

"If American life is on the whole, as I make no doubt whatever, more innocent than that of any other country, nowhere is the fact more patent than in Mr. Howells' novels, which exhibit so constant a study of the actual and so small a perception of evil."[4]

In this case, although we could say that Howells' *novels* are "animated by a love of the common, etc." without altering the sense of James' judgment, it is not possible to translate James' idea by saying that Howells' novels *love* what is common, immediate, familiar, and vulgar. In other words, while the impossibly awkward adjectival phrase "common-, immediate-, familiar-, and vulgar-loving" is applicable to Howells, it is not applicable to his novels. The second example from Trilling's book is rather more complicated.

(3) Homer gives us, we are told, the object itself without interposing his personality between it and us. He gives

[4] *The Opposing Self* (New York: The Viking Press, 1955), p. 86.

us the person or thing or event without judging it, as Nature itself gives it to us. And to the extent that this is true of Homer, it is true of Tolstoi. But again we are dealing with a manner of speaking. Homer and Nature are of course not the same, and Tolstoi and Nature are not the same. Indeed, what is called the objectivity of Homer or of Tolstoi is not objectivity at all. Quite to the contrary, it is the most lavish and prodigal subjectivity possible, for every object in the *Iliad* or in *Anna Karenina* exists in the medium of what we must call the author's love. But this love is so pervasive, it is so constant, and it is so equitable, that it creates the illusion of objectivity, for everything in the narrative, without exception, exists in it as everything in Nature, without exception, exists in time, space, and atmosphere.

To perceive the character of Tolstoi's objectivity, one has only to compare it with Flaubert's. As the word is used in literary criticism, Flaubert must be accounted just as objective as Tolstoi. Yet it is clear that Flaubert's objectivity is charged with irritability and Tolstoi's with affection. For Tolstoi everyone and everything has a saving grace. Like Homer, he scarcely permits our sympathy either to Hector or to Achilles, nor, in their great scene, either to Achilles or to Priam, so we cannot say, as between Anna and Alexei Karenin, or between Anna and Vronsky, who is right and who is wrong.[5]

It is interesting to note here that Trilling is talking about the objectivity of some works of literature as well as the objectivity of their authors. Homer, Tolstoi, and Flaubert are objective and so, at once, are *The Iliad*, *Anna Karenina*, and *Madame Bovary*. "Objective" thus works the way that other

[5] *Ibid.*, pp. 68-69.

anthropomorphic predicates do when applied to art. But Trilling is also talking about the "love" and "affection" of Homer and Tolstoi and the "irritability" of Flaubert. And while his statement implies that the former two writers are loving and affectionate and the last irritable, it does not imply that *The Iliad* and *Anna Karenina* are loving and affectionate or that *Madame Bovary* is irritable. The reason is not that these predicates are inapplicable to a literary work, for surely one could write, say, an irritable reminiscence or an affectionate biography. But in these sorts of cases the subjects of the work, i.e. what one remembers and the life of a person, are real. The characters in the above works are, at least insofar as they concern Trilling, fictional. And it is precisely towards these fictional characters that the love, affection, and irritability is directed. It is surely senseless to suppose that a novel can be affectionate or irritable towards its characters.

In the following passage the art historian Walter Friedlaender distinguishes two styles of art in terms of what he calls two distinct "attitudes" or "outlooks."

(4) Thus there arose an "ideal art" which, however, at the same time laid claims on nature, indeed in a strikingly canonical sense. Only what this artistic attitude set up as right and proper in proportions and the like counted as beautiful and, even more than that, as the only thing truly natural. On the basis of this idealized and normative objectivization, the individual object of the classic style, especially the figure of man, was removed formally, in its organization, and physically, in its gestures and expression, from any subjective, purely optical, impression. It was no longer exposed to the more subjective whim of the individual artist, but was heightened and idealized to something objective and regular.

Sharply opposed in many and basic elements to this high, idealistic, normative attitude which in Florence (aside from Raphael) Fra Bartolommeo presents in a somewhat stiffly dogmatic way, and Andrea del Sarto in a more conciliatory, easy-going and happily colorful fashion, stands the attitude of the anticlassical style, normally called Mannerism.

What is decisive is the changed relationship of this new artistic outlook to the artistically observed object. No longer, as in idealistic standardized art, does the possibility of observing an object in a generalized intersubjective way, by heightening it, and raising it to something canonical and regular, form art's immovable basis. Similarly, little attention is paid to individually conditioned variations produced by the outward circumstances of light, air, and distance. The mannerist artist, in the last analysis, has the right or duty to employ any possible method of observation only as the basis for a new free representational variant. It, in turn, is distinguished in principle from all other possibilities of seeing an object, for it is neither made valid by any standardized abstraction nor is it causally determined in an optical way, but answers only to its own conditions. This art too is idealistic, but it does not rest on an idea of a canon, rather upon a *fantastica idea non appoggiata all'imitazione*, an imaginative idea unsupported by imitation of nature. Thus the canon apparently given by nature and hence generally recognized as law is definitely given up. It is no longer a question of creating a seen object in an artistically new way, "just as one sees it," or, if idealistically heightened and ethically stressed, "just as one ought to see it." Neither is it a matter of recreating the object "as I see it," as the individual person

53

observes it as a form of appearance. Rather, if one may use a negative expression, it is to be re-created "as one does not see it," but as, from purely autonomous artistic motives, one would have it seen.[6]

Here the "attitude" characteristic of High Renaissance art is described in terms which can also be applied, with the same meaning, to the art itself, i.e. "high," "idealistic," "normative." Friedlaender's description of the Mannerist "attitude," however, is quite different. He does not describe it straightforwardly, with simple adjectives. Rather, he describes it in predominantly negative terms contrasting it with the earlier "attitude." These negative terms, moreover, are not simply negative *adjectives* like "non-normative" and "non-idealistic." Friedlaender's description of the Mannerist "outlook" takes the entire last paragraph just quoted. It is surely not possible to encapsulate that description into a relatively small number of adjectives that might also be truly applied to all Mannerist paintings.

Despite their differences, the following four statements can be discussed together, for the "subjective factors" which are mentioned are all ways of being "sensitive" to a sort of thing. Indeed, from now on I shall refer to subjective factors like these collectively as "forms of sensitivity."

(5) It [a carved figure] is at once the expression and the habitation of a spirit. And again, by means which seem to escape from our comprehension, the miracle of an intense inner life is achieved. The vivid gesture of the hands holding the bowl, the head bowed forward with infinitely patient resignation, and the strange melancholy of the almost unseeing eyes:

[6] "The Anti-Classical Style," in *Art History: An Anthology of Modern Criticism*, ed. Wylie Sypher (New York: Random House, 1963, Vintage Books edition), pp. 263-264.

everything here—even the most surprising distortions —hangs together and co-operates in the realization of the idea. And what intense subtle understanding of form, what delicately unemphatic sensibility there is in the way the eyebrows are just indicated upon the curve of the brow.

This spirit head has the complex, elusive, indefinable quality of the human spirit coloured, as almost always in Negro art, by the sense of suffering and resignation. . . .[7]

(6) Roman architecture also thinks of the building primarily as of a sculptured body, but not as one so superbly independent. There is a more conscious grouping of buildings, and parts are less isolated too. Hence the all-around, free-standing columns with their architrave lying on them are so often replaced by heavy square piers carrying arches. Hence also walls are emphasized in their thickness, for instance, by hollowing niches into them; and if columns are asked for, they are half-columns, attached to, and that is part of, the wall. Hence, finally, instead of flat ceilings— stressing a perfectly clear horizontal as against a perfectly clear vertical—the Romans used vast tunnel-vaults or cross-vaults to cover spaces. The arch and the vault on a large scale are engineering achievements, greater than any of the Greeks, and it is of them as they appear in the aqueducts, baths, basilicas (that is, public assembly halls), theatres, and palaces, and not of temples, that we think when we remember Roman architecture.

However, with very few exceptions, the grandest creations of the Roman sense of power, mass, and

[7] Roger Fry, *Last Lectures* (Boston: Beacon Press, 1962), p. 79.

plastic body belong to a period later than the Repub-
lic, and even the Early Empire. The Colosseum is of
the late first century A.D., the Pantheon of the early
second, the Baths of Caracalla of the early third, the
Porta Nigra at Trier of the early fourth.[8]

(7) Thus it happens that one begins reading such a tale
as *St. Ronan's Well* with pleasure, and yet when one
comes to the romantic, that is, to the artificial part,
boredom sets in, though at the same time a fine trait
here and there will give life to the portrait of the
priest Saint Ronan (as I have mentioned that novel),
which is executed with a feeling for goodness at once
moving and graceful. This smile of goodness is per-
haps Walter Scott's most purely poetical possession,
for it illumines even his comic personages, who some-
times descend to the level of the stereotyped, but are
often contained within just limits. For this reason, I
am inclined to look upon *The Heart of Midlothian* as
the best of his novels, because it is compacted of good-
ness, not only in certain details, but in the very web
of the narrative itself. Here, too, we find plenty of in-
trigues, and the usual brigands, who are not brigands,
but high-souled gentlemen, and other properties of the
repertory. But who can resist being carried away by
the story of sweet Effie, imprisoned (on the false accu-
sation that she has put her own child to death), and by
the adamantine veracity and courageous temperament
of her sister Jean, who will not lie to save her, and
yet saves her by confronting every peril, and obtains
her pardon? And how can one avoid being delighted
with the lead-like heaviness, yet timidly sentimental
love-making, of the Laird Dumb Dikes, or fail to ad-

[8] Nikolaus Pevsner, *An Outline of European Architecture*, 7th ed.,
(Hammondsworth: Penguin Books, 1963), pp. 19-20.

mire the character of crazy Madge, malign and generous, clever for all her madness at outwitting suspicions, and although described in the most realistic manner, yet enfolded in pity? The author collects and renders clear what of pedantry, of the habit of preaching, and of complacent vanity, there is in good David Deans, the pious father of the two girls, yet shows how he can remain noble and moving in the midst of his bitter predications and severe religious notions.[9]

(8) Howells, it is thought, can give us the pleasures of our generic image of the Victorian novel. He was a man of principle without being a man of heroic moral intensity, and we expect of him that he will involve us in the enjoyment of moral activity through the medium of a lively awareness of manners, that he will delight us by touching on high matters in the natural course of gossip.[10]

One feature which a sense of suffering and resignation, a sense of power and mass, a feeling for goodness, and an awareness of manners have in common is that they all must be described in terms of their "objects." For it is precisely in terms of what an "awareness," a "sense" or a "feeling" is *of* or *for* that it is distinguishable from other "awarenesses," "senses," and "feelings" of this sort. Now it is possible to designate these forms of sensitivity in an adjectival way and to apply the adjective phrase to persons. A person might thus be sensitive to the suffering and resignation of others; he might be sensitive to the goodness of other people; he might be especially sensitive to what is powerful and massive; he might be aware of the manners of his time in an especially

[9] Benedetto Croce, *European Literature in the Nineteenth Century,* trans. Douglas Ainslie (New York: Haskell House, 1967), pp. 74-75.
[10] Trilling, *The Opposing Self,* p. 77.

lively way. But it is surely nonsense to characterize sculptures, buildings, or novels in these sorts of ways. Forms of sensitivity, therefore, figure in art criticism in a way different from anthropomorphic "qualities."

Consider next the following passage from a critical essay by Lionel Trilling on Dickens' *Little Dorrit*.

(9) The imagination of *Little Dorrit* is marked not so much by its powers of particularization as by its powers of generalization and abstraction. It is an imagination under the dominion of a great articulated idea, a moral idea which tends to find its full development in a religious experience. It is an imagination akin to that which created *Piers Plowman* and *Pilgrim's Progress*. And, indeed, it is akin to the imagination of *The Divine Comedy*. Never before has Dickens made so full, so Dantean, a claim for the virtue of the artist, and there is a Dantean pride and a Dantean reason in what he says of Daniel Doyce, who, although an engineer, stands for the creative mind in general and for its appropriate virtue: "His dismissal of himself (was) remarkable. He never said, I discovered this adaptation or invented that combination; but showed the whole thing as if the Divine artificer had made it, and he had happened to find it. So modest was he about it, such a pleasant touch of respect was mingled with his quiet admiration of it, and so calmly convinced was he that it was established on irrefrageable laws." Like much else that might be pointed to, this confirms us in the sense that the whole energy of the imagination of *Little Dorrit* is directed to the transcending of the personal will, to the search for the Will in which shall be our peace.

We must accept—and we easily do accept, if we do

not permit critical cliché to interfere—the aesthetic of such an imagination, which will inevitably tend toward a certain formality of pattern and toward the generalization and the abstraction we have remarked. In a novel in which a house falls physically to ruins from the moral collapse of its inhabitants, in which the heavens open over London to show a crown of thorns, in which the devil has something like an actual existence, we quite easily accept characters named nothing else than Bar, Bishop, Physician. And we do not reject, despite our inevitable first impulse to do so, the character of Little Dorrit herself. Her untinctured goodness does not appall us or make us misdoubt her, as we expect it to do. This novel at its best is only incidentally realistic; its finest power of imagination appears in the great general images whose abstractness is their actuality, like Mr. Merdle's dinner parties, or the Circumlocution Office itself, and in such a context we understand Little Dorrit to be the Beatrice of the *Comedy*, the Paraclete in female form. Even the physical littleness of this grown woman, an attribute which is insisted on and which seems likely to repel us, does not do so, for we perceive it to be the sign that she is not only the Child of the Marshalsea, as she is called, but also the Child of the Parable, the negation of the social will.[11]

Here the "subjective factor" is what Trilling calls the "imagination" of the novel. The entire passage is, in effect, a description of that "imagination," but it is not a description translatable into an anthropomorphic description, however lengthy, of the novel itself.

In the following passage of music criticism the reference

[11] *Ibid.*, p. 64.

to "nobility of soul" makes it clear that the critic is talking about a certain moral character identifiable in Bartok's music.

(10) Hans Heinsheimer, visiting in Boston the premiere performance of Bartok's Concerto for Orchestra, has recounted how at the end of the piece a neighbor turned to her husband and said, "Conditions must be terrible in Europe." She was right, of course. They were, especially in Central Europe, where Bartok had lived. And she was right in sensing their relation to the expressive content of Bartok's music. It is here, I think that his nobility of soul is most impressive. The despair in his quartets is no personal maladjustment. It is a realistic facing of the human condition, the state of man as a moral animal, as this was perceptible to a musician of high moral sensibilities just come out of Hungary.

No other musician of our century has faced its horrors quite so frankly. The quartets of Bartok have a sincerity, indeed, and a natural elevation that are well-nigh unique in the history of music. I think it is this lofty quality, their intense purity of feeling that gives them warmth and that makes their often rude and certainly deliberate discordance of sound acceptable to so many music lovers of otherwise conservative tastes.[12]

Here Thomson does attribute certain anthropomorphic "qualities" to Bartok's music, e.g. loftiness, sincerity. Furthermore, he does point out factors which can be construed as "qualities" of the music; "nobility of soul" and "despair in his quartets" could plausibly be rephrased as "noble music

[12] Virgil Thomson, *Music Reviewed, 1940-1954* (New York: Random House, 1967, Vintage Books edition), pp. 274-275.

with a pervasive despairing quality." Nevertheless, the complete sketch of a moral character cannot be done by a string of adjectives or even adjective phrases. What, after all, are we to make of Thomson's statement that the despair in Bartok's quartets "is a realistic facing of the human condition," if we put it into gerundive form and apply it to the music. Music cannot face the human condition, or anything else, realistically (or unrealistically), and Thomson is not saying that it does.

Finally, in the passage below we have in effect an extended portrait of a "personality" which Croce has discovered in Baudelaire's poetic work.

(11) His inspiration drawn from lubricious, sad and bestial sources, remains lofty and serious; bound to a sensual world which he cannot overcome, he succeeds in rendering it colossal, tragical, sublime, and here too he appears as a "rebel angel": a heroic poet compressed and yet unable to abandon his heroics, which he creates upside down, by means of the lustful and the horrible. What there is in his creations that flashes out in irony, or rather in satire, is nothing but the consciousness of evil, inseparable from his mode of embracing the evil. Satan sometimes laughs, because, if he did not, he would be a maniac or a madman, and no one has yet insulted him with such a name. But Satan is also sometimes seized with nausea and disgust of himself, because he is not altogether able to suffocate the memory of the nobility that once was his. At other times, too, he feels himself opening his soul to that image "of holy youth, of simple air, of gentle brow, of eyes as limpid and clear as running water," or he envies him "who rises above life with a vigorous stroke of the wing and frees himself from it, and un-

61

derstands without effort the language of flowers and
of things mute." Or he melts altogether in tenderness
for the poor dead servant girl, "the great-hearted serv-
ant," beneath whose eyes he grew up, and of whom
his mother was "jealous," and who now sleeps beneath
the humble grass of the little field. His Satan, in fact,
is not the traditional Satan, but a man-Satan.[13]

By no exertion of imagination can Croce here be construed
as giving a simple adjectival description of a *body of poetry*.
The referential phrase "Baudelaire's poetry" cannot be sub-
stituted for "rebel and angel," "heroic poet," or "Satan" and
make any sense. Here is an ultimately complex sort of sub-
jective factor, namely, a total "person" discovered in poetry,
which cannot conceivably be "eliminated" in favor of a
"quality," however complex, of the poetry.

As THE preceding demonstrates, there is a large variety of
subjective factors which critics talk about in art but which
are not describable simply by anthropomorphic adjectives
predicated of the art works themselves. And these factors
seem to be phenomena with which an Expression Theory
of Art would be very centrally concerned. But what is so
puzzling about the Canonical Position is that it completely
ignores the above sorts of critical discourse in its construal
of Expression Theory. How can that fact be accounted for?
 There are, I think, two explanations. The first is relatively
simple. Most contemporary philosophers who have written
on expression have been victimized by the common tend-
ency to think of expression only in connection with feeling
or emotion. We quite naturally think of anger, sadness, or
grief when casting about for an example of what is ex-
pressed. But, having thought of such examples, recent phi-

[13] Croce, *European Literature*, pp. 291-292.

losophers have generally looked for no others before begin-
ning to theorize about expression. Recall that both Beardsley
and Bouwsma base their results on the single example of
sad music. But whatever differences might *eventually* be
discovered between expressions of anger, sadness, or grief,
on the one hand, and expressions of a love of nature, of a
sense of mass and power, or of nobility of soul, on the other,
we ought certainly not *initiate* an inquiry into expression by
excluding the latter without reason or excuse. Very possibly
most people talk *less frequently* about expressions of the
latter sort. But surely that is because the contexts in which
there is occasion for such talk are the comparatively formal
and specialized ones in which works of art are discussed.
Furthermore, there are no commonplace expressions, like
gestures or grimaces, of a sense of mass and power, of a
delight in nature, or of the other sorts of subjective factors
exemplified above. And that further explains why expres-
sions of the latter are less frequently discussed; they are
simply not encountered very often by most people. But
these facts surely do not justify the assumption that sub-
jective factors of the sorts exemplified above cannot be le-
gitimately spoken of as "expressed."

The second reason which explains the neglect of the lat-
ter cases of expression is *prima facie* more legitimate. The
Canonical Position assumes, I think, that if "Art is expres-
sion" is to be taken as a serious theoretical hypothesis about
art, it ought to call attention to properties of art rather than
to relations between art works and something else, e.g. their
creators. Such austere concern for the work of art isolated
from the conditions of its creation shows, of course, the in-
fluence of New Critical theories of literature. Apart from
this influence, however, there are plausible reasons for ex-
pecting a theory of art as expression to uncover something
"in" the art work "itself." We have only to consider the most

63

accessible forms of expression such as cries, grimaces, and gestures to realize that what they express is somehow perceptible "in" them. The faces of sadness have characteristic looks in virtue of which they are called sad faces; the gestures of anger have characteristic patterns in virtue of which they are identifiable as angry gestures. But the various subjective factors which the critics in the above passages were talking about cannot be attributed to works of art, as I was at pains to point out, in just the way that sadness and anger can be attributed to faces and gestures—or to music and poetry.

It might seem reasonable to a proponent of the Canonical Position, therefore, that even if it is legitimate to speak of what I have called subjective factors as being expressed, "express" must have a different import, perhaps a different sense, in these cases from the one it has when it relates to the anthropomorphic "qualities" in art works. Beardsley suggests to us what that different sense might be: "Sometimes when people talk about musical expression, we can see that they are really talking about the state of mind of the composer; to them, 'The scherzo of Beethoven's *A Major Symphony* expresses joy' means 'Beethoven felt joy when composing that scherzo, and was impelled by that emotion to compose it.' "[14] Beardsley then goes on to distinguish this use of "expression" from the use in which some quality is attributed to the music. The latter use is for Beardsley the only use relevant to the philosophy of art. Yet we may reasonably suppose that what Beardsley says about joy in the above passage he would also want to say about the sorts of subjective factors mentioned earlier. If so, the implication would be that we should interpret the critical passages quoted above as statements about the respective artists and why they created the works in question

[14] Beardsley, *Aesthetics*, p. 326.

rather than about the works themselves. This point is like the objection to my analysis of artistic acts which I concocted earlier on behalf of the Canonical Position.

In this chapter I shall argue that subjective factors like love of nature, awareness of manners, nobility of soul, and Satanic personalities are as integrally related to works of art as are artistic acts which are aloof, cruel, witty, or sentimental. First, it is worth reiterating that it is simply not true that critical statements like the ones quoted must refer *either* to a work of art *or* to its artist and the conditions of its creation. Those passages themselves reveal how difficult it is in critical writings to decide whether the passage is about an artist or his art. Is Trilling describing *Little Dorrit* or Dickens in passage (9)? An obvious answer would be: Both. For he refers to both the novel and to the novelist without calling special attention to the distinction. Virgil Thomson in passage (10) clearly purports to describe *both* Bartok *and* his quartets. The same is easily discovered in most of the other passages.

More important, however, than the fact that interpretive writing fails to make distinctions which Beardsley would force upon it is the fact that in all of the quoted passages the overwhelming preponderance of the evidence for the interpretive remarks comes from the artistic works rather than from independent biographical sources. This is most obviously true in passage (1) where the only evidence for the "love of nature" and "delight in nature" which are mentioned is brought forth in detailed descriptions of the paintings. In these two cases there simply is no extant evidence regarding the painters, other than their paintings, which is relevant in determining their attitudes towards nature.

In most of the other cases, however, the situation is more complicated simply because there is a considerable amount that can be known about the artists from sources other than

their art. Thus Trilling in justifying and explaining Henry James' remarks on Howells can and does draw upon Howells' theoretical statements regarding novel-writing, and he quotes some of Howells' writing defending "the commonplace." But Trilling does not quote Howells in these contexts because he is obliged to do so in order to make his case about Howells' novels. Throughout his essay Trilling assumes what anyone who has read a Howells novel knows, i.e. that Howells' artistic *work* is permeated by his love of the common. After all, that is what makes the novels so drab and dull. Similar points can be made about Friedlaender's description of High Renaissance art. His description can be supported by reference to theoretical statements of the artists. High Renaissance theory saw contemporary art as "ideal" and believed it should represent "norms" of beauty. But one must still look at the paintings produced under this theory in order to verify that that art does indeed embody those theoretical principles. One recognizes by *looking* at the art that the "attitude" behind it is "idealizing" and "normative."

Perhaps Thomson's passage on Bartok (10) presents the most ambiguous case of them all. Thomson very explicitly mentions the relation between Bartok's historical situation, which is known only from extramusical sources, and his music. One wonders, moreover, whether the peculiar combination of nobility and despair in the music would have added up to "a realistic facing of the human condition, the state of man as a moral animal" for Thomson, had he not known that the composer lived in Central Europe between the World Wars. The "state of man as a moral animal" is much too specific a content to get out of (or into) nonrepresentational music alone. Nevertheless, we can see what Thomson is driving at in this description; we see that he wants to call attention to a peculiarity of Bartok's music

which is more than just its despair plus its nobility plus its sincerity. We might take the liberty of rephrasing Thomson's point like this: In Bartok's music there is a calm and unflinching confrontation of abstract horror together with a despair distanced and depersonalized by that abstractness. This modified description neither mentions nor depends upon what we might know of Bartok's historical situation. Yet no more than Thomson's original remark can this modified version be transformed into a statement simply attributing "qualities" to the music or, even less plausibly, transformed into a statement alleging that the *music* confronts, and despairs over, the abstract horror of things.

It does not follow from the facts (a) that the evidence for a critic's statements come wholly or predominantly from a work of art and (b) that the critic does not distinguish in his statements between reference to the work and reference to the artist that such statements *are* descriptive of the art as well as of (or rather than) the artist. I imagine that defenders of the Canonical Position might still insist on construing critical talk of love and delight, attitudes, outlooks, moral characters, and forms of sensitivity as statements about artists which are *inferred* and/or *hypothesized* on the basis of evidence available in their art. On this interpretation, statements like the ones quoted earlier derive their plausibility from the nature of the respective works of art, but they cannot be verified without evidence about the artist gained from extra-artistic sources. On the basis of certain features of Cretan paintings Devambez might be entitled to infer that the painters loved nature; but until we discover more about the particular painters in question, we cannot confirm or disconfirm Devambez's hypothesis.

There are simple but powerful arguments against this suggestion. First, in a case like that of the Greek painters it is obvious that neither Devambez nor any intelligent

reader would treat the statement as a sort of hypothesis awaiting confirmation. The likelihood of discovering the relevant sorts of information in this case is extremely remote. After all, what is it for a person to be "imbued with a love of nature"? It is to want to be in natural surroundings a good deal of the time; it is to pay special attention, in a large variety of contexts, to birds and bees, hills and trees; it is to want to protect natural things from violation and destruction; it is to rhapsodize about nature. Devambez knows better than most people that there is no realistic hope of discovering these sorts of facts about his Cretan artists and therefore he would not construct idle hypotheses concerning them.

The situation is different when the artist involved is more accessible, as is Howells or Tolstoi or Bartok. But even in these cases the critics do not act as though they were concerned primarily with characteristics of the artists. Although some of the critics refer to, and make use of, extra-artistic sources of information in their statements, none of them even attempt the sort of personal sketch one would expect if their primary focus were on the artist. Even Croce in the passage on Baudelaire (11), which takes the form of a personality sketch, believes he is talking primarily if not exclusively about Baudelaire's *poetry*. This is clear in the sentence which immediately follows the passage quoted earlier: "In making these remarks, we do not lay any claim to having done justice to the poetry of Baudelaire." His point, of course, is that the quoted passage is only a sketch of the "character" of Baudelaire's poetry, not a full-scale characterization of his poetic output.

Someone who is determined to interpret the statements (1)-(11) as hypotheses about the artists might try to discount the way the critics view their own statements as simply a professional blindness to what they really are up to.

Perhaps then another sort of argument will be more convincing. Let us take two examples of what are clearly and indubitably hypotheses made about an artist on the basis of his work and compare them to the critical statements quoted earlier. Suppose that upon reading *The Iliad* one notices in that work how objectively yet sympathetically Homer treats his characters no matter which side of the conflict they are on. Suppose that this observation leads us to speculate that the author must have been brought up in an exceptionally benign environment, that he must have come from a large and affectionate family in which no conflicts ever generated bitterness. Or suppose that we surmise from a study of Raphael's paintings that the painter was taught early in life by example and precept that all human beings are noble and dignified creatures, that the world is an harmonious and well-ordered place, and that one should not allow the facts of man's actual behavior and the occasional freaks of nature to turn us from what man and nature are like essentially and ideally. Let us further assume that nothing were known about the early life of either artist but that the hope of finding relevant extra-artistic evidence could be realized by applying a little industry and ingenuity. In such circumstances, the two supposed hypotheses would not be unreasonable ones to make. But it is clear that certain discoveries about Homer and Raphael would require that the hypotheses be abandoned. That would be so, for example, if it were discovered about Homer that as a small child he was stolen away from his home by pirates, was made a kitchen slave, and was especially harshly treated because his blindness made him inept at most kitchen tasks. Or if it were found out that Raphael was reared by a woman who operated a bordello and a cruel and misanthropic father who arranged cock fights for a living. Admittedly, there is a *prima facie* reason for thinking that

the critical statements cited earlier are like the two imaginary hypotheses just set forth. Surely there would be *some* effect on those statements if certain facts about the respective artists were discovered, or if the facts were discovered to be different from what they are now known to be. As an example, let us imagine that it were known about one of Devambez's vase painters that he took no interest in natural things apart from painting them, that he even went out of his way to avoid contact with nature, that he stayed close to an urban and "artificial" environment, that he was overheard to remark on the "messiness" and "untidiness" of uncivilized places, and finally, that he had once said that the sooner the forests and marshes were cleared and drained the better, since they are unsightly, unsafe, and unsanitary. In such circumstances it is hardly conceivable that Devambez's statement about the painter's love of nature would not require some sort of alteration. But the important question is: Would Devambez's statement have to be rejected as *false*?

To insist that Devambez's statement would thereby be falsified is to exhibit a gross misunderstanding of what he is doing. As I pointed out above, neither Devambez nor the other critics quoted self-consciously distinguish between a reference to an artist and a reference to the artist's work. But their writing is not on that account defective, because as the statements stand there are no points to be made by such distinctions. But what the facts about the Greek vase painter in the imaginary case we are considering would do is precisely to require that such a distinction be recognized by Devambez. Thus in the face of such an implausible set of facts Devambez would be obligated to distinguish between what is known about the painter's attitudes and feelings and what is discoverable in his art work. He would be so obligated not only because he should not mislead readers

less learned than he but also because he would want to let his scholarly peers know that he was aware of that rather odd discrepancy among the facts. It is important to note that the discrepancy in such a case would be between the *facts*, that is, between the facts about the artist gleaned from extra-artistic sources, on the one hand, and the facts about the art he produced, on the other. The discrepancy could *not* be simply between the facts about the artist and what Devambez "hypothesizes" about the facts.

The nature of the discrepancy can be likened to the discrepancy in the following situation. Suppose that I visit the home of an old friend Sam whom I have not seen for years. In that interval my friend has married and I meet his wife Felicia but only very briefly. A few days later I mention my visit to a second friend George who not only knows Sam but Felicia as well. I remark on what a morose and sullen woman Felicia is. George is taken aback at my description. He says he has known Felicia for years and that she is one of the most vivacious, gay, and charming women of his acquaintance. I am mildly surprised but say, "Well of course I only saw her for a few minutes. Yet I got a clear—and negative—impression of her as a person. She *looked* and *acted* unmistakably morose and sullen." George assures me however that he knows Felicia very well, that probably there was some trouble at Sam's place, and that he would call Felicia in the morning to check. In this sort of situation I have no reason at all not to believe George, and I must therefore conclude that my impression of Felicia was incorrect.

Even with such a conclusion however there remains a discrepancy of a sort, namely, that between what I have good reason to believe Felicia *is* like, on the one hand, and what she *acted* and *looked* like, on the other. *That* discrepancy is not eliminated by my concluding on the basis of George's

testimony that my impression of Felicia is false. For I do not thereby also conclude that I misperceived Felicia's face and behavior. Indeed, George resolves to call Felicia precisely because he has, on the basis of my testimony, every reason to think that Felicia *did* look and act morose and sullen. In other words what I am forced to do when confronted with facts about Felicia's true personality is to distinguish explicitly between the "real" Felicia and her behavior of the night before. I see that the moroseness and sullenness which I clearly and distinctly perceived must have a different significance from what I took it to have.

If the parallel which I have attempted to draw between the above case and the case concerning Devambez's vase painter is convincing, there is no need to construct similar cases with respect to the other critical statements quoted earlier. It seems evident that under analogous circumstances the authors of all those statements would react in a similar way and would in no way be obliged to repudiate their judgments concerning the art works which they are discussing. From this it follows that those statements are not like the sorts of inferences imagined earlier. That is, they are not like the hypotheses that Homer was brought up in a benign environment or that Raphael's idealism was inculcated at an early age. In fact, whatever plausibility those imagined hypotheses possess rests in large part upon the truth of Trilling's remarks on *The Iliad* and Friedlaender's description of High Renaissance painting. It is the sympathy and "affection" with which Homer treats all his characters in *The Iliad* which might give that hypothesis the merest breath of reasonability. After all, one is not likely to contrive a similar hypothesis about, say, Dante on the basis of *The Divine Comedy*. Similarly it is because a certain attitude shows itself in Raphael's painting that the supposition about his childhood could suggest itself. By contrast, the same hy-

pothesis concerning the young Picasso would seem gratuitous or stupid if devised solely on the basis of *Guernica*. These considerations suggest in yet another way that what the critics quoted earlier are doing in those passages is describing features of art which make art works significantly like Felicia's face and behavior, like, that is, common *expressions* of feelings, attitudes, moods, qualities of mind, or personality and character traits. In the following I hope to spell out in greater detail (1) how it is that the subjective factors identifiable in works of art *are* like common expressions, (2) the way in which these factors are like and unlike the artistic acts discussed in Chapter One, and (3) the ways in which the various subjective factors distinguished above differ from one another.

In Chapter One the eliminability of discourse about art which applies anthropomorphic predicates to artistic acts was discussed and rejected. The same sort of issue naturally arises with respect to the kinds of critical discourse exemplified earlier in the present chapter, and there seem to be better reasons for hoping that some sort of elimination is possible in the latter cases. First, whereas the crucial descriptive terms in the analysis of artistic acts were simple adjectives, in the cases cited in this chapter the relevant descriptions are lengthy and complicated passages. The possibility of discovering a way of reformulating, without loss of meaning, a single word seems rather less likely than finding a way of rephrasing one of the above statements by Croce, Trilling, or Thomson. We naturally feel that there must be dozens of ways of putting the "same" points made by the authors of those passages. Some of those ways surely need not look like a description of a person's character, personality, "imagination," or "outlook."

Second, complicated critical descriptions seem more "dis-

73

pensable" than anthropomorphic adjectives because there are no models which come immediately to mind with which we could compare such discourse. Whereas when we consider angry poetry or sad music, we easily think of the application of "angry" and "sad" to things other than people. We thus compare sad music to sad trees or sad faces. But when we consider a description of the "attitude" of High Renaissance art or the "personality" in Baudelaire's poetry, we do not immediately know where to turn for an interpretation of this language once it becomes clear that it does *not* apply immediately and simply to the attitudes and personality of a human being. It is certainly not the case that we normally and naturally speak of the personality of behavior or of a face or of the attitudes of a mountain or a tree.

It is therefore a plausible conclusion that discourse which appears to describe subjective factors is really figurative discourse, and that because it is figurative, it is translatable into less problematic language. Of course the presumption is that once such a translation is effected, the works of art in question will no longer be much like *expressions* of anything. In what follows I shall show that in the examples of critical writing presented above the more or less explicit descriptions of subjective factors can indeed be "eliminated." They can be replaced by descriptions of a wide variety of artistic acts, which may or may not be described in anthropomorphic terms. I shall argue, however, that it is precisely in virtue of this eliminability that the respective art works *are* like expressions of the subjective factors mentioned or suggested in the original critical statements.

The points which Fry, Pevsner, Croce, and Trilling are making in passages (5), (6), (7), and (8), respectively, can easily be rephrased without using terms like "sense of," "feeling for," or "awareness of." What Fry means when he speaks of the sense of suffering and resignation in religious

wood carvings is, in part, that the represented figures and faces have the look of people who suffer and are resigned to it. But he means more than simply that Negro carvers made faces and figures with that sort of look in them. A moderately intelligent and competent person can draw, paint, sculpt, or carve a face with that kind of look. But not every such product would evince a "sense of suffering and resignation." In the passage Fry is doing more than simply describing Negro sculpture; he is also admiring and praising it. The phrase we are discussing is at once a term of praise and an expression of his own admiration for it. Thus Fry is saying something to the effect that the sculptor of the head in question has portrayed (or represented or caught) the look of suffering and resignation in a particularly sensitive way, that he was able to carve the face with an especially fine understanding of the mood of suffering and resignation. Fry's phrase implies that the sculptor gives us not merely a gross image or schematic "form" of resignation and suffering of which we can confidently say, "That is supposed to be a suffering and resigned face." Rather it implies that the artist has put suffering and resignation themselves into the wooden face; he has made suffering and resignation "come alive" in a carving of wood. It implies that the suffering and resignation are delineated in an especially vivid way.

A similar analysis of "the Roman sense of power and mass" can be made. By the use of this term Pevsner means more than simply that Roman buildings looked powerful and massive. He means, in part, that the power and massiveness of Roman buildings were characteristic *virtues* of Roman architecture. That is, Roman architects skillfully and intelligently "brought out" these aspects of their work; they used materials perceptively and sensitively in order to get them to yield the "effects" of power and mass. Similarly, Croce's phrase embodies an admiration for Scott's subtle and

sensitive way of bringing out the goodness in some of his characters, his vivid way of rendering this quality in the persons he created. And Trilling, too, when he speaks of Howells' "lively awareness of manners," wants to say more than just that Howells *represents* the customs and habits of the society he describes. As Trilling uses this phrase the feature it designates is one of the very few virtues of Howells' art. But it *is* a virtue. Had Trilling not wanted to convey that implicit judgment, he could have described Howells' works simply as novels of manners. But according to the meaning of Trilling's phrase, Howells does more than simply write novels about manners; he describes manners in an especially perceptive way. Trilling means that Howells notices more about manners than the ordinary person and renders it in such a detailed and vivid way as to offer his readers some insight into the mores of the middle classes in the decades after the Civil War.

It is clear from the above analyses of passages (5), (6), (7), and (8) that the problematic terms designating forms of sensitivity are not needed in the description of the respective works of art. But let us remind ourselves of what the characteristic behavior is of a person who has a sense of suffering and resignation, a sense of power and mass, a feeling for goodness, or a lively awareness of manners. We immediately notice that there is very little, if any, behavior which is at once characteristic of these traits and is both non-artistic and non-verbal. What does one expect a person to do who has, say, a sense of suffering and resignation? We expect him to be able to notice and point out to us signs of suffering and resignation in persons, in art, in culture, perhaps in the animal world, which most people do not detect. We expect him to be able to describe in an especially vivid way his own or other people's suffering or resignation or perhaps to be able to paint or sculpt in an interesting

way the expressions of suffering and resignation. We can now see a parallel between Negro sculpture of the sort Fry was describing and ordinary expressions of common emotions. We might expect a person who is angry, for example, to scowl, shout, stamp his feet violently, hurl china, glower, fume, etc., etc. These kinds of behavior are generally *characteristic* of angry human beings, and therefore particular cases of them could count as *expressions* of anger. Similarly, a slow pace, drooping head, tears, a turned-down mouth, mournful tone of voice are all *characteristic* behavior of sad persons and are, thereby, commonplace *expressions* of sadness in people.

A note should be interjected here concerning the concept of "artistic act." From the preceding paragraph on, the notion of "artistic act" is a bit different from the one used in the first chapter. In Chapter One "artistic act" was introduced primarily as a way of categorizing certain anthropomorphic adjectives. The term can now be seen more generally as a designation for "acts" of an artist which must be described in terms which are discernible in the artist's work. Under this new characterization, acts described by anthropomorphic adjectives still fall under the concept "artistic act." But so do such acts as "portraying the look of suffering and resignation in a particularly sensitive way," "carving a face with an especially fine understanding of the moods of suffering and resignation," "putting suffering and resignation themselves into a (carved) face," "making suffering and resignation 'come alive' in a (carved) face," and "delineating suffering and resignation in a vivid way."

The latter, of course, are the acts which, according to my analysis of Fry's statement, "add up" to a "sense of suffering and resignation." The analysis of other subjective factors will bring to light a variety of other artistic acts and thereby fill in the range of acts covered by the term "artistic acts."

77

Some indication of this range can be conveyed by noting that even "painting an orange line" and "sculpting a large mass" are artistic acts; they must be described in terms of the *works* they produce. Of course, neither the painting of an orange line nor the sculpting of a large mass *need* have any anthropomorphic adverbs applicable to them. The broadening of the notion of artistic act, therefore, has the important effect of no longer requiring that every artistic act be anthropomorphically qualified.

We may understand the relation between artistic acts anthropomorphically qualified and those not so qualified as follows. The relation is rather like the relation between the class of expressive acts, e.g. smiling sadly, shouting anxiously, waving your arms angrily, and the wider class of vocalizations and bodily and facial movements. Obviously, acts of the latter sort must always be describable in terms of the sounds uttered, the faces made, the movement patterns made. Yet, equally obviously, not all such utterances, faces, and movements are describable in *anthropomorphic* terms. This is to say only that not every facial configuration, bodily movement, or vocalization of a person, even when the person is responsible for it, is an expression. Likewise, not every artistic act, as just re-defined, is expressive.

However, some muscle movements or vocalizations which are not themselves expressions of anything are "constituents," as it were, of a larger "pattern" of movements or vocalizations which are expressions of some feeling or emotion. Thus, merely drawing my upper lip back, merely raising one eyebrow, merely showing my teeth, merely tightening the grip on my right hand, or merely bringing my foot down hard on the ground would in most cases not be describable as "angry" ("angrily") and would not count as an expression of anger. But all of these acts together, with perhaps more added to them, would likely make up a behav-

ioral *gestalt* which would be expressive of anger. Analogously, as the analysis of this chapter will point up, even artistic acts which are not expressive in the way discussed in Chapter One may figure in a "pattern" of such acts characteristic of some more or less complex subjective factor. Let us return to those analyses.

Once the parallel between the artistic acts in Fry's Negro sculpture and the characteristic behavior expressive of common emotions is grasped, it is easy to see how it is that Fry can describe carved heads, but not necessarily the carvers of the heads, in terms of a "sense of suffering and resignation." As was noted in Chapter One, the acts expressive of anger are standardly described as angry; and the same is true, *mutatis mutandis*, of sadness, happiness, gaiety, etc. There are angry shouts, sad smiles, happy jigs, and gay laughter, which are respectively the shouts, smiles, jigs, and laughter characteristic of angry, sad, happy, or gay persons. It is worth remarking, moreover, that neither an angry shout nor a sad smile "need" be described as angry or as sad. There are in principle other ways of describing those features of a shout or a smile which make them angry or sad, just as there are other ways of describing Fry's Negro carvings without using the term "a sense of suffering and resignation." But a pale, weak, droopy, listless smile accompanied by dull and distant eyes starting to fill with tears is probably a sad smile whether the word "sad" is applied to it or not. Similarly a carved head in which suffering and resignation are vividly but subtly and sensitively portrayed does exhibit a sense of suffering and resignation whether or not any critic says it does. Fry's problematic phrase is indeed "eliminable" but not in a philosophically interesting sort of way.

It is obvious that analyses like the preceding one can be performed on the terms "sense of power and mass," "feeling for goodness," and "a lively awareness of manners," and with

similar results. We may therefore turn to an analysis of the other sorts of subjective factor listed earlier. Consider first the "love of nature" which Pierre Devambez professes, in passage (1), to find in certain Cretan paintings. What in the paintings leads him to this claim? The claim is based upon the fact that the artists have filled the paintings with plants and animals as well as upon the fact that they have individualized these figures rather than making them fit a rigid pattern. Furthermore, the artists have taken special care in working upon each figure and have attended painstakingly to detail. Finally, they have, as it were, "focused" closely upon the objects they represented; that is to say, they have painted "close-up" views of these natural objects.

What does all of this have to do with a *love* of nature? Let us imagine a person, not a painter, who loves nature. He likes to devote most of his attention to plant and animal life; he arranges his life so that his work is concerned with nature. He knows and appreciates the subtle differences which separate closely related varieties of plants and animals, and he is even sensitive to individual differences wrought within a single variety by subtle differences in environment. He likes to spend hours examining closely and in detail even the smallest and least obvious of nature's products. To be sure, a love of nature can be manifested in other ways too, but this sketch describes at least one variety of a love of nature. Notice that the term "love of nature" to describe the collection of facts listed in the sketch functions to identify a kind of pattern among those facts. If a person does all of those things, what he does "makes sense," fits together, in a certain way. All of these facts "add up" to the further fact that the man does have a love of nature. Notice also that the description of the non-painter is analogous to the description we must make of Devambez's Cretan painters on the basis of their paintings. We can therefore expect that a painter

who loved nature in ways similar to our imagined non-painter would paint the sort of paintings which Devambez describes in passage (1). Of course one *need* not say that those Cretan paintings are "imbued with a love of nature." But it is still true that some of the artistic acts discernible in the paintings form a pattern of "activity" characteristic of a person who loves nature.

"Delight in nature," also used by Devambez in (1), is subject to the same type of analysis and requires no extended attention. It is interesting to note however exactly how the "pattern" among artistic acts which is called "delight in nature" differs from the pattern which is "love of nature." The painter who "expresses his delight in nature" fills his work with floral and animal figures too, but he views nature as predominantly pretty and gay, making a light, graceful, busy though uncluttered design of his subject matter. Moreover, he does not "focus" closely on his subjects but presents a "panoramic" view, as if to include as much of nature as possible in the painting. He approaches nature extensively rather than intensively. To take delight in nature is to have a more superficial, less intense attitude toward nature than one has when one loves nature. This follows simply from the difference in the natures of delight and of love.

No new issues are raised by Henry James' phrase "love of the common and vulgar" (3) or by Trilling's talk of Homer's and Tolstoi's "love" for their characters (4). James may be taken to mean (a) that Howells treats at length and in detail the ordinary activities and environment of ordinary people; (b) he does so with care and with sympathy; (c) he focuses almost exclusively on such ordinary matters. This pattern of "behavior" is just what one would expect of a person (and a novelist) who "loves" what is common and vulgar. Similarly, Tolstoi loves his characters because (a) he portrays them compassionately regardless of the immor-

81

ality of their acts and (b) he presents their motives as "understandable" ones in that he suggests that his characters are, to an extent, victims of their uncontrollable passions and/or circumstances. This is the way we are inclined to view the sins of (real) people whom we love.

The case of Walter Friedlaender's description in passage (4) of the two distinct "attitudes" or "outlooks" in High Renaissance and Mannerist painting seems on the surface to be more complicated than the cases so far discussed. That is probably because his *descriptions* of the two attitudes are more complicated. A relatively short and simple phrase like "love of nature" or "sense of power and mass" will evidently not capture the sort of attitudes Friedlaender is describing. Yet it is just the fact that there are no simple words or phrases to describe those attitudes that leads us to suspect that there are no "attitudes" or "outlooks" at all where Friedlaender locates them, i.e. in the art. Friedlaender could have written his paragraphs, we perceive, without ever having used the terms "attitude" or "outlook." And, unlike the omission of phrases like "love of nature" or "delight in nature," such an omission would have deprived us of no insight into peculiar "patterns" which exist among the "artistic acts" comprising the two painting styles. Friedlaender could have said merely that High Renaissance painters idealize and objectify human figures, that they "remove them from the subjective impression," that they "lay claims on nature." But why should one want to say that *therefore* there is a special High Renaissance "attitude" or "outlook" discernible in the paintings of the period? Friedlaender's use of "outlook" and "attitude" seems vacuous.

The apparent vacuity of terms like "attitude" and "outlook" is not confined to their uses in criticism of art. We might sum up the attitude of a man towards life in general in the following way:

He lives each day as if it were his last, taking as much pleasure from it as he can. Indeed, he devotes considerable ingenuity to ferreting out pleasure and to inventing new forms of it. He makes a point of never looking back on yesterday and never forward to tomorrow. And although he does not run from responsibilities, because that would usually be too troublesome, he takes the few which he does acknowledge lightly, not worrying if they go unmet.

When we call this passage a description of an attitude, the term "attitude" adds nothing (we might say) to our understanding of the description, which simply summarizes the ways in which the man acts and does not act. But so to object to the use of the term "attitude" in this case shows a misunderstanding of it. For to describe what a man does and does not in the way illustrated is just to describe his attitude towards life. Moreover, such a description may be the only way to describe that attitude. Most attitudes are not nameable by simple terms like "love," "respect," "devotion," etc. In general they are best described by spelling out the patterns of thought and/or action characteristic of the attitude or outlook. Thus there is no difference in principle between the attitudes that Friedlaender finds in High Renaissance and Mannerist painting and the love, delight, and affection which Devambez, James, and Trilling find in Greek paintings, and in the works of Homer, Howells, and Tolstoi.

The phrase "imagination of *Little Dorrit*" as used by Trilling in passage (9) functions very much like Friedlaender's terms "attitude" and "outlook." Trilling is neither saying something about *Dickens'* imagination in a rather confused way nor saying something nonsensical. What is it to have a "generalizing" kind of imagination (or mind, or mentality— the word is not important)? What would a person with such

an imagination characteristically do? Of course he might do many different things, even as a novelist. But such a person might very well write a novel in which (a) he names characters solely by the words designating their occupations, (b) he creates characters of pure goodness, like Little Dorrit, (c) he treats his characters as symbols rather than as lifelike human beings, (d) he generally arranges his material to express an abstract moral idea. But, as we learn from Trilling's passage, that is precisely what Dickens does in *Little Dorrit*, and that is precisely why Trilling speaks of the generalizing imagination *of the novel*. Just as we are justified in speaking of the sadness *in a smile*, so is Trilling justified in locating a generalizing imagination *in* Dickens' work. What Dickens does in that work is characteristic of a person with a generalizing imagination, just as smiling sadly is characteristic of a sad person.

In passage (11) Croce apparently describes a *person* whom he variously calls a "rebel angel," and "heroic poet," and a "man-Satan." What we are required to do in order to see Croce's point is to imagine the personality of a person who could be aptly so named and to discern that what Baudelaire does in his poetry is what such a person might characteristically do. Similarly, in Virgil Thomson's passage (10), the "moral character" which is nominally ascribed to Bartok may also be taken as a description of Bartok's music. Thomson in effect sketches a portrait of a man of noble soul who is not personally maladjusted, who realistically faces the human condition, who left Hungary in a time of troubles, and who frankly faces horrors of the sort which were common in Central Europe between the wars. But if Thomson were describing Bartok's music alone, could he not have said more simply that Bartok injects horror and despair into his quartets, but with a sincerity and elevation which is noble and not whining? Of course he could have said that and elimi-

nated his character sketch altogether, but in this instance only by losing some specificity in the description. For what Thomson does in his character sketch is to qualify the despair, the horror, the sincerity, and nobility. We are being told that Bartok's music shows the sort of despair, sincerity, and nobility which a person like the one sketched would characteristically feel towards the kind of horror peculiar to the time and place mentioned. In this way Thomson's description can locate a kind of "moral character" in the music itself.

This lengthy discussion of subjective factors in art has shown that insofar as they are described in the ways exemplified in passages (1) through (11) works of art must be considered just as expressive as works whose artistic acts are qualified by anthropomorphic adverbs. Had proponents of the Canonical Position recognized this fact, their interpretation of Expression Theory would not have had even the *prima facie* plausibility which it has had. The expressiveness of art amounts to more than the anthropomorphic properties it has.

THIS chapter completes a line of argument whose results I shall rely on in the following chapters. In Chapter Three I shall argue that language is expressive in ways which parallel the two sorts of expressiveness in art discussed in this chapter and the preceding. Chapters Four and Five discuss two species of artistic act, which are themselves varieties of expression, and argue that they are always anthropomorphically qualified and are thus expressive in the sense of Chapter One.

Before entering into these discussions, however, two brief notes are in order. One concerns the notion of "being characteristic of." I have implied that it is essentially involved in being an expression and yet have offered no analysis of

it. There are two reasons for this apparent omission. The first is that my analysis of "being an expression of" comes in Chapters Six through Nine. The second is that, even in that analysis, it will be more illuminating to discuss ideas involved in expression other than "being characteristic of." "Being characteristic of" is not, after all, a concept uniquely relevant to expression; and its particular meaning with respect to expression will be implied by much of what I say in Chapters Six through Nine. My reliance upon the concept in these early chapters is fundamentally a tactical ploy, since it seems to me the most convincing way to link art and language to commonplace expressions, thus preparing the scene for an analysis of what it is to be an expression.

The second note concerns what I call the "epistemological problems" of expression in art. People concerned with the expressiveness of art seem never to be able to avoid questions like: Is the expressiveness of art "really" in the art? Or is it merely projected into it by an observer? Does one really merely see or hear this expressiveness? Or does one also feel along with it? Are attributions of expressiveness "intersubjectively verifiable"? Are they merely "recommendations" about responding to the art? Must one sympathize with the artist in apprehending the expressiveness of the art? Is the expressiveness of a work of art merely a "way of looking" at that work? Is it an "aspect" of the work? Is the expressiveness of art possibly an illusion? Is it a "semblance"? A mere "appearance"?

In this book I deliberately and steadfastly avoid confronting these questions head-on. One reason is that they lead to topics far beyond the scope of this essay. A second reason is that the points I have made and shall make can be made independently of any answers to those questions. The final reason is that the results of my investigations do imply answers to some of those questions. These implications are

brought out in Chapter Nine. By no means do I regard the "epistemological problems" of expression as unimportant. I think they have an ultimate importance. It is merely that the subject matter of the present book has a logical priority over them, which I hope will eventually be evident even though it will not be demonstrated.

chapter three

Language and Expression

∾

The results of the preceding two chapters suggest two points: (1) the question of expression in art cannot be separated from an inquiry into expression in general; and (2) a general study of expression encompasses many forms of culture, such as language, science, historiography, and philosophy, some of which are not ordinarily considered in the least expressive. This chapter will argue in support of these points.

As the preceding chapters brought out, there are certain features about works of art which make these works characteristic products of persons with certain emotions, feelings, attitudes, qualities of mind, personalities, temperaments, or moral characters. These features explain the common practice in criticism of the arts of perceiving feelings, emotions, attitudes, etc., etc., "in" art works somewhat as we perceive such things "in" common expressions like grimaces, cries, and gestures. As soon as this similarity is seen between art and the so-called "natural expressions" it becomes clear that (1) linguistic utterances of many sorts are expressive in similar ways and, furthermore, (2) that linguistic expressions form a kind of "connecting bridge" between art and natural expressions.

On the one hand, language is almost always spoken with some particular "expression" in the voice, an expression which is traceable to some combination of rhythm, inflection, tempo, emphasis, or other features such as sudden aspiration. It is the latter sort of features in spoken language

which allows us to say that a thing is said (or asked, demanded, expressed, described, etc., etc.), e.g. angrily, tenderly, gently, kindly, proudly, coldly, sarcastically, bitterly, passionately, casually, dully, or plaintively. In this respect language is obviously like those non-articulate vocal expressions such as cries, calls, shrieks, croonings, yells, and wails whose tonal characters justify describing them as, e.g. mournful, angry, loving, or anguished.

On the other hand, some examples of language use approach the condition of verbal works of art in that they can be described in "anthropomorphic" terms irrespective of how, or of whether, they are orally delivered and irrespective of what we know about their authors independently of their "work." That Cicero's second Philippic against Antony, for example, is a vicious and savagely angry attack on a political enemy can be known by a person who is quite ignorant of any historical context which is not revealed in the speech and who is quite ignorant of the way in which it might have been delivered. To be sure, Cicero was a skillful practitioner of the "rhetorical arts." The latter phrase itself indicates how close a speech like his might be to some more clear-cut examples of verbal art works. Speeches like Cicero's are skillfully put together, are polished and worked, and are calculated to be "effective" much in the way that poems and novels can be.

But even language utterances[1] which are not so "artistically" formed and which do not exemplify any more or less established form of talking or writing can be described in similar ways. For example, words like the ones which Oedipus directs at Tiresias when the latter tells him that he is the cause of Thebes' misfortune are obviously *angry* words: "Am I to bear this from him?—Damnation / Take you! Out

[1] For convenience only, I shall use "utterance" to refer to both written and spoken language.

of this place! Out of my sight!"[2] And we know that these words are angry without hearing them interpreted by an actor knows that he is to pronounce them in an angry tone did not know the context in which they occur in the drama. In fact, it is only because we know the words to be angry words that we know Oedipus to be angry here and that an actor knows that he is to pronounce them in an angry tone of voice. The reason that the words are angry, and easily recognized as such, is simply that damning someone and ordering him away are characteristic acts of a person who is angry. And anyone[3] speaking, and meaning, words like Oedipus's is performing those acts, just as anyone who composed the Grandfather theme from "Peter and the Wolf" made a witty musical sketch of an old man.

The above considerations show that "language" can be expressive if cries and groans are expressive and if art is. The fact is hardly a new discovery, however. The Logical Positivists had a big stake in insisting on the fact. Benedetto Croce, from within an entirely different tradition, believed that the fact is of central importance for an understanding of language. Croce thought expression to be the very essence of art, and he evidently thought that it is in a similar way essential to language. In fact, he went so far as to identify the general study of aesthetics with "general linguistic."[4] I am not sure what exactly Croce had in mind by that, but surely his position entails the thesis that *all* language is expressive. And this thesis can reasonably be interpreted to mean that *every linguistic utterance* is truly describable either in terms of anthropomorphic adjectives or in terms of

[2] Sophocles, *The Oedipus Cycle*, trans. Dudley Fitts and Robert Fitzgerald (New York: Harcourt, 1949, Harvest Books ed.), p. 22.

[3] Anyone real or fictitious. The fact that this example of angry words is taken from a drama is absolutely irrelevant to the point.

[4] Benedetto Croce, *Aesthetic*, trans. Douglas Ainslie (New York: The Noonday Press, 1965), pp. 140 ff.

the sorts of subjective factors discussed in the preceding chapter.

If that is indeed what Croce had in mind, however, he was clearly wrong. Speeches like Cicero's and outbursts like Oedipus's are not paradigmatic of all linguistic utterances. One can think of thousands of simple statements, questions, and commands which, considered merely as lexical, grammatical, and syntactical forms apart from any tone or inflection used in pronouncing them, are characteristic of no feeling, attitude, mood, temperament, or character. The case is even clearer when we turn from conversational utterances to the considerably longer "utterances" which are the writings of journalists, literary critics, historians, philosophers, and scientists. Exhibition of passions, feelings, or even of personal attitudes are relatively rare in such writings, and when they occur they are often considered to be "deviant" in a number of ways. There is, for example, haughty scorn in the following passage from David Hume's *Treatise*:

> Nothing is more usual and more natural for those, who pretend to discover anything new to the world in philosophy and the sciences, than to insinuate the praises of their own systems, by decrying all those which have been advanced before them. And indeed were they content with lamenting that ignorance, which we still lie under in the most important questions that can come before the tribunal of human reason, there are few, who have an acquaintance with the sciences, that would not readily agree with them. It is easy for one of judgment and learning, to perceive the weak foundation even of those systems, which have obtained the greatest credit, and have carried their pretensions highest to accurate and profound reasoning. Principles taken upon trust, consequences lamely deduced from them, want of coherence

in the parts, and of evidence in the whole, these are everywhere to be met with in the systems of the most eminent philosophers, and seem to have drawn disgrace upon philosophy itself.[5]

But this passage is the first paragraph in the book, and it occurs in the Introduction, where Hume is establishing and justifying his purpose in writing the book. One expects "rhetoric" in such places. Even the great Newton in that greatest of scientific books, the *Principia*, was moved to write what is, in effect, an admiring and worshipful hymn of praise to God.

In him are all things contained and moved, yet neither affects the other; God suffers nothing from the motion of bodies, bodies find no resistance from the omnipresence of God. It is allowed by all that the Supreme God exists necessarily, and by the same necessity he exists *always* and *everywhere*. Whence also he is all similar, all eye, all ear, all brain, all arm, all power to perceive, to understand, and to act; but in a manner not at all human, in a manner not at all corporeal, in a manner utterly unknown to us. As a blind man has no idea of colors, so have we no idea of the manner by which the all-wise God perceives and understands all things. He is utterly void of all body and bodily figure, and can therefore neither be seen nor heard nor touched; nor ought he to be worshiped under the representation of any corporeal thing. We have ideas of his attributes, but what the real substance of anything is we know not. In bodies we see only their figures and colors, we hear only the sounds, we touch only their outward surfaces, we smell only the smells and taste the savors, but their inward substance are not to be known

[5] David Hume, *A Treatise of Human Nature*, ed. L. A. Selby-Bigge (Oxford University Press, 1888), p. xvii.

either by our senses or by any reflex act of our minds; much less, then, have we any idea of the substance of God. We know him only by his most wise and excellent contrivances of things and final causes; we admire him for his perfection, but we reverence and adore him on account of his dominion, for we adore him as his servants; and a god without dominion, providence, and final causes is nothing else but Fate and Nature. Blind metaphysical necessity, which is certainly the same always and everywhere, could produce no variety of things. All that diversity of natural things which we find suited to different times and places could arise from nothing but the ideas and will of a Being necessarily existing. But, by way of allegory, God is said to see, to speak, to laugh, to love, to hate, to desire, to give, to receive, to rejoice, to be angry, to fight, to frame, to work, to build; for all our notions of God are taken from the ways of mankind by a certain similitude, which, though not perfect, has some likeness, however. And thus much concerning God, to discourse of whom from the appearances of things does certainly belong to natural philosophy.[6]

But in Newton such talk is easily ignored or excused; the scientific weight of his book is so great that no lapse into extra-scientific concerns can lessen it. And in any case Newton was writing at a time when theology and science were not commonly kept separate.

Passages like these from Hume and Newton can be found nearly anywhere in the literature of any discipline or subject matter. And yet there are far more passages not only in Hume and Newton but in the countless volumes of nonfiction prose in which the authors apparently are simply de-

[6] *Newton's Philosophy of Nature: Selections from his Writings*, ed. H. S. Thayer (New York: The Hafner Library of Classics, 1953), pp. 43-45.

scribing, naming, referring, arguing a position, marshalling evidence, organizing data, or explaining events. The latter activities, unlike damning and ordering away, are not generally characteristic of any particular feeling, mood, or attitude, to say nothing of a personality or character. Indeed it has become something like a point of honor among practitioners of many intellectual disciplines that nothing of themselves be revealed in their prose. We cannot deny that there are honorable men among them and therefore that Croce is wrong about the essential expressiveness of language.

WE MIGHT be willing at this point to think no more of Croce's apparently false belief about language were there no reasons to doubt that we were interpreting Croce's meaning correctly. But there are such reasons. In the first place, it is a rather gross and obvious fact that there are many linguistic utterances in which nothing of the utterer is expressed. The fact is so gross and obvious that it is hard to believe that Croce could not have noticed it. And in the second place, since the term "express" and its grammatical variations are used in such a wide variety of apparently unrelated ways, to think of language as expression might not be to think of it as expressing anything *of its users* at all. Consider the following uses of the term "expression."

(a) A French expression for "The weather is fine" is "Il fait beau."
(b) "Lift" is a British expression for "elevator."
(c) "The cat's pajamas" is a slang expression, current in America during the 1920's, indicating approval.
(d) "Blacks" is an expression used by more or less left liberals and radicals to refer to Negroes.

94

(e) "Zook" is an expression fourteen-year-old John uses when he is astounded.

(f) "Subsistent" is an expression found in books of Medieval philosophy and means (roughly) "independently existing."

Might it not be that when Croce implies that all language is expression, he means that the language used in any language utterance must be a linguistic expression of the sorts exemplified here?

On such an interpretation of Croce, of course, his point seems trivial and uninteresting. For in (a) through (f) "expression" seems to be no more than a general term for "word," "phrase," or "sentence." It is not unreasonable to take this use of "expression" as designating any meaningful unit of language of sentence-length or shorter. It is this meaning of "expression" which is relied upon in certain technical and specialized uses of the term. The linguist Louis Hjelmslev, for example, makes the systematic distinction between the level of "expression" and the level of "content" in any language.[7] In this way he intends to mark a distinction roughly between the class of phonologically or graphologically describable elements of a language and their "meanings." Similarly, the philosopher D. S. Schwayder propounds a notion of expression very much like the current linguists' idea of "morpheme." For Schwayder, even meaningful suffixes and prefixes like the *en* in *oxen*, the *zer* in *zerlegen* are expressions, respectively, of English and German.[8] Furthermore, in specialized disciplines like symbolic logic and mathematics "expression" is often used to designate those units of a nota-

[7] Louis Hjelmslev, *Prolegomena to a Theory of Language*, trans. Francis J. Whitfield (Madison: University of Wisconsin Press, 1961), pp. 47 ff.

[8] D. S. Schwayder, *The Stratification of Behavior* (New York: Humanities Press, 1965), p. 349.

tional system which are roughly analogous to meaningful units of a natural language. Thus symbols for constants and variables of all varieties as well as formulas in logic are referred to as "expressions."

But while all of these uses of the term "expression" are unquestionably legitimate, it is a mistake to assume that they simply reflect the common and less self-conscious use of the term when it used to designate units of natural languages. For it is not the case in the latter use that "expression" is simply a more general word for "word," "phrase," "term," or "sentence" and functions in particular contexts just as one or another of the latter. There are no cases in which "expression" refers to a word, phrase, or sentence and in which the terms "word," "phrase," or "sentence" respectively could not serve as well. The reverse however is not true, as the following sentences show. They are examples of "questionable" uses of "expression."

(1) Suppose in a course on typography, the instructor distributes sample books containing a running text, every sentence of which is printed in a different type face. He says, "Students, I want to call your attention especially to the second *expression* from the bottom on page 92."

(2) In a grammar book, in a section covering the explanation of adjectives, suppose we find the following *expression*:

(3) "The *expressions* 'blue,' 'round,' 'high,' 'straight,' 'angry' are examples of commonly used adjectives."

(4) Suppose in response to a request to translate a sentence into French in a French class a student says "'La plume est sur la table' is the French *expression* for 'The pen is on the table.'"

Case (1) is simply an incorrect use of the term "expression." But is too strong to say that "expression" is used *incorrectly*

in cases (2), (3), or (4). They exemplify uses about which an English teacher should comment that the terms "word," "phrase," or "sentence" would be "better." Perhaps the best reason that they would be "better" is that it is *pointless* to use "expression" in these cases. I shall try to clarify why it is pointless to use "expression" in cases (2), (3), and (4).

The reason that case (1) simply shows an incorrect use of "expression" is that the instructor merely wants to make a point about the typographical "look" of the second sentence from the bottom. Referring to the sentence as an "expression" suggests wrongly that the typography instructor is interested in the sentence as a functioning part of a language and is concerned with such aspects as its grammar, style, vocabulary, or meaning. But in cases (2), (3), and (4), the interest *is* clearly on the meaning and/or grammatical function of words and sentences. Why, then, are those words and sentences "questionably" designated "expressions"? In order to find out, let us contrast (2), (3), and (4) with the unquestionably appropriate uses of "expression" in (a) through (f) above.

All of the latter uses occur in contexts in which the characteristic *users* of the expression in question, or its characteristic *conditions of use*, or both, are indicated and in which the *meaning* (or function or use) of the expression is given. It thus appears that if, in any context, a unit of language is appropriately designated an "expression" it is important in that context that attention be called to characteristic users or conditions of use, on the one hand, and their characteristic uses, on the other. Cases (2) and (3) above fail to meet this condition. In (2), both the user (the grammar book's author) and the use (to explain the concept "adjective") are indeed mentioned. But neither this user nor this use is *characteristic* of the alleged expression. There is no sense that the alleged expression is a grammarian's expression for

explaining the concept of an adjective in the way "Black" is a radical-liberal expression for Negro. The case of (3) is slightly different from (2). On the one hand, the use of the words mentioned is indicated. Moreover, the use in question, i.e. as adjectives, is a characteristic use of the words in question. But, on the other hand, no indication is given of the words' users or their conditions of use. And to call attention to them in the context would be quite irrelevant.

Case (4) presents yet a different problem. For it does as a matter of fact call attention to the characteristic users of "La plume est sur la table" (i.e. French people) as well as to the meaning of that phrase. But what makes the designation "expression" inappropriate is the fact that while in the context it is directly to the point to give the meaning of the French phrase, it is *not* to the point to call attention to certain characteristic users of the phrase by calling it French. The problem with (4) would not be eliminated simply by omitting the word "French" either. For then the use of the term "expression" to designate the phrase would *imply* reference to a characteristic group of users or characteristic conditions of use. Yet since in that case the reference would be implicit but not clearly and unambiguously understood, there would be no point in making the implication.

There are apparent counter-examples to the principle that for a unit of language to be appropriately designated an "expression" in a context it is important in that context that attention be called to characteristic users or characteristic conditions of use of the alleged expression. If, for example, in (4) we were to substitute "Il n'y a pas de quoi" for "La plume est sur la table," the designation "expression" would not seem inappropriate even though the general context were kept the same. What this fact suggests, then, is that some linguistic units are, independent of any context, ap-

propriately called "expressions." And such does seem to be the case. Thus it is quite natural to call such phrases as "How are you?", "You're welcome", "What's the matter?", "Don't trouble yourself" English *expressions* regardless of the context in which they are so called. Yet it is quite unnatural to designate "Look under the table", "Hold up your finger", "What color is your living room carpet?" as English *expressions* in every context.

But these are only apparently counter-examples. In order to see why that is so, we must inquire further into the implications of designating any linguistic unit an "expression." Let us look again at (a) through (f) above. It is easy to elaborate on (a) through (f) in the following way.

(a₁) "Il fait beau," or literally "It makes beautiful," is one way the French have of saying that the weather is fine.

(b₁) The British use the term "lift" as a characteristically more direct and less Latinate way of talking about elevators.

(c₁) Using "the cat's pajamas" to indicate approval is an example of the flippant way of talking characteristic of slang at all times.

(d₁) "Black" is a more aggressive, militant way of designating Negroes than "Negro."

(e₁) "Zook" is an example of John's typically idiosyncratic way of expressing things.

(f₁) "Subsistent" is a technical way Medieval philosophers and their English translators had of saying "independently existing."

In (a₁) through (f₁) what were designated as "expressions" are described as "ways of talking (saying, designating, expressing)." Expressions other than the ones here exemplified might, of course, be described as ways of naming, calling,

describing, referring, speaking, representing, giving an alarm or a warning, putting a point, asking, ordering, announcing, suggesting. The list of possible verbs is, I believe, coextensive with the list of verbs denoting what William Alston calls "illocutionary acts."[9] What (a_1) through (f_1) show, then, is that expressions of language are ways of performing illocutionary acts. For the sake of brevity, however, I shall henceforth use the term "ways of speaking" to mean "ways of performing illocutionary acts."

Now when one talks of expression x as a way of speaking, one is typically not interested merely in stating that x is a way of speaking. As (a_1) through (f_1) show, one is typically interested in saying or at least suggesting that x is a certain *sort* of way of speaking. The interest is thus in the way that the way of speaking is properly describable. Presently I shall have more to say concerning descriptions of ways of speaking. Here I want only to note that the given or suggested description of a way of speaking is in an obvious, if vague, way a function of its characteristic meaning (or function or use) and of its characteristic users and/or conditions of use. Concerning this function, too, I shall have more to say later. Given such a functional relationship, however, it is clear that calling attention to x's characteristic meaning, users, and conditions of use is implicitly to call attention to x as a special way of speaking. It follows, then, that to designate any linguistic unit as an expression, while indicating its characteristic meaning, users, and/or conditions of use, is implicitly to call attention to it as a special way of talking. But if that is so, then to call a linguistic unit x an expression when "expression" is not being used in the technical way described earlier and when no indication is given of x's characteristic meaning, users, and/or conditions

9 William P. Alston, *Philosophy of Language* (Englewood Cliffs, N.J.: Prentice-Hall, 1964), p. 35.

of use is to imply that x both is a special way of talking and does have a characteristic meaning, group of users, and/or set of conditions of use.[10]

I suggest that it is precisely the latter double implication which is operative when such common phrases as "How do you do?" are contextlessly denominated "expressions." But such an account obviously does not yet explain why some linguistic unit, which could in appropriate contexts be labeled an expression, could not thereby, in general and apart from the context, be designated an expression. The explanation is that common expressions can be contextlessly called "expressions" because they are already commonly recognized as special ways of speaking. Although to call them expressions is to call our attention to them as special ways of speaking, the attention, as it were, needs no such calling, and therefore no questions are raised concerning the point of so calling our attention. This is not to suggest that the special ways of speaking represented by expressions like "How do you do?" are commonly and well known. On the contrary, as I shall point out, describing such common ways of speaking is especially difficult in virtue of their very commonness. I mean only that calling attention to such expressions as ways of speaking raises no questions because it seems obvious to everyone that they are ways of speaking. However, if a phrase like, say, "living room carpet" were to be called an expression (as, for example, in this sentence) when no reason for so calling it is given or indicated, calling attention to the phrase as a special way of speaking immediately raises the questions of how and why it is a special way of talking. And yet, since it would be irrelevant to give or suggest answers to such questions, given the con-

[10] I assume here that there is no likely third sense of "expression" according to which x could be called an expression, because I haven't discovered such a sense.

101

text, say, of the preceding sentence, calling attention to the phrase as a special way of speaking (assuming now that it is such) would be gratuitous.

My argument has been that there is a common, standard, and non-technical use of "expression" which is more specific than the use of the term simply as a generic term for any meaningful unit of a language, artificial or natural. One final consideration may buttress my thesis. There are contexts when even artificial symbols like those of logic should not be designated "expressions" even though those very symbols can in most contexts be called "expressions" according to the "technical" sense which does not involve a "way of speaking." Thus we might say using the latter sense of "expression":

(g) The expressions Ax and Ex are logical symbols meaning roughly "all" and "there is at least one thing."

But the following is at least misleading because the syntactical position of "expressions" suggests the common and more specific sense of the term.

(h) Ax and Ex are expressions used by some contemporary logicians to stand roughly for "all" and "there is at least one thing."

In (h) the use of "symbols" for "expressions" would relieve the feeling of a promise undelivered. On the other hand, in the following sentence the use of "expression" could be construed in either sense.

(i) Logicians who value typographical accessibility will generally use the expressions Ax and Ex to represent the quantifiers.

It is at least plausible to interpret (i) as suggesting that Ax and Ex are typographically unproblematic and therefore more efficient *ways of representing* the quantifiers.

LANGUAGE AND EXPRESSION

I HAVE argued thus far that to designate an element of language an expression is, unless the more or less technical sense of "expression" is being used, to call attention to that element as a "way of speaking." Thus we can say that such an expression *is* a way of speaking; we can also say that such an expression *represents* a way of speaking. But since a way of speaking is always a certain (or certain sort of) way of speaking we must be interested in the ways that ways of speaking can be described. And since we are interested here in ways of speaking insofar as they are, or are represented by, linguistic expressions we shall only be interested in such descriptions of ways of speaking as are also, with appropriate grammatical adjustments, descriptions of their corresponding expressions.

One sort of description which the preceding restriction removes from consideration is the sort which is applied to an illocutionary act in virtue of the tone of voice used. I might, for example, tell you gently to get out of my office by saying "Get out" in a gentle way. Since "get out" is far from being a gentle expression (compare it only to "please leave"), the term "gently" does not apply to the act of telling in the relevant way. On the other hand, I might tell you to leave my office bluntly and rudely if I say "Get out" in a short, hard tone of voice. In this case, "bluntly" and "rudely" apply to the telling not only in virtue of the tone of voice, which might also be called "blunt" and "rude," but also in virtue of the phrase "get out," which is blunt and rude.

Let us categorize the sorts of descriptions of expressions which might also describe the corresponding ways of speaking. First, there is a class of terms which denote, roughly, the "effect" which an expression has or might have upon a hearer or reader of it. This class includes "charming," "interesting," "exciting," "disturbing," "offensive." Second, there

is a class of terms which describe expressions with respect to syntactical, grammatical, and/or physical properties of the expression. Examples of this class are: "long," "simple," "brief," "complicated," "adjectival." Third, there are words describing expressions in terms of the way they relate to what they mean, designate, or denote. Such terms as "clear," "precise," "direct," "literal," "metaphorical," "vivid" belong to this group. Fourth, there are terms which describe expressions by indicating the particular language or dialect of which it is an element, e.g. "English," "French," "Southern," "local." Fifth, some descriptions of expressions indicate a style, such as "colloquial," "dialectal," "slang," "technical," and "scientific." Finally, there is a class of terms which is coextensive with the class which I called "anthropomorphic" in Chapter One. These are terms which can also denote feelings, emotions, moods, attitudes, temperaments, personalities, characters, and qualities of mind of human beings. Although this list of categories is reasonably comprehensive, it makes no claim to be exhaustive. The categories also probably overlap at the edges and do not clearly and unambiguously sort all descriptions of expressions. The list will be useful nevertheless.

The category I am most interested in is the last. One reason for this interest is that most of the terms other than the anthropomorphic terms, when they apply to ways of speaking, frequently relate in a variety of ways to anthropomorphic terms. An expression might, for example, be charming *because* it is witty, offensive *because* it is rough and vulgar, or disturbing *because* it is maudlin. Or an extraordinarily long and grammatically complicated expression for a simple idea might be *thereby* pompous or pretentious. Again, one expects a technical expression to be in general a "cold" or "unemotional" way of referring to a thing, e.g. "affective response" for "feeling." And one has a right to expect a

colloquial expression to be "informal" and a slang expression to be "flippant" or "breezy," even though not all of them are.

Finally, some terms of the third category, like "precise," "direct," "clear," are already very much like anthropomorphic terms. For those terms can also be used to characterize attitudes and/or qualities of mind. Most persons would probably not place such terms in the class of anthropomorphic words, but that is so probably because of the motives which have led philosophers to deal seriously with anthropomorphic terms. No philosopher, as far as I know, has considered the problem of the latter sort of term with respect to anything but art. But what has motivated the problem with respect to art is that to call music or a painting "sad" is *prima facie* puzzling because words like "sad" seem to belong *properly* to persons. Yet because adjectives like "clear," "precise," "literal" seem to belong *properly* to expressions and to belong to people (or their "minds") only because people *use* those expressions, such adjectives would not appear to fall under the rubric "anthropomorphic terms." Nevertheless, because of their dual use in describing both persons and expressions, words like "precise," "literal," "vague," "clear" might, in certain contexts, have the same sort of significance as words like "witty," "pompous," "aloof," "sentimental," etc., because of what they might tell us about persons *using* the expressions.

It is only the terms of the first category above which do not generally relate to anthropomorphic descriptions or to anything resembling them. Thus from " 'Adieu' is a French expression for 'good-bye' " we may get " 'Adieu' is the French way of saying 'good-bye.' " But one can hardly suppose that the latter statement implies, presupposes, or even suggests any anthropomorphic description of the bidding of farewell in French by means of "adieu." There are some exceptions to my generalization about the first category,

however. One sometimes has occasion to describe an expression as "very British" or "very American" or "very Southern." On such occasions the context makes (should make) clear what the *further* characteristics of British, American, or Southern expressions are taken to be. I might, for example, be discussing what I take to be general characteristics of the British and make the assertion that they are typically modest and restrained and hence given to understatement. In this context I might later assert that the expression "that's a bit of all right," meaning "that's quite good" is very British, by which I would be implicitly referring to the understatement and thereby the restraint and/or modesty of the expression. Or I might call the expression "to kick upstairs" very American and, believing that American characteristics are coarseness and vulgarity, be thereby calling attention to the coarseness and vulgarity of the expression.

The fact that so many various ways of describing an expression can be related to anthropomorphic descriptions of expressions suggests strongly, though it does not imply, that any expression, regardless of how it actually is described on any occasion, is in principle describable in anthropomorphic terms or at least in terms like "clear," "precise," "literal" which can function as anthropomorphic terms. And this suggests that any linguistic unit which can in the right contexts be labeled an "expression" does represent a way of speaking[11] whose character is properly described in anthropomorphic terms. But what arguments can show that such a suggestion is correct? For on the surface it appears that anthropomorphic "characters" are not possessed by all expressions. The French expression for "The weather is fine"

[11] I hope it is clear that any linguistic element, which it is possible properly to call an expression, unqualifiedly *is* an expression. That is, although I argued earlier that only in certain circumstances is it relevant *to call* something an expression, it does not follow, nor is it true, that only in those circumstances *is* that thing an expression.

is "Il fait beau"; but what possible *anthropomorphically describable* character does it have? One might refer to "flecked with foam" and "beaded with perspiration" as adjectival expressions composed of verb phrases. But is their character further describable in anthropomorphic terms? It seems not; certainly no such description immediately springs to mind. Apparently, it is quite false that all expressions have anthropomorphic characters.

Consider, however, that we would not balk at the assertion that all *persons* have some sort of personality. We do not balk, of course, because we know that a universal feature of persons is having a personality. Still, we might very likely not be able to describe the personality or even to mention a personality trait of persons we see frequently such as the paperboy, the bank clerk, the neighbors across the street. But we are not willing on that account to believe that these persons do not have personality traits. We have every reason to assume that if we were to become more familiar with a person, or if we were to observe him in more contexts, or if we simply were more observant of him, we would as a matter of course be able to discover something of his personality. To be sure, persons and expressions are quite unalike. And yet—they *are* both able to bear descriptions of a certain important sort. Might there not be a method of observing expressions more closely and/or more systematically, and thereby of becoming more familiar with them, which will enable us to discover their anthropomorphic characters?

I believe there is such a method. The method is based upon the fact that an expression can always be "localized" with respect to a characteristic set of users and/or conditions of use. It is also based on the fact that so to localize an expression is implicitly to contrast it to other similarly localized expressions with sufficiently similar meanings (or

107

functions or uses). It consists in (1) setting a given expression in a series of other expressions with the same function, meaning, or use and (2) constructing a set of parallel series of expressions in such a way that the corresponding places in each series form sets of expressions which, though different in function, meaning or use, are alike with respect to the group of persons who would characteristically use them or to the conditions under which they are characteristically used. Consider these examples:

Schema I
A (1) How do you do.
　 (2) Hello.
　 (3) Hi!
　 (4) Greetings to you.

B (1) Do you want some help?
　 (2) Could you use some help?
　 (3) Need a hand?
　 (4) May I be of assistance?

C (1) Don't mention it.
　 (2) Sure. Any time.
　 (3) That's O.K.
　 (4) You are most welcome.

The anthropomorphic character of the rather ordinary expression "How do you do" is shown by this schema to be rather more formal than either A(2) or A(3), considerably more polite than A(3), but friendlier and less aloof than A(4).

Schema II
A (1) flecked with foam
　 (2) covered with bits of foam
　 (3) spume-spangled

B (1) beaded with perspiration
 (2) dotted with drops of sweat
 (3) sweat bejeweled

C (1) bedecked with finery
 (2) got up in rich clothes
 (3) regally garbed.

In this schema the adjectival expression "flecked with foam" is shown to be, like B(1) and C(1), dull, banal, and ordinary, less vulgar but also less direct than A(2), B(2), or C(2), but not infected with the pomposity and/or pretentiousness of A(3), B(3), or C(3). We can, in this way, come to understand the character of A(1) in an anthropomorphic way.

On the face of it, the Method of Expansion and Contrast seems potent enough to disclose an anthropomorphic character in any expression. Even without using the Method on any more examples, it does not seem plausible that any linguistic expression would fail to yield to it. The Method brings out, after all, those characteristics of ordinary language which, though unnoticed by most people, some novelists and dramatists are especially sensitive to. This sensitivity enables them to create characters partly by means of the language they are made to speak. And the range and extent of the language which can be so used in characterizations is, of course, practically unlimited.

But there is some further reason to suppose that the Method is universally applicable to expressions. As I argued earlier, being an expression depends upon being "localized" to a group of uses and/or set of conditions of use. It is precisely this feature of expressions which is used in the above schemas to bring out anthropomorphic characters. Being able to make up Schema I depends upon knowing the ways certain sorts of persons would say or do the things represented respectively in I A, I B, and I C. The construction of

Schema II depends upon similar insights. We imagine, for example, that very plain and not especially literate persons might say A(2), B(2), and C(2); that somewhat better read but not especially imaginative persons might say or write A(1), B(1), or C(1); and that A(3), B(3), C(3) might be used by persons who believe that "fine writing" is called for in the circumstances or by persons who characteristically do things in inflated and exaggerated ways. An implication of this fact is that any linguistic unit whatsoever in which an anthropomorphic character can be discovered by the Method of Expansion and Contrast is an expression, since being an expression depends upon being "localized."

Of course it does not *follow* that, because all expressions are "localized," and because bringing out an anthropomorphic character of a linguistic element depends upon "localizing" that element, all expressions have anthropomorphically describable characters. It might be that the localizing users or conditions of use which justify a phrase being called an expression do not imply any anthropomorphic character at all. For example, "flecked with foam" is called an adjectival *expression* because foam flecking can be thereby denoted when an adjectival construction is desired. Not only does the latter condition of use have nothing to do with the phrase's character as brought out in Schema II above, but in itself it suggests no anthropomorphic characteristic. Consider, however, the following schema.

Schema III
A (1) The water was flecked with foam behind the boat.
 (2) The churning wheel flecked the water with foam.
 (3) Flecks of foam dotted the water behind the wheel.
 (4) The churning of the wheel caused the flecking of the water by foam.

B (1) In the heat his brow was beaded with perspiration.
 (2) The stifling heat beaded his brow with perspiration.
 (3) Beads of perspiration dotted his brow.
 (4) The sudden rise in temperature caused the beading of his brow with perspiration.

C (1) The girls were bedecked with finery for the holidays.
 (2) The girls bedecked themselves with finery for the holidays.
 (3) Bedeckings of holiday finery covered the girls.
 (4) Bedecking themselves with finery was one way the girls celebrated the holidays.

What these three series represent are the "same" meanings being expressed in different ways: by adjectival expressions, verb expressions, noun expressions, and gerund expressions. Moreover, each row across the three series displays a character different from the others. Allowing for the banality of the root phrases, A(2), B(2), and C(2) are rather more forceful and dynamic than the other expressions; A(3), B(3), and C(3) in particular are rather awkward and plodding, though not unvigorous, ways of making their respective statements; and the overinflated, stilted character of A(4), B(4), and C(4) can hardly be missed. A(1), B(1), and C(1), on the other hand, seem more insipid, if straightforward, than the other expressions in their respective series.

What Schema III points up is that the localization of a phrase simply in terms of adjectival use does neither immediately imply nor suggest an anthropomorphic character, but that there is such a character discoverable, a character which is in some not perfectly clear way related to its adjectival use. In other words, Schema III provides further evidence of the universality of anthropomorphic characters in

111

expressions, but it provides no grounds for thinking that this universality is *necessarily* connected with being an expression. Nothing *guarantees* that *all* expressions have anthropomorphic characters. This much is true, however: (1) a large number of linguistic expressions can be easily and obviously described in anthropomorphic terms; (2) there exists a Method for disclosing the anthropomorphic characteristics of expressions when these characteristics are not obvious; (3) there *appear* to be no cases of expressions which elude this method of disclosure; (4) any linguistic unit is always properly designated an expression simply in virtue of having an anthropomorphic characteristic. Everything points to a deep-running connection between being a linguistic expression and having an anthropomorphically describable character.

There is a final, rather back-handed argument in favor of thinking that all linguistic expressions are anthropomorphically describable. There is a parallel between linguistic expressions which are anthropomorphically qualified, on the one hand, and works of art which are anthropomorphically qualified in virtue of artistic acts, on the other. The anthropomorphic description of a linguistic expression can be transformed without changing its sense into a description of the illocutionary acts performable by means of the expression; that is just the significance of the fact that an expression is, or "represents," a *way of speaking*. Moreover, such ways of speaking can, though they need not, express the respective feeling, attitude, mood, mental and personal character of the persons who perform the illocutionary acts in those ways. Such being the case, an anthropomorphically described linguistic *expression* is also *"expressive"* in the sense discovered in Chapter One. In general, therefore, performing an illocutionary act in anthropomorphically describable way F is quite like smiling, frowning, grimacing, shrieking,

gesturing, or moving in way *F*. And just as the smile, frown, grimace thereby produced may be an expression of whatever *F* is characteristic of in a person, so the linguistic expression used in that illocutionary act may function as an expression of that same "thing." Of course, it may be that two quite different senses of "expression" could cover the same class of phenomena, i.e. linguistic forms, without being otherwise connected. But if there were some deep conceptual link between linguistic expressions and the possibility of anthropomorphically describing them, then the fact that certain linguistic forms can on occasion be designated "expressions" in two distinct senses would at least be more than a pure accident of language. The two senses of "expression" might be related as, for example, "bear" meaning "carry" or "support" is to "bear," as in "bear fruit" or "bear offspring," rather than as the two senses of "bear" in "bears bear in the spring."

In the foregoing I have merely brought forth interesting considerations pointing to a profound connection between linguistic expressions and such common expressions as smiles, cries, and gestures. It is quite plausible that Croce had such a connection in mind, however dimly, when he claimed that all language is expression. And if he did, his claim is far from trivial. For it links language and art in an essential way, just as Croce was concerned to do. But, as stated above, Croce's thesis (if it *is* Croce's thesis) is still false. Quite obviously, the language used in each language "utterance" does not necessarily constitute *an* expression. An author might argue a single point for several sentences, paragraphs, or pages, and all the language used will not constitute a single expression. Linguistic expressions are typically rather short pieces of language: words, idioms, phrases, short sentences. Croce's point, therefore, is probably best

construed in the following way: The language used in any utterance, no matter how long and elaborate, is very much *like* a linguistic expression in that it represents a distinctive anthropomorphically describable "way of speaking."

Interpreted in such a way, Croce's thesis is still false, but it is illuminating. It is false for very much the same reason that it is false that every painting embodies a single distinctive way of "acting artistically." A painting may well be simply incoherent, and the incoherence may be the result of the fact that its identifiable artistic acts are incompatible. Imagine that Poussin's *Rape of the Sabine Women* had contained a couple of figures painted in the more vigorous, passionate, "painterly" manner of a Rubens or a Delacroix. The figures would most likely appear to be gratuitous intrusions in a basically cool, classical work, and would "make no sense" in their context. Similarly, any piece of language purporting to have some unity in virtue of the fact that it is used to perform a single linguistic act, such as stating a position, arguing for a point of view, marshalling evidence, etc., might well be infected by a similar sort of incoherence. Even short utterances may be so infected. Suppose someone says "Hey, you! Shut the door, huh? I should not like to contract pneumonia." This utterance does not represent a distinctive way of talking but rather a ludicrous juxtaposition of a coarse order and a refined assertion.[12]

The way in which Croce's thesis fails to be true shows what significance it has. For it at least suggests that there are no *sorts* of language uses in which the possibility of the above kind of incoherence does not obtain. And that implies that language of any sort, used for any sort of purpose, might possess a distinctive anthropomorphically describable

[12] Of course, such a ludicrous juxtaposition might be made deliberately, in which case the whole utterance might be quite witty and not incoherent at all.

114

character. If that were true, then uses of language commonly held to be "objective" and detached from human feelings, attitudes, and personalities might be expressive in very much the way that art—allegedly the bailiwick of the "subjective" —was found earlier to be expressive. Such, in fact, is the case and the following is a documentation of it.

(1) In the following passage Lytton Strachey characterizes Gibbon's "treatment" of Roman history by characterizing the language—what he calls the "style"—of *The Decline and Fall of the Roman Empire*:

> . . . Even more fundamental than the element of scale, there was something else that, in reality, conditioned the whole treatment of his material, the whole scope and nature of his History; and that was the style in which it was written. The style once fixed, everything else followed. Gibbon was well aware of this. He wrote his first chapter three times over, his second and third twice; then at last he was satisfied, and after that he wrote on without a hitch. In particular the problem of exclusion was solved. Gibbon's style is probably the most exclusive in literature. By its very nature it bars out a great multitude of human energies. It makes sympathy impossible, it takes no cognizance of passion, it turns its back upon religion with a withering smile. But that was just what was wanted. Classic beauty came instead. By the penetrating influence of style—automatically, inevitably—lucidity, balance and precision were everywhere introduced; and the miracle of order was established over the chaos of a thousand years.[13]

Strachey is here referring to the aloof, impersonal, dispassionate way in which Gibbon *describes* the characters of Roman history, to his ironic way of *referring* to religion and

[13] *Portraits in Miniature and Other Essays* (New York: Harcourt Brace, 1931), p. 161.

the religious, to his clear and precise way of *stating a point*. The characteristics of all these linguistic acts which constitute Gibbon's *History* add up, in Strachey's mind, to form a single character of the whole work.

(2) Unlike Gibbon, Leopold von Ranke is not known for his style. Moreover, Ranke is often regarded as the very model of the objective historian, one who effaces the self in deference to the facts. One might therefore expect his language to be devoid of any "character." But it is precisely the characteristic of objectivity which is embodied in Ranke's style, thus "coloring" it with a human attitude. Ferdinand Schevill says of Ranke:

> He never departed from the quiet, tolerant manner of expression that was native to him and that he had adopted from the time of his earliest attempt at authorship as the tone appropriate to historical exposition.[14]

"Quiet" and "tolerant" are here used to describe the way that Ranke *narrated* historical events and *described* historical personalities.

(3) Stylistic descriptions are as applicable to philosophical writing as to other forms of prose. And they are never more appropriate than when applied to the work of David Hume, who self-consciously strove for style in his prose. Strachey writes of Hume:

> It is in the sense that Hume gives one of being committed absolutely to reason—of following wherever reason leads, with a complete, and even reckless, confidence—that the great charm of his writing consists. But it is not only that: one is not alone; one is in the company of a supremely competent guide. With astonishing vigour, with heavenly

[14] *Six Historians* (Chicago: University of Chicago Press, 1956), p. 136.

lucidity, Hume leads one through the confusion and the darkness of speculation.[15]

And again:

Nothing could be more enchanting than Hume's style when he is discussing philosophical subjects. The grace and clarity of exquisite writing are enhanced by a touch of colloquialism—the tone of a polished conversation. A personality—a most engaging personality—just appears. The catlike touches of ironic malice—hints of something very sharp behind the velvet—add to the effect.[16]

Strachey's points can be rephrased in a way that makes clear that what Hume *does* in his philosophical writing—his "illocutionary acts"—are describable in anthropomorphic terms: Hume *writes* ironically, colloquially, gracefully, and clearly; he *drives to his conclusions* with lucidity, with confidence, with vigor, and with a total commitment to reason.[17]

(4) But even philosophers with no literary aspirations exhibit a characterizable manner of expression. Thus Herbert Marcuse has found some anthropomorphic characteristics in certain philosophical utterances of Ludwig Wittgenstein and Gilbert Ryle.

The style in which this philosophic behaviorism presents itself would be worthy of analysis. It seems to move between the two poles of pontificating authority and easy-going chumminess. Both trends are perfectly fused in Wittgenstein's recurrent use of the imperative with the intimate or condescending *"du"* ("thou"); or in the open-

[15] *Portraits in Miniature*, p. 142. [16] *Ibid.*, pp. 145-146.

[17] Notice here that some anthropomorphic terms appear, not as adverbs, but as nouns in prepositional phrases functioning adverbially. It is obvious, I take it, that such terms can be treated by essentially the same analysis as that used on simple anthropomorphic adverbs in Chapter One and the earlier part of the present chapter.

ing chapter of Gilbert Ryle's *The Concept of Mind,* where the presentation of "Descartes' Myth" as the "official doctrine" about the relation of body and mind is followed by the preliminary demonstration of its "absurdity," which evokes John Doe, Richard Roe, and what they think about the "Average Taxpayer."[18]

(5) According to popular mythology, it is in scientific writing that one does not find any trace of the writer. Therefore one would expect that such writing not exhibit any anthropomorphically describable characteristics. The following passage, however, written by a reputable scientist on a scientific subject, shows that such an expectation is not universally met.

> One of my main aims will be to explain why we get a different answer to this when we take account of the dynamic nature of the Universe. You might like to know something about the observational evidence that the Universe is indeed in a dynamic state of expansion. Perhaps you've noticed that a whistle from an approaching train has a higher pitch, and from a receding train a lower pitch, than a similar whistle from a stationary train. Light emitted by a moving source has the same property. The pitch of the light is lowered, or as we usually say reddened, if the source is moving away from us. Now we observe that the light from the galaxies is reddened, and the degree of reddening increases proportionately with the distance of a galaxy. The natural explanation of this is that the galaxies are rushing away from each other at enormous speeds, which for the most distant galaxies that we can see with the biggest telescopes become comparable with the speed of light itself.

[18] *One Dimensional Man: Studies in the Ideology of Advanced Industrial Society* (Boston: Beacon Press, 1966), pp. 173-174.

My nonmathematical friends often tell me that they find it difficult to picture this expansion. Short of using a lot of mathematics I cannot do better than use the analogy of a balloon with a large number of dots marked on its surface. If the balloon is blown up the distances between the dots increase in the same way as the distances between the galaxies. Here I should give a warning that this analogy must not be taken too strictly. There are several important respects in which it is definitely misleading. For example, the dots on the surface of a balloon would themselves increase in size as the balloon was being blown up. This is not the case for the galaxies, for their internal gravitational fields are sufficiently strong to prevent any such expansion. A further weakness of our analogy is that the surface of an ordinary balloon is two dimensional—that is to say, the points of its surface can be described by two co-ordinates; for example, by latitude and longitude. In the case of the Universe we must think of the surface as possessing a third dimension. This is not as difficult as it may sound. We are all familiar with pictures in perspective—pictures in which artists have represented three-dimensional scenes on two-dimensional canvases. So it is not really a difficult conception to imagine the three dimensions of space as being confined to the surface of a balloon. But then what does the radius of the balloon represent, and what does it mean to say that the balloon is being blown up? The answer to this is that the radius of the balloon is a measure of time, and the passage of time has the effect of blowing up the balloon. This will give you a very rough, but useful, idea of the sort of theory investigated by the mathematician.[19]

[19] Fred Hoyle, "Continuous Creation and the Expanding Universe," in *Theories of the Universe: From Babylonian Myth to Modern Science*, ed. Milton K. Munitz (New York: The Free Press, 1957), p. 422.

Here Fred Hoyle is *explaining* a rather abstruse astronomical theory in a genial and homely fashion. This manner is characteristic of Hoyle's entire essay. But the obvious thing to say in this instance is that Hoyle's essay is not real, work-a-day science. Here is not a scientist going about his business but rather a scientist trying to bring what is technical and specialized down to the level of the layman. Hoyle's essay is a popularization of science and thus could be expected to exhibit certain characteristics like geniality and homeliness. Not only would *such* characteristics be totally out of place in ordinary scientific discourse, it might be said, but no anthropomorphic characteristics whatsoever are discoverable where the real business of science is done.

(6) To see that even ordinary scientific prose is not immune to such characterization, however, let us look at some typical scientific prose describing an experiment in the field of psychobiology.

Two hundred Swiss-Webster mice (60 to 70 days old) were used as subjects. All animals were given two trials, separated by 24 hours, on an inhibitory, avoidance-learning task (5). On each trial a mouse was placed on a small (2.25 by 6.25 cm) metal platform extending from the outside wall of a box and directly in front of a hole (3.75 cm in diameter) leading to the darkened interior of the box. A 40-watt bulb was located 19 cm above the platform. The apparatus was placed on the edge of a table so that the platform was approximately 1 cm from the floor of the room. All mice were given one "training" trial and one retention test trial 24 hours later. On each trial the time the mouse spent on the platform before it stepped into the box was recorded.

The mice were divided into ten groups, each with ten

males and ten females. The treatments given the different groups are shown in Fig. 1. Mice in the six groups shown on the left received a footshock of approximately 3 ma as they stepped from the small platform into the box. The controls received no other treatment.[20]

Certain features of this passage stand out as characteristic: the use of technical jargon, the use of mathematical expressions, the use of passive verbs, the use of the simple subject-predicate sentential form, the use of a simple vocabulary, apart from technical terms. Now it is just these features which make the language precise, straightforward, sober, and passionless. Of course these are the acknowledged virtues of scientific writing; scientists are *supposed* to write like that. But what is crucial in this context is to note that these characteristically scientific "ways of speaking" *are* as anthropomorphic and, hence, as expressive as are passionate, angry, or tender ways of talking and writing.

I HAVE presented both an informal interpretation of Croce's identification of aesthetics and linguistics and some reasons for believing that his thesis is true. We have, it has turned out, every reason to believe that there are no sorts of linguistic acts which are inherently incapable of being described in anthropomorphic terms and, consequently, that "language" is expressive in the way that art was earlier discovered to be. But just as we found that the expressiveness of art is not limited to those cases in which anthropomorphic adjectives describe works of art, so it is that non-artistic sorts of activities which make use of language can be expressive in ways which are not dependent simply upon anthro-

[20] James L. McGaugh and Herbert P. Alpern, "Effects of Electro-shock on Memory: Amnesia without Convulsions," *Science*, April 29, 1966, vol. 152, no. 3722, p. 665.

pomorphic descriptions of the language used. The following paragraphs describe a variety of instances in which "subjective factors" are detectable "in" the writings of historians, philosophers, and scientists but in which those factors are not designated by an adjective descriptive of the language used or, correspondingly, by an adverb describing the "way" in which a language act is performed. These subjective factors are obviously analogous to those discovered in works of art in Chapter Two.

(7) In example (2) in the preceding section Ferdinand Schevill is quoted characterizing Leopold von Ranke's language. But Schevill also finds other qualities in Ranke's historical work, qualities which are exhibited, of course, in Ranke's writing but not simply as attributes of the language he uses. Thus:

> He was a religious man possessed as only a religious man can be of a deep inner harmony, and this harmony set a corresponding imprint on his Christianity, causing him to shed a mild, pervasive optimism over all his work. Although historical Christian teaching presented God sometimes as a vengeful, sometimes as a loving, deity, for Ranke he was always a God of love. Unconsciously yielding to this temperamental bias, he was moved to ignore or at least lightly to pass over the more cruel and disturbing aspects of the human scene. While he could not and did not suppress the wars into which the fierce rivalries of the European powers periodically exploded, he was disinclined to concern himself with their details and particularly with their attendant barbarities. And when it came to such infamous horrors as the Peasant War in Germany and the purge of St. Bartholomew in France, which many of his less sensitive confreres through the ages have ridden as their prancing battle horses, he was

pleased to dispose of them in a cool, abbreviated account free from all emotional overtones.[21]

The "mild optimism" which Schevill here discovers in Ranke consists of more than his cool, unemotional language ("accounts"). Even more importantly, it consists in the fact that Ranke does not dwell on the cruel and barbarous aspects of human events. It consists in the sort of selectivity Ranke exercised in narrating events.

(8) While Herbert Marcuse identifies the "style" of Wittgensteinian analysis as a mixture of authoritarianism and chumminess, he finds in this sort of philosophy character traits which go deeper than the kind of language its practitioners use.

Austin's contemptuous treatment of the alternatives to the common usage of words, and his defamation of what we "think up in our armchairs of an afternoon"; Wittgenstein's assurance that philosophy "leaves everything as it is"—such statements exhibit, to my mind, academic sadomasochism, self-humiliation, and self-denunciation of the intellectual whose labor does not issue in scientific, technical or like achievements. These affirmations of modesty and dependence seem to recapture Hume's mood of righteous contentment with the limitations of reason which, once recognized and accepted, protect man from useless mental adventures but leave him perfectly capable of orienting himself in the given environment.[22]

In this passage Marcuse does not base his characterization on how the philosophers say what they say, i.e. imperiously or familiarly. Rather, it is *what* they say that betokens, for him, a certain complicated set of attitudes which he labels (perhaps hyperbolically) "sado-masochism." But however

[21] Schevill, *Six Historians*, pp. 145-146.
[22] Marcuse, *One Dimensional Man*, p. 173.

apt the latter term may be to denote a certain complex attitude, it cannot be converted into an adjective descriptive of any of the *language* which Wittgenstein or Austin use and which Marcuse thinks is relevant to his point. It is true that Wittgenstein's dictum that philosophy leaves everything as it is can be considered a *modest* characterization of philosophy. But it is not simply the modesty of statements like these that add up, for Marcuse, to sado-masochism. It is this modesty together with Austin's more violent behavior—his "contemptuous treatment" of certain terminology and his "defamation" of speculation—which completes a pattern of "action" which Marcuse believes characteristic of a kind of sado-masochism.

(9) In the opening passage of his book on Aristotle, John Herman Randall, Jr. characterizes the "mind" of his subject thus:

His great aim in life was to understand—to understand the world in which the Greeks found themselves. This was Aristotle's all-consuming passion. Indeed, his may well be the most passionate mind in history: it shines through every page, almost every line. His crabbed documents exhibit, not "cold thought," but the passionate search for passionless truth. For him, there is no "mean," no moderation, in intellectual excellence. The "theoretical life" is not for him the life of quiet "contemplation," serene and unemotional, but the life of *nous*, of *theōria*, of intelligence, burning, immoderate, without bounds or limits. There is in him a tremendous energy, an indefatigable industry, a sheer power of thought, that fascinates anyone who takes the trouble to understand what he is doing.[23]

[23] *Aristotle* (New York: Columbia University Press, 1960), p. 1.

124

When Randall says that Aristotle's mind is "passionate" he is quite clearly not referring to the *language* of the Aristotelian texts. Aristotle's passionate intellectualism is shown in the persistence with which he sought to know all sorts of things and in the fact that he considered nothing beyond the powers of reason, that literally everything was considered worthy of study. These facts are discernible in Aristotle's writings—discernible not in the properties of the language of those writings, but in what Aristotle does and says in those writings.

(10) Even in scientific or—if Giordano Bruno's cosmology does not quite qualify as science—in quasi-scientific writing, emotions can be discovered which are not merely attributable to the linguistic expressions used. Of the following passage by Bruno concerning the infinity of the universe, Alexander Koyré says that the author "rejoices" in the infinity of the world.

To a body of infinite size there can be ascribed neither center nor boundary. For he who speaketh of emptiness, the void or the infinite ether, ascribeth to it neither weight nor lightness, nor motion, nor upper, nor lower, nor intermediate regions; assuming moreover that there are in this space those countless bodies such as our earth and other earths, our sun and other suns, which all revolve within this infinite space, through finite and determined spaces or around their own centres. Thus we on the earth say that the earth is in the centre; and all the philosophers ancient and modern of whatever sect will proclaim without prejudice to their own principles that here is indeed the centre.[24]

[24] Cited in Alexander Koyré, *From the Closed World to the Infinite Universe* (New York: Harper Torchbook, 1958), p. 41.

We can see from this passage what Koyré means. Bruno's "joy" is closely related to stylistic features of the passage, especially to the long series conjoined by "neither . . . nor . . ." But while this series might plausibly be called an "intense" passage it is certainly nothing so specific as "joyous," so that by using the series to adumbrate the meaning of an infinite world Bruno would thereby be "rejoicing" in that infinity. Bruno's joy in this passage is determinable not only by the relative intensity of his language, but also by the fact that Bruno is explaining in that passage the meaning of a concept which he not only accepts but even flaunts before every other cosmological tradition which held falsely that the earth is the center of things.

(11) Perhaps a more interesting example of finding mental characteristics in scientific activity is Pierre Duhem's distinction between the strong, narrow mind, on the one hand, and the broad, weak mind, on the other. These two types of mind are evident in all sorts of human activity, according to Duhem, including art. Duhem nevertheless defines the two mental types with respect to the physical theories they produce.

> To bring directly before the visual imagination a very large number of objects so that they may be grasped simultaneously in their complex functioning and not taken one by one, arbitrarily separated from the whole to which they are in reality attached—this is for most men an impossible or, at least, a very painful operation. A host of laws, all put on the same plane, without any classification grouping them, without any system coordinating or subordinating them, appears to such minds as chaotic and frightening to the imagination, as a labyrinth in which their intelligences go astray. On the other hand, they have no difficulty in conceiving of an idea which

abstraction has stripped of everything that would stimulate the sensuous memory; they grasp clearly and completely in following, untiringly and unwaveringly, down to its final consequences, the reasoning which adopts such judgments for its principles. Among these men, the faculty of conceiving abstract ideas and reasoning from them is more developed than the faculty of imagining concrete objects. . . .

For these *abstract minds* the reduction of facts to laws and the reduction of laws to theories will truly constitute intellectual economies; each of these two operations will diminish to a very large degree the trouble their minds will have to take in order to acquire a knowledge of physics. . . .

But not all vigorously developed minds are abstract minds. There are some minds that have a wonderful aptitude for holding in their imaginations a complicated collection of disparate objects; they envisage it in a single view without needing to attend myopically first to one object, then to another; and yet this view is not vague and confused, but exact and minute, with each detail clearly perceived in its place and relative importance. . . .

But this intellectual power is subject to one condition; namely, the objects to which it is directed must be those falling within the purview of the senses, they must be tangible or visible. The minds possessing this power need the help of sensuous memory in order to have conceptions; the abstract idea stripped of everything to which this memory can give shape seems to vanish like an impalpable mist. A general judgment sounds to them like a hollow formula void of meaning; a long and rigorous deduction seems to them to be the monotonous and heavy breathing of a windmill whose parts turn constantly but crush only the wind. Endowed with a power-

ful faculty of imagination, these minds are ill-prepared to abstract and deduce.[25]

Duhem goes on to correlate the former type of mind with French physicists and the latter type with British physicists. Then, in a passage much too long to quote, Duhem specifies those features of British treatises in physics which reveal the British peculiarities of mind: the use of picturable models, the avoidance of deductive theorizing, the lack of interest in making their physical models into metaphysical theories, the use of familiar and homely models, the use of algebraic calculation, and the absence of rigorous definitions. French treatises reveal traits opposite to these and thus they present a pattern of features which together are characteristic products of the "strong, narrow" mind.[26]

(12) Walter F. Cannon, in an analysis of the text of Darwin's *On the Origin of Species*, comes to conclusions which can be considered a sort of corroboration of Duhem's thesis about the "British Mind." For according to Cannon a "visualizing" kind of mind is discernible in Darwin's presentation of his theory. Darwin, says Cannon, always asks us to "see" the entire world both in space and across time with plants and animals moving and changing over this cosmic landscape. Characteristically, Cannon points out, Darwin even "sees" abstract laws, tendencies, and generalizations. Cannon makes quite clear that this "vision" of Darwin's is not a part of his theory; it is simply the way in which Darwin imagined the world, and it was due to this vision that he came upon his evolutionary theory. That theory, says Cannon, may be stated in other terms, partly in mathemati-

[25] Pierre Duhem, *The Aim and Structure of Scientific Theory*, trans. Phillip P. Wiener (Princeton: Princeton University Press, 1954), pp. 55-56.
[26] *Ibid.*, pp. 69-93.

cal terms; but in Darwin's book it is not. In Darwin's book it is presented as a vast panoramic *view* of the geography and history of the world.[27]

But to envision things in this way—and this is a consequence Cannon does not draw—is characteristic, not of a rigid, formalistic, logical mind, but rather of an insightful and imaginative, if slightly untidy mind. It is certainly characteristic of what Duhem calls "the ample mind." But, as Cannon quite correctly says, to consider Darwin as *presenting* his theory in the way Cannon describes, no matter what sort of mind we think such a presentation to be characteristic of, is *not* to make a point about Darwin's "language"—that is, about his "style" or "rhetoric."

> Darwin never found an over-all metaphor, or guiding image, which he was willing to affirm. "My theory" is "descent with modification by natural selection"; and there is no more vivid way to put it without falsifying it. A tree, a bank, Dame Nature, a struggle, a chain, a beehive: these were all too simple to be taken seriously. Only a vision of the whole world with all things that have ever lived moving over it in space and all time in a complex pattern of intuitively comprehensible principles could be enough; and Darwin was not the poet to create the necessary new language in vivid and unified fashion.[28]

Cannon's point is not that Darwin presents his theory by means of a certain sort of language but that he presents it by revealing, in a wide variety of ways, a peculiar vision. And *we* may plausibly conclude, taking up Duhem's insight, that so to present a theory is a characteristic act of the "ample, but weak" mind.

[27] Walter F. Cannon, "Darwin's Vision in *On the Origin of Species*," in *The Art of Victorian Prose*, ed. George Levine and William Madden (Oxford University Press, 1968), pp. 154-176.
[28] *Ibid.*, p. 172.

THE line of argument in Chapters One, Two, and Three has led a long way from the interpretation of Expression Theory offered by such philosophers as Monroe Beardsley and O. K. Bouwsma. In particular, I have argued that (1) expression in art is not simply a question of certain "properties" being applicable to a set of "objects"; (2) that, even in the realm of art, expression applies to more than simply those cases in which art is described by means of anthropomorphic adjectives; and (3) that cultural "works" other than art works may properly be called "expressive." The last point, however, must not be misconstrued. I have not tried to suggest anything so absurd as that philosophy, history, and science are "really" or "nothing but" art, or that they are even species of art. I do not want to suggest that all modes of analysis, criticism, evaluation, or interpretation proper to art are always appropriate to other cultural forms. My claim is a relatively restricted one: namely, that works of art, history, philosophy, science, and indeed of any activity requiring the use of language share an important feature with ordinary sorts of expressions like gestures, grimaces, and inarticulate cries. This feature is that they are construable as "acts" characteristic of persons who have certain emotions, feelings, or attitudes, who are in particular moods or states of mind, or who possess certain personality, character, temperamental, or mental traits.

One must naturally expect a legion of differences between expressions like gestures and grimaces, on the one hand, and works of art, history, and science, on the other. And just as there are differences between facial expressions and inarticulate cries, there are differences in the "expressiveness" of art, science, history, philosophy, political oratory, theology, and art criticism. These differences especially concern (1) the conditions under which the various sorts of "expressive" phenomena can actually function as

expressions of someone's emotion, attitude, quality of mind, etc., and (2) the degree of expressiveness possible in the various sorts of expressive phenomena. That is, it seems obvious that certain kinds of things are not expressible at all in certain activities or in certain contexts; and it seems equally obvious that the ranges of expressiveness of, say, art, science, and hand movements would differ enormously. In the remainder of this book I shall not attempt to spell out all these differences in a systematic way. The tedium of such a project would be matched only by its irrelevance. However, as I continue to explore the concept of expression and its consequences for the concept of mind, some of the more important and interesting of those differences will inevitably be uncovered.

In the following two chapters I shall examine three further varieties of expression. Two are species of artistic act, and one is a kind of illocutionary act. None of them is usually taken account of in discussions of expression in art or in language. And when they are, they are not sufficiently disentangled from other sorts of expression. I shall argue that, although the three varieties are indeed distinct from others as well as from one another, they are nevertheless related to the kind of expressiveness worked out in these first three chapters.

chapter four

Expressing the Objective World

◈

There is an old use of "expression," now almost entirely extinct, which relates the term to art, particularly to sculpture and painting. According to this use, a work does not express feelings, attitudes, moods, characteristics, etc., which are possessed by its maker or which can seem to be possessed by its maker. Rather, statues or paintings of people can be said to "express" parts of the body or features of the face belonging to the sculpted or depicted *subjects*. Likewise, artists can express persons in bronze or in stone; or they can express flesh or the texture of cloth in paint.[1] This use of "expression" used to occur where it is now much more common to use terms like "depict," "sculpt," "render," "draw," "delineate," "portray," "represent." There is a current use of "expression" which, although clearly related to the older sense described above, is interestingly different. Consider the following statements.

(1) *The Golden Wall* by Hans Hofmann, with its rather roughly painted but brilliantly colored rectangles, expresses the dynamic interrelationships of colors.

(2) In some of his later works Turner expresses the pure luminosity and impalpability of light and atmosphere.

[1] See *The Oxford English Dictionary* (Oxford University Press, 1933), III, 446; *Dictionary of World Literature*, ed. Joseph T. Shipley, rev. ed. (Totowa, N.J.: Littlefield, Adams, 1964), pp. 149-151.

132

(3) The background landscape in Perugino's *Saint Sebastian* in the Louvre expresses a placidity which mirrors that of the suffering saint.

(4) The sculpture of fifth century Athens typically expressed the dignity and nobility of the human body.

(5) In the first play of the *Oresteia*, Aeschylus expresses by means of characterization, plot, and imagery the utter violence and barbarity of the pre-political world.

(6) In his descriptions of Venice in *Der Tod in Venedig*, Mann expresses the decadence and corruption of the city.

In all of these statements the use of "expression" is like the older use of the term in that what are expressed are abstract properties or features ("dynamic interrelationships") of parts of "the world" which the artist is manipulating, describing, or representing. These properties or features are "objective" from the point of view of the artist. But it obviously makes no difference whether the "objects" to which the expressed properties belong really exist or ever could exist. Thus the statement

(7) *The Last Judgment* of Michelangelo expresses the awfulness and terror of Judgment Day.

also exemplifies the sense of "express" here being examined. Furthermore, even when that which is expressed is something "subjective" like emotion, for example, it may still be expressed in the "objective" sense if the emotion belongs to someone, real or fictitious, who is not the artist. Thus in

(8) Wagner's "Liebestod" theme expresses the all-consuming passion of Tristan and Isolde for one another.

133

the term "express" is used very much as in examples (1) through (6) above. Moreover, although this sort of expression is possible to achieve in music as (8) shows, even though music is among the least "representational" of the arts, it seems always to apply to music which is either explicitly pictorial, which is composed for a dramatic context, which has a verbal text, or which is clearly bound to some context, as, for example, a march. Thus it is that the "Liebestod" is able to *express* in this sense. The following are also examples of musical "expression," in the objective sense.

(9) The so-called "light" parts of Schubert's G Minor Mass express the grandeur and spaciousness of Heaven.

(10) *La Mer* expresses the many moods of the sea, from violence to serenity.

Given its connection with "representation," this sense of "expression" appears not to apply at all to architecture. Yet even here an example comes to mind:

(11) Saarinen's TWA Flight Center in New York expresses the dynamics of flight.

But it is highly significant that the Saarinen work is one of the very few works of architecture which are deliberately and obviously "iconic."

There seems to be more than merely a "close connection" between "representation" and related concepts, on the one hand, and the use of "expression" exemplified in (1) through (11), on the other.[2] For in most of the examples given above, "expression" could be eliminated without error in favor of some term belonging to the family of

[2] I shall refer to this sort of expression henceforth as "objective expression."

"representation" terms. Only in examples (8) and (9) do no substitutes seem possible. In example (10), however, which concerns a style of music which is self-consciously a sort of "musical depiction," the term "expresses" is eliminable in favor of "portrays" or "depicts" or even "represents." These considerations suggest, then, that objective expression is a *species* of representation, or at least, that it belongs to the same family of concepts as does "representation." In the following I shall argue that such is not the case.

THE family to which the concept "representation" belongs inhabits the realm of the pictorial and plastic arts chiefly. Thus "representation" itself is most at home in speaking of art like painting and drawing; its close relatives are "portraying" and "rendering" as well as "drawing" and "painting," where these verbs take objects designating subject matter. The same words are often used in speaking of verbal, dramatic, and quasi-dramatic works, although "drawing" and "painting" are used here less frequently and with a greater sense of their being metaphorical. Related words which are properly suited to verbal art are "describe" and "characterize." Thus a passage of a novel might either describe or portray a fictitious character, might characterize a fictitious place or represent it (as, say, gloomy and mysterious). Of course not every case of describing or characterizing in verbal art is a case of portrayal or representation, and *vice versa*. A portrayal usually presupposes a rather extended description; and we may speak of the *representation* of a complete fictitious "world" in a novel which is never explicitly *described*. There is no question that musical and choreographic portrayals and characterizations are possible; one has only to think of Elgar's *Enigma Variations* and Sir Frederick Ashton's balletic interpreta-

EXPRESSING THE OBJECTIVE WORLD

tion of that music. There is no disputing, moreover, that Vivaldi's four concerti are musical characterizations of the four seasons or that Pavlova's famous dance represents a swan dying. No doubt there are interesting and significant differences among the various sorts of "representation." But I shall not be concerned with these differences. Rather, I shall attempt to show that objective expression, in any of the arts, is essentially unlike any variety of representation in any of the arts.

A salient feature of "express" in its objective sense is that, unlike verbs of the "representation" family, it never takes as its grammatical object designations for objects, persons, events, places, situations, or any parts thereof; it never even takes as an object a designation for relatively simple perceptual properties such as "redness," "roundness," or "smallness." What are expressed are properties such as placidity, luminosity, grandeur, evil, or rather abstract relations and patterns like the "dynamics of flight" (i.e. movement patterns) or the "dynamic interrelationships of colors" (i.e. the way in which colors appear to recede and advance depending upon the ways they are juxtaposed). Sometimes "essences" are also spoken of as expressed as in "Cézanne can express the very essence of an apple" or "Cranach expresses the essence of woman in the Eve panel in the Uffizi." Thus, what can be expressed is always peculiarly "abstract" compared to what can be represented.[3]

As I pointed out earlier, in many of the instances in which some abstraction is expressed, some word for representation can do the same job as the term "express." That is only the case however when we speak of some work, or of some portion of a work—e.g. Act II, the final couplet, or the landscape in the background—as expressing a qual-

[3] Throughout this discussion "represent" and its cognates will be used as shorthand for all verbs of the "representation family."

136

ity, or when we speak of an artist expressing a quality in a work or portion thereof. But there are other ways of using the objective sense of "expression." It is always relevant to inquire in any instance in which an artist, a work, or a portion of a work expresses something *how* it is that the expression is accomplished. This means: By what *means* is the expression done? And anyone asking this sort of a question wants to be shown those features of the work, or the relevant portion thereof, which contribute most directly or immediately to the alleged expression. In the case of a Turner painting, for example, one might point to the facts that whatever objects are depicted are shown only as light and shade, that outlines are evanescent to the point of disappearance, that the light source is made especially intense, and that all substances are made to reflect light in a brilliant way. In Aeschylus' *Agamemnon* one might mention the violent and bloody plot, the fierce ambitions and passions of the main characters, the preponderance of animal imagery, all of which imply a comparison of human beings to beasts. Finally, with respect to Saarinen's TWA building, one could point to the apparently irregular curving lines of the walls, the "flow" of one interior space into another and the exterior shape suggesting a winged creature.

It is especially significant that we may speak of the sorts of details listed in the preceding paragraph as themselves expressing what we previously spoke of as expressed by the work in which they occur. We might say that the brilliant highlights, the evanescent outlines of objects, and the intense light source in Turner's *The Dogana, San Giorgio, the Zitelle* express the rich luminosity of the Venetian setting; or that the fierceness of the characters, the bloodiness of the action, and the suggestions of bestiality in the imagery in the *Agamemnon* express the violence and barbarity of the pre-political world; or that the flow of interior spaces,

the curving lines of the walls, and the winged exterior of the TWA terminal together express the dynamic qualities of flight. In the latter sort of contexts, moreover, it is not the case that terms of representation may be substituted for "express"; here the term "express" is precisely the right word. Therefore, there is considerably less reason to interpret it as a member of the family of representation terms.[4]

These considerations suggest, if they do not demonstrate, that objective expression is different from representation. They suggest in particular that the relation between a work and what it expresses is different from the relation between a work and its subject matter content. In the following I shall spell out this difference.

An important feature of objective expression is that insofar as any work expresses any "objective" abstraction it is an artistic success. Representation, on the other hand, is neutral with respect to artistic success or failure. One may draw a cat badly or well, render fabric textures exquisitely or indifferently, depict horses in motion with greater or less skill, or give an authentic or inauthentic novelistic representation of life in the slums. Yet one cannot badly express the luminosity of the atmosphere in a painting, or poorly express the decadence and corruption of Venice in a description of the city. One either expresses a thing or does not express it. Thus it is that a standard metaphorical substitute for "express" is "capture": Saarinen has captured the soaring, energetic quality of flight in his building; Turner

[4] There is a sense of "represent" according to which it means something like "stands for" or "is a symbol of," and which I do not include in the family of representation concepts. I take it that this sense of "represent" is sufficiently different from the way the term is used in, say, "This picture represents two cows" when the picture is *of* two cows, to justify my exclusion of it. I mention it, however, because it is not only possible to say but it may be true to say, e.g., that the fierce characters and animal imagery in the *Agamemnon* represent (are symbols of) the barbarity of the pre-political world.

138

captures the luminosity of the Venetian setting.[5] Capturing luminosity or a soaring, energetic quality is like capturing an armed Turk; one either gets him or does not get him. One cannot capture him poorly or badly, even though one may go about trying to capture him skillfully or clumsily, or one may secure him poorly and he may get away.

The fact that objective expression is inherently successful accounts for the fact that it is frequently described with approval terms and never with terms of disapproval. A work may be a splendid, marvelous, beautiful, stunning, glorious, exquisite, or perfect expression of some quality, but it is never a miserable, awful, wretched, or stupid expression of anything. The function of these terms of approval in qualifying an instance of expression is not to distinguish the successful from the unsuccessful expression. It is rather to lend an effusive emphasis to a description of a work of art; it is to give to the work the admiration which it merits in virtue of its expression.

Of course, to say that a work expresses some "object" is not to say that it deserves unqualified praise. One might

[5] "Capture" cannot replace "express" uniformly in statements (1) through (11). The light parts of Schubert's Mass do not necessarily capture the grandeur and spaciousness of Paradise. (How would we know?) The "Liebestod" does not capture the passion of Wagner's lovers. The reason that "capture" cannot be used here, however, is only that there is doubt in the first case that there is a Paradise to be grand and spacious and knowledge, in the second, that there is not a Tristan and Isolde, apart from the opera, who are passionate. To say a thing is captured presupposes it exists. We may nevertheless paraphrase statements (8) and (9) in the following way, using "capture."

 (8_1) The "Liebestod" captures the all-consuming passion which Wagner intends that his lovers feel for one another.

 (9_1) Schubert's Mass captures the grandeur and spaciousness traditionally associated with Paradise.

These paraphrases, incidentally, point up the sense of "objective" in "objective expression." What is objectively expressed need have only "intentional inexistence"; it requires "objective" reality but not "formal" reality, in the old terminology used by, e.g. Descartes.

say of Van Dyke's portraits that they express the splendor and hauteur of an aristocratic class. Yet one might fault Van Dyke's work as being ultimately superficial precisely because of its concern with such a limited range of human values and possibilities. One might similarly judge that just because Bosch's grotesque fantasies express such unalleviated evil they cannot be considered the highest form of art. In cases like these, the adverse judgment is made in spite of, not because of, the fact there is objective expression in the work.

But if to express objectively is to bring off some sort of success, it is pertinent to inquire into the mode of that success. In this, too, expressing differs from representing in that it is inappropriate to speak of expressing accurately or correctly. This point goes deeper, however, than the simple fact that adverbs like "accurately" or "correctly" are not used to modify the verb "express." For it might be supposed that in virtue of the fact that "expression" does denote a success, it already implies accuracy or correctness and, therefore, that the reason expressions are not described as accurate or correct is that such descriptions would be redundant. The fact, however, is that accuracy and correctness have nothing to do with expressing in the sense here being examined.

This fact is a rather surprising one. For when we speak of Turner expressing the rich luminosity of the Venetian atmosphere or of Saarinen's building expressing the soaring and energetic qualities of flight, we seem to suppose that there is in Turner's painting the very luminosity we might find in the real Venice and in the lines of the TWA building the very qualities we recognize in the phenomenon of flight. Yet, we know it cannot be *Venice's* luminosity "really" there in the picture or those "real" properties of flight there in a building which is not in flight at all. What we

140

see in the painting or building *must* be some sort of image or copy of those real properties.

If we attempt to apply standards of accuracy or correctness to cases of expression, however, we are at a loss to know how to go about it. We sometimes do have occasion to discuss the accuracy or the correctness of a picture or drawing. For instance, we might admire a small child's drawing of a human figure and point out features that make it more accurate than is usual for the work of a child at that age: the five fingers on each hand, the even placement of the eyes, the proportions of the body, etc. In this kind of situation we do not necessarily compare the drawing point for point with some actual human figure, because the standard of accuracy here is sufficiently gross and our knowledge of the human body sufficiently good not to require that sort of comparison. But such a more explicit comparison might be called for when, for example, the incorrectness of the child's drawing is being shown to the child by explicitly pointing out features of the child's own body in a mirror.

But the sort of judgment of accuracy or correctness possible with respect to a drawing is not even in principle possible with respect to objective expression. The reason is the simple one that the "abstract" properties which are expressed are not articulated into parts which can figure in a point for point comparison. How, for example, does one compare in a sequential way the energy of flight visible in the Saarinen building with the energy found in the flight of planes? To what does one point first? Of course, as mentioned earlier, there are features of the building which relate to the energy expressed: the curving lines, the flowing spaces, the winged and "poised" exterior appearance. But these are what one points out to show *that* the structure expresses the energy of flight. They are not "parts" of that

energy the way that eyes and fingers are parts of a human figure. Nor are they properties of that energy in the way that having evenly placed eyes and having five fingers are properties of a human being. The "energy of flight" does not even *have* parts or properties the way human beings— or anything else which may be accurately represented—do. The same obviously holds for "rich luminosity," "terror," "decadence," "barbarity," "passion," or anything else which is objectively expressed.

It might be objected that the above argument trades too heavily on the obvious fact that more or less abstract properties, relationships, patterns, and emotions are different from depictable situations, things, events, persons, etc. Correct copying and accurate reproduction is possible, after all, with respect to all sorts of properties. For example, one might mix a bucket of paint to match the existing color of a wall. It is also possible to manufacture perfumes to match the scent of roses even though roses are not used in the manufacture; and the synthesis of imitation flavors is an imperfect but not an inherently unperfectible art. And in the case of judging a match of colors, scents, or flavors there is no recourse to a point for point comparison in the normal case. Usually to judge a color match one puts the color samples close together, glances quickly from one to another, changes the lighting, backs off, peers more closely, and so on, until one is satisfied that there is indeed a match.[6] Could it not be that the success involved in expression is something like that involved in matching colors, flavors, or scents?

[6] One could, however, bring to the judgment a kind of checklist of what to look for in comparing the color samples. Suppose one has failed a number of times to match a shade of brown in mixing a pot of paint. One might approach the judgment of the next try muttering to oneself: "Remember to check for the darkness this time especially carefully; watch for the 'milky' quality; and don't forget the reddish touch."

It is possible in principle to treat Turner's expression of the rich luminosity of Venice's atmosphere in *The Dogana, San Giorgio, the Zitelle* as a match between something painted and something real. One might carry the Turner painting about through Venice for days to see if it really does express that sort of luminosity. Using this technique, one might even reasonably decide that it is true that the Turner expresses that quality. But that is obviously not the normal procedure for verifying that sort of statement about a painting. One gets to know Venice and then one is *ipso facto* in a position to assess the statement about the Turner painting.

Suppose, however, that, drawing upon one's accumulated knowledge of Venice, one judges that the Turner does not express anything of Venice's atmosphere, that Venice never looks so rich and blaze-like. Does it follow that one must at once deny that Turner's painting exhibits objective expression? Surely not; for one might concede that however faithful Turner's picture is to the atmosphere of Venice, it nonetheless expresses a quite remarkable atmospheric luminosity. Similarly, one could never test by any procedure whatsoever whether Michelangelo's *Last Judgment* expresses the terror of Judgment Day or whether the "Liebestod" expresses Tristan and Isolde's passion. Yet one need not refrain from speaking of expression in these cases *on that account*. It must not be supposed either that in the latter sort of case one could compare the expressed "object" in the art with some *intentions* of the artist or someone else (see above, note 5). For in the first place, making such a comparison would surely *not* be like judging a color match. But, in the second place, even if it could be ascertained in certain cases that the expressed "object" were just what was intended, that fact would in no way justify the use of the term "expression." It all depends upon what was

143

intended. After all, if Wagner, for example, had only an uninteresting conception of his characters' passion, however well his music matched his intentions, it could never on that account *express* an all-consuming passion. Objective expression, therefore, is no more like matching a color, flavor, or scent than it is like making an accurate or correct representation.

There is some reason to suspect that what makes expression inherently successful is that "express" belongs to the category of so-called "success verbs" or "achievement verbs" like, e.g. winning, catching, hitting (the mark), proving, scoring, descrying, capturing. Indeed, one of the facts that suggests this is that the term "capture" can often be used as a synonym for "express." One way in which "express" is like success verbs is that there is no proper use of the continuous present of "express." In other words one can never be *engaged in* expressing a property anymore than one can be engaged in catching a ball, proving a theorem, descrying a lighthouse, or capturing a Turk. When Saarinen was designing his air terminal he was not properly describable as "expressing the dynamic qualities of flight in concrete and steel" even if that were precisely his intention in designing the building. For no one could possibly be in a position to describe Saarinen in terms of what he expressed until the building design already expressed it. Of course the architect might have so described himself during the process of designing the terminal. But he could only mean thereby that it was his *intention* to express those qualities and he fully expected to fulfill his intention. In this way one can say that one is proving a theorem when one is working on the theorem and feels himself on the verge of success. Strictly speaking, however, either one has not yet proved the theorem or one has already proved it. Likewise, there were times at which Michelangelo had

not yet expressed the terror of Judgment Day in his fresco and then there were times at which he had already done so.

To make this point about expressing is not to imply that there is necessarily a determinable instant at which the expression is accomplished. There are such instants when a catch, hit, or a score is made or when a win is secured. There *might* even be such instants when an expression is accomplished; a single brush stroke might make the crucial difference.[7] Very probably, however, in the course of painting, composing, or writing there would be a time during which one would simply not be sure whether a property were truly "expressed" or whether it still were merely "promised." The important point is that what fills any time between when a property clearly is not expressed and when it clearly is (already) expressed cannot be the *activity* or *process* of expressing it. "Objective expression" does not denote an activity or a process.

Despite the link between "express" and the category of achievement words, there is an important feature of the latter which "express" does not share. Ryle says that "in applying an achievement verb we are asserting that some state of affairs obtains over and above that which consists in the performance, if any, of the subservient task activity."[8] And it is due to this essential dependence of "achievements" upon "states of affairs" that achievements may occur by chance, luck, or accident. But objective expression does not ever come about by chance, luck, or accident.

[7] I am far from suggesting here that everyone would *agree* that the single brush stroke made the crucial difference. But then I am also far from suggesting that everyone would agree that any qualities at all (or which ones) were expressed in any work of art. My point here is just that it is a conceptual possibility that someone might identify a single instant as the one at which such and such an expression was accomplished.

[8] Gilbert Ryle, *The Concept of Mind* (New York: Barnes and Noble, 1962), p. 150.

This is so because expressing does not depend essentially upon there obtaining any sort of conditions, circumstances, or state of affairs. I am not denying here the quite obvious fact that many properties of works of art come into being by chance, luck, or accident. Some of these properties might even be those which "contribute" to the expression in a work. Artists are often able to make use of chance or accidental occurrences to work up artistic ideas or to enhance artistic "effects." But no amount of accident, chance, or luck which aids in the genesis of a work of art is enough to make any artist express anything in that work by chance, luck, or accident, for that is a conceptual impossibility. Thus if anyone suspected—however groundlessly and absurdly given the historical facts of the case—that precisely the "effect" of gorgeous luminosity in *The Dogana, San Giorgio, the Zitelle* was due entirely to a great stroke of luck, or was a mere fluke, he could not consistently speak of Turner as *expressing* that quality in that painting.

The above point holds good despite the great practical difficulties in determining whether any allegedly expressed "object" does depend essentially upon chance, luck, or accident and despite the great theoretical difficulties of determining what would count as chance, luck, or accident. There is probably no way of determining the latter in a simple, general formula. Yet we can say in general that such factors as an artist's immaturity, insanity, drunkenness, druggedness, hypnosis, and incompetence, as well as sheer mishap and inadvertence might be relevant in considering whether an artistic "effect" depended upon chance, luck, or accident. These are roughly the same "parameters" incidentally, which are relevant in determining whether or not a work embodies an (anthropomorphically qualified) artistic act.[9]

[9] See Chapter One, p. 45.

146

LET us take a new tack in the search for the sort of success implied in objective expression. Let us approach a work of art "phenomenologically" and ask: "What is a work like when some abstract property is *expressed* in it?" "How does such a work differ from one in which that same property is simply recognizable in, displayed in, contained in, or possessed by a work?"

It is obvious that there might be any number of paintings of the same Venetian scene depicted in Turner's *The Dogana, San Giorgio, the Zitelle*. All of these paintings, moreover, might depict the scene with the same sort of light as Turner and all of them might even make the light effects as important to the painting as Turner does. They might, for that matter, be imitations or copies of the Turner. Yet for all this presence of "luminosity" in these paintings, it is not necessary that any of them "express the rich luminosity" of the scene. For what makes luminosity "expressed" in a painting is the fact that it is made to "stand out" especially vividly, to "leap out at us," to "strike our eyes" especially forcefully; it is especially "heightened" or "enhanced"; it is "brought to life." The appeal to metaphor here is natural and unavoidable. Correspondingly, we would be inclined to say of those paintings to which the term "expression" is inapplicable that the luminous "effect" does not quite come off, that the light is "dull" or "uninteresting," that the light remains "inert" or "lifeless."

This point applies to the other examples of expression as well. A dramatist may portray a barbarous and violent world before the advent of political society, as Aeschylus does, but fail to make the barbarousness and violence "come through" in the "striking" way it does in the *Agamemnon*. A writer may describe a physically and morally rotten Venice without yet making us "feel the presence" of corruption and decadence in an "immediate" way. A composer may paint in

music the serene and turbulent moods of the sea without yet "evoking" the ocean's serenity or turbulence and making it a "living presence" in the music itself.

It seems now that we are being swept away by a whirlwind of metaphors. Can we discover the relatively still center of the whirlwind? Do all of the metaphors suggest a phenomenon to which they implicitly compare the way an expressed quality in a work of art appears to us? I think they do.

We all have experiences in which certain rather abstract properties of our environment or of something in our environment are perceived very vividly. Sometimes these experiences just "come to us," either for reasons which are rather clearly known or simply gratuitously; sometimes we can deliberately induce these experiences. We might step out of our house on a spring morning and be struck at once by a pervasive gentleness and sweetness in the world; these qualities seem to come through in every part of the scene— the light, the color of the hills and the sky, the wind, the song of the birds. Or suppose we are driving across a particularly flat and sparsely settled part of the Los Angeles basin on a hot afternoon. The smog is heavy; it stings our eyes, casts a muddy haze over all visible objects, and completely obscures the view of the neighboring hills. For a moment we lose our sense of where we are and we are strongly aware of a sinister, threatening, almost evil character of the scene. Or suppose that we are driving towards some of the dry and relatively bare mountains of Southern California on a clear day when the setting sun brings out the shadows thrown by every ridge and boulder. Suddenly the harshness and roughness of the hills "leap out at us" with a clarity we have never experienced before. Again, imagine attending to the wood grain on your desk and dwelling upon the flowing, dynamic quality of the pattern

it makes until that is "all you see" of the desk top. Or listen to the twig tapping against the window pane in a wind- and rainstorm until your attention "slips gears" and nothing comes through to you but the delicacy and sprightliness of the rhythm being tapped out. Or imagine staring at a rather calm ocean during a sunrise and being almost hypnotized by the motion of the waves and the way they reflect the sun until your attention is completely captured by the shimmer and pulsing glow of the pattern of "sun points" on the surface of the water.

I suggest that in experiences of the above sort "abstract" properties of just the sort which can be expressed "stand out" in our "field of consciousness" in a way analogous to the way expressed qualities "stand out" in works of art. This analogy cannot be "proved"; yet there are considerations which indicate that it is a just analogy. Notice, for example, that roughly the same family of metaphors which describe features expressed in art are suited to the description of the properties which "stand out" in the sort of experiences listed above. The features to which we especially attend in the above experiences "strike" our consciousness, they "leap out" at us, they "come through" all of the particulars in the scene. Furthermore, they "stand out" while other features of what we see or hear fade, as it were, into the background. They present themselves to us as more "vivid" and "lively" than other features in our field of consciousness. The properties "come alive" for us in these experiences, in contrast to the way they appear to our casual attention in less concentrated experience. Our consciousness of them is, we say, "heightened" or "enhanced." Significant, too, is the fact that it is apt and even commonplace to say of an expressed property in art that an especially "concentrated attention" is brought to bear on it, or that it is a "focus of attention" in the work.

149

The "achievement" involved in objective expression, therefore, is that what is expressed "stands out" in a work of art in a way peculiarly like the way it might stand out in a "field of consciousness." And when one reflects upon the enormous differences between what we call, however misleadingly but helplessly, a "field of consciousness," on the one hand, and works of art, on the other, then the achievement of artistic expression seems quite remarkable indeed.

It DOES not follow from the preceding result, although it might appear to, that "expressing some property P in work y" *means* something like "making y so that P "stands out" in it in a way analogous to the way P might "stand out" in a field of consciousness." It does not follow because expression cannot be like making or any variety of "making" verb such as painting, drawing, writing, composing, choreographing, sculpting. As pointed out above, there is no proper use for the continuous present tense form of "express," but there is such a use for the continuous present of "making" verbs.

It is true, nevertheless, that for an artist x to express P in y implies that x made y and that P "stands out" in y in a way analogous to the way P might "stand out" in a field of consciousness. From this it is tempting to infer that "x expresses P in y" *means* nothing more than that x made y and that P "stands out" in y etc., etc. But since we have discovered above that expressing can never be done accidentally, by chance or by luck, we would have to add the proviso that P is not in y as a result of accident, chance or luck. The considerations of the preceding section strongly suggest, then, that to speak of x expressing P in y (or, alternatively, of y expressing P) is to mean nothing more than that y, which was made by x, is such that (i.e. has the following property:) P "stands out" in y in a way analogous to the way P might

"stand out" in a field of consciousness, and that the fact of P's so "standing out" in y is not a fact about y merely in virtue of an accident, or chance or luck. What is at stake in this suggestion is whether, when we seem to be talking about an "act" of an artist, i.e. his expressing something, we are talking about anything like an act at all; whether, instead, we are not talking about a very complex "property" of a work of art. I think it is not the case that such an analysis of objective expression talk can be made. My reasons for so thinking will uncover some important features of objective expression.

My argument is (1) that objective expression is an artistic act which can be described anthropomorphically; (2) that it is essential to acts of objective expression that they be anthropomorphically describable; and therefore (3) that to express something "objective" is at once to do something which is "expressive" in the sense established in Chapter One. Consider the following:

(a) One can imagine a dramatist writing a play "about" the barbarity of the early Greek world in such a way that his own bitterness and/or disgust towards that barbarity is revealed. It might be then correct to say that he expresses with intense bitterness (or with unconcealed loathing) the utter barbarity of the pre-political world. Aeschylus of course has not written that sort of a play in the *Agamemnon*. That play is imbued, rather, with an exalted religiosity so that it seems more appropriate to say of it that it expresses in a tone of awe-struck and pious horror the utter barbarity of the primitive world.

(b) Turner's late obsession with light in his paintings was by no means unheralded in his earlier work. In fact, during a trip to Italy in 1819 he did a watercolor of Venice, another view of San Giorgio, in which he also expresses, but with delicacy and refinement, the luminosity of that place.

151

Of course his late oils hardly show delicacy and refinement. In *The Dogana, San Giorgio, the Zitelle* Turner expresses Venice's luminous quality with extreme vigor and intensity.

(c) For all of Saarinen's concern for the dynamic properties of flight in the TWA building, the building gives an impression of heaviness, even of sluggishness when one is very close to it and inside it. These qualities do not detract from but merely qualify Saarinen's expression. One can imagine a building with the same dynamic qualities but airier, lighter, much, much higher, filigreed and decorated, which might express the dynamic qualities of flight in a gay, whimsical way instead of with the gravity and earnestness with which Saarinen's creation actually does express those qualities.

(d) Because Wagner's opera has almost preempted the right to the subject matter, it is difficult to imagine a different sort of *Tristan and Isolde*. Yet the plot is most certainly a love story and should therefore be subject to a tender, lyrical treatment. It is probable however that a tender and gentle expression of the two lovers' passion could never be an expression of "all-consuming passion," as Wagner's is. It is the superhuman, almost cosmic passion of Wagner's characters for one another which demands that he express it in his strenuous, full-blooded, and even grandiose way.

Now (a) through (d) illustrate that anthropomorphic qualifiers may be applied to acts of objective expression. Furthermore, they show that an appropriate anthropomorphic description is always truly applicable to *every* act of objective expression. The argument here is obviously analogous to the Method of Expansion and Contrast of the preceding chapter. The result here, however, is more clear-cut, I think, simply because it is a question here of works of art rather than (rather small) bits of language. The incomparably greater expressive (in the sense of Chapter One) artic-

ulateness of art compared to snippets of language can hardly be anything but obvious. The difference is roughly comparable to that between the expressive potential of a whole face, on the one hand, and a single eyebrow, on the other.

There are considerations, moreover, which indicate that such describability in anthropomorphic terms is essential to objective expression. We can imagine artistic acts which on some grounds qualify as acts of expression but which are nevertheless not acts of expression and which are not anthropomorphically describable. Think of the very many excellent examples of photography which figure as parts of advertisements in popular magazines. These photographs may "capture" the moist tenderness of a chocolate cake, the tempting succulence of a steak, or the cool effervescence of a glass of cola. We are inclined to describe these qualities of the photographed objects in much the same way that we describe the expressed qualities in art: they are vivid, and "alive"; they strike us especially forcefully; they are "heightened" and "enhanced." It is these facts which lead us to speak of them as "captured," a word which can sometimes function as a synonym for "expressed." But in the photographs, the "captured" properties cannot properly be said to be "expressed." This is not the case only with respect to photographs of homely objects made for commercial purposes. A news photo can capture the terror of wartime or the grace of a basketball player. A nature photograph can capture the stillness of a rain forest or the fragility of a blade of grass. But even in these cases "express" would not work as a substitute for "capture." This point holds, furthermore, even when we assume that the photographic "capture" is not made by chance, luck, or accident.

Photographs as described above can of course be quite different from one another even when they "capture" the "same" quality of the "same" subject. The differences among

153

them will be differences between what is shown or not shown in the pictures, between the views from which the subject is taken, between properties of the photographic prints themselves, i.e. size, glossiness, graininess, or contrast, or between qualities of the image, such as sharpness, dimness, fuzziness. There might be "expressive" differences too, such as the sensitivity to texture in one compared with the sensitivity to light effects in another. But two photographs of, say, a forest will not differ in terms of the anthropomorphic descriptions of their respective "captures" of the forest's stillness. One may capture that stillness by focussing on highlights and deep shadows; the other by focussing on rigid trunks rather than lacy foliage. One photographer may have captured that stillness with fine-grained film and a sharp image; the other by using very coarse-grained film and a fuzzy image. But these ways of describing the "captures" do not imply differing anthropomorphic descriptions of the "capturings."[10]

It is significant, however, that were the stillness of the forest "captured" in *paintings* which presented "images" like the photographic ones described above, anthropomorphically describable artistic acts would be suggested. Thus, a "misty," "coarse-grained" image in paint might suggest a *nostalgic* way of expressing the forest's stillness. A painting which emphasized intense highlights and deep, mysterious shadows might express the forest's stillness in a *respectful*, almost *religious* way. Just when "express" seems to be the correct designation for artistic acts, anthropomorphic descriptions of those acts become possible. This argument shows that a photograph which *captures P* can be described

[10] I am not suggesting that it is impossible for artistic acts in photographic art to be qualified anthropomorphically. On the whole, however, it is possible only in photographic works which are "wrought" in some relatively elaborate way—by, for example, multiple exposure, or photographic collage.

as a work y which is such that P "stands out" in y as P might "stand out" in a field of consciousness. Yet this is not sufficient to make a case of objective expression out of a photographic "capture." Only when an anthropomorphic description is applicable to a "capturing act" is the latter an act of expression.

We may further ground the difference between photographic capture and objective artistic expression as follows. The photographic capture of P is only possible if P actually exists in the photographed subject. Photographic capture is thus dependent on some state of affairs independent of the photographing activity. It is thus that a photograph *might* capture some P by accident, chance, or luck. But a case of objective artistic expression, even when it is truly designable as a "capture," is never like any case of photographic capture, even a case that is *not* effected by chance, luck, or accident. For in the case of objective artistic expression there is always some description of what is expressed such that the actual presence of what is expressed in anything external to the art in question is not presupposed.

In this chapter I have argued that an interesting and important, if little discussed, sense of "expression" cannot, despite initial impressions, be reduced to a species of "representation," be understood as anything like the achievement of a correct copy or accurate match of an external subject matter, be essentially dependent upon states of affairs beyond control of the artist, be reduced to designating a special sort of property of art works. Objective expression, rather, is essentially a variety of artistic act and is, moreover, always and necessarily expressive in the sense discussed in Chapter One.

chapter five

The Expression of Ideas

❧

One of the commonest ways of using "expression" and its cognates is to speak of a person expressing his ideas on a subject, his judgment of a person, his views on an issue, his opinions or beliefs on a topic. This sort of expression is done by making some sort of statement in a language or by doing what can be construed as a statement, such as nodding, raising one's hand or groaning. Moreover, the ideas, beliefs, views, etc. which are expressed are always describable in propositional form. That is to say, they are describable as, e.g., the idea *that* DDT is dangerous, the judgment *that* John is untrustworthy, the view *that* the war should be ended immediately.

In what follows I shall refer to all cases of expression of this sort as "the expression of ideas." The designation is used merely for the sake of convenience, and not because everything covered in this sense of expression is truly an "idea." Indeed, what essentially marks a case of this variety of expression is that whatever is said to be expressed may be described in terms of a proposition introduced by "that." Therefore, even the expression of certain sorts of feelings, attitudes, and emotions is included in this sort of expression. In spite of the fact that the direct objects of "express" in the following are not ideas in any obvious sense, therefore, the statements do refer to expressing ideas as far as my discussion is concerned.

156

(a) The critic expressed his feeling that John's play was poor and would have a short run.

(b) The general expressed his fear that the war was being lost.

(c) The board expressed its concern that the children were not being nourished properly.

Now although expressing an idea is commonly a linguistic act having no relation to art, such expression may also occur *in* works of art. Surely it is true that Alexander Pope expressed the opinion that the proper study of mankind is man, as well as many others, in his famous poem. Such instances of expression frequently occur in novels when the authors "editorialize." The Epilogues of Tolstoi's *War and Peace* present obvious examples of this. But expressing ideas in art in this way is not problematic at all. Such cases of expression are merely linguistic acts distinguished by their occurrence in works of art. But sometimes a whole work of art, whether it is a verbal work or not, can express an "idea" describable by means of a "that" clause. Even when such expression occurs in a verbal work, moreover, it is by no means the case that the idea is simply and unproblematically *stated*. Consider the following examples.

(1) In the unfinished Rondanini Pietà, Michelangelo expressed his final judgment about man and his condition, namely, that he is a helpless creature utterly dependent upon God.

(2) The Eve panel in the Uffizi expresses Cranach's idea of the essence of woman, i.e. that she is a beguilingly beautiful temptress and seductress.

(3) In *Dr. Faustus* Thomas Mann expresses his view of the German national character, to wit, that it is torn

157

by a tragic tension between the humane and orderly, on the one hand, and the demonic, on the other.

(4) Praxiteles expressed in his Hermes the classic Greek notion that man is a beautiful and dignified creature.

The use of "expression" represented by (1) through (4) is a perfectly natural way of speaking, and it is frequently used in critical and historical discussions of art. There has been a marked antagonism in some recent philosophical aesthetics, however, toward the idea that art, and especially non-verbal art, can express anything which takes a propositional form if there is no sentence which acts as the "vehicle" for the propositional content. The antagonism has been expressed by saying that discourse of the sort exemplified by (1) through (4) is somehow an incorrect way of speaking. Monroe Beardsley, for example, implies as much in his discussion of the "Proposition Theory" of "artistic truth."[1] I have some trouble understanding the motivation for such antagonism, especially since Beardsley himself admits that critics frequently speak and write in the way exemplified by (1) through (4) and further admits that there is little "practical" objection to their continuing to do so. I suspect —but it is only a suspicion—that Beardsley and others have been overimpressed by the theories of philosophers of logic, who originally introduced the notion of "proposition." Since that notion was derived just in order for there to be something for a set of *sentences* to express, it might seem illicit to treat non-sentences as expressing propositions. But if that is the only difficulty, it is easily avoided by not insisting that art works express propositions. "Proposition" is, after all, an artificial concept whose meaning is rather obscure, if its function is not. The critical discourse which motivates talk about the "Proposition Theory" does not employ the term

[1] Beardsley, *Aesthetics*, pp. 369 ff.

"proposition" but uses words like "view," "belief," "idea," "judgment," etc. When I asserted above that the ideas which are expressed in art are propositional, I did not intend to raise the spectre of the logicians' "proposition" but only to indicate that the ideas so expressed as describable in terms of "that" clauses.

Whatever motivates Beardsley's antagonism, however, at least one of his objections to the Proposition Theory can be treated on its independent merits. That is his idea that a statement about what a work expresses can be rephrased in terms of what the work represents a thing as. Thus (1) above might be translated thus:

(1_1) In the Rondanini Pietà Michelangelo represents man as helpless and utterly dependent upon God.

Similarly (2), (3), and (4) would be translatable respectively as:

(2_1) Cranach represents woman in the Eve panel as beguiling and seductive.

(3_1) Mann represents the German national character as torn by a tragic tension between the humane and the demonic.

(4_1) Praxiteles represented the human being as beautiful and dignified.

But Beardsley is wrong in suggesting that statements like (1_1) through (4_1) capture the meaning of statements like (1) through (4). It does seem true that (1) through (4) imply, respectively, (1_1) through (4_1). But the implication does not go the other way. In general, an artist may represent a subject S as P without expressing the "idea" that S is P, where "represent" stands, as I believe it does for Beardsley also, for anything which belongs to the family of representation concepts. The reason is that "propositional expres-

159

sion" in art depends upon the objective expression discussed in the preceding chapter. Thus, (1) through (4) imply, under a condition to be mentioned, the following:

(1_2) In the Rondanini Pietà Michelangelo expresses the utter helplessness of man and his dependence upon God.

(2_2) In the Eve panel Cranach expresses the beguiling seductiveness of woman.

(3_2) In *Dr. Faustus* Mann expresses the tragic tension between the humane and the demonic in the German national character.

(4_2) Praxiteles expressed in his Hermes the beauty and dignity of human nature.

Now only under the assumption that the ideas expressed in (1) through (4) are "true" do the latter imply (1_2) through (4_2). For to make any of the statements (1_2) through (4_2) is in effect to authorize what in (1) through (4) is called merely a judgment, idea, view, or notion of the artist. One cannot legitimately say that Michelangelo expresses what (1_2) asserts he does unless one believes man to be utterly helpless and dependent on God. The same is true for (2_2) through (4_2). Yet not even under this assumption is it the case that (1_1) through (4_1) imply, respectively, (1_2) through (4_2). The reason for this is implicit in one of the main theses of the preceding chapter: objective expression is in crucial ways unlike representation. One has only to imagine some rather crude cartoon in the style of those which appear on the editorial page of a daily newspaper to realize that anyone with a modicum of cleverness could devise graphic representations which would fit the descriptions given in (1_1), (2_1), and (4_1). It also requires no great powers to imagine a clumsy allegory in which the German character is represented as torn between the humane and

THE EXPRESSION OF IDEAS

the demonic. In short, (1_2) through (4_2) imply an artistic achievement; (1_1) through (4_1) do not.

If my claim is correct, it follows that statements of the sort exemplified by (1_1) through (4_1) do not imply corresponding statements like (1) through (4). That such is indeed the case can be seen again by imagining relatively crude examples of representation. If a three-year-old makes a crayon drawing of his father and mother with the father figure considerably bigger and heavier than the mother figure, he can be said to have represented his father as more powerful than his mother. We are not inclined to say, however, that the child in his drawing *expressed the idea* that his father is more powerful than his mother. And this is so even if we go on to infer from the drawing, as we might, that the child *thinks* of his father as more powerful than his mother.

Likewise we cannot infer from the fact that the author of the comic strip "Andy Capp" represents the English lower class as violent, shiftless, and irresponsible that he *expresses his opinion* in his comic strip that the English lower class is violent, shiftless, and irresponsible. Notice, though, that even if we knew the author to be of that opinion, his comic strip would still not be describable as an expression of his opinion that etc., etc. This case is a bit complicated by the fact that sometimes "opinion" can be used colloquially to denote something like an attitude which is not describable in propositional terms. "View" is sometimes used like that also. Thus we might agree that "Andy Capp" expresses its author's opinion (or his view) of the English lower class. But the "opinion" or "view" here would take only descriptions like "negative," "unfavorable," "poor," "dim," i.e. descriptions which do not specify a propositional content of the opinion or view. It should be noted, of course, that "Andy Capp" might correctly be taken as *indicating, reveal-*

161

ing, betraying, or *suggesting* the writer's opinion *that* the British lower class is violent, shiftless, and irresponsible.

The propositional sense of expression is used in roughly two sorts of cases: (1) cases of ordinary prose in which what is expressed is either explicitly stated or is directly indicated by a conventional language substitute and (2) cases in which at least the "predicate" of the idea expressed "stands out" in the peculiar way explained in the last chapter. As far apart as these sorts of cases seem, they are nevertheless related in virtue of being connected to yet another sense of "express." That is the sense in which it means "explicit" or "direct." When one *expresses* an idea in expository prose, one does not merely imply, suggest, indicate, or hint at it; one states it directly and explicitly.

Likewise, when an artist expresses an idea in his work, it is not implicit, hidden, or merely suggested in the work; it is there with obviousness and clarity—a kind of explicitness —because of the way in which the "predicate" element in the idea is so vividly "present" in the work. There may be ideas suggested, implied, or hinted at in a work which are not expressed. For example, *Dr. Faustus suggests,* but does not *express,* an obvious interpretation of World War II in virtue of what it expresses about the German character. Again, Michelangelo's *Last Judgment* expresses the notion that God the Judge wields an absolute and awful power over men; and it thereby *implies,* but does not *express,* the judgment that men should respect and fear God. Again, it is reasonable to say that Shakespeare *hints* in *Richard II* that any monarch who claims absolute power ought to be deposed. But he certainly does not *express* that idea in his play.[2]

[2] The ideas which are expressed in art, therefore, are not identical with what have been called "implied truths" in art. Cf. John Hospers, "Implied Truths in Literature," *The Journal of Aesthetics and Art*

THE EXPRESSION OF IDEAS

PROPOSITIONAL expression in art is not simply a variety of representation in the way that Beardsley has suggested. Yet it might seem on other grounds that the expression of ideas in art is a variety of representation. It is certainly not a misuse of language to say, for example, that Cranach's Eve panel *represents* the painter's idea of the essence of woman or that Cranach *painted* his idea of woman in the Uffizi panel. It is equally reasonable to think of *Dr. Faustus* as a fictional *representation* of Mann's view of the German character. We might even say that in the unfinished Pietà Michelangelo *carved* his final judgment on man's condition, even though in this case there is a sense of the term "carved" being used in a somewhat figurative way. It is more straightforward to say simply that the Rondanini Pietà *represents* the artist's last judgment about the condition of man. And we can similarly say of Praxiteles' Hermes that it is a *representation* in marble of the pervasive Greek notion of man's beauty and dignity.

All these uses of "representation" and representation words suggest that the expression of ideas is to be understood somewhat on the model of portrait painting (or sculpting) or, in the verbal arts, on the model of novelistic or poetic descriptions of actual persons, places, and events. The only important difference would be that whereas in the latter something real and external is rendered or described, in the expression of an idea the artist represents something "internal."

To make the model more plausible, of course, we should think of the ideas in question as mental images somewhat like internal and insubstantial pictures. Then when an artist expresses this idea, the model suggests, he either describes

Criticism, XIX (1960), 37-46. Also Morris Weitz, "Art, Language and Truth," *Philosophy of the Arts* (Cambridge, Mass: Harvard University Press, 1950), pp. 134-152.

163

or characterizes or draws or paints or sculpts what he has a mental picture of. Note that the model is not very plausible if one interprets it to imply that the artist represents, describes, characterizes, draws, paints, etc., his *idea* rather than the *content* of his idea. One is hardly inclined to think of a statue, for example, as "resembling an idea" if this does *not* mean "resembling what the idea is *of*." The act of expression might thus be a bit like painting a scene from a photograph or sculpting a head from a set of photographs.

There is no reason to doubt that the following is a logical possibility. An artist has a recurring mental image of a woman whom he realizes he has never seen. She is bewitchingly beautiful with a faint but obvious hint of danger about her. He realizes that she is a creature of his fancy and resolves to paint her. In doing so he finds that he can close his eyes and use his own image of the woman as a kind of model because it is so vivid and detailed. He completes the picture and shows it to his friends, telling them the story of its genesis. They acknowledge the painting to be an expression of his conception of woman.

There is nothing absurd about this story, however unlikely it may be. But what the artist's friends cannot correctly *mean* when they say that the painting expressed the artist's conception is that the artist painted it "from" his mental image in the way described. For if that is what "expression" *means* in these cases it would at least have to be true that every time an artist is correctly described as expressing an idea in a work, that work must have originated according to the above pattern. One need not know a great deal about art to realize that such is not the case. Furthermore, if "expression" were analysable according to the above model, it would be necessary to have observed the artist as he was making the work and to have his introspective reports in order to support any claim that the artist did express some

idea or other in his work. This consequence, however, is not consistent with the characteristic way in which such a claim is supported.

What would a dispute be like concerning the truth or falsity of the claim, for example, that Michelangelo's Rondanini Pietà expressed his final judgment on the human condition? Suppose I scoff at this claim of yours and accuse you of over-interpreting. "Why," I ask, "do you think that Michelangelo is 'saying' that man is a helpless creature dependent upon God and his mercy? After all, the Pietà is a representation of the dead Christ, who is *of course* 'helpless' and must be supported. And *of course* his mother is grief-stricken; she always is in a pietà."

"There is more there," you insist. "The Christ figure takes on a certain abstract import. Part of this is due to the sketchy nature of the work: details are lacking, the surface is rough and incomplete. Part is due to the fact that the overall effect of the lines of the work is an overwhelming despondency. There is no sign in these lines of the harmonious composition characteristic of High Renaissance art. The lines are purely expressive. Moreover, Christ's body itself is surprisingly slight and small. Yet even so, Mary is weighted down by it, her stooped form echoing the helplessness in the form of Christ. It is significant, too, that the artist has represented Christ as anything but God-like. The slightness of his body is relevant here, but it is important, too, that there is no sign that the dead figure is indeed the Christ. God is represented here as a mere man and as a man at his most ungod-like, i.e. when he is dead."

"You're beginning to convince me," I admit. "But I think you're on shaky ground when you refer to the lack of details and the rough surface. The work is unfinished and the evidence is that Michelangelo intended to complete it. Who knows what it would have looked like when finished."

"Yes," you concede, "it undoubtedly would have looked different when finished, though not, I suspect, so different that its character would be changed. There is after all a certain rightness about the sketchiness of the work as it stands, as if the characteristic polish and articulation of High Renaissance style did not have anything essential to do with this particular work. But, agreed that not a great deal can be proved by the unfinished character of the *Pietà* alone, the other features of the work which I mentioned are decisive because they are obviously so much more important than detail and polish in this work. It is significant that it does not seem to be an obstacle to understanding this work that it is unfinished; we do not feel before it as if anything is missing."

The preceding sketch of a discussion of the Rondanini Pietà, regardless of the aptness and perspicacity of any of the remarks in it, shows the *sort* of considerations which would be relevant in deciding whether a claim about a work expressing an "idea" is just or not. I do not believe that examples taken from other arts would change the picture we get here. That picture shows us that statements about a work expressing an idea are not about how the work originated with respect to a mental image of the artist's. Rather, they constitute a certain sort of *interpretation* of the work, of the "meaning" of the work. And, as is the case with most interpretations, such statements are justified by reference to certain properties of the work, to intentions of the artist, to the artistic milieu in which the work was done, to the subject matter of the work, etc., etc.

If EXPRESSING (an idea) is like representing something, therefore, it cannot be like representing something which *exists*, even in the mind. For an idea which is expressed in

a work is discovered most typically without any reference at all to the furniture of the artist's mind. In this respect, therefore, expressing an idea, if it is like representing anything, must be more like representing what is not real. It might seem, then, to be rather like drawing something like a dragon. Not only need a drawing of a dragon not be a drawing of a particular real dragon, just as a drawing of a man need not be a drawing of any particular real man, but it is impossible that a drawing of a dragon be a drawing of some particular real dragon. In fact, the parallel between expressing an idea and drawing a dragon seems particularly close because a dragon is an *imaginary* creature. It is a mental figment, and as such it is very much like an "idea." Moreover, calling a dragon "imaginary" is not to locate it inside anyone's mind (or head). To verify whether a drawing is of a dragon one first of all looks at the drawing. If what is drawn has dragon-properties it may be, but is not necessarily, a dragon. In case of doubt one inquires what the intentions of the author were in drawing the picture. And if, as might be the case with a young child, the artist cannot express his intentions clearly, one inquires whether there were any dragon pictures accessible to the child of which the drawing might be a copy, however rough.

Now in many respects expressing ideas does not seem, in general, to be very much like drawing dragons. The following considerations may show the value of pursuing this parallel further. To draw a dragon is, among other things, to make a drawing of a dragon. Or, to spin out the implications further, drawing a dragon is making a configuration of lines in which a dragon "appears." Of course the dragon "appears" because the configuration was made so that a dragon would appear. Now when one expresses an idea in art he makes something (a poem, novel, painting, etc.) in which that idea

167

"appears" and he makes that something *so that* that idea appears.[3] It would seem, then, that the artist stands to his idea in expressing it in much the same way that he stands to the dragon in drawing it.

Yet for all the *prima facie* reasonability of understanding expressions of ideas in terms of drawings of dragons there is also a *prima facie* case against understanding them in that way. The ideas that I express are frequently, if not always, what I believe in. They are what I am deeply committed to or, at least, what I am in some measure "involved" in. They are often what I am willing to defend. They can show me at my best and worst, my most reasonable and most foolish, my most noble and most self-centered. Generally, whenever I express my ideas I am putting some part of *myself* forward. On the other hand, I need have no such intimate relations with dragons in order to draw a passable one. This difference is, of course, a function of the difference between ideas and dragons. Nevertheless, the special relations holding between a person and the ideas he expresses, which do not obtain between a person and the dragons he draws, are reflected in two features of the term "expression" when it is used to denote the expressing of an idea in an art work.

The first important feature about expressing an idea is that it only occurs in a situation in which the idea in question is in some way identifiable as the artist's idea. Thus it is that if one is satisfied that *Dr. Faustus* expresses a certain judgment about the German character, it is not a further

[3] This formulation does not demand that the artist describe or even be prepared to describe his production in terms of its expressing that idea. The artist might simply not know how to apply the term "expressing an idea" to artistic situations. There are many critical terms in the use of which many artists are unskilled. Similarly, a child might make a drawing of a dragon without knowing that what he drew is called a dragon.

question whether it is Thomas Mann's judgment therein expressed, as long as one has no doubt that Thomas Mann was the author of *Dr. Faustus*. Another way of making the same point is to imagine that the manuscript of *Dr. Faustus* had been found buried beneath a former concentration camp and that the identity of the author was undiscoverable. In that situation we would still have no qualms about attributing the judgment therein expressed to "the author."

Essentially the same point can be brought out in another way. Suppose that the statue we know as the Rondanini Pietà were discovered to be a very clever, even a remarkably sensitive, copy of the real work which had been hidden away by the forger. We may even suppose that by every test the copy is indistinguishable from the original in those respects which lead one to say that the original expresses Michelangelo's judgment concerning the condition of man. We should further suppose that it is known that the forger had any one of a number of more or less ignoble motives: to prove to himself that he was as great an artist as Michelangelo, to perpetrate a hoax, to get rich, etc. In these circumstances, it is obvious that it is true neither that the forger expressed his own judgment concerning the condition of man nor that he expressed Michelangelo's judgment on that subject.

It appears that there are cases of expression of ideas in art, however, in which the idea in question is not that of the artist. This seems to be the case, for example, when we say that Praxiteles expresses the Greek notion of man's beauty and dignity. It is true, of course, that in the latter locution we imply that Praxiteles' work shares an ideational content with a set of other expressions produced by Greeks of the fifth and fourth centuries B.C. Such references to the expression of ideas, therefore, focusses on the fact that the idea in question is not a peculiar contribution of the author of

the expression. Nevertheless, such references to expression are only used when the author of the expression is *associated* in some essential way with the groups of persons producing the set of expressions indicated in the reference. The modes of association are, of course, various. Thus Praxiteles could express the (classical) Greek idea of man's beauty and dignity because he *was* a Greek of the classical period.

Similarly, it is plausible to assert that El Greco expresses in some of his paintings Byzantine religious ideas only in part because of certain techniques, forms, and motifs which are manifest in his works and which are common in Byzantine art. A crucial part of the plausibility of so asserting consists in the plausibility of assuming that El Greco was, in his early life, imbued with the ideas of Byzantine Christianity and that he might have been partially trained by artists working in the Byzantine style. On the other hand, the propriety of claiming that Raphael expressed classical pagan ideas about man in some of his paintings stems from the fact that Raphael was decisively influenced by literary, artistic, and educational movements deriving from and modeled on classical pagan culture. In cases of these sorts, therefore, the ideas expressed *are* ideas of the artists; they are simply not ideas originated by the artists; they are ideas which the artists share with persons in a particular social and/or cultural milieu.

There are still other conditions under which a person might express an idea which is not "his own" and which cannot be assumed to be his in virtue of his membership in a cultural group, his cultural environment, or his training and education. Consider the case of Modesto O'Malley ("Mod" for short). Mod is a leather-jacketed motorcyclist and a frequenter of the wildest discotheques. He surrounds

himself with the largest examples of Pop Art which his considerable wealth can buy. He refuses to furnish his house with anything resembling conventional furniture, preferring instead to use piles of bricks, packing crates, and bales of straw. People who have known Mod since birth, moreover, attest that despite a certain fashionability in Mod's habits and tastes, Mod's style is genuine; it is simply that the times at last were right for him and provided him with the means to be himself.

Now let us suppose that Mod is exceptionally gifted verbally. He has a mastery of English, an astounding talent for mimicry, an ear for dialect, and an uncanny ability to pick up foreign languages quickly. This talent with language has led him to no more exalted position in life than an assistant professorship of literature. One year he is assigned the sophomore survey course in the history of English literature. Several of his students think they see in Mod a soul-mate who is teaching this course, as they are taking it, as a "requirement." They mock and scoff at nearly everything but at nothing more than at Sir Philip Sidney's high, "golden" style and Neo-Platonic content. Far from encouraging them, however, Mod takes their attitude as a challenge to enlarge their sympathies and widen their sensibilities. He writes a beautiful sonnet in Sidney's manner on the glories of one of his female students—leader of the group of scoffers. Much to everyone's surprise, the students are truly affected by Mod's sensitive and sympathetic expression of an alien notion of love and beauty applied to a subject of their own experience.

In this case Mod does express an idea characteristic of a period and a civilization and a style of life which is far removed from his own and which had no discernible influence on him. Yet in virtue of his intelligence and his talent, but especially in virtue of his motives and his sympathy in

171

writing the sonnet, Mod was, as it were, momentarily accepting the foreign style and content as his own. Perhaps it is more accurate to say that in writing the sonnet he was *acting as if* he shared the Renaissance ideas in the poem.[4] That is what allows us to describe him as *expressing* those ideas.

The features of the above case can be put into relief if we imagine a somewhat different description of Mod and a different history of his sonnet. Suppose now that everything about him is true as above except that he is not a teacher of literature. Suppose further that he is something of a wastrel and a sot and that he has the attitudes toward historical styles which the students in the last story did. Now imagine him in a bar with an acquaintance, a poetry teacher, who casually says that his class is just now studying Sidney. "Oh, Sidney!" says Mod in a voice clouded by liquor and loaded with sarcasm. And he spins off, with hardly a pause for thought, but in a scornful and mocking tone of voice, an incredibly good sonnet on Sidney's themes and in Sidney's manner. Surely in this case, no matter how "good" his sonnet is, Mod is not describable as expressing anything except contempt for Sidney's poetry. And even that expression is marred by the fact that, in spite of himself, his effort is an excellent imitation of Sidney. But it is only an imitation. Because of his attitudes he cannot be considered as having gotten "on the inside" of Sidney, and thus the genuinely Renaissance ideas in his sonnet never became, even provisionally or hypothetically, "his own."

[4] The notion of "acting as if" can be used in earlier cases of expressing ideas. Some may object to the idea that if an idea is expressed in a work, it is the artist who expresses his idea. It is true that even in cases like, e.g., Mann's *Dr. Faustus*, there always remains the logical possibility that the author owes no special allegiance to the idea he expresses in his work. In such a case one can at least say that the author in writing the book *acted as if* he held to the idea he expresses in the book.

WE TURN now to the second important feature which distinguishes the artistic expression of ideas from drawings of imaginary creatures. This feature depends upon the fact that the expression of ideas in art always presupposes the expression of some abstract and objective property as described in the last chapter. I have argued that the latter sort of expression is always done in some anthropomorphically describable way. It therefore is reasonable to suppose that the expression of ideas in art must also be done in some similarly describable way. The following examples will reinforce this supposition.

The following are plausible ways of elaborating statements (1_2) through (4_2) above by describing the way in which the expressing was done.

(1_3) In the Rondanini Pietà Michelangelo expresses with *intensity and even with anguish* the utter helplessness of man and his dependence upon God.

(2_3) In the Eve panel Cranach *frankly and forthrightly* expresses the beguiling seductiveness of woman.

(3_3) In *Dr. Faustus* Mann expresses with *compassion and understanding* the tragic tension between the humane and the demonic in the German national character.

(4_3) In his Hermes Praxiteles expressed, *with rather more amiability and openness than earlier artists,* the beauty and dignity of man.

It seems obvious without spelling it out that the same italicized phrases could be used to describe, respectively, the way in which Michelangelo expressed his judgment, Cranach expressed his idea, Mann expressed his view, and Praxiteles expressed the Greek notion as these are represented in (1) through (4) above. Moreover, the italicized adverbial phrases in (1_3) through (4_3) can be transformed in obvious ways into adjectival phrases, using the same anthro-

pomorphic terms, which are descriptive of the respective works of art. The above cases of expressing ideas in art thus belong to the variety of the artistic acts discussed in Chapter One.

There are further grounds for believing that all cases of expressing an idea in art are describable by some anthropomorphic terms. In order to discover some appropriate anthropomorphic description of a particular case of expressing an idea one has only to compare that case with a sufficiently different case, either real or imagined, of a sufficiently similar idea. Those sorts of comparisons are frequently incorporated into the description itself, as in (4_3). Even when they are not so incorporated the comparisons are obviously lurking in the background. For example, Cranach's Eve in the Uffizi is distinguishable from many of his earlier paintings of nude women in that the same features of his subjects are not presented in a leering, adolescent way but are clearly expressed more "maturely," i.e. frankly and forthrightly. Some anthropomorphic descriptions, such as those in (1_3) and (3_3) above, are obvious enough without any sort of explicit comparisons. Nevertheless it seems true that *any* case of this sort of expression can be compared to another to yield a true anthropomorphic description of it. This point is reminiscent of the one I made with respect to linguistic expressions in Chapter Three and also with respect to objective expression in Chapter Four. The resemblance is not purely coincidental.

The drawing of dragons, unlike the expressing of ideas in art, need not be done in an anthropomorphically describable way. In order to see this point let us first make a distinction between the way in which a dragon is drawn which is discernible in the drawing itself and the way in which a drawing is done which is not discernible in the drawing. I might take up a crayon and briskly or self-importantly or

shyly draw a dragon without producing a brisk, self-impor-
tant, or shy drawing of a dragon. But I might draw a dragon
wittily or imaginatively if what I make is a witty or imag-
inative drawing of a dragon. It is not hard for anyone with
modest-to-poor drawing skill to convince himself that it is
possible to draw a dragon in no anthropomorphically de-
scribable way whatever which is discernible in the drawing.
Completely characterless, uninteresting, and/or "nonde-
script" drawings of anything, including dragons, are easy
enough for most people to produce.

ON CLOSE examination, therefore, the comparison between
expressing ideas in art and representing imaginary beings
breaks down. Let us then try a more obvious approach to
understanding what is going on when an artist expresses an
idea in a work of art. *Prima facie* it would seem that what
such expression is most like is the expression of ideas in
ordinary conversational or expository prose. It is easy to
think that the expression of some idea artistically is just a
more complicated and subtle way of expressing what could
be expressed in ordinary prose. It is quite common to think
of artists' techniques and media as specialized sorts of lan-
guages, languages which they use more skillfully than they
do conventional spoken languages for the conveyance of
their ideas. However like or unlike natural languages art is
found to be when an extended comparison is made, the
rather simple fact remains that some works of art are like
some ordinary linguistic utterances in that they express
ideas. Thus if we can find out what expressing ideas in "or-
dinary" language is, we can gain some understanding of the
expression of ideas in art as well.

Now it seems clear that expressing one's ideas in extra-
artistic contexts is not at all like representing an imaginary
being: there is no *prima facie* reason to reach for such an

unlikely analogy in order to understand the ordinary linguistic expression of ideas. When we express an idea, in ordinary prose, it seems, we simply *say*, *tell*, or perhaps *relate* what our idea is. Such a gloss on "expressing" is attractive for a number of reasons. First, it is the most obvious and "natural" way of explicating the term. Second, it appears to be universally true that whenever we express our idea we do say (either orally or in writing) what our idea is. Third, such a gloss provides further corroboration of the earlier point that expressing an idea is always done in some anthropomorphically describable way. For if it is true that expressing an idea is putting an idea into words and if it is the case that the words used can be seen as a "linguistic expression," then to put an idea into words is to put it in some anthropomorphically describable way (or ways). In this respect, language is generally more "expressively articulate" than pencil lines or brush strokes, which might represent a dragon or a unicorn. Therefore, it seems just to conceive all cases of expressing ideas along the lines of the verbal expression of ideas.

In spite of the close connection between expressing an idea and saying what the idea is, however, there is more to the former than to the latter. In particular, expressing an idea requires a sort of "personal involvement" with the idea which simply saying or telling does not. This means something more specific than simply that expressing an idea must be done in some anthropomorphically describable way. It means that it must be done with at least a minimal degree of conviction and force or with some evidence of a positive attitude and favorable feeling towards the idea being expressed.

One consequence of this fact is that one cannot be described as expressing an idea without feeling, listlessly and/or dully (when "dull" means not "uninteresting" but "dis-

playing no interest"). Imagine a situation in which I am overheard by a friend of the Dean saying that my department chairman is weak and ineffectual. Suppose that it would be useful for the Dean's purposes to have me give this opinion to him and so he calls me in and tries to get me to repeat my opinion to him in the presence of the Vice-chancellor. Not wishing to play into the Dean's hands, I resist at first. Being no match for the inquisitorial Dean, however, I am at last intimidated by the sheer energy of the man, his veiled threats, and the realization that he would inevitably win. I finally say dully, without feeling or animation what my opinion of the chairman is, and I quickly leave the room. In such circumstances I can hardly be said to *express* my opinion to the Dean.

But even my telling my opinion with feeling in my voice will not always count as expressing my opinion. Let us change the preceding Gothic fantasy slightly and suppose that the Dean has browbeat me in the antechamber and requests that I go into the Vice-chancellor and deliver my opinion with some force and conviction. Even if I can tell the Vice-chancellor what my opinion is so that *he* thinks I am expressing my opinion to him, it is still questionable that I am indeed expressing my opinion. An apter description of what I am doing is telling him my opinion and injecting some firmness and conviction into my voice. Although what I tell may truly be my opinion, the firmness and conviction I project are not truly *my* firmness and conviction. They are a firmness and a conviction I have "put on." Therefore what I do fails to be an *expression* of my opinion.

Let us change the story again slightly. Suppose now that in telling my opinion of the chairman to the Vice-chancellor notes of bitterness and scorn come into my voice. The bitterness and scorn, though taken by the Vice-chancellor to be directed at my chairman's ineffectuality, are really directed

at myself on account of my own weakness. In these circumstances, too, it is not the case that I am bitterly and scornfully expressing my opinion of the chairman, even though the opinion is mine, as are the bitterness and scorn. Once again, for failure to have the right sorts of attitudes directed in the right way, I fail to *express* my opinion. It is important to see, however, that because it is perfectly possible to express an opinion of this sort scornfully and bitterly, the Vice-chancellor might have every right in the above situation to take me as doing so.

Another feature of the expression of ideas is that it is more closely associated with the expression of one's *own* ideas, whereas the same is not the case with saying and telling. In fact, the latter seem almost more appropriately done with respect to other persons' ideas rather than one's own. It is commoner for me to tell you what my friend George's opinions are and to tell my students what Aquinas's ideas are than for me to *express* George's opinions or Aquinas's ideas. Nevertheless, the latter sorts of expressions can occur, and it is interesting to see under what conditions.

Suppose that George cannot be at an important faculty meeting. When it is wondered what George thinks about abolishing the deanship of the school, I am able to tell my colleagues what George thinks. However, it might also happen that George, knowing he will be absent, asks me to speak on his behalf on the subject of the deanship. Therefore, when asked about George's opinions I say, "Let me try to express George's opinion." Now if I am to succeed in doing so, I must do more than simply say what George thinks. I must say what George thinks in a way that George might be expected to: I must present his opinions with some firmness and force in my voice; I must present his ideas fully, precisely, and in detail; I must present them in as favorable a light as possible together with supporting

arguments. I must, in short, present them with understanding and sympathy.

Similarly, good historians and teachers of philosophy have the ability to present an alien philosopher's ideas with sympathy and understanding. Under these conditions, they are said to *express* that philosopher's ideas. This entails seeing the philosopher's problems from his own point of view and against his own historical background. It demands setting forth his arguments as clearly as the text permits to support the philosopher's point. It especially demands a persuasive and serious manner and tone of voice. In some cases—say, for the presentation of Plato's notion of the Good—it might even require some passion and some elevated rhetoric.

The criterion that the expression of the ideas of another person be done with sympathy and understanding clearly excludes the possibility of expressing those ideas sarcastically, laughingly, scornfully, sneeringly, mockingly, or flippantly when the ideas in question are the *objects* of sarcasm, laughter, scorn, sneers, mockery, or flippancy. But such limitations do not apply simply to saying what or telling what another's ideas are. Furthermore, it is not even possible to say or tell what another's ideas are understandingly and sympathetically when it is the ideas which are being treated with understanding and sympathy. I can tell Sam sympathetically what (unflattering) things (nasty old) George thinks of him, but in this case my sympathy is with Sam and not with George's opinion. Likewise I might tell Reginald, with some understanding of his position, what his neurotic wife Penelope believes of him but devote thereby no "understanding" to Penelope's beliefs. And if I am said to *tell* my students with sympathy and understanding what Aquinas's idea of the body-soul union is, that would suggest some sort of offensiveness in Aquinas's idea, not a bond between me and Aquinas.

What, then, does the necessity to give sympathy and understanding to another's ideas have, in general, to do with the expression of ideas? First, it is obvious that the "sympathetic" expression of ideas is related to the sense of "sympathy" which refers to an agreement or accord in feeling and/or attitudes. If you are in sympathy with the Guelphs, you share the Guelph enmities and friendships. And thus it is that to present another person's ideas *as if* one shared the feelings and attitudes of that person is to present that person's ideas sympathetically. But so to present another's ideas is to present them in a way which shows attitudes and feelings which, one presumes, that person has with respect to those ideas. And these attitudes and feelings are, one further presumes, ones which that person would show in *expressing* his ideas.

The very same point can be made with respect to the phrase "with understanding." When one presents another's ideas *with understanding*, the term "with understanding" does not specifically refer to the fact that the person presenting the idea understands what the idea is and understands many things about, and implications of, that idea. Rather, the sort of understanding referred to is precisely the sort which obtains between persons who are in sympathy with one another. When such persons understand one another, they each understand *how* the other feels. And this sort of understanding is more than just understanding *that* the other has feeling A or attitude B; it is, at least to some degree, sharing that feeling or attitude. Of course, to *present* another's ideas with understanding does not presuppose sharing to any degree that persons' feelings or attitudes. But it does entail expressing those ideas as the person would presumably have expressed them.

Granting these points, it is easier to see why the term "expressing," which seems so much more appropriate for

what *I* do to *my* ideas, can be applied to what *you* do with respect to *my* ideas. It can be applied precisely when a condition is satisfied which is also a crucial condition of my expressing my own idea, namely, that my feelings and attitudes with respect to the ideas be evident in the way that my ideas are articulated. That the latter *is* a condition of my expressing my ideas has already been argued in a variety of ways. That this condition must also be satisfied when someone else expresses my ideas can be seen as a corroborating argument for that earlier point.

In an obvious way, though, we have not answered the question set at the beginning of this chapter, namely, what is it to express an idea in art? We have mainly discovered what it is not. It is not to "represent" anything, nor is it to state or tell anything. It is, however, surprisingly like the expression of ideas in ordinary prose. But the likeness does not consist in the fact that art is a kind of language. Even if it were, we would not know what the expression of ideas in art is, because we do not know what the expression of ideas in ordinary prose is. The most that we can positively say at this point is that to express an idea, by any means, is to do something "expressive." For once again a sort of expression, which is *prima facie* quite different from expressions like sad smiles, angry gestures, and anguished shrieks, is shown to be intimately connected with just the sort of expressiveness that smiles, gestures, and shrieks possess.

chapter six

Signs and Expressions

∾

Let us take stock of what the preceding chapters have and have not shown. In the first place, all of the preceding discussion has presumed that there is a class of human acts, gestural, "facial," and vocal, which are indisputable examples of expressions. Thus shaking one's fist can be an expression of anger, smiling can be an expression of joy, shrieking can be an expression of anguish. Correspondingly, the shake of the fist expresses anger, the smile expresses joy, the shriek expresses anguish. I further presumed that although there is no shake of the fist without a shaker, the shake of the fist which is expressive of anger may or may not express the anger of the shaker. The same is true of the smile and the shriek.

In Chapters One and Two I argued that in at least some respects some works of art are like common facial, gestural, and vocal expressions. This argument makes clear and precise the thread of truth running through classical expression theories of art. The claims in Chapters One and Two, however, do not amount to a theory of art for three reasons: (1) I do not claim that *all* art does show the expressive characteristics I isolate; (2) I do not claim that these expressive characteristics of art are the only characteristics of art; (3) I do not claim that the expressive characteristics of a work are its most interesting or important characteristics.

The general significance of the arguments in Chapters One and Two is that the range of phenomena which can function

as expressions of a person's feelings, emotions, attitudes, moods, states of mind, personal traits, and/or qualities of mind is widened far beyond the so-called "natural" expressions, such as grimaces, gestures, and vocalizations. Chapter Three further enlarges the range of what can serve as expressions to include utterances of articulated language, both spoken and written. Such utterances may also include the elaborated verbal productions of historians, philosophers, and scientists. This enlargement of the range of expressive phenomena incidentally shows that the significance of the concept of expression is not restricted to art and the philosophy thereof.

Chapters Three, Four, and Five analyze four uses of "express" and its cognates which have rarely been the objects of philosophical attention. These analyses discover that to use a linguistic expression, to express in a work of art an abstract, "objective" property or feature, or to express an idea, either in an art medium or not, is always and at the same time to do something which has important formal and functional features in common with "natural" expressions like gestures, grimaces, and cries. Thus it is that some important and quite various sorts of expression are related, as arcs of a circle to its center, to that variety of expression exemplified by gestures, grimaces, and cries. It should be emphasized, however, that I have not claimed that *all* varieties of expression are so related. As I pointed out, the "expressions" of technical languages such as logic and mathematics are not so related. There are also other sorts of expression which I have neither mentioned nor discussed, and shall not.

It is with this "central" sort of expression that most of the remainder of this study will concern itself. Some qualifications should be made, however. In what follows I shall not be occupied solely with the so-called natural expressions,

but rather with the whole range of phenomena which, I have argued, can function as expressions of some person's feeling, emotion, attitude, mood, state of mind, his traits of temperament, personality, or character and/or his mental qualities. There is no doubt a real distinction to be made between "natural" expressions and expressions which are explicitly cultural phenomena. But, as I hope will be evident by the end of this inquiry, the distinction does not bear upon the basic nature of expression, which both sorts of expressions share.

My opinion on this is not shared by prominent theorists of expression. John Dewey, for example, insists on the distinction between what he calls "emotional discharge" and "intrinsically expressive acts," only the latter of which is true expression.[1] Susanne Langer also honors the distinction in terms of mere "symptoms" of feeling, on the one hand, and symbols of feeling, on the other.[2] More recently Richard Wollheim has expressed the distinction, or what is very close to the distinction, in terms of "natural expression" and "correspondence."[3] I do not intend to argue explicitly against the importance of such distinctions, for that would entail full scale polemics against rather elaborate theories. Distinctions of this sort almost always have a primarily strategic importance in philosophical discussion. Therefore, the ultimate test of such distinctions is whether they illuminate or obscure more of the total subject matter. I therefore shall rely upon the general persuasiveness of the following inquiry to justify my ignoring this distinction. I stress that, although there is surely a distinction to be made where

[1] John Dewey, *Art as Experience* (New York: Putnam, 1958, Capricorn Books edition), pp. 61-62.
[2] Susanne K. Langer, *Problems of Art* (New York: Scribner's, 1957), pp. 24-26.
[3] Richard Wollheim, *Art and Its Objects* (New York: Harper and Row, 1968), pp. 26-28.

184

others have made it, the issue concerns whether one must make it a fundamental one at the *beginning* of an inquiry or whether one can "handle" it as a consequence of certain philosophical results at the *end* of the inquiry.

Furthermore, I shall only be concerned with the range of expressive phenomena *insofar as* they actually express some feeling, emotion, attitude, etc., etc., of a person. My question will be: What is it for anything to be an expression of the above sorts of "things" under such a condition? I am under no illusion that it is always easy or even possible to determine in given cases whether (1) a particular person really does (or did) have a certain feeling, attitude, trait, etc. indicated by his "actions," or (2) what a given expression in fact expresses. These determinations are notoriously difficult to make, especially when an artist and/or his work are the subjects of the inquiry. These are matters for historical and art critical interpretations, and I do not pretend to deliver up a method for solving problems of interpretation. The following inquiry, furthermore, does not presuppose any belief concerning how frequently it has happened, or how important it is for the History or Theory of Art when it has happened, that works of art express something of their creators.

I should also make clear that it is *not* necessary in order for a thing to count, for purposes of the following investigation, as an *expression* of a person's F that that person *express* his F in that "thing." Thus the joyful gleam in x's eyes may count as an expression of x's joy, even though x did not express his joy in any way. (He just sat there, unchanged except for the joyful gleam that lighted his eyes.) Thus too, the baby's bawl may be an *expression of pain*, even though it is doubtful that the two-day-old child *expresses his pain*. Sometimes, too, an artist may betray, and not express, say, his sentimentality in his work; but in such a case his senti-

mental work still counts as an expression of the artist's sentimentality. It takes an *expression of x's F* to betray *x's F*; but it cannot take *x's expressing* his *F* for his *F* to be betrayed. These points do not run counter to some common uses of "expression." There is of course some point in distinguishing between a person expressing, venting, betraying, and revealing his *F*, as several philosophers have done. I shall not be concerned to do so simply because my subject matter is not the use of "expression" according to which a *person* is said to express his *F*.

Of course, my conclusions are intended to *apply* to cases in which a person expresses his *F*, for in such cases *expressions of F* do figure. Thus, for example, if an artist expresses his anti-war feeling in a lithograph, the lithograph must be an expression of his anti-war feeling. We may therefore ask about the lithograph, as about a gleam in the eyes, what makes it an expression of what it expresses. I believe that the answer can be given independently of the fact that the artist *expressed* his feeling in the lithograph. Indeed, since a person can express his *F* only if an expression of his *F* is produced but not the converse, the question "What is it to be an expression of *x's F*?" is logically prior to the question "What is it for a person *x* to express his *F*?" I believe, further, that once the former question is answered, the answer to the latter will be relatively obvious.

A CERTAIN notion regarding the relation between an expression and what is expressed has exerted a powerful influence on the imaginations of recent philosophers. The influence has been upon their imaginations, rather than their thought, for it is rarely possible to find the notion clearly and unambiguously stated; I can find it nowhere elaborated and argued for. It has two parts: (1) that expressions are signs (sometimes "symptoms") of what they express, and (2) that

these signs are in some manner causally connected with what they express and belong therefore to a category sometimes called "natural signs." Here are Ogden and Richards introducing the idea with respect merely to verbal expression:

> Besides symbolizing a reference, our words also are signs of emotions, attitudes, moods, the temper, interest or set of the mind in which the references occur. They are signs in this fashion because they are grouped with these attitudes and interests in certain looser and tighter contexts. Thus, in speaking a sentence we are giving rise to, as in hearing it we are confronted by, at least two sign-situations. One is interpreted from symbols to reference and so to referent; the other is interpreted from verbal signs to the attitude, mood, interest, purpose, desire, and so forth of the speaker, and thence to the situation, circumstances and conditions in which the utterance is made.
>
> The first of these is a symbol situation as this has been described above, the second is merely a verbal sign-situation like the sign-situations involved in all ordinary perception, weather prediction, etc.[4]

Here is Susanne Langer describing the sort of sign which Ogden and Richards refer to at the end of the preceding passage:

> A sign indicates the existence—past, present, or future—of a thing, event, or condition. Wet streets are a sign that it has rained. A patter on the roof is a sign that it is raining. A fall of the barometer or a ring round the moon is a sign that it is going to rain. In an unirrigated place, abundant verdure is a sign that it often rains there. A

[4] C. K. Ogden and I. A. Richards, *The Meaning of Meaning*, 8th ed. (New York: Harcourt, Brace, 1956), pp. 223-224.

smell of smoke signifies the presence of fire. A scar is a sign of a past accident. Dawn is a herald of sunrise. Sleekness is a sign of frequent and plentiful food.

All the examples here adduced are *natural signs*. A natural sign is a part of a greater event, or of a complex condition, and to an experienced observer it signifies the rest of that situation of which it is a notable feature. It is a *symptom* of a state of affairs.[5]

In a later work Mrs. Langer indicates that this notion applies to expressions of all sorts:

A work of art is often a spontaneous expression of feeling, i.e., a symptom of the artist's state of mind. . . . And besides all these things it is sure to express the unconscious wishes and nightmares of its author. All these things may be found in museums and galleries if we choose to note them.

But they may also be found in wastebaskets and in the margins of schoolbooks. This does not mean that someone has discarded a work of art, or produced one when he was bored with long division. It merely means that all drawings, utterances, gestures, or personal records of any sort express feelings, beliefs, social conditions, and interesting neuroses; "expression" in any of these senses is not peculiar to art, and consequently is not what makes for artistic value.[6]

Monroe Beardsley makes use of these basic ideas while adding complications of his own. He appears to agree that common expressions like grimaces and gestures are (or are very much like) "natural signs" in that they are the effects of

[5] Susanne K. Langer, *Philosophy in a New Key*, 3rd ed. (Cambridge, Mass.: Harvard University Press, 1963), p. 57.
[6] Susanne K. Langer, *Feeling and Form* (New York: Scribner's, 1953), pp. 25-26.

188

what they express. He is skeptical that art works can be expressions like grimaces and gestures, however, precisely because it seems impossible to *establish* the sort of connection between an art work and what it (allegedly) expresses that does obtain between common sorts of expressions and what they express.[7] Beardsley's scepticism is ill-founded. It is based upon the unanalyzed conception of an expression as a sign, which is also an effect, of what it expresses. In the following extended argument I shall show that although there are sound intuitions behind such a conception, the uncritical assumption that expressions are essentially like other so-called natural signs in being the "natural effects" of what they signify is false.

THE inclination to include expressions in the general category of natural signs is understandable because some expressions are indeed signs of what they express. For example, Tom's anger may be expressed in a momentary flash of his eyes or in a slight hardening of his face. If he brings his anger under control or disguises it quickly, or if he is simply not very angry, these might be his only expressions of anger. Tom can be described as having showed a *sign* of anger.

Take another example. Professor Alphonse is known to have a generally hostile attitude toward Professor Beauregarde for a variety of reasons: envy, personality incompatibility, disagreements on policy, etc. In a department meeting Professor Alphonse allows himself only one expression of hostility towards Professor Beauregarde. That is the mildly sarcastic reference to the latter's pattern of dispensing high grades to his students. This remark, we might say, was the only *sign* of Alphonse's hostility which was evident at the meeting.

Suppose now that Professor Beauregarde has some reason

[7] Beardsley, *Aesthetics,* pp. 315-337, *passim.*

to expect to be elected chairman of the department even though he knows that there is another leading contender for the position. When he is notified that he has not been elected, his only expression of disappointment is a momentary falling of his face. He quickly brightens, however, as he congratulates the new chairman. In this case, the term "sign" could be as appropriately used as "expression," to designate the professor's facial change.

Consider this final example. A teacher of art history is lecturing on Ingres and is comparing the classicism of the latter with the romanticism of the contemporary Delacroix. "Nevertheless," he says, "even Ingres expressed in his work something of an interest in the exotic and alien common to the romanticism of his time. In particular there are signs of such an interest in his paintings and drawings of odalisques." In this context "sign" and "expression" can, with no discomfort, be used interchangeably. Clearly, it is not implausible to suppose that expressions are like common sorts of natural signs. But it does not follow from the fact that some expressions are signs of what they express that all expressions are such signs. And the latter is, in fact, false. In order to see this, let us consider some examples of expressions which parallel the ones given immediately above.

Suppose that Dick is more than just slightly angry and that he makes no effort to control himself. Suppose that he shouts and curses, grinds his teeth, kicks the dog, and smashes the china. Suppose, in short, that he expresses his anger in an especially violent and intemperate way. Are any of his acts, in this context, describable either separately or collectively as *signs* of anger? To so describe them would be grossly hyperbolic; and the hyperbole would in most contexts not even have a point. Were you to ask me, not having been present on the occasion of Dick's tantrum whether he showed any signs of anger, my response would

be something like "*Signs* of anger?! He flew into a towering rage!" The point is that to call *such* expressions of anger "signs of anger" would be to misrepresent what Dick did. One might, of course, say of Dick that he showed some signs of anger if one meant to be clever. Presumably, though, that is not what theorists of expression intend when they speak of expressions as signs.

Let us suppose that Professor Alphonse's hostility towards Professor Beauregarde is expressed throughout a long and uncomfortable meeting. Alphonse takes issue with everything that Beauregarde says in matters both great and small. Alphonse speaks to and about Beauregarde in the most sarcastic and abrasive of tones. Further, he continually whispers petty personal remarks to those near him concerning Beauregarde's choice of words and the color of his tie. In this case, too, it would be a considerable and pointless understatement to say that Alphonse showed *signs* of hostility to Beauregarde during the meeting.

For similar reasons, one does not say that Beauregarde showed *signs* of disappointment at not being elected chairman if he mopes about school for days, if he reproaches the members of the department for their lack of appreciation and recognition of his services and abilities, and if he pities himself aloud, rehearses how he had hoped and planned so long for his day of triumph. Here, too, the term "signs" has the wrong connotations as a straightforwardly descriptive term for Beauregarde's behavior.

The art history instructor, in his lecture on the Romantic interest in the exotic and alien, might use as his prime examples some of the works of Delacroix. Suppose that he says that this interest of Delacroix's receives its clearest and best expression in *The Death of Sardanapalus*. But the very features which could make that painting the clearest and best expression of such an interest are precisely what preclude

calling it a *sign* of that interest. Calling it a "sign" would suggest that the alien and exotic were present in a subdued, marginal, or otherwise unimportant way in the painting. Yet the whole "point" of the Sardanapalus painting is to portray richly and vividly an event itself so rich and vivid in its exoticism, namely, the self-ordered burning of an oriental potentate together with all his property, including wives and horses. The exoticism in the Delacroix is incomparably more striking than that in Ingres' odalisque works. In the latter the exotic element is little more than background and is used as a more or less plausible pretext for exhibiting the cool, classical qualities of line and form in the nude human body.

These four cases show that not all expressions are, in a straightforward way, signs of what they express. However, they do not show any clear-cut way of distinguishing a class of expressions which are signs from a class which are not signs. But they do suggest a "parameter" with respect to which expressions might be "measured" and by which they might be determined as more or less liable to be appropriately called "signs" of what they express. On the basis of the above two sets of examples of expressions it is easy enough to imagine four sets of expressions of anger, hostility, disappointment, and interest in the alien and exotic, respectively, each of which form a series with the expressions which are clearly signs at the beginning and those which are clearly not signs at the end of the series. The parameter according to which they would be arranged in the series I will label, for want of a standard term, *vividness*. The less "vivid" an expression is, the more likely it is to be appropriately labelled a sign of what it expresses. The more "vivid" an expression, the less likely it is to be such a sign.

192

OBVIOUSLY the notion of *vividness* needs some analysis. We should first try to see what vividness is not. First, vividness is not the same as, nor is it necessarily connected with, what might be called the "intensity" of what is expressed. Of course, "intensity" may refer to the way one sort of expressible compares to another. Thus the emotion of anger is, on some obvious scale, generally more "intense" than the mood of serenity. Yet both anger and serenity may have expressions which are vivid and some which are not. On the other hand, "intensity" may refer to the "magnitude" of a particular case of anger, or of serenity, measured against the scale of possible degrees of anger, or of serenity. Given this sense of "intensity," of course, one can expect that the greater the magnitude of what is expressed, the more vivid will be its expressions. But this connection does not necessarily hold. After all, a person who is very angry may control himself so well that mere suggestions of his anger escape him. In such a case the expressions of his (great) anger will be not very vivid at all.

Second, it might be supposed that what I have called "vividness" is a measure of the confidence with which one may infer from the expression to what is expressed. But this hypothesis surely is false. The degree of confidence which we are entitled to have concerning what emotion or attitude a person has, or whether he in fact does have it, is generally a function of what we know about the total situation in which an expression occurs and not simply a function of the expression by itself. Knowing the whole situation surrounding the election of a department chairman, we might know with utmost certainty, in the first set of examples above, that Professor Beauregarde was disappointed despite his not very vivid expression of it. It is equally clear that an actor on stage might act out an especially vivid expres-

sion of anger while the audience would have no reason at all for supposing that the *actor* is angry. What this means is that the "vividness" of an expression is determinable independently of the fact that it actually expresses something. Thus it is that a set of would-be expressions of F may be ranked with respect to vividness without the knowledge that they in fact express some person's actual F.

The vividness of expressions is in some interesting ways like the vividness of representations. A photographic print, for example, may be more or less vivid than another taken from the same negative. The less vivid print will show less of the subject, details of features will be missing, outlines will be indistinct. A related sort of vividness attaches to memory. I may be able to remember a visit to Venice more vividly than a visit to Bologna. And that would imply that I remember *in more detail* my visit to Venice than to Bologna. Such vividness, too, would be a function of the amount of detail in each image.[8] It was probably such a notion of vividness that David Hume had in mind when he spoke of impressions being more "vivid and lively" than ideas.

Vividness in representations is not a function of verisimilitude or accuracy, however. Paintings of fictional scenes like, e.g., Delacroix's *Liberty Leading the People*, may be more vivid than paintings of real ones, e.g. Benjamin West's *The Death of Wolfe*. Descriptive passages of incidents which never have occurred may be much more vivid than a newspaper account of, say, a fire which destroys hundreds of lives in an apartment building. Unlike the vividness of a photographic print or of a memory image, though, vividness in representational art is not always a function of the clarity

[8] This sort of vividness would presumably be measured, in turn, by the amount of detail one could, as it were, "read off" from one's image.

and detail with which the subjects are rendered. Thus West's classical and academic brushwork makes his painting, if anything, clearer with respect to minute details than Delacroix's. But Delacroix's work "captures" (see Chapter Four) the action, excitement, fervor, idealism, and violence of his mythicized revolutionary scene. West's picture, on the other hand, with its posed figures and stagey attitudes expresses nothing at all of its subject matter. The latter judgment, moreover, would not be overturned even if it were demonstrable that West's picture is a faithful record of General Wolfe's actual death scene, which, of course, it is not.

Similarly, it is not journalistic detail *per se* which makes a description vivid. A newspaper account of a fire might contain hundreds of details concerning, for example, the victims' biographies, the items of property destroyed, the amount of equipment called out to fight the blaze, etc. Yet if nothing of the excitement, horror, and tragedy of the disaster were "caught" in the description, it would not be a vivid one. By contrast, Thucydides' account of the defeat of the Athenians at Syracuse must count as one of the most vivid descriptions in Western literature. Especially in the description of the scene at the river Assinarus, Thucydides' reportorial style brings out the degradation of the Athenian rout and the completeness of the disaster, which was both military and spiritual. Here too the vividness of the account does not depend upon how accurately the scene is described. Indeed, it cannot, since we have no way of checking up here on Thucydides' accuracy. The vividness is rather a function of those "abstract" features of the scene which are "expressed" by Thucydides' writing.

Despite the different ways in which the idea of "vividness" applies to different sorts of representations, there is a significant common ingredient in them all: in general, the

more vivid a representation is the more features of its subject matter are "contained" in it.[9] We may now see a parallel between representational vividness and the vividness I claim to find in expressions of feelings, emotions, moods, attitudes, etc. In an expression of anger, for example, which is not very vivid, such as a flashing glance or hardening face, we may recognize only the sharpness or coldness, respectively, of the emotion. But in the shouts, curses, kickings, and smashings of Dick's anger we can recognize the turbulence, violence, brutality, and destructiveness of the anger. It hardly matters, of course, that we cannot distinguish in any clear way the violence from the brutality of either of these from the turbulence and destructiveness or that we cannot "point them out," as it were, separately. The significant fact is that a "fuller," that is to say, more elaborate, description of what is expressed is possible on the basis of Dick's more vivid expressions.

Similarly, Professor Alphonse's behavior in the first set of examples above shows nothing more than his antagonism towards Professor Beauregarde. But in the second set of examples his behavior allows us to call his hostility to Beauregarde bitter, aggressive, immoderate, persistent, unrelenting, savage. Likewise, Professor Beauregarde's fallen face alone shows hardly anything "about" his disappointment. But his elaborate behavior in the second example gives evidence of a sour, mean, complaining, and self-pitying disappointment. Finally, although Ingres' interest in the exotic shows itself in his odalisque works, only the casualness of that interest is evident there. In *The Death of Sardanapalus*, however, we see more than a bare "interest" in the exotic

[9] What differentiates the vividness of photographic prints, memories, mental images, paintings, and descriptions is the sort of "features" which are to be counted in the assessment of vividness. Of course the way in which these features are "contained" in the representation must also vary.

and alien. We can describe that interest further as a rich, intense, detailed, fascinated, passionate, and even sensual interest in the exotic.

It is misleading, of course, to say simply that a more vivid expression shows *more* of what is expressed than a less vivid one. For it makes no difference to the comparative vividness of, e.g., Ingres' works and Delacroix's painting, that there might simply have been no "more" to Ingres' interest in the exotic. To compare the Ingres and the Delacroix with respect to vividness is only to say that in the latter there is evident a more fully elaborated interest in the exotic than in the former. The implication of this fact is that the vividness of an expression of F does not depend upon whether the expression is an expression of somebody's actual F. This is possible, as I argued in Chapters One through Three, simply because F is evident "in" whatever *can* function as an expression of someone's F whether it *actually* so functions or not. In other words, vividness as a parameter with respect to which expressions may be compared pertains to what is evident in the expressions rather than to how those expressions relate to the (real) feelings, emotions, attitudes, moods, and/or personal and mental qualities which are expressed by means of them.

NOT ALL expressions of F, therefore, are signs of F. But it is also true that not all signs of F are expressions of F. In order to see that this is so let us consider some examples of signs which parallel the earlier sets of examples of expressions of anger, hostility, disappointment, and an interest in the alien and exotic. The examples, in order to be convincing, require some fairly elaborate stories.

(1) We know that Harry was reported in his youth to become angered very quickly and to show it in immoderate and violent ways. Being sensitive and intelligent, however,

197

he took it upon himself to find ways of correcting this fault. Over the years he learned that whenever he felt anger surging over him he could control it briefly until he had left the scene which occasioned his anger and was able to jog for a mile or two. This activity seemed, as it were, to flush the anger from his system. As he continued to practice this method of control, it began to have nearly miraculous effects. A person who did not know Harry's history would not be able to detect even the slightest anger in Harry's face or behavior when he calmly turned from a scene which in former years would have made him livid with rage and began to run down the street. To his friends and family, however, such behavior was a sure sign of Harry's anger, and they were careful not to stand in his way on such occasions.

(2) Suppose that before we really get to know Professor Alphonse we notice that he conceives apparently groundless antagonisms towards many people. He, of course, believes that his hostility is in each case justified by the stupidity, viciousness, deviousness, laziness, and/or incompetence of its object. But nothing he says and nothing we know convinces us that his hostilities are in fact justified. Gradually we learn that Alphonse is simply very assertive, that he has an unshakable conviction that he is always right, and that he is intolerant of persons who do not measure up to his idiosyncratic expectations, which he is wont to call "standards." Besides all of this, Professor Alphonse tends to be a bit paranoid. He is, in sum, downright cantankerous.

Even those who dislike Alphonse recognize him to be, despite these traits, an intelligent, efficient, and generally "capable" man. He is ultimately elevated to a top bureaucratic post in the university. The position is a "sensitive" one calling for great tact and diplomacy, and Alphonse's associates privately wonder how long he'll last at the job. But to

198

their surprise Alphonse performs excellently and soon has a reputation as a skilled diplomat.

Only his closest friends, however, know at what cost this turnabout has been effected. They know the tremendous effort which Alphonse has exerted to control his natural impulses. Most strangely, moreover, an itchy rash generally associated with nervous tension has reappeared on the skin of Alphonse's hands; it had been absent since Alphonse's infancy. The rash is not continuously troublesome to Alphonse, but people have noticed that it is in meetings with persons towards whom he is most antagonistic that the rash flares up and causes him to rub surreptitiously the itchy patches. His friends soon learn that there is no better sign of his hostile attitude towards a visitor in his office than for him to start rubbing the backs of his hands even though his face and behavior remain calm and amiable.

(3) Suppose, as in our earlier examples, Professor Beauregarde has been notified of his failure to gain the chairmanship of his department. But suppose that, unlike the last case, Beauregarde is too well-mannered and gracious to succumb to his great disappointment and that, unlike even the first case, he has himself so well under control that not a flicker of disappointment crosses his face. Rather, he immediately smiles and congratulates his successful opponent heartily. His colleagues remark among themselves later how well Beauregarde took what they knew to be a large disappointment. "Why, I detected no signs whatsoever of disappointment," says one. "I wonder if he really cared at all." "Oh, there was one," says another, who is Beauregarde's closest friend. "You noticed, didn't you, how he left rather soon after offering his congratulations, how he went to his office and closed the door?" The others agree that that behavior was not characteristic of the gregarious Beauregarde.

They agree as well about how complete a gentleman Beauregarde is to have quietly withdrawn rather than let any expression of his real disappointment escape him.

(4) Jane Brown is a spinster librarian. She lives her orderly, routinized, drab existence all alone. She is proper to the last degree, never doing anything "unseemly," as she would say. High collars and "sensible shoes" typify her style of dress. Her most interesting meal is a New England boiled dinner. The one "amusement" she allows herself is window shopping, which she does usually with her friend Millie. It is on these window tours that Millie notices an apparently anomalous fact about Jane. Jane will almost always linger over the exhibits in the offices of airlines like Air India, Air Japan, and Quantas with their displays of hookahs, kimonos, and boomerangs. It is not that Jane ever remarks about these things or even alters her stiff demeanor before them. Her straight expression never changes; she just stands in front of these displays a noticeably longer time than she does before other windows. Millie does not know what to make of this fact and she never mentions it to Jane.

Millie has wondered, and even worried, about the repressed and restricted life Jane leads but has never broached the subject to Jane. But one day Jane drops a comment which indicates to Millie that Jane feels some dissatisfaction with her drab life. "What you need, Jane, is to do something striking, something different from your ordinary pattern of life," advises Millie. Jane protests that she wouldn't have the slightest idea how to go about that or how to begin breaking up the pattern of her existence. Then Millie remembers the exhibits of exotica in the airlines' displays, and she suggests that the fact that Jane lingers over these exhibits seems to be a sign of an interest in things alien and exotic. Poor Jane! She had been so repressed that she had not even noticed this fact about herself until Millie brought

it up. But she sensed immediately when the thing was mentioned that Millie was reading the signs right. Millie then urged Jane to develop this interest, to get it out into the open. She might begin by learning to cook foreign meals, and perhaps later she could learn to paint and thereby discover some more than half-hidden fantasies about exotic times and places. "The important thing," Millie says, "is not to repress what is inside you; you must express these things. After all, there's no harm in it; a little interest in the exotic never hurt anybody."

What these stories give us are some examples of signs which are not expressions. In both the case of Harry and Professor Beauregarde the signs of anger and disappointment are signs precisely because of the conscious desire and deliberate effort not to *express* the respective emotions. In the case of Professor Alphonse's hostility, it is probably just Alphonse's heroic attempts *not* to express his wonted attitudes which has given rise to the outbreak of skin rash. Alphonse's hostility has been, as it were, channeled into a minor disease so that a flareup of the rash—necessitating the rubbing—functions as a kind of substitute for the expressions of hostility which he no longer permits himself. In the case of Jane Brown we see an attitude—interest in the exotic —which is so faint that it has no expressions. It has only signs, and only one of those. Millie could urge Jane to express her new found interest precisely because up to that point Jane's merely *indicated* interest had never before been expressed.

"Expression of x's F," thus, cannot *mean* the same as "sign of x's F." Nor are the terms coextensive. It is, nevertheless, natural to think of an expression as a sign of what it expresses. A reason for this is that expressions of x's F serve at least one important function in common with signs of x's

F. Both expressions and signs of *x*'s *F* can *show that F* is attributable to *x*. Tom's hardened face shows that he is angry; Dick's violent behavior shows that he is angry. Likewise, Harry's leaving the room and running a mile shows— to those who know his story—that Harry is angry. The odalisque paintings of Ingres, *The Death of Sardanapalus*, and the fact that Jane Brown looks longer at the airline exhibits all show that Ingres, Delacroix, and Jane respectively have an interest in the alien and exotic. The same holds for the signs and expressions of hostility and disappointment exemplified above, and for any other expressible *F*. With respect to the function of "showing that," therefore, both signs and expressions exhibit the same "logical behavior."

But an interesting and very significant feature distinguishes expressions of *x*'s *F* from mere signs of *x*'s *F*. Whereas Tom's hardened face shows his anger and the violent tantrum shows Dick's anger, the mile-long jog does not show Harry's anger. Similarly, although Professor Alphonse's single sarcastic remark as well as his unrelentingly hostile behavior during the department meeting both show his hostility, his surreptitious scratching of his skin rash does not. Likewise, Professor Beauregarde's merely retiring to his office after congratulating the victor does not show his disappointment. Nor does Jane Brown's merely looking longer at the airlines' exhibits show her interest in the exotic. In the last two cases it is important to heed the qualifier "merely," however. What the term indicates is that there were no other signs, which were also expressions, of Beauregarde's disappointment and of Jane's interest. For if Beauregarde had retired to his office in a dejected, crestfallen way, then his retiring, or his *way* of retiring, would have shown, as well as have expressed, his disappointment. Likewise, if Jane were to have looked at the exhibits wistfully, lovingly,

or even with an unusual light in her eyes, her looking (her look) would have shown, and also expressed, an interest in the exotic. On the other hand, Professor Beauregarde's fallen face as well as his complaining, bitter remarks clearly show his disappointment. Similarly, there are elements in the Ingres paintings which show the painter's interest in exotic things; and nearly everything about the Sardanapalus painting shows Delacroix's considerably more intense interest in the foreign and exotic.

In general, therefore, an expression of F shows F. As some reflection will discover, moreover, F shows in the expressions of F.[10] But signs of F which are not also expressions of F relate to the notion of "showing" in neither of these ways. Obviously the notion of "showing" stands in need of analysis. Chapter Eight will be occupied with such analysis. As that analysis proceeds, it will become even clearer how wide and how important is the gap between the expressions of F and its mere signs.

[10] It may occur to some readers that expressions of pain are exceptions to this general point. I may suddenly have a sharp, searing pain rip through my head and cry out in pain. In this case my cry clearly qualifies as an expression of pain. Does my cry show my pain? Does my pain show in my cry? Surely it is not the sharp, searing pain in my head which shows in my outcry. To say so would be to suggest that the kinaesthetically felt aspects of the pain—its sharpness, its searingness, its location—were, or at least could have been, *shown* in my cry of pain. But that is false. Still, it seems just to say that the pain (I was in) momentarily showed in my pained outcry. The solution of this dilemma lies, I think, in the recognition that the term "pain" has at least two important uses. On the one hand, it can designate a more or less complex painful sensation. On the other, it can designate a momentary or prolonged condition or state. The difference can be marked as the difference, respectively, between the pain one *has* and the pain one *is in*. In "an expression of pain" the term "pain" is used in the latter and not the former way. Therefore, expressions of pain do show the pain the expresser is *in*, but they do not show the pain the expresser *has*. Note also the difference between "His contorted face showed the great pain he was in" and "His contorted face showed the great pain in his toe." The latter is absurd.

BEFORE the implications of the notion of "showing" for the concept of expression are developed, we must discuss a special class of expressions which do not relate to "showing" in the way specified above. I shall call expressions of this sort *avowal expressions*. There are feelings, emotions, moods, and attitudes which one can express in linguistic formulas which have the grammatical form of an ascription of that feeling, emotion, mood, or attitude to the speaker. Thus saying something of the form "I am concerned that p" can express concern; saying something of the form "I am disappointed that p" can express disappointment; saying something of the form "I'm afraid that p" can express fear. Saying "I love you" can express love.

Of course, not just any utterance of a form of words of this sort would count as an expression of the respective feeling or attitude, even if the speaker actually had the feeling or attitude mentioned in the expression. To count as an expression, an utterance of this type must surely be meant as an expression. And a sign of its being so meant is its being delivered in a properly serious tone of voice and accompanied by properly serious demeanor. It is not necessary, however, that what is expressed by the form of words be also expressed in the demeanor, facial expression, or tone of voice of the speaker. Naturally, one *might* look, act, and sound quite different when one says (and means) "I love you" from when one says (and means) "I am concerned that old Sal is lost." On the other hand, the same serious look, behavior, or tone of voice *might* do as well for the genuine expression of love as for the genuine expression of disgust, when the form "It disgusts me that p" is used for the latter. In other words, in utterances of this sort what is expressed may or may not *show* in the look, behavior, and/or tone of the speaker, and yet the utterance may still count as an expression of it. Moreover, it is surely clear that what is expressed does not show in the words themselves. The form of words

"I love you" does not show love. Nor does the form of words "I am disgusted" show disgust. It is thus quite possible that in expressions of this sort what is expressed not be *shown* in the expressions. How can we understand this fact?

As I indicated earlier, expressions of the above sort are unique among the expressions we are considering in this chapter in that they have the grammatical form of declarative sentences descriptive of the speaker. By virtue of this form, moreover, such expressions are standardly used to *inform* others of the speaker's feelings, attitudes, states of mind, etc. Thus it is that by saying to Clemmie "I love you" I can express both my love for Clemmie and the *fact that* I love Clemmie. In this respect "avowal" expressions are more like statements like "I have a broken finger" than they are like howls of pain, joyful smiles, and sad faces. I can express the *fact that* I have broken a finger by saying "I have a broken finger," but I do not express the *facts that* I am in pain, I am joyful, and I am sad when I howl in pain, smile joyfully, and pull a sad face. And although my howl, smile, or grimace may inform you of my pain, joy, or sadness, I do not normally howl, smile, or grimace *in order to inform* you of my pain, joy, or sadness.[11]

It is interesting to note that some of the things which can be expressed seem to be expressible *only* by means of avowal

[11] When we choose these ways to inform someone of our *F*, our howls, smiles, or grimaces cannot count as expressions of *our F* even though they are expressions of *F*. To the extent that we deliberately contrive an expression of *F*, that expression is not an expression of *our F* no matter how truly *F* is attributable to us. This point will be elaborated in following chapters.

As I pointed out earlier, however, I am primarily interested in this chapter and the following ones with expressions of *x*'s *F*, not in the expressions of *F*. Naturally, much of what can truly be said of the former applies as well to the latter, for any expression of *x*'s *F* is an expression of *F*. Thus, for example, *F* shows in all the expressions of *F* (and the latter show the former) just as *x*'s *F* shows in all the expressions of *x*'s *F* (and the latter show the former). It is also true, incitentally, that *F* shows in the expressions of *x*'s *F* and that the latter show the former.

expressions. Desires and intentions are like that. Desires are characteristically expressed by sentences of the form "I want . . . ," "I would like . . . ;" intentions, by the forms "I intend to . . . ," "I am going to. . . ." There are, of course, *signs* of desires and intentions. Your saying "it would be wonderful to go to the fair again!" might be a sign that you want to go to the fair. It would not be an *expression* of your desire; it would certainly not *show* your desire to go to the fair.[12] It might, nevertheless, *show that* you want to go to the fair.

Similarly, a sign of your intention to quit your job might be your looking through the want-ad columns under "Employment Opportunities." But such activity neither expresses nor shows your intention despite the fact that it might *show that* you have that intention. There are, in fact, no expressions of desires or intentions which do *show* the desire or the intention. This statement does not hold, of course, when "desire" indicates passion or lust. My lust for Clemmie may show in my face as I watch her walk away from me down the hall if I have a lustful expression on my face.

It is also worth noting that frequently our intentions do show in our actions. I may declare my intentions often enough to get my manuscript in by the deadline. The fact that I arrange my affairs so as to have plenty of time for writing and the fact that I have actually started writing earnestly several times do *show* my intentions in this regard. Nevertheless, these facts are not *expressions* of my intention. The upshot of all this is that avowal expressions in crucial ways do not fit the pattern of "being an expression of" analysed in this chapter. My discussion of expression in the following chapters, therefore, will apply neither to avowal expressions nor to anything that can only be expressed by such expressions.

[12] Note however that, depending upon how you say it, it might show your *eagerness* to go to the fair.

206

chapter seven

Causation and Expression

∾

In arguing that to be an expression of x's F is not necessarily to be a sign of x's F, I have, I trust, uncovered some interesting features about expressions. But a major issue has still not really been settled, namely, whether an expression is a sort of natural sign. For it is still possible to maintain that in spite of the way the term "sign" is used with respect to expressions, an expression relates to what it expresses as a natural sign relates to what it signifies. In other words the "sign theory" of expressions can be construed as claiming, not that all expressions are (natural) signs, but that "being an expression of" can be understood on the model of "being a (natural) sign of." I shall examine this idea by comparing expressions with some examples of natural signs.

Contrary to the belief apparently held by philosophers who talk of natural signs, there are several quite diverse sorts of natural signs. The following list is representative:

(1) The clouds rolling in from the ocean are a sign of approaching rain.
(2) Croci in bloom are a sign of spring.
(3) Smoke is a sign of fire.
(4) Mouldering walls are a sign of excess dampness in the atmosphere.
(5) Pawprints in the butter are a sign of mice in the house.
(6) Coughing, congestion, and fever are signs of a cold.
(7) A shiny coat on a dog is a sign of health.

(8) Drying skin and graying hair are signs of the advent of middle age.

(9) A bright red color is a sign of freshness in meat.

(10) A slackened gait, drooping eyelids, and thickened speech are signs of fatigue.

As reflection will show, all of these signs share the characteristic of signs noted earlier. They all *show that* something is the case. Most of them, however, are unlike expressions in an important way. They do not *show* what they signify, and what they signify does not *show in* them. The clouds do not show the rain; the smoke does not show the fire; etc. This point holds clearly for (1) through (6). The following however, are acceptable uses of "show."

(7_1) A dog's health will show, among other ways, in his shiny coat.

(8_1) The advent of middle age shows in a person's drying skin and graying hair.

(9_1) The freshness of meat will show in its bright red color.

(10_1) A person's fatigue will often show in his slackened gait, drooping eyelids, and thickened speech.

On the other hand, while the following are not clearly *incorrect* uses of "show," they are somewhat awkward.

(7_2) A shiny coat on a dog shows his health (healthy condition?)

(8_2) Drying skin and graying hair show the advent of middle age.

(9_2) The bright red color of a piece of meat shows its freshness.

But considerably less awkward and quite correct is the following use of "show."

208

(10_2) John's slackened gait, drooping eyelids, and thickened speech showed his fatigue.

On the basis of these considerations, then, there is reason to think that expressions are indeed like the signs in (10) and probably like the signs in (7), (8), and (9). There are, however, further and rather clearcut differences between the latter signs and the signs in (10). Thus the following statement not only makes sense, it seems to be true.

(10_3) Fatigue in a person will often make (or cause) his eyelids (to) droop, his voice (to) thicken, his gait (to) slacken.

The following statements, however, seem to be false, because they each appear to identify as a cause of a phenomenon what it seems absurd to think of as its cause.

(7_3) The freshness of a piece of meat makes it (or causes it to be) a bright red color.

(8_3) A dog's health makes its coat glossy (or causes its coat to be glossy).

(9_3) Middle-age (or the state of being middle-aged) makes (or causes) a person's hair (to) turn gray and his skin (to) dry out.

Freshness, health, and middle-age, unlike fatigue, are not efficacious in the production of their signs; they are not thought of as *causes* of their signs. Furthermore, it seems to be more than an empirical fact that such causality does not obtain; it seems rather that what is signified in (7), (8), and (9) are not the sorts of things which characteristically *can be* causes. Of course an *account* of their respective signs can be given in terms of freshness, health, and middle-age. It is surely true, and it might be informative on occasion to say, that meat might be bright red *because of* its fresh-

ness, a dog's coat might be glossy *because* it is healthy, and a man's hair might be graying *because* he is middle-aged. But the current notion of "cause," unlike the notion of the ancient Greeks, does not center around the idea of "account" but rather around the idea of "efficacy." And so much is safely assertable despite the obscurity of the concept of "cause" and despite the tremendous diversity of the phenomena which fall under it.

Because a causal relationship exists, then, between fatigue and its signs, the relation between an expression and what it expresses is, at least provisionally, comparable only to this sort of natural sign relation. For the intuitions of philosophers who have insisted on the parallel between expressions and natural signs have a sound basis; there is no denying that a causal relation obtains between expressions and expressed. Our most natural uses of language commit us to a view of expression as fundamentally causal in nature. When we are angry our anger makes us do things we would not otherwise do or want to do: kick the dog, smash the china, scowl, growl, and curse. Our sadness affects our posture and the way we walk; it changes the way we see the day and our future and affects thereby the way we describe them. Moreover, we all admit that the qualities of our mind, of our imagination, affect what we write, paint, or compose. It is the brilliance and acuity of our minds, we know, that makes our theories brilliant and our arguments acute. Our sensitivities also affect what we say and do; our feeling for and sympathy with others will make our descriptions and characterizations in our novels sensitive and sympathetic. The bold and daring nature of a man is expected to cause him, if he is a sufficiently good architect, to conceive bold and daring structures. The gentleness and fragile sensibility of a poet will, quite likely, produce a gentleness and fragility in his verse.

210

CAUSATION AND EXPRESSION

Obviously, it is not the case that the term "cause" or its cognates will serve in every case and on every occasion to indicate the connection between expressions and what they express. But, equally clearly, terms like "make," "influence," "affect," "produce" are enough to establish that the connection is a causal one, even though they by no means show what sort of causal connection it is. For, contrary to what many philosophers appear to believe, calling a relationship "causal" is not necessarily to adopt solutions to all, or even the most significant philosophical problems surrounding the relationship. Rather, it simply raises the philosophical problem of determining the relevant meaning of "causal." Some recent philosophers, intuiting the causal nature of the expression relation, believe it sufficient to explicate this nature by reference to natural signs. As we have seen, though, there are many sorts of natural signs, and only one of them seems very much like expressions. Furthermore, considering the ambiguity of the term "cause," it is still obscure how the "natural signs" of fatigue are *caused* by what they signify. Thus, even once it is admitted that the expression relation is a causal one, nearly everything philosophical remains to be done.

In order to see how it is that an expression could be caused by what it expresses it is important to see that all expressions are reducible to a certain "essential form." They all belong to a single formally definable category. *Prima facie* this seems not to be the case. For although what we can call expressions seem to be always what we denominate by *nouns,* beyond that there is no similarity. Expressions may be as diverse as smiles, blushes, shakes of the fist, books, paintings, speeches, buildings, songs, gardens, theories, and clothes. However, as I argued earlier, it is precisely insofar as the above "things" are nominal ways of designating "acts" that

they are expressive in a way relevant to the present discussion.

A smile, a blush, a fist shake are expressive because the respective "acts" of smiling, blushing, and fist shaking are expressive. Correspondingly, it is, roughly speaking, the *writing* of that book, the *painting* of that painting, the *authoring* of that speech, the *designing* of that building, the *composing* of that song, the *planning* of that garden, the *conceiving* of that theory, the *wearing* of those clothes, or any acts subordinate to these, which make the "things" expressive. In other words, what is an expression of x's F must always be analyzable as "acts" of x.[1] And thus, although we say that smiles and gestures, poems, and paintings are expressions, we can also say that smiling, gesturing, treating (poetically), or handling (in a painting) are expressions.

We may thus refer to an expression in a nominal or a verbal way. But we may also refer to an expression in an adverbial way. Not only are x's smile and his smiling expressions of his sadness, but it is specifically his *way* of smiling which is an expression of, or which expresses, his sadness. Similarly, it is the *way* Wordsworth ends his poem which expresses his sentimentality, assuming he has sentimentality to express. Likewise, it is the *way* that Homer presents his characters that expresses (or could express) his affection for them.

Now ways of doing expressive "acts" can be described in

[1] I trust it is obvious that I am using "act" very broadly to cover anything a person can "do." Anything can count as an act which takes a verb form. Of course, there are a few cases of expression in which the *person* apparently does not do anything, e.g. when his *hands* tremble in fear or when his *eyes* gleam with joy. It surely is just an unimportant fact about the English language, however, that the subjects of the verbs "tremble" and "gleam" are the person's hands and eyes. One can easily imagine there being verbs which take the person as their subject but which *mean* that the person's hands tremble or that his eyes gleam. There is already one such verb, namely, "to blush" which means that one's face turns red.

different ways. For example, x's way of smiling, which is an expression of his sadness, may be described as "pale," "wan," "droopy," "sad," or any combination of these. Smiling in an ecstatic, happy way may express x's joy as well as can his joyful way of smiling. Kicking the dog viciously may serve as well as kicking it angrily as an expression of anger. In other words, the way of doing which is identifiable as an expression of F may be described anthropomorphically or not, and it may be described in terms of F or not.

But in spite of the fact that a "way of doing" which is an expression of F in a given case is describable in a number of different and equally acceptable ways, there is also an "essential" or "proper" way of describing those ways. If x's kicking a dog viciously is, in a given case, an expression of x's anger, it *must* also be the case that x kicked the dog *angrily*, even though, of course, one need not *describe* the kicking as angry. Similarly, x's smiling in a pale, wan, weak, and/or droopy way *must* also be a smiling in a sad way if his smiling is an expression of his sadness. And, analogously, if Ingres' odalisque paintings are expressions of his interest in the exotic and alien, there *must* be an artistic act of Ingres which is describable in terms of the phrase "interest in the exotic and alien." We might say of one of these paintings, for example, that despite his preoccupation with form and line, even the cool Ingres selected his subjects with an interest in the exotic and alien that is unmistakable if clearly less intense than that of his Romantic contemporaries.

On the whole, it is more difficult to come up with such a description of the "acts" expressive of the more complicated sorts of expressibles like "interest in the exotic and alien," simply because they do not all translate into simple adverbs, as Chapter Two made clear. It is just for that reason that I deliberately phrased my principle in relatively vague terms; all that is required of an "essential" or "proper" description

of an expression of F is that it be a "way of doing" described *in terms of F* or a grammatical cognate of it. It should be clear that no matter how complex x's F is, and no matter how complex its expression is, that is, no matter how complex the pattern of acts is which constitute the expression (see Chapter Two), it would always be possible to describe F's expressions in the following form: x's expressive acts, G, H, and I are done in such a way as to exhibit (or manifest or show) F. In fact, the latter form *could* even be used as a way, an admittedly prolix and crabbed way, of describing the essential way of doing anything which is expressive of F. Thus, for example, if x's sad smile expresses his sadness, it is true that x's smiling is done in such a way as to show sadness.

Generally speaking, then, all ways of doing which are expressive of x's F are, in principle, describable in terms of F. Moreover, there is reason to think of such descriptions as more proper or basic or essential than other descriptions of expressive "acts." Consider that while we can say that *in general* or *for the most part* or *frequently* pale, droopy smiles are expressions of sadness, we can say that sad smiles are *always* expressions of sadness. (I do not say that they are always expressions of the smiler's sadness, of course, for the sad smile may be, for any number of reasons, a fake. But a fake sad smile is still an expression of sadness. What one does, indeed, when one wants to fake sadness is precisely to fake expressions of sadness.) Note now that "sad smiles are always expressions of sadness (whether genuine or fake)" is a true statement whereas "pale, droopy smiles are always expressions of sadness (genuine or fake)" and "sad smiles are always expressions of grief (genuine or fake)" are probably false. This fact alone is accountable by the facts (1) that not all pale, droopy smiles are sad smiles and (2) not all sadness is the sadness of grief. But notice that we *know*

that the first statement is true despite the fact that we are not acquainted with all sad smiles.

The reason is that there is an element of necessity about the statement. The necessity does not lie in the connection between smiles and expressions of sadness, which is neither constant nor necessary, nor in the connection between smiles and expressions (of anything), which *may* be necessary but would not account for the fact that "gay smiles are expressions of sadness" is false. The root of the necessity lies in the fact that what is expressed is intimately related to the description of the expression. We may generalize this fact as follows. It is a sufficient condition for an "act" (or a set of "acts")[2] to be an expression of F that it be correctly describable in terms of F. I have already argued that the latter is also a *necessary* condition of the former. Note, however, that while it is a necessary condition of x's act G being an expression of x's F that G be correctly describable in terms of F, the latter is not a sufficient condition of the former.

Thus any expression, G, of x's F has an "essentially expressive description" or a "properly expressive description" which is just any description of G in terms of F. Anything at all which can ordinarily be called an expression of x's F is so-called in virtue of some sort of connection with a so-described way of "acting." If, then, x's F is in some way a "cause" of the expressions of that F, as I have argued it is, it would be sufficient that F be such a cause only of what are most properly and essentially described as the expressions of that F. Strictly speaking, in other words, F need cause x only to do something in a particularly describable way. But, of course, to cause x to do a thing in a certain way is not necessarily the same as causing x to do that thing.

[2] This provision is necessary because of those complicated "subjective factors" discussed in Chapter Two.

Nor is causing x to do a thing in a certain way necessarily causing x to do that thing in a certain way under every description of that way.

This point is extremely important, for it means that it is quite possible to hold both that x's F is the cause of F's expressions and that x's "acts," which are expressive of x's F, are either caused by something other than F or are not *caused* at all. Thus, for example, it is surely true that the dilation of blood vessels at the body surface causes the face to redden when it reddens with anger. But the dilation is not the specific cause of the face reddening *with anger*, i.e. of the expression of anger. Similarly, while one might walk behind a coffin because funerary ritual dictates it, one might walk *sadly* behind a coffin because one is genuinely sad. In this sort of case, then, the way one walks expresses one's sadness. Again, Ingres' selection of the subjects of his odalisque works both with an eye to the opportunities they afforded for painting the human form and with unmistakable if casual interest in the exotic and alien must be explained in virtue of two distinct "causes"—one for each description of his selection. He both *desired* to paint human forms and he had an *interest* in the exotic and alien.

It is important to notice that it makes no difference to my point here whether or not Ingres' desire or the dictates of funerary ritual are conceived as *causes*, respectively, of Ingres' selecting what he did or of the person's walking where he does. The fact that funerary ritual specifies that he walk behind the coffin may well be merely a *reason* for, but not a cause of, his walking where he does. It is plausible to think that Ingres' desire in the above case is neither a reason nor a cause of his selection of subject matter. One might want simply to say, quite agnostically, that Ingres' desire is merely what one appeals to as an *explanation* of Ingres' selection. In any case, my point is quite independent of the outcome

of the philosophical controversies concerning whether all reasons are causes, whether all human acts are caused, and whether all explanations of actions are given in terms of causes, or of reasons. The crucial point is simply that if F is a "cause" of its expressions, the notion of "expression" itself dictates *only* that F be the "cause" of a way of "acting" insofar as it is described in terms of F.

Once the distinctions are made between an act and the way it is done and the ways that way can be described, and once it is recognized that all of them, as well as the "product" of the act, are often designated "expressions," some of the puzzles engendered by this flexible use of "expression" disappear. In particular, one is no longer tempted to believe that if a painting, poem, or sonata is an expression of its creator or of something about him, it cannot be the result of anything else such as skill, deliberate effort, training, tradition, etc. And one is also not impelled to reject the possibility that art works are expressions because of the obvious fact that such works *are* the products of skill, effort, training, and tradition. On the other hand, accepting the possibility that works of art, as well as other cultural and intellectual "works," may be expressions does not entail the belief that they must also be, from the point of view of traditions, techniques, or the availability of materials, purely gratuitous occurrences. Nevertheless, it cannot be too strongly underscored that insofar as the "essentially expressive" way in which an artistic act—or an "act" of any other sort—is done, even though it appears to be an expression of some person's F, is in reality either an effect or a product, or a consequence, or a result of something other than F, or if it is simply "due to" or "explainable by" something other than F,[3] it is not, and cannot be, an expression of that person's F. I shall try to support this claim in the following section.

[3] Important exceptions are discussed later.

CAUSATION AND EXPRESSION

THE PRINCIPLE enunciated immediately above is obviously true in cases in which something is done in a way which is expressive of F but in which it is so done solely to pretend or to imitate. Thus, if I am feigning anger or am aping someone else's anger I may frown angrily. The anger in my frown is explainable by my desire to pretend or to imitate as well as by my deliberate contorting of my face into a certain configuration. It is not due to my anger for the good reason that I am not angry. The situation is no different in cases of acting out anger on a stage and "trying on" an angry expression.

Analogous cases in the arts also occur. We may think that Giotto portrayed the figures in his Madonna and Child panel in the Uffizi in a relatively aloof and austere way compared to the way Raphael, say, was to paint them. Nevertheless, it is a plausible and, I believe, accepted reason for his so doing that he was trained by painters in the Byzantine tradition, in which such a way of painting the Mother and Child was the conventional and indeed the only acceptable way of painting them. One does not know whether Giotto was, in fact, an austere and aloof person. Evidence from his frescoes at Assisi and Padua might lead one to believe that he was not. But it is at least quite possible that he was not. And in that case his way of painting the Madonna and Child would not express Giotto's own aloofness and austerity, for it is the product of something other than such traits in Giotto himself.

But there are more interesting sorts of cases which demonstrate the principle more clearly. These are cases in which (1) F is truly attributable to a person x, (2) x does something in a way that is everything that an expression of x's F ought to be except that (3) it is not the effect of x's F but (4) is the "effect" of something else. Cases of this sort are not, however, as plentiful as blackberries; nor are they as common. The following cases, therefore, are mostly con-

cocted and even bizarre. They nevertheless illustrate that expression fails to occur when the (would-be) expressions come from something other than the (would-be) expressed.

(A) Sadie Murgatroyd has in middle age arrived in the upper ranks of the upper middle class. She is the wife of a Vice-president of a Company and has the means to dress well and expensively. Her personality, however, betrays her lower class origins; she still has her former moroseness, rigidity of attitude, and bluntness of mind. Not surprisingly, moreover, Sadie is rather less than more intelligent, and she is unperceptive concerning others and herself. The trappings of success have even convinced her that she has acquired a refined mind and an open and genial personality. But, as a matter of fact, the only "qualities" that she has acquired are arrogance and pretentiousness. These eventually lead her to hire a couturier to "create" some special items for her which will "express," as she puts it, "her very own personality."

The couturier perceives the real Sadie at once and feels he would be doing her a disservice to outfit her in accordance with her own idea of herself. Not cruelly, then, but merely honestly, he designs for Sadie a wardrobe reflecting just those qualities he detects in her: moroseness, rigidity, bluntness. The wardrobe is replete with square shoulders, graceless skirts, informal and rough-textured materials in dull, earthy colors and obvious checks and plaids. Sadie, of course, is delighted, seeing in her new wardrobe precisely those qualities she sees in herself.

The question is: Is Sadie expressing her own nature by dressing in this dull, rigid, blunt way? She is clearly not expressing the personal qualities she believes she has, for (1) she is incorrect in this belief, and (2) her new clothes could not express *such* a personality in any case. However, Sadie is not expressing her actual personal traits either—

219

though not for the reason that she is unaware of her true personality. For the case would be quite different if Sadie had *selected* for herself ready-made clothes of a similar description under the impression that, by dressing in such a way, she would express her traits of refinement and geniality. In such circumstances, Sadie's dressing in what is, in fact, a dull, rigid, and obvious way would be an expression of her true personality. For we could think that it was precisely Sadie's personal traits which led her to choose just the clothes which match her personality so well. But in the case we have here constructed, although there is a "match" between Sadie's clothes and her personality, Sadie is not responsible for that match. Therefore, it cannot be that Sadie's personal qualities influenced her to dress as she does. She dresses as she does simply because the designer made her clothes like that. And that there exists a "match" between her and her clothes is a result solely of the *designer's* insight and skill and honesty.

Now there might have been a case of expression here if some of the important facts were altered. If, for example, Sadie were well aware of her actual qualities, if she were satisfied with herself that way, and if, after seeing the wardrobe, agreed that it was just as she had ordered, then we might comfortably admit that she was expressing her personality in dressing in those clothes. For in this situation, the couturier would simply act as an "instrument" of Sadie's. He would function, in the absence of any designing ability of Sadie's, as a means by which she is able to dress so as to match her personality.

(B) Suppose that the mad scientist B. S. Skimmer, famous for his work on the human emotions, believes that he has discovered the physiological and neurological principles of the emotion of anger in human beings. Such a discovery allows him, he thinks, not only to predict precisely what

expressions of anger a given person will manifest in a given situation but also, by means of an elaborate electronic apparatus hooked up to the brain, to cause such a person to produce, as if he were a robot, his characteristic and appropriate expressions of anger for any given situation. In order to demonstrate this discovery to his skeptical colleagues, Skimmer devises the following ghoulish exhibition using as his experimental subject G.S., one of his beginning graduate students.

A significant feature of the exhibition is that G.S. does not know much at all concerning the demonstration or about Skimmer's discovery. G.S. is first rendered unconscious by means of a drug which allows him to regain consciousness for intervals of three minutes at intervals of thirteen minutes. In addition, G.S. is administered a potion which will make most of his muscles, including those of his face, unusable to G.S. for the duration of the demonstration. The demonstration begins with G.S. prone on a table and secured to it with bands across his torso. After five minutes the spectators are surprised to see G.S.'s eyes blink and, after a few moments, his arms begin to flail, and his legs to kick. A scowl comes to his face, and he begins to shout angrily for his release. Finally he starts to curse and denounce poor Dr. Skimmer for deceiving and humiliating him. He then apparently lapses into a coma.

The spectators are even more surprised when, five minutes later, precisely the same thing occurs. The "performance" is repeated six times in all, after which G.S. is taken unconscious back to a comfortable bed in an attractive room where he eventually awakes and answers the questions of the persons who had watched the demonstration. G.S. reports that he awoke three times on the table in the demonstration room. The first time he was extremely confused and puzzled to find himself there. But what was most confusing

and puzzling was that he seemed to have no control over himself. Rather, it was as if his body and face were being moved for him in incoherent ways and he "found" his mouth moving and emitting loud, violent words. The second time he awoke, however, he was merely angry. He could no longer feel the restraints on his own movements. He shouted for help and said some unkind things about Dr. Skimmer, which he deeply regrets. The third time he awoke, however, was extremely weird, and he began to be afraid. For not only did he feel powerless and feel that his body was being moved "for him," but he could also recognize that "he" was acting in precisely the way he had actually acted the time before when he had regained consciousness.

At G.S.'s report Skimmer's colleagues are understandably impressed, for what the demonstration had showed was that Skimmer's techniques had enabled him to "match" a set of expressions of an emotion with an emotion. There is no question, of course, of G.S. actually expressing his anger the second time he awoke. He did not. For it was clearly not the case that the anger of G.S. affected what he did on the table or caused him to utter those things. It is, rather, mad Skimmer's machine which makes G.S. do what he does all six times. That there was no felt "gap" between the emotion and the "expression" thus artificially produced attests not to the genuineness of G.S.'s "expressions," but to the cleverness of Dr. Skimmer.

It is interesting to note, moreover, that the case would not be essentially different if Skimmer had himself volunteered to serve as the subject of the demonstration. (The main difference would be that the demonstration would have been considerably less convincing to his skeptical colleagues.) In other words, it would not be sufficient for Skimmer to have discovered the principles and devised the apparatus for it to be a genuine case of *his* expressing his

own anger. For even in that case *he* would not be gesturing and shouting. It would still be simply that his muscles were being moved for him in just the "right" ways.

(C) Annie Limburger, having just completed an Aesthetics Course in University Extension, now realizes that she, like many artists, is troubled by great and burdensome feelings. She has convinced herself that for the sake of the health of her own soul she ought to express her pent-up feelings in poetry. Fortunately for Annie, McClutz Bros. has recently put on the market their poetry-by-feeling kits, hoping to match the earlier success of the paint-by-numbers kits of another firm. The kits are just what Annie needs. For by simply knowing what feeling one has with all its nuances and specifications one can look that feeling up in the Master Feeling Chart, and next to the entry will be a verse.

Feeling chart ready, Annie waits for her next feeling and, when her pet poodle dies, she has an opportunity to try the kit out. She finds the entries (1) sorrow-intense, (2) sorrow-intense-death, (3) sorrow-intense-death-pet dog, (4) sorrow-intense-death-pet dog-sole companion; and she writes down in order the corresponding verses. Annie is quite pleased with her sad poem and forthwith feels relieved of her feeling. Actually, the poem is, by whatever miracle, quite a fine little poem—poignant, true, and touching. Perhaps it is the only interesting piece that could be generated by the wretched chart. Yet we cannot imagine, as Annie does, that she has expressed her sorrow in the poem. Annie simply did not write this poem and therefore did nothing *sadly* in writing the poem. Either the poem she wrote down simply came together in that way, as a sort of accident, or it was in reality written in that way by someone other than Annie. In either case, the sadness in the poem was not a result of Annie's sorrow no matter how clearly she, and we, might recognize the very quality of her sorrow in it.

223

(D) A case with interesting differences from Annie's is that of Interior Decorator Zelda Mutz. Zelda has always been known in the trade as an eccentric, and not the smallest of her eccentricities is her famous Mood Chart, which she devised at the start of her career and which she has kept up to date. It consists of a vast list of moods, carefully described and discriminated, correlated with detailed descriptions of a series of rooms. The rooms are listed with respect to function, e.g. bedrooms, ballrooms, etc., as well as to style, e.g. Directoire, Eclectic Traditional, Pop, etc.

With the marriage of her youngest daughter Zelda feels the burdens of motherhood lifted from her. This, together with her recent election as President of the local professional association, causes her to feel a new freedom and breezy self-confidence, and she resolves to express this new mood of hers by redecorating her parlor. When she gets a moment's freedom from her busy schedule, therefore, Zelda sits down with the Mood Chart and, without a moment's hesitation, turns to the right page, runs her finger down to "middle-aged freedom (female)" and "renewed confidence in work," across to "parlor" in the "room" column and over to "Laguna Beach Artiste" in the "style" column. She immediately telephones her orders in to various supply houses and soon her parlor is complete. Zelda is thoroughly satisfied with it, especially when her friends tell her that they can see the new Zelda in the decor.

The essential difference between Zelda's case and Annie's is that Zelda is a moderately clever craftswoman who devised her own chart, while Annie has no claim to talent or skill in writing poetry and used a ready-made chart. What is common to both cases is that the feeling in the one and the mood in the other are both "matched" by their would-be expressions. But does Zelda express her mood by decorating her parlor any more than Annie expresses her feeling by

writing down the verses? It is certainly less clear that she does not. After all, it *is* Zelda's own chart. On the other hand, she devised that chart so many years ago, when she was so different, and certainly when she was not *in* the mood which she has just (allegedly) expressed. Was anything more "going on," after all, when she decorated her own room than goes on when she uses the chart to decorate a client's room? Surely not. She seems to have had the same relationship to her own mood in this instance as Sadie Murgatroyd's couturier had to Sadie's personality. She stood over against it as if it were some "object" which she then had to "match" in a medium.

What appears especially odd about Zelda's story is that a person with Zelda's talent and experience, who was in that sort of mood, should have *needed* to "look up" her decorating directions in a chart—her own or anyone else's. Would it not simply *happen* that Zelda's mood would be expressed in her decorating scheme, given her admitted ability to capture moods in interiors? But if it would just have happened anyway that Zelda's parlor look as it does when redecorated, then all that Zelda had to do was pick up the telephone and order what she did without first consulting the chart. Consulting the chart was a redundancy, done out of habit, but having no effect on the outcome of the room.

If, on the other hand, we assume that Zelda would not have been able in this case to express her mood in her redecoration job without using her chart as she did, she cannot have expressed her mood in her new parlor any more than Annie Limburger expressed her sorrow in the poem. For in that case it would be owing solely to the excellence of the Mood Chart and her ability to *describe* her own mood that the characteristics of the mood were "matched" in the parlor decor. She would be in a position rather like B. S. Skimmer's were *he* the subject of his own demonstration.

The "behavior" he would evince on the table would be, not the effect of his anger, but the result of his own ability to predict his behavior together with his own ingenious apparatus.

We cannot, in other words, decide whether or not Zelda's mood was expressed in the decorating of her parlor. But what Zelda's case at least shows is (1) that if she did not need the chart, she *did* express herself, and (2) if she required the chart, her mood alone was ineffective and therefore that the new parlor did *not* express her mood. We know this because we know *a priori* what "being an expression of" involves, namely, that expressions must be the effect of the expressed and not of something else. This principle can be demonstrated by yet another case which raises an issue similar to the one raised in Zelda's story.

(E) Professor Clementi is a whiner and indulges in self-pity. Thus when he is informed that he was not elected chairman of the department, everyone expects him to show his disappointment by much complaining and lamenting. But instead he gives no indication that he is disappointed. He simply looks at his colleagues calmly while they all wait for an emotional scene. Then he begins, in matter-of-fact tones to relate a scenario, as it were, with himself as the leading man, which describes what he is going to do on account of his disappointment. He tells how his face is going to fall, how he will slap his right hand with his left fist, how he will curse his successful rival (giving exact words), how he will rehearse in whining tones what had been his plans for developing the department. When he is finished, he begins, to the astonishment of all, to do all that he said he would do just as he described it. His "performance" is just the sort of thing his colleagues expected, knowing the situation and Clementi's character.

Is what Professor Clementi does an expression of his dis-

appointment? Given the situation as described, we simply cannot say. Suppose, however, we add to the above that as Clementi begins to relate his "scenario," his eyes glaze and his voice takes on a tone of trance-like vagueness with just a hint of mocking sarcasm in it. And suppose, further, that ever after that day Clementi is "different." It is not that his basic character and personality change; he is just a bit distracted, distant, and pensive in a way that he did not used to be. In such circumstances we might be inclined to explain the bizarre occurrence described in the preceding paragraph as some sort of "crossing of the wires," a momentary aberration both psychical and neurological. The aberration need not be a "meaningless" one, however. It might signify some sudden, blindingly clear "realization" of what sort of person he was before he "tragically," as it were, gave expression to his feelings.

(F) But now let us subtract the trace of vagueness and hint of sarcasm in Professor Clementi's voice, as well as the changes in Clementi himself, from the hypothesized situation. Let us add, instead, that Clementi was asked to explain his odd behavior and that he says, even more oddly, "Why, I simply *decided* to do those things and did them." The "scenario," we are given to believe, was a kind of announcement of his decision, and his behavior was the result of his decision. Professor Clementi avers, under further questioning, that this is the first time that he has ever acted in this admittedly characteristic way on the basis of such a decision.

We ask him then the crucial question, "Did you feel the disappointment which your behavior showed?" Suppose that he says "Of course I did; do you think that was just a phony act?" If we believe the implications of this remark, i.e. that his behavior was not faked, then we cannot believe him when he said he *decided* to do those things. His "scenario"

could not have been the report of a *decision*, for there could have been no "room," as it were, for such a decision between his disappointment and its expression. Suppose, on the other hand, that he answers, "Of course not; I simply *resolved* to act in that way and did it!" In that case, it is not his story which is unbelievable but his "expression" which is. There could not have been any disappointment— at least a disappointment commensurate to Professor Alphonse's behavior—which was "behind" that behavior. For, if there had been, the disappointment would have stood in no *need* of a decision in order for its expression to occur.

THE PRECEDING six stories further demonstrate the notion that x's expressive acts express x's F only if they are the "effects" of F. They also show that if an act—or, more precisely, the "essential" *way* in which it is done—can be explained in terms other than x's F, it is not an expression of x's F. We may apply this principle now to an area almost homely compared to the situations described in the preceding cases. We understand now why it is that a person who writes a scientific laboratory report, say, in an exact, unemotional, aloof way is not thereby expressing his own unemotional, aloof nature or the exactitude of his mind. This is so even if he is, in fact, exact, unemotional, and aloof. The reason is that his writing his reports in such a way can be explained by the fact that such a style is the canonical style for laboratory reports. He *must* write them in that way if he is to be a competent and disciplined scientist. And he writes them in that way because he is a good scientist, not because of his own affective and intellectual constitution. This holds even if it is true, as it might well be, that he was *attracted* to science precisely because of the "match" between the attitudes which it demanded as a discipline and the attitudes he was especially and naturally able to take.

It is germane at this point to mention that, as far as I understand his position, Richard Wollheim and I disagree radically on the point here being discussed. Wollheim holds to an "intentional notion of expression," which, I believe, is supposed to give an account of, among other things, "G being an expression of F" when F is x's F and x does G. He says ". . . smiling and scowling would be [under his concept] intentional verbs having as their aims the bringing about of something insofar as it fell under a certain description."[4] Presumably the same is to hold for any other expressive acts. This implies, I take it, that cases (D), (E), (F), and possibly (C) above would be decided differently by Wollheim. For in all of those cases there is some intentional act which aims to bring about something which falls under a certain description (of the sort Wollheim has in mind).

Wollheim comes to this position in the following way, if I follow him—and I am not at all sure that I do. It cannot be the case that G is an expression of x's F if G "just happens." Also, it must not be the case that G *necessarily* be an expression of x's F, even if, just as a matter of fact, it is such an expression. Therefore, we need a connection between F and G which is "tighter" than mere conjunction and "looser" than necessity. The intentional notion of expression fulfills this need by injecting the variable of x's seeing G as "matching" his F and bringing it about just because he does so see G.

There is no question that Wollheim's solution solves the problem as he presents it. However, this "dialectical" argument is Wollheim's only justification for his thesis, as far as I can tell. He totally ignores the "causal" ingredient in the notion of expression and thus he is not led into the con-

[4] Richard Wollheim, "Expression," in *Royal Institute of Philosophy Lectures*, Vol. I, 1966-1967: *The Human Agent* (New York: St. Martin's Press, 1968).

siderations which led me to pose cases (A) through (F) above.

Had Wollheim been aware of the causal aspects of expression, however, an obvious solution to his problem, different from his own, would have presented itself. Expressions of x's F do not, indeed, just happen; they are caused by F. And, of course, causation by no means implies a necessary relationship; x *need* not do G, even when G is necessarily an expression of F and F is truly attributable to x. This solution, moreover, has the additional virtue of being supported by independent intuitions concerning expression. Wollheim's solution not only does not have the latter advantage, it has the decided disadvantage of requiring us to believe in a great deal of mythical "mental work" which goes on between our feelings and even their most spontaneous expressions. Indeed, in his most recent statement, Wollheim hints that our perceptions of our own activities, our seeing them as matching our feelings, and our consequent pursuance of these activities in order finally to bring about an appropriate expression of them must be thought of as "inchoate or unconscious" "feedback."[5] But an appeal to anything that nebulous and elusive seems only to *guarantee* that we shall have no support for Wollheim's thesis other than the (inadequate) dialectical considerations mentioned.[6]

[5] Richard Wollheim, *Art and Its Objects*, p. 28.
[6] This critique of Wollheim assumes a rather straightforward interpretation of "intentional act." It might be possible, however, for Wollheim to develop a notion of unconscious intentions which operate on a "sub-personal" level and which are such as not to conflict with the causal account of expression I give. Compatibility could then be established between Wollheim's position and my own by construing these "unconscious" and "sub-personal" intentions as in some way conditions on or causes of x's F. As I shall argue in the next section, there would be no incompatibility between my causal account of expression and conceiving of *such* intentions as causing F's expressions under their properly expressive descriptions. Wollheim, however, does not develop his idea of "intentional" so that we do not know what his

As I indicated earlier, there are interesting exceptions to the principle that an "act" fails to be an expression of a particular person's *F* if the relevantly described way in which it is done is explainable in terms of anything other than *F* itself. Note the following schemata. In each, the third line can function as an answer to the questions in the first two lines. Yet in each set the first question requests an explanation of some act expressive of *F*, while the second question asks for an explanation of *F*.

(1) What is making Aloysius cry (so sadly)?
What has made Aloysius so sad?
The bad news he just got from Peoria.

(2) What made Belisarius act so angrily?
What made Belisarius so angry?
His son dented his third fender in a month.

(3) What makes Callie select such simple, obvious, and even naïve clothes to wear?
What accounts for Callie's simple, obvious, and even naïve nature?
She comes from an extremely unsophisticated, uncomplicated rural background.

(4) Why did Ingres' selection of his subject matters manifest some interest in the exotic and alien?
Why did even Ingres have some interest in things exotic and alien?
He was influenced by the fashions of his times.

These examples show that an expression may be explainable in terms of something other than what it expresses. Note, however, that what the expression is explained by is identical to what explains that which it expresses. We shall return to this point presently.

own intentions are in this matter. On the notion of intentions operating on sub-personal levels see D. C. Dennett, *Content and Consciousness* (London: Routledge and Kegan Paul, 1969).

First, though, it is interesting to point out further parallels between expressions and the signs of fatigue mentioned earlier. It should be obvious that cases could be concocted with respect to fatigue and its signs which are analogous to (A) through (F) in the preceding section. Moreover, those cases would illustrate an analogous principle: If the (alleged) signs of fatigue in a person have their origin in something other than the person's fatigue, the "signs" are not signs of the fatigue. Our intuition tells us that, with respect to signs of fatigue like slackening gait, dragging voice, and drooping eyes at least, nothing must "come between" the fatigue and its signs.[7] Furthermore, we can discover situations in which a sign of fatigue is explainable in precisely the same terms as the fatigue itself. The dog is slowing down (or he is tired) because he has been running for an hour without rest. My eyelids are drooping (or I am fatigued) because I have been up all night reading. The parallels between expressions in general and the "natural" signs of fatigue are close indeed.

Because of this close parallel we must look to the case of fatigue and its signs for a clue concerning the way in which what is expressed *causes* its expressions. Fortunately, enough is known about fatigue to allow us to do so. Fatigue is primarily a bodily condition which has some psychological manifestations. Therefore it is quite reasonable to suppose that the way in which fatigue "brings about" the signs listed earlier can be discovered by the physiology of fatigue. Even though the precise mechanisms and chemistry of fatigue are not fully known, it is known that the presence of

[7] This holds only for the signs of fatigue which *show* fatigue. One can imagine an experimental apparatus connected to a dog's muscles in such a way that a red light comes on when the dog is fatigued. The red light might be a serviceable *sign* of fatigue in such circumstances but the dog's fatigue could hardly be said to *show* in the red light coming on.

excess lactic acid in the blood hinders contraction of the muscles, and the muscles are thus unable to work as efficiently as before. Lactic acid begins to accumulate in the blood when the oxygen supply becomes insufficient, which occurs during fatigue. When the muscles work less efficiently, of course, they tend to relax. And when muscles in one's legs, eyelids, larynx, tongue, and lips relax, one's step slows, one's eyelids droop, and one speaks more slowly and unclearly. It appears, therefore, that what it *means* to say that fatigue causes its own natural signs to occur is that certain bodily conditions bring about certain visible changes in the activity in an organism. And considering the parallels between fatigue and those mental phenomena which are expressed, it is most reasonable to suppose that what is *meant* by saying that what is expressed causes its expressions is that certain bodily factors within the organism which are essentially connected with the expressed mental phenomenon bring about its expressions.[8]

There is nothing in such a supposition which necessarily conflicts with what has already been said concerning the causes and/or explanations of expressions. However, if there were such bodily factors which are causes of the expressions of some person's F, and are causes of these expressions specifically with respect to their "essential" descriptions as expressions, they must either be identical with x's F or be the causes or other explanatory conditions of his F. Otherwise, the principle would be violated that the ("proper") expressions of x's F must not be in any way caused or explained by anything other than x's F itself unless it is by that which causes and/or explains x's F. Notice that the physiological causes of the signs of fatigue meet

[8] "Bodily factors" is a term made deliberately vague so as to include any of the following, or any combination thereof: physical, chemical, neurological, and physiological actions, reactions, processes, functions, states, and conditions.

these requirements. For the buildup of lactic acid not only causes the mentioned bodily signs to occur, but it also is a contributing cause of the fatigue itself. What this requirement means, furthermore, is that whatever is identified as the bodily factor causing an expression of x's F must not be a cause simply of one (or one sort of) expression of that F. It must be a cause of all of them, just as the buildup of lactic acid ultimately brings about all of the signs of fatigue which show fatigue.

It cannot be argued on *a priori* grounds, I think, that there *cannot* be any such bodily factors which cause all the expressions of a given x's F. Despite (what I take to be) the fact that none have been discovered even for the simplest expressibles such as anger and sadness, it remains a possibility that such factors will be discovered, a possibility that will continue no doubt to inform research in fields such as psychobiology and psychiatry. On the other hand, the *likelihood* of such bodily factors being discovered which will explain such diverse phenomena as aspects of behavior, linguistic utterances, works of literature, painting, sculpture, and music must seem to most people extremely small. And the fact that no such factors have yet been uncovered may seem to confirm the opinion that there are none to be uncovered. This much, then, is true with respect to every expressible: There are no known bodily causes of all of its expressions, and there is a possibility that none such exist.

But if that is the case, then the supposition that the sort of causation involved between something expressed and its expressions is anything much like the sort of causation obtaining between the buildup of lactic acid in the blood and the signs of fatigue must be false. For if it is true that for everything that is expressed we do not know whether there is some bodily factor which causes and/or conditions it

which is also the cause of all its expressions, then on the above supposition we would not know whether the expressed is the cause of its expressions. But, as a matter of fact, we do know that everything which is expressed is the cause of its expressions. Thus while it is possible that for x's F there are no "bodily factors" which cause and/or condition it and which also cause F's expressions, it is not possible that x's F is not the cause of its expressions.

One might object that these considerations alone do not show that the above supposition is false. Might it not be that in cases where there are no such "bodily factors" conditioning x's F, x's F has no real expressions. Such a suggestion would imply that the term "expression of x's F" is only correctly applied to the relevantly described ways in which "acts" are done on the condition that they are all caused by bodily factors of the required sort. If such an implication held, then the suggested analysis of the sort of causation involved between expressed and expression would, of course, be tenable.

Unfortunately though, the implication entails the consequence that up to the present point of scientific progress and for sometime in the future, we have not and shall not know whether what we have called and will call expressions are truly such. This consequence is manifestly false and even borders on the absurd. For in an enormous number of instances we are able to acknowledge the existence of a particular F only on the basis of its expressions. Whether what appears to be an expression of x's F truly is such has been, and shall continue to be, determinable independently of whether they are caused or explained by some bodily factors which in turn cause, explain or condition what they express. It is not the case, therefore, that what *we mean* (and have meant for some time) by the expressions of x's F

235

being "caused" by x's F is that certain of x's bodily factors conditioning x's F cause all of F's expressions.[9]

I TRUST it is clear by now that I have no intention of denying that all the expressions of x's F are or could be caused in a purely physical, chemical, or physiological way by some features of an organism which are somehow essential to the existence of x's F. My claim is simply that one's intuition concerning the causal efficacy which x's F has on its expressions is not *analyzable* in terms of such sorts of causes. The task remains, then, to discover the sort of causation that is at work. But how shall we proceed?

We may get a clue by reminding ourselves of the following: (1) If G, H, and I are ("proper") expressions of x's F, then they are caused by F. (2) If G, H, and I are expressions of x's F, then they "show" x's F and it "shows" in them. Of course, it does not follow from (1) and (2), though it is suggested by them, that if we understood the sense of "show" in (2) then the sense of "cause" in (1) might become clear. The suggestion is strengthened by the fact that, just like the causal relation we are looking for, the "showing" relation obtains only between x's F and its expressions and does not obtain between any of the bodily causes, explanations and/or conditions of F and F's expressions.

Interestingly, this is also a fact about the relation between fatigue and the signs of fatigue mentioned above. One's fatigue shows in one's droopy eyes and slackening gait, but the buildup of lactic acid in the blood does not show therein.

[9] By underscoring "we mean" I do not mean to suggest a difference between what *is meant* and what *we mean*. For what we mean, in this case at least, *is* what is meant. I mean only to preclude any speculations about what talk about the causation between expressed and expressions "could" mean in some logical fairyland or fantastic tomorrowland. Conceivably in those places it "could" mean anything, including the suggested "thing." And possibly it will (or has).

236

Nor do the eyes and the gait show the buildup of lactic acid. They might show, however, *that* there is a buildup of lactic acid in the blood, if they are truly signs of fatigue. In other words, the signs of fatigue function with respect to the bodily factors essential to fatigue more as signs of F which are *not* expressions of F function with respect to F than as expressions of F do.

The same would hold, it should be clear, between the expressions of some person's F and any bodily causes or conditioning factors of F. And this means, incidentally, that the parallel between fatigue and expressed mental phenomena is still significantly close. For it may be that the causation between x's F and its expressions is indeed like that between fatigue and its signs, even though it clearly is not like that between the bodily conditions of fatigue and the signs of fatigue. Due to the way that "showing" functions with respect to fatigue and some of its signs, in other words, it may be that we must understand the causation between fatigue and those signs in the way that we understand the causation between x's F and its expressions. An investigation of the concept of "showing" in these contexts is therefore required.

chapter eight

Showing and Expressing

∾

The strategy of this chapter will be to bring forth a number of different uses of "show" in order to discover by comparison and contrast the way in which the concept functions with respect to expressions.

There is a common use of "show" according to which it means, roughly, "display." At agricultural fairs, for example, exhibits have become common in which the various stages of a chicken's development inside the egg is described and depicted in a sequence of display windows containing eggs at designated stages. In the penultimate display window are eggs just ready to hatch; some of them even hatch before one's eyes. Of such a display we can say that

(1) The penultimate window shows chickens pecking their shells open as they hatch.

But sometimes "show" is used to mean "unhidden" or "unobscured." For example, when visiting the fairgrounds, we might go to the Omash County canned vegetable and fruit display where, we understand, Mrs. MacDonald's canned beans are displayed. Unable to locate her beans, however, we notify Mrs. MacDonald. She notices that the beans had been moved out of place and were behind the beet section. In high dudgeon she goes off to rectify the blunder.

(2) "I've made sure my beans show now," she says, "I've set them in the very front row!"

238

Sometimes the term "show" is used in place of "demonstrate" or "prove." For example, despite the proud claims of his owner, I may be skeptical of the courage of Augie, the runty Beagle, until one day when he gives battle to a badger, refusing to run even though severely wounded. Later, when the badger has been frightened off, Augie's owner justifiably gloats to me,

(3) "That shows his pluck, doesn't it."

Finally, there are times when "shows" means "depicts," or, more generally, "represents." Thus, when showing an acquaintance through the family photo album, I may say

(4) "This one shows Aunt Penelope and Uncle Roger cutting the cake, and this one shows them setting sail for Europe on their wedding trip."

The way in which an expression of x's F shows F is not like any of the above. As has already been mentioned, not only do the expressions of x's F show F, but F shows in its expressions. Each of these two showing relations, moreover, appears to be the converse of the other. But none of the uses of "show" illustrated above works in this way; (1_1) through (4_1) below are not the *converses* of (1) through (4) even if they are implied by the latter.

(1_1) Chickens hatching show in the penultimate window.
(2_1) The Omash County display now shows Mrs. MacDonald's beans.
(3_1) Augie's courage showed in the battle with the badger.
(4_1) Aunt Penelope and Uncle Roger cutting their cake and setting sail show in the snapshots.

Of the above, (3_1) is problematic. That is because in one sense of "show"—a sense very much like the one used for expressions—Augie's courage did show in his battle with the badger. But in the sense of "show" meaning "prove" or

"demonstrate" (3_1) is incorrect English; the correct verb is "was shown."

Now there exists another use of "show" which indicates that what is expressed is not being hidden.

(5) Peter showed his irritation while Paul did not (Peter grumbled irritably and Paul was calm and silent).

Here "showed" means something like "revealed." We might also say that Peter's behavior showed his irritation, while Paul's betrayed not a trace of his. But the phrasing "Peter's irritation *showed in* his muttering comments" appears to go more happily with "while Paul's showed in his trembling hands and flushed face" than with "but Paul's was kept in check." In other words, the verb form "showed" to mean "revealed" demands an implicit or explicit contrast to what is "unrevealed." But the phrase "showed *in* G" seems to demand a contrast not with "unrevealed" but with "showed in H." Of course, the latter sort of contrast can also be made if "showed" is used alone, i.e. without the "in" phrase indicating a particular expressive act. For we can say "While Peter's violent behavior showed his anger, only Paul's frigid face showed his." In this case, there is no implicit or explicit contrast with what is unrevealed, for there is nothing unrevealed. The term "showed," therefore, is used in the latter sentence simply as a way of referring to the showing which is characteristic of expressions, *apart from any contrast to what is concealed, unrevealed, or kept hidden.* And it is, unlike the term "showed" in (5), the converse of "shows in."

Even apart from these grammatical points, however, it should be clear from the way in which the concept of "showing" was first introduced that its applicability to expressions is not confined to those contexts in which the revelation or concealment of what is expressed is an issue. Rather, the notion of "showing" serves to distinguish the

way in which an expression of x's F makes F evident from the way in which a mere sign of F makes it evident. Therefore, even in case (6) of "showing," which exhibits, in (6_1), the "right" grammatical conversion, there is no proper parallel with the "showing" relevant to expressions.

(6) Notice that in the second artist's proof the small trees in the lower left show whereas in the first proof they do not.

(6_1) The second proof shows the small trees in the lower left whereas the first does not.

In (6), of course, the contrast is between what is visible and what is obscured. And that this sort of context is a necessary condition of the use of "show" exemplified by (6) and (6_1) is proved by the fact that it is not appropriate to speak in every context of any and all details and/or parts of a picture as "showing." What point, after all, would there be in simply noting of, say, Titian's *L'homme au Gant* that the young man's eyes and nose *show* in the portrait unless the possibility of their being, say, covered over or eroded away were a point of discussion?

The meaning of "to show" which we are seeking and which is universally applicable to all expressions is, therefore, not the same as "to display," "to reveal," "to represent," "to prove," "to be unhidden," or "to be unobscured." Rather, we must gloss "to show" roughly in terms of "to be evident" and "to be apparent" and "to be manifest." Thus when anger *shows* in my face and my behavior it is *evident* or *apparent* therein. When my face and behavior *show* my anger, they *manifest* my anger. Note that my expressions of anger make my anger evident or apparent (in the sense of "making my anger appear"), or, even better, they make my anger manifest. They do not merely make it evident *that*, apparent *that*, and manifest *that* I am angry. *Signs* of anger, which are not

241

expressions of anger, can (but do not necessarily) make it evident, apparent, or manifest *that* I am angry. They do not, however, make my anger evident or apparent, nor do they manifest my anger. My anger is not manifested in my simply leaving the room and jogging for a mile if I do not *do* anything in an *angry* way.

Of course, to gloss the concept of "showing" in the preceding way does not tell us everything we want to know; it simply sets us looking in the right direction. However, such a gloss does let us see how the points made in the early chapters of this study bear upon the topic under discussion. In Chapters One and Two we began with the insight that certain "forms of mentality" were discernible "in" works of art independently of whether or not those forms of mentality were known to apply truly to the artists. We discovered that it is precisely this feature of art works and other cultural "works" that make them like common sorts of expressions. And thus it is that certain anthropomorphic terms designating simple emotions as well as complicated descriptions describing subtle personality types can be applied to the *expressions*, however simple or complex, of that emotion or personality. This logical fact about expressions, therefore, corroborates our intuition that whatever is expressed is apparent, evident, and/or manifest in its expressions. Let us use this fact and this intuition to help specify more precisely the way in which expressions *show* what they express.

THE following cases of "showing" have, for all their differences, three features in common: (a) whenever a thing is said to *show in* another thing, it is also true that the latter *shows* the former; (b) whatever shows in a thing is evident, apparent, and/or manifest in that thing; and (c) when one thing shows in another, the latter is describable in terms which have an implicit reference to the former.

(7) The ink stain shows in the shirt. (The shirt is ink-stained or has an ink stain.)

(8) The advent of middle age shows in the drying of the skin. (One has middle-aged skin.)

(9) Sean's Tartar ancestry shows in his high cheekbones and narrow eyes. (He has Tartar features.)

(10) This leaf specimen shows the characteristic round shape of the young silver dollar gum leaf. (The shape of this silver dollar gum leaf is characteristically round.)

(11) The unusual blue color of the spruce in my backyard shows especially well in this branch. (The branch is that unusual shade of blue.)

(12) The old redwood fence now shows the effects of the weather. (The fence is weather-beaten.)

(13) The piece of sedimentary rock shows the outline of a leaf perfectly. (The imprint in the rock is leaf-shaped.)

(14) The informality of my cabin in the mountains shows in the crude stone fireplace, the rough wood walls, and the "homespun" textures of the fabrics. (The fireplace, wood walls, and the fabrics in the cabin all are informal in feeling.)

(15) Joseph's remarkable skill with his hands shows in this fine piece of cabinet work. (The cabinet is skillfully made.)

(16) Sergeant Wayne's bravery showed in the way that he rushed through the mine field to get the message to headquarters. (A brave action!)

(17) Hepzibah's informality shows in the way she dresses, her style of speech, and her casual way of entertaining guests. (She dresses, speaks, and entertains very informally.)

In order to carry out the comparison between the above cases of showing and the showing relevant to expressions, we will keep two questions in mind. First, we will inquire what the relation is between what is shown, on the one hand, and those features of what it is shown in by virtue of which it is shown in them, on the other. Second, we will inquire whether that relation is identical with, includes, or entails some sort of causal relation. For, as was pointed out above, it is in virtue of certain features of an act, i.e. of the *way* in which it is done under a certain description, that an act is expressive. It is therefore the essentially expressive feature of any act which not only shows what is therein expressed but which also constitutes the specific "effect" of what is expressed.

In order to make the following discussion easier to follow, I shall preface each discussion of a particular case of showing with its number in the above list.

(7) There is surely very little temptation to imagine that what is expressed is to its expressions like an ink stain to a shirt. The reasons are easy to find. First, the shirt shows the ink stain because (a) there is some ink on the fabric of the shirt, and (b) the color of the shirt contrasts with the spot. The ink stain cannot be said to *cause* either condition (a) or (b). Second, the ink stain is identical with the ink on the shirt. By no stretch of fantasy can we suppose, say, that my anger is identical with the "anger" in my scowl. Thus we feel strongly that "angry" is predicated of my scowl differently from the way "angry" is predicated of me. But in the case of the ink stain there is nothing even remotely analogous to the person-act distinction so that the ink stain can "belong" to two sorts of things in different ways, as anger "belongs" to me and my scowl in different ways.

(8) In this case, like the last, there is no temptation to think of the advent of middle age *causing* the drying of the

skin. The reason is that "the advent of middle age" is a description of a complex combination of many bodily processes and changes. The drying of the skin is just one of these; it is a *part* of the advent of middle age. To call it the "effect" of the latter seems to make into something substantial what is really a collection of many things designated by the comparatively "artificial" and "abstract" term "the advent of middle age."

What is it, though, in virtue of which drying skin shows the onslaught of middle age? Surely it is some sort of regular conjunction of occurrences. "Middle age," while it designates a collection of various processes and conditions, seems also to designate in a more basic way a period of life which is temporally definable. Therefore, whatever can be taken as showing the coming of middle age is any process or change which regularly, but not necessarily always, occurs during this period. That this is so can easily be seen simply by imagining processes and changes, internal or otherwise, which accompany this period of life. Whatever they might be, so long as they meet the mentioned condition, they may be said to *show* the advent of middle age. The same even holds for psychological and/or behavioral changes which apparently have no organic basis, as, e.g., the alleged tendency of middle-aged men to resume the pursuit of young females.

If it is "constancy of conjunction" which accounts for showing in a case of this sort, however, is there not a similarity between case (8) and expressions? It certainly *appears* to be the case that the expression of x's F, and probably therefore, the showing of F, is grounded upon the regularity of conjunction with F. We have thus quickly flushed our quarry.

The notion that the expressions of F are such in virtue of the regularity with which they accompany F is, for all its

attractiveness, either uninterestingly true or clearly false. In order to argue the point, let us not take literally the Humean formula of *constant* conjunction. Let us settle for the more relaxed requirement of regularity of conjunction. When we do so, we immediately see that cases of any expressible F are regularly accompanied by one or more expressions of it. Anger, for example, is comparatively rarely unaccompanied by an expression of anger from the angry person. Most things which are *expressible* actually have *expressions*. Thus, there is a regular conjunction between expressions and expressed. Note, however, that the conjunction we have discovered cannot *ground* the attribution of "expression of F" to any sort of act, which is the requirement we have to meet if a parallel with case (8) is to be proved. For in order to establish such a ground, we must find a regular conjunction between cases of an expressible F and occurrences of expressions of F identified in terms other than "expression of F" and "showing F." And we would be able to do so, if it were possible either to give a uniform description of all the possible expressions of F, without using the terms "expression of F" and "showing F", or to show regularity of conjunction between F and each of the subclasses of possible expressions of F which are determinable by descriptions excluding the aforementioned two. Neither of these, however, is possible.

First, it is a salient feature of any expressible F that the total range of its expressions exhibit no common features. It is hard to know what could "prove" this claim, but some illustrations ought to make it readily acceptable. What are some of the expressions of anger, for example? First there are verbal expressions ranging from practically inarticulate sounds through all sorts of expletives and curses to eloquent formal speeches and even poetry, like Coleridge's "The Dungeon." Then there is a range of behavior including

merely walking fast and firmly, waving arms and clenching fists, hitting, kicking, biting, scratching, throwing, and smashing. Third, there are facial expressions like turning red and the stiffening of jaw muscles. There are scowling brows, blazing eyes, clenched teeth, and any combination of these. Finally, there are more esoteric ways of expressing anger, such as by producing a scathing political cartoon. We can even imagine that writing music of a certain kind might, in certain circumstances, count as an expression of anger. Suppose that in response to a verbal insult offered by one composer to his rival, the latter nurses his anger and finally expresses it by composing a piece which is a devastating parody of his enemy's style, bringing out in a rather cruel and brutal way all the superficialities and pomposities latent in that style. Suppose, further, that he arranges to have this composition performed at an important gathering of the musical community. The music would be functioning like a clever but biting diatribe against the offending composer.

A catalog of possible expressions of a cool, uninvolved attitude reveals the same magnitude of diversity. Such an attitude can be expressed in an immobile, unperturbed face; by calm, unhurried body movements; by a quiet, unagitated tone of voice; by the measured and deliberate rate at which one speaks. The stylistic features of verbal expressions of such an attitude can be tremendously varied: a high proportion of mathematical terms or terms of measurement; a preponderance of drab sentences with a simple subject-object structure; the dominance of declarative over imperative, exclamatory, or interrogatory sentences; a large percentage of verbs in the passive rather than active voice. Moreover, there seems to be no art form in which such an attitude cannot be expressed. The example of Poussin has already been mentioned. But such attitudes might also be expressed in

247

such diverse styles as that of Piero della Francesca, Piet Mondrian and some "minimal" artists. The attitude might be found, as well, in Lever House, in Gregorian Chant, in the clothing of the American Pilgrims. Going outside the realm of art, we might even see this sort of attitude in the rigid austerities of Kantian ethics. It is sufficiently clear, I take it, that any hope of finding common features of all the expressions of a given F is futile.

Is there, then, a regular conjunction between F and each of the *sorts* of expressions of F, given any reasonable way of determining sorts? Here too the answer must be negative. One has only to pose the question: Which of the many sorts of expressions of anger regularly accompanies anger? One has no idea what to answer. Do *scowls* regularly accompany anger? Anger in whom? Doesn't that make a difference? What sort of anger? In what circumstances? Don't these factors make a difference to our answer? How regular must regular be? Must it be more than half the time? Can we honestly say, from our own experience, that scowls do accompany anger more than half of the time? Yet scowls are among the commonest forms of expressions of anger. What about the hypothetical musical composition suggested earlier. That has never "regularly" accompanied anything, and yet it can be recognized as a possible expression of anger. Of course, you say, but the music can always be described in such a way that places it as belonging to a particular *sort* of angry expression. What, then, is that sort? Parodies? That surely will not do. Savage and cruel parodies? Such parodies can be the product simply of a mean-tempered soul as much as of anger. Even the very commonest sorts of expressions of the commonest feelings seem to accompany what they express with far less "regularity" than the conjunction of middle age and drying skin exhibits.

This may not be universally true, of course. Suppose that

it could be documented, as seems possible, that embarrass-
ment is very frequently accompanied by blushing. Suppose
that a sizeable number of such regular conjunctions could
be established. It would not be sufficient to prove the regu-
larity thesis. For that thesis demands that the fact that
any expression of *any* expressible is properly so-called be
grounded on regularity of conjunction. But such universal-
ity simply does not obtain.

A final consideration on this issue: It seems intuitively
clear that efforts to subdue one's anger (control one's grief,
hide one's disappointment, etc.) accompany this emotion as
"regularly" as any one of its common "sorts" of expressions.
If the regularity thesis were correct, such efforts, or the acts
which reveal such efforts, should count as expressions of the
feeling. Similarly, *success* in subduing, controlling, or hiding
one's feelings might "regularly" accompany those feelings.
It would follow, then, that succeeding in hiding a feeling
is an expression of the feeling, and hence shows the feeling,
as much as behavior which does not hide the feeling. These
consequences of the regularity thesis are simply absurd.

(9) We do not suppose that anyone's ancestry causes
him to have whatever features are characteristic of that
ancestry. The most we can say in this case is that the *fact
that* Sean has Tartar ancestors accounts for the typically
Tartar features he possesses. Furthermore, the way in which
Sean's eyes and cheekbones relate to his ancestry is that his
features share characteristics with the features of a signifi-
cant portion of his ancestors. The relation is clearly much
more like that between Sean's dourness and the dourness of
his father and grandfather than it is like the relation between
his dourness and the dourness of his countenance. In the
first pair there is no shift in the category to which "dour-
ness" belongs, whereas in the second pair there is a shift
from dour *character* to dour *look* or *aspect*. Such a cate-

249

gorial shift, or a similar one, always occurs between an anthropomorphic description of a person and a description, in cognate anthropomorphic terms, of an expressive act of the person.

(10) This case is remarkably like the preceding one, despite superficial differences. Once again the individual which does the showing shares a certain property, namely, possessing a round leaf, with a significant proportion of individuals of the same sort belonging to the same genetic strain. In this case, also, there is no inclination to think of the characteristic leaf shape *causing* its own appearance in an individual leaf, even though it is presumed that each instance of the characteristic shape has the same sort of cause.

(11) This case is not greatly different from the immediately precedent one. The blueness of the branch shows the blueness of the tree, and "blueness" applies to the same category in the two cases. And, of course, the blue color of the tree does not produce the blue color of the branch. Rather, the blueness in the branch seems more like a part of the blueness of the tree; it goes to make up the color as we see it on the whole tree. Yet in this respect case (11) comes a shade closer than (10) to the case of expression. For angry behavior is a kind of part of the angry person and shares, as it were, in the anger which "covers" the person. Although "part" and "shares" become metaphorical in these uses, they are not, on that account, completely unilluminating.

(12) This case is *prima facie* interesting because of what is said to be shown, to wit, "effects." Nevertheless, it surely is not the case that the weather effects on the fence *cause* the weather-beatenness, that is, let us say, the dried and faded condition of the fence. For the dried and faded condition of the fence is nothing but, i.e. is *identical with*, the effects of the weather on the fence.

But notice some complications. The effects of the weather can also be described as "the fading and drying effects of the weather." These are effects of the fading and drying which are caused by the weather. Certain processes, i.e. fading and drying, have "slipped in" between the weather and the condition of the fence; and they are both the effects of the weather and the causes of the fence's condition. Yet the condition of the fence does not show the effects of the fading and drying processes, but of the weather. It is as if the processes of fading and drying, produced by the weather and producing the condition of the fence, must be included in what is designated by "effects of the weather." But if that is so, can we still assert the *identity* of the effects of the weather with the condition of the fence? Fading and drying are not the same as a faded and dried condition. True; but is there ever, *can* there ever be, some fading and drying without something of a faded and dried condition? The two go hand-in-hand, and necessarily so. The latter is not the effect of the former in any sense of "effect" which implies that some circumstance might interfere and cause there to be no fadedness and dryness as a result of the fading and drying that went on.

In the final analysis of (12), then, what is shown is indeed a kind of cause of some features of what it is shown in. Is this the sort of cause between expressed and expression? No. For there is not about the latter the same "inevitability"; one can refrain from expressing whatever one has, on this occasion or that, at least. The sort of cause described in the last paragraph is rather like the relation existing between smiling and the smile, scowling and the scowl, described in Chapter One. If we take the latter comparison seriously, we are then led to think that what is expressed is to the expression roughly as the *weather* is to the condition of the fence. For the smile does not express the smiling, it expresses

251

what "causes" the smiling (under the proper description). And in (12) it is the weather which causes the fading and drying which (necessarily) result in the faded and dried condition. However, we cannot think of the relation between expressed and expression as like that between the *weather* and the fence either. For it is not the weather which is shown in the fence; it is the effects of the weather. Yet it is not the smiling which is shown in the smile, but the joy behind the smiling. Once again we fail to find an adequate model for the expression relation.

(13) In this case there is a rather surprising parallel to cases of expression, despite some disanalogies. It is, of course, in virtue of the shape of the imprint in the rock that the rock shows the shape of the actual leaf. The shape of the imprint, however, is in some obvious way *identical* with the shape of the leaf. This is so even though the imprint most likely does not show every detail of the actual leaf. For "shape of the leaf" need not refer to every detail of its outline. But even if we claim only that the shape of the imprint is *roughly the same as* the shape of the leaf, the parallel to expression seems not at all close. For what is expressed is not even "roughly the same as" those features of human "acts" which are its expressions. Anger in a man is an *emotion*; anger in a face is a *cast* or a *look*.

Nevertheless, we can ask what it is that makes the imprint in the rock to be of just that shape, i.e. the shape of the leaf. Of course, it is the various pressures that formed the rock plus the resistance of the real leaf which made the *imprint*. But surely the shape of the leaf *caused* the imprint to have *that* shape. It is the *shape* of the leaf which produced, not the imprint, but the *shape* of the imprint. But perhaps we must say—since it seems improbable that something can be its own cause—that the shape *in* the leaf produced the shape *in* the imprint. But do we have here a true case of causation?

252

We do not know until we know what true causation is. We certainly are inclined to speak as if there were a cause-effect relation, just as we are inclined to speak as if the expressed is a cause of its expression. The most relevant question, then, is whether there is any deep-going similarity between the leaf-imprint relation and the expressed-expression relation, setting aside the idle question whether they are "truly" causal relations.

The parallel between expression and case (13) does not continue very far. We only need notice that between the shape in the leaf and the shape in the imprint a point-for-point comparison could be made. ("Could," that is, in principle, if we could but stretch far enough in time.) Change the case only slightly from an imprint in rock to a fresh imprint in sand. Then we might actually check, by comparison, to see whether *this* leaf made *this* imprint. But what could such a point-for-point comparison ever be when applied to an emotion, say, and its expressions. The analogy thus immediately breaks down.

I might seem to give the possibility of an analogy in this case more attention than it appears initially to deserve. That would be true were it not for the fact that one influential expression theorist, Susanne Langer, has taken very seriously the notion that there is some formal congruence between the expressive features of art and "feelings," a sort of congruence which she glosses in one place as that between a "cast and its mold."[1] As was easy to see, the cast-mold relationship (or the leaf-imprint one) is an inadequate model for expression. It demands that the expressed and its expressions be separable and comparable in a way that is obviously impossible. Mrs. Langer has indeed recognized the inadequacy of a simple cast-mold model, though prob-

[1] Susanne K. Langer, "Expressiveness," in *Problems of Art*, pp. 13-26.

ably not for the reasons I point out. At any rate, she has formulated a notion of "dynamic form" which, she apparently believes, can be used more adequately to describe the relation between "feeling" and the expressive features of art.[2] As her paradigm of a dynamic form she gives the shape a river takes as it flows. If we can imagine the bed of the river apart from the water, we shall have imagined a "static form" which "expresses" (the term is hers) the dynamic form of the river. The static form apparently includes not only the shape of the river course, but also the contours of the riverbed shaped by the volume and currents of the water.

One advantage of this model over the cast-mold (or leaf-imprint) model is that the independence and separability of the leaf and the imprint do not apply to the river and its bed. There is not the shape in (of) the river, on the one hand, and, on the other, the (same or a similar) shape in the earth. A point-for-point comparison of the shapes in this case is just as impossible as a comparison of the form of a feeling and the form of a work of art. (Despite this, Mrs. Langer persists in speaking of "congruence" even here.) But what is a gain on this score is a loss on another. For precisely because there are not two shapes (or the "same" shape instantiated twice) there is also no "showing" of the one in the other. Neither the shape of the bed, nor the bed itself, nor the valley in which the river runs *shows* the shape of the river; nor does the shape of the river show in any of

[2] I realize that, strictly speaking, the relation Mrs. Langer is trying to grasp is not that which I am discussing. For she explicitly disclaims in the aforementioned essay any interest in the relation between an actual feeling and its expressions (what she insists on calling its "symptoms"). Despite this disclaimer, what she says is still relevant to my problem. She admits elsewhere that works of art actually can and do function as expressions (symptoms) of some real feeling of their creators. If so, they presumably do so just in virtue of the "congruence" of form between those works and those feelings.

them. There are no such uses for "show" in instances of this sort. The "show" idiom requires the independence of two shapes.

Notice, further, what results if we ask: What made the Willamette River bed to be shaped like *that*? If we explicate "like that" merely as "Willamette River-shaped," the question has no answer. If we explicate "like that" in terms of some features of the bed ("twisted in such a fashion," "*so* deep," "*so* wide," etc.), the answer (a) is different depending on the feature we mention and (b) must be couched in terms of factors such as water volume, pressures, current speeds, and topological features. In short, there is no inclination to think of the "dynamic" form of the river as the *cause* of the static form of the riverbed. Rather, the shape of the riverbed is the resultant both of the river's water—its volume, speeds, and weight—and the terrain over which it flows. Neither of these, however, is *shown* in the shape of the riverbed.

Without question there is a great inclination to think of what is expressed in terms of liquid models. As mentioned earlier, one distinct sense of "express" has to do with juices and oils, and this fact carries over as metaphorical imagery behind the mentalistic use of the term. Thus the stock metaphors of the inner life run with liquid imagery: our feelings overflow, grief wells up, waves of relief pour over us, we spew torrents of angry abuse, we channel our drives, contain our emotions, and stir up our feelings. Mrs. Langer has been caught up in this tide of popular feeling. Her attempt to make something serious and theoretically viable of this common sentiment is finally unsatisfactory. The concept of "dynamic form," just like the primitive notions which underlie it, remains radically metaphorical. Metaphors can be enlightening, no less in philosophy than in poetry. But philosophizing which ends with a metaphor comes to a dead end.

(14) If we take very seriously the fact, pointed out earlier, that among all the possible expressions of x's F there is no common feature or set of features,[3] then our fourteenth case of showing is interestingly analogous to cases of expression. For the differences among a stone fireplace, homespun fabrics, and exposed wood walls seem as great as those among, say, cursing, striking out, and scowling. One might object, though, that the informality in the fireplace, fabrics, and walls is a function of a single feature, namely, the texture of these items. That is so. Nevertheless, "texture" covers in these contexts an extraordinary diversity of properties. The rough texture of a natural stone fireplace is surely not just like the rough texture of homespun fabrics. We can, however, extend the list of features of my mountain cabin which show its informality. The informality also shows in the irregular arrangement of the furniture, in the use of simple boxes for chairs, in the designs of the fabrics (checks and plaids). It shows, further, in the open plan of the house, which separates the "rooms" by half-partitions and see-through room dividers.

Now no one would suppose, I trust, that the informality of the cabin as a whole in any way *causes* the informality

[3] It is important that we speak of "possible" expressions and not merely actual ones. For it is, of course, possible that if some person x expresses his anger, say, only by a burning glance and then immediately subdues it or conceals it, there *is* some "common" feature in his anger's expressions. The "possible expressions" of x's F, then, should be taken to include all those expressive acts which x conceivably could have done which might express an F of that same character. The only limitations on the "conceivability" of the act, thus, is that it be "coherent," with respect to the expressible features of what it expresses, with the other possible expressions of what it expresses. It is thus no limitation on the conceivability of x's expressions of anger, for example, that x is not a painter, a musician, or a skillful speech maker. The range of possible expressions of F is quite protean, therefore, and not very clearly definable. That is exactly what one should expect, however, for the latter features also are characteristic of F itself.

256

of its constituents. Nevertheless, we might inquire whether in any *other* respects the informality of the cabin is related to the informality of its "parts" as, for example, anger or aloofness of attitude in a person is related to the anger or aloofness of the person's expressive acts. Notice, first, that the relation between the informal constituents of the cabin and the cabin itself is considerably more complex than the relation between the blue branch and the blue tree in case (11). Indeed, the way that a floor plan is a part of a cabin seems quite different from the (also very diverse) ways that the fireplace, the fabrics on the furniture, and the arrangement of the furniture are parts of the cabin. Consequently, it seems false to say even that these "parts" share a property, even the "property" of informality, with the cabin as a whole, in the way that all the blue branches share the same property—blueness—with the tree.

The crucial question, however, from the point of view of an analogy with expression, is whether the way in which "informality" applies to the cabin as a whole is different from the way in which it applies to any of its "parts." The answer is obviously yes. For "informal" applies to the cabin in virtue of different features from the features in virtue of which it applies to any of its parts. But we still want to know whether what is denoted by "informal" belongs to different *categories* when the term is predicated of the cabin and of its parts. For, as we noted above, it is just this difference in category between, say, the anger of a person on the one hand, and the anger of his face, or words, or gestures, on the other, that seems crucial in cases of expression. But we are not sure what to say about this categorial difference or similarity in the case of the informal cabin because we are not sure how to categorize "informality" when applied either to the cabin or to its "parts." Let us try, however.

Admitting that "feeling" is metaphorical in these contexts, we still know that we may speak of the informal *feeling* of the fireplace, of the furniture arrangement, and also of the cabin itself. On the other hand, we may refer to the informal *look* of the walls, the fabrics, the furniture arrangement; but it seems inadequate to speak merely of the informal *look* of the cabin as a whole. That is because it is not informal merely to look at but to talk in, to walk around in, to live in. We might more satisfactorily speak of the *mood* of the cabin. But it seems exaggerated to speak of the mood of the fabrics, the floor plan, the walls, even though it might be right to speak of the mood of the fireplace. Probably the correct conclusion is that, for all the differences between the informality of the cabin and the informality of its "parts," this difference is not essentially unlike the differences among the informality of the floor plan, the fabrics, the design, the fireplace, and the furniture arrangement. As corroboration of this point, we might notice that an informal cabin might itself be a constituent of some larger informality, of, say, a village, a resort, or a park.

Is this situation so different, after all, from cases of expression? Can a person's emotion, mood, attitude, or character be, in turn, the expression of someone else's emotion, mood, attitude, or character? The religiously inclined might say yes. Was not Attila's ferocity, no less than the Black Death and the Great Flood, an expression of God's wrath? There is a point of view, in other words, from which the difference between a man's anger and the anger of his behavior, even if it remains a "categorial" difference, appears no more fundamental than that between the cabin's informality and the fabric's informality. Notice that this point of view would not deny the difference between, say, anger in a man and the anger in his expressions; it would simply deny a certain significance to that difference. But then we do not want to

deny the difference between the informality of the cabin
and the informality of its parts, either. It is just that we are
not, in the latter case, inclined to "hallow" this difference by
calling it "categorial."

Naturally, the religious point of view sketched above
might be purely fantastic. It might be incorrect to think of
human emotions, moods, characters, etc., as expressions of
God's mind. But whatever the grounds on which the incor-
rectness of such thinking might be established, they could
not include the claim that so to think is to make a category
mistake. There is certainly nothing *inherently* incoherent in
supposing a human mind, or any of its modes, to be the
creation of God, as there is, for example, in supposing sugar
to be a quality or oxygen to be a process. Of course, one
cannot suppose that a man's emotion can be *its own* expres-
sion, but that supposition is not involved in the religious
thesis. In any case, neither can one suppose that the infor-
mality of the mountain cabin is one of *its* own constituents.
The sort of "showing" involved in expression is, therefore,
intriguingly close to the sort of "showing" in example (14).

(15) Of course the parallel is far from perfect. For (14)
is an example neither of expression nor of the sort of causal-
ity implicit in expression. Clearly it is time to turn to cases
of showing in which human beings and their actions are
essentially involved. One would expect, after all, that in
cases (15), (16), and (17) the parallels to expression would
be closest and most enlightening. For in these cases the cate-
gorial differences between what is shown and what it is
shown in should precisely parallel what is expressed and its
expressions. Skills, to be sure, are quite different from emo-
tions, attitudes, and qualities of mind, but can we honestly
say that they appear to differ more greatly from all the latter
than the latter differ among themselves? I think not. We
should therefore expect some enlightenment from case (15).

Notice, first, that to describe Joseph's ability as simply "skill with his hands" is imprecise. For Joseph may be skillful with his hands in many ways: he may be able to pick locks expertly, for example. Yet surely the skillfully-made cabinet does not show *that* skill. It shows only Joseph's cabinet-making skill, a specific sort of skill with his hands. Now skillfully-made cabinets may vary a great deal among themselves, but the class of properties which make them skillfully made is rather narrowly circumscribed; they are sturdy, straight, solid, neat, unscarred and precise. Further-more, to the degree to which any of these features is lacking in a cabinet, to that degree the cabinet is unskillfully made; and it *shows* a correspondingly lesser skill in its maker. There is at least this difference, then, between showing x's F and showing x's skill. Whereas there are no common features unifying the range of expressions, there is a small number of readily specified common features unifying the range of products of a skill. Later on we shall see the significance of this difference.

Now to some persons, especially to anyone versed in Plato and Aristotle, it may seem that, although an act cannot be an *expression* of a skill, it may be the *effect* of the skill. The features in Joseph's cabinet in virtue of which it is skillfully made are, we might say, *products* of Joseph's skill. But is it Joseph's skill which *makes* him cut the boards straight, which makes him join the corners precisely? It seems not. We are much rather inclined to speak of his skill *enabling* him to make a well-made cabinet. And this is so because, having a skill, one may choose to exercise it or apply it or not, as long as there are no external impediments to applying it. But it is not the case that, having a skill, one *will* exercise it, whenever there is the opportunity, unless one restrains oneself from applying it. That is to say, one

must *apply* or *exercise* one's skill if that skill is to be shown in any activity. Not only does (can) one not *apply* or *exercise* what is shown in one's expressive acts, but, even more fundamentally, one's F is always expressed—if one does an act which is capable of showing that F at the time that F is attributable to oneself—unless one succeeds in preventing it from being expressed. Thus one need not do anything analogous to applying or exercising what is expressible in order for it to be expressed.

Furthermore, if one were to do with respect to one's own F anything analogous to applying a skill, that F would *ipso facto* not be expressed. It is precisely for the reason that Zelda Mutz "put" her mood into her parlor, i.e. "applied," as it were, what she knew of it to her decorating job, that she is not considered to have expressed it. It was her act of "applying" her mood (applying her knowledge of it) that *sufficiently accounted* for its being detectable in her new parlor. But for her new parlor to have been an expression of Zelda's mood, it was sufficient for Zelda, on the assumption that she had the requisite skill, simply to have been *in* the mood. By contrast, simply having a cabinet-making skill is *never* sufficient to make one build cabinets skillfully; but having a skill and applying it in what one does *always* sufficiently accounts for its being shown in what one does.

(16) In order to act bravely Sergeant Wayne *need* not do anything like "apply" his bravery. He need not, for example, *decide* to run the mine field *because* it is a brave thing to do. On the other hand, he might well so decide and such a decision would by no means cast doubt upon his bravery. His bravery might very well be a very self-consciously sustained characteristic, and, some would argue, if his bravery were to have any moral worth, it would have to be so sustained. But, in any event, such self-conscious acts of

bravery could not be said to be caused by Wayne's bravery. It is the intention to act bravely which causes the action, if anything does.

A brave act is always done deliberately and it may be done deliberately *because* it is brave. By contrast, if the "properly" expressive *way* in which any "act" is done is the result of deliberateness on the part of the actor, the act *ipso facto* fails to express what it appears to express. For in such circumstances, that which is allegedly expressed could not be the cause of the act under its properly expressive description. The latter would be perfectly explainable by saying that the person acted that way *deliberately.*

It is, of course, possible that if a person is angry, he will scowl angrily *deliberately.* One might do that especially with respect to a small child who has run into the street, for example, in order to impress upon him the dangers of so doing. But in such a circumstance the angry scowl, though it is an expression of anger, is not an expression of one's own anger. If one has to scowl *deliberately* the scowl must not be commensurate with one's anger but must be exaggerated for a special purpose. If one's anger is great enough to be expressed in a scowl, one *will* scowl angrily unless one deliberately refrains from so doing. Likewise, in all cases of expression of one's F if one can simply *decide* to act in a way which is an expression of F and then *do* it, the expression of F does not count as an expression of one's own F.

This is not to say that one may not deliberately perform an act which is expressive of one's F, however. It is merely that one cannot deliberately perform it under its properly expressive description. When angry, one may deliberately throw the china and even deliberately throw it violently. One may not deliberately throw it *angrily*, however, if it is to count as an expression of one's anger.

(17) In this case of showing we appear to have the com-

bined virtues of cases (14), (15), and (16) and none of their respective defects. That is, we see the widely diversified range of "showing" items as well as the fact that these items are human activities which show the characteristics of the person. Moreover, acting informally, no matter what one does, certainly *need* not be done deliberately. One *may* act informally, in a whole host of ways, quite naturally and without thinking about it in the least.

Yet in spite of the closeness between showing Hepzibah's informality and showing her (expressible) *F*, Hepzibah is not correctly said to "express" her informality if she acts informally and is an informal person. This fact is probably related to the further one that a person's informality is not regarded as one of his "inner" qualities. In this respect, informality is like such attributes as sophistication, politeness, pomposity, and flamboyance. Such personal attributes, although they may be connected with so-called "internal" and expressible characteristics, attitudes, feelings, etc., are themselves simply characteristics of *behavior patterns* of a person. "Informal," "polite," "sophisticated," and such terms, therefore, although they are applied to persons, basically denote overall features of patterns of behavior. In this respect, they contrast neatly with terms for what is expressible. For if *F* is an expressible, the acts expressive of *F* are described in terms of *F* because those acts are characteristic of persons with *F*. But a term like "informal" applies to persons in virtue of the fact that informal behavior is their characteristic behavior. In other words, unlike terms for what is expressible, terms like "informal" apply *primarily* to behavior and *secondarily* to persons.

Furthermore, a person's informality does not *cause* him to behave informally. If anything is the cause of his informal ways of behaving, it is the way he was brought up and the influences on him in his formative years. And these are also

just the factors that made him into an informal person. But there seems to be no causal efficacy exerted on his behavior by his own informality in addition to that exerted by his early environment.

The same appears to hold for such characteristics as sophistication, politeness, flamboyance. Indeed, to conceive these attributes as *causing* the relevant behavior appears to put the cart before the horse. For if these attributes are overall characters of behavior, it is they which depend upon the individual acts which make up the behavior pattern and not the converse. To think otherwise is surely to indulge in illicit Platonizing.

chapter nine

The Romantic Mind Triumphant

✲

As we showed in Chapter Eight, among the cases of showing which are not cases of expression, there is none which manifests a causal relation between what is shown and that in which it is shown. Apparently, trying to find the way in which expression is causal by analyzing the notion of "showing" has led to a dead end. More seriously, though, the analysis has evidently led to an absurdity. For it seems that the way in which an expression shows what it expresses not only leaves the causal aspects of expression obscure but makes us doubt that there can be such a causal aspect to expression.

The case of showing which comes closest to cases of expression is the one concerning a person's informality. This fact suggests that what is expressed is essentially an overall characteristic of a pattern of (actual and possible) behavior, and that its expressions are constituents of that pattern, constituents which exhibit that overall characteristic in quite diverse ways. The relationship between expression and expressed, therefore, as far at least as the analysis of "showing" is concerned, is a special variety of the universal-particular relation in which the particulars are parts of a whole of which the universal is also predicated.

Yet it is just this sort of relation between expression and expressed which seems to preclude there also being a causal relation between the two. There seems to be no way to grasp how an overall feature of a pattern would *cause* its "appearance" in the pattern's constituents. Any plausibly-

called "causal" relations in such a context would seem, in any case, to work in the other direction. For generally it is in virtue of the character of its parts that a pattern exhibits some overall character, and not the converse.

There is another difficulty, too, in interpreting "expression" according to case (17) in Chapter Eight. There can be no pattern, and hence no overall character of it, if there are no constituents of the pattern. If what is expressed is just such a character, how are we to account for the fact that there may be unexpressed feelings, emotions, attitudes, and moods? We can be aware of such things "in" ourselves even when there is no pattern of acts which show them. Of course, not everything which is expressible can be unexpressed in any way. It is impossible that a fundamentally skeptical attitude towards life, a deep sensitivity to nature, an abstracting imagination, a Satanic personality can exist without ever being expressed in some way. Nevertheless, one may be aware of such sorts of things about or in ourselves by means other than observing "acts" which are expressive of them. For example, one might notice one's own inclinations to mistrust what people say or to doubt that an issue will come out for the best. Yet this mistrust or doubt, in a given instance, may not be expressed at all. One may know that one *feels like* saying something which would express such mistrust or doubt, and yet one refrains from so expressing them. And yet just having those feelings and inclinations can be for me an indication of my generally skeptical attitude towards life. Similarly, one might "catch oneself" looking at persons and seeing them as Dickens-like symbols of abstract notions. This "seeing" might be visual or it might be verbal. That is, one might find one's visualization of these persons abstract or might find oneself "thinking of them" (to oneself) in abstract terms.

There are, in short, for all sorts of things which are ex-

pressible all sorts of so-called "private experiences"—kinaes-
thetic feelings, urges, and inclinations, as well as visual,
aural, olfactory, and tactile imagery, and cases of the "soul
talking to itself"—which allow us to be aware of what we
may or may not express. "Allow us to be aware" is deliber-
ately vague. The phrase is meant to be neutral with respect
to any philosophical description of the relation between such
"experiences" and our *knowledge* of our own feelings, atti-
tudes, qualities of mind, etc. It seems sufficient in the present
context simply to point out that those things of ours which
are in principle expressible are on occasion "accessible" to
us independently of their actually being expressed. It is be-
cause of this fact, no doubt that these things about us which
are considered expressible are also considered to be "inner"
phenomena and that "expression," therefore, suggests the
"externalization" of what is "inside" the mind.

As long as we do not make the error, which Gilbert Ryle
has elaborately warned us about, of taking the terms "inner,"
"internal," and even "inside" in a spatial sense, we must ad-
mit that whatever is expressible is indeed "inner." However,
it is precisely their "innerness" which apparently conflicts
with the idea that they are (or are very much like) overall
characteristics of patterns among human "acts." For how
could we be "privately" and "inwardly" aware of what is
essentially a character of our acts? The fact that expressions
of x's F *show* F therefore seems incompatible both with the
fact that they are *caused by* F and with the fact that they
are "*externalizations*" of F. Is there any way of bringing all
these ingredients of the concept of expression coherently to-
gether? I believe there is.

WHAT we must do is to inquire into the "principle of unity"
among all the possible expressions of any person's F. What
makes such an inquiry initially interesting is that there are

no common properties among all the possible expressions of
x's F, and there is no reasonable hope of finding any com-
mon feature by bending one's efforts especially to the task.
Moreover, it is this fact about the total range of F's expres-
sions which gives point to the search for a principle of unity.
Why, we must ask, do all of the extremely diverse "acts"
which are expressive of F, show F? But the only thing that
makes it puzzling how they can show F is just that they
share no non-relational property in virtue of which F can
be seen to be exhibited in them all.

The problem of the unity of all of F expressions would
not even arise, of course, if it were not a *prima facie* reason-
able expectation that the possible expressions of x's F share
some non-relational property. For the very fact that F is
shown in its expressions leads us to expect such a property.
We recognize F "in" its actual expressions and we could
recognize F in its merely possible expressions, just as we
recognize informality in the various elements of the moun-
tain cabin. Were there not the possibility of such recogni-
tion, of course, we should not be able to identify some quite
novel and even unique artistic or intellectual "act" as expres-
sive of F and yet entertain the possibility that F is not truly
attributable to the author of the "act."

The problem of the principle of unity in F's expressions
arises, thus, because "being an expression of F" seems to be
both a relational property and a non-relational one. Were
"being an expression of F" similar to, e.g., "being evidence
of F" or "being a sign of F," there would be no such prob-
lem of unity. True, the range of "entities" which instantiate
the latter two properties are at least as heterogeneous as the
range of F's expressions. For example, John's red face, his
clenched fists, his quiet but sudden departure from the room,
the disarray and damage in John's office, the ragged hole in
John's office wall, John's crying secretary may all, in ap-

propriate circumstances, be "signs" or "evidence" of John's fit of rage. Nevertheless, we do not, on that account, expect to find anything in them which they have "in common." That is simply because we know that what is a sign of John's rage, or evidence of it, in some circumstances and to some persons is not always so in all circumstances and to all people. Being a sign of x's F, or evidence of it, depends in part upon particular facts about F as well upon what we know about F. It does not depend upon what is *shown in* the sign or the evidence.

There is a large variety of explanations to which we might appeal in order to account for our ability to recognize (or imagine) F's expressions despite our inability to specify any common element in them. It may be due simply to the way we "interpret" F's expressions that they show F. Perhaps it is a way in which we perceive F's expressions. And we "perceive" F's expressions as showing F either because of the "original synthetic powers of the human mind," or because some peculiarity of our language has led us to see them as such, or because we were taught from infancy on up to see anger in anger's expressions but not in anything else. Perhaps it is because we are proto-theoreticians of human behavior that we see F in F's expressions; "showing F" would be thus a kind of a theoretical term which "organizes" our naïve experience in an original way.

All of these sorts of explanations and more of their kin immediately come to mind, for they have been, at least since Hume, the common stock of modern philosophy. It might seem cavalier not to treat each individually and on its own merits but for the fact that they all share a feature which renders them equally unserviceable in the present inquiry. They are all *intentional explanations* of the unity of F's expressions. That is, they explain how all of F's diverse expressive acts can show F merely in terms of how all of those acts

are seen, apprehended, interpreted, organized, synthesized, or collected together "by the mind." Any such account, however, is incompatible with the primary fact that all of *F*'s expressions show *F* in virtue precisely of the same features in virtue of which *F* is their *cause*.

A fundamental "realism" with respect to the unity among *F*'s expressions is thereby forced upon us. Acts *G*, *H*, and *I* show *F*, if they are expressions of *F*, not because "we" see them as showing *F*, but because *F* caused them to be such as to show *F*. Whatever else we can or must say about the relation between *F* and its expressions we are obliged to admit that *F* shows in the (however various) ways that it does because of what *F* is. The principle to which I am appealing is, however vague and even vacuous, absolutely universal with respect to causal relations. The reason, thus, that the effects of the weather, say, are what they are—no matter how diverse those effects are—is first of all because the weather is what it is, and not merely because we *see* them all as being the weather's effects.[1] As a matter of fact, the answer we must give to the question "How can all of *F*'s diverse expressions show *F*?" is that that is *F*'s nature. The principle of unity among *F*'s expressions is simply the nature of *F*. In what follows I shall try to remove the natural impression that this conclusion is stupefyingly inadequate.

First, it is not the case that to appeal to the nature of *F* is to appeal to the mysterious or the occult. It does not commit us to claiming that, e.g., anger, love, sensitivity to nature, or ampleness of mind have special, if obscure, sorts of things

[1] I do not mean to exclude the possibility that what are taken to be *F*'s effects are "theory-dependent" in some subtle way. But whatever such a phrase might mean, it cannot mean that *F*'s effects are *in*dependent of what *F* is. That is, however the determination of *F*'s effects are "dependent on theory," the determination of *F*'s "nature" must be also theory dependent so as to preserve the principle that *F*'s effects are determined by *F*'s nature.

called "natures." This is so regardless of whether talk of natures at anytime in the history of philosophy or science has led to occultism. It may well be that the intuitive realization that an appeal to the "nature" of anything expressible is necessary has encouraged in the Romantic Mind its tendency towards obscurantism. However, all that I mean by "the nature of F" is "what F is." What F is explains how it is that F is expressible in its particular diverse ways. Furthermore, what F is is discoverable in quite ordinary ways: what caused it, what are its objects, what are its expressions. To speak in terms of F's "nature" moreover, is not to imply that what F is, is necessarily given in an "essential definition" of F.

But if the appeal to "natures" in this case is not obscurantist, it is bound to seem vacuous. Especially if what F is is known through its expressions, how does it help to account for the "unity" among its expressions by appealing to its nature? Why are F's expressions such? Because F is of such a nature. What is F's nature? It is such as to have *such* expressions. Are we not "accounting" for F's expressions simply by acknowledging that they are what they are?

Whatever the appearance of circularity here, however, an appeal to F's nature in this instance is not vacuous. For such an appeal implicitly rules out other ways of accounting for the unity among the diversity in F's expression. It rules out an account in terms of the "nature" of F's *expressions*, for one thing. As we have seen there is no nature which they share apart from being F's expressions and showing F. For another thing it rules out purely linguistic, conventionalistic, and other intentionalistic accounts of this unity. In short, this appeal to F's "nature" gives a special metaphysical status to F. It affirms a certain "reality" of F, in a traditional sense of "reality." It affirms that F exists independently of the particulars which it unifies; and it affirms that it exists independ-

271

ently of any mental "intention" which takes it as its object.

Even allowing that this appeal to F's nature is neither obscurantist nor vacuous, one is still inclined to complain that it is insufficient. Do we not still want a unified explanation of F's diverse expressions analogous to the explanation of fatigue's diverse signs in terms of the presence of lactic acid in the blood? One must suppose that, in this hard age, "we" do want such an explanation. Yet that we desire (want) such an explanation cannot establish that we lack (want) such an explanation, for it is still an open question whether there are such explanations, which we might truly be said to lack. Yet if we do not lack such explanations, but only desire them, the appeal to the "natures" of such forms cannot be insufficient. Since, as I have mentioned before, the existence of such explanations, if by no means logically impossible, is by no means logically necessary, and since the discovery of such explanations is in any case not the job of philosophy, the charge of insufficiency can only be substantiated by some future scientific successes.

Finally, it might be objected against this account that, however convincing the dialectic may be which engendered it, it ultimately flies in the face of the obvious fact that the expressions of F are culturally relative and, hence, inescapably "conventional." Of course "conventional" is a much-abused term, and our grip on any concept it stands for is bound to be unsure. What is often meant, however, by the thesis of conventionality is simply that certain forms of language, art, or behavior are habitually or standardly or normally used with a certain expressive import within a specific culture or society or within any sub-group thereof. As the work of E. H. Gombrich[2] can be used to show, however, this

[2] Especially *Art and Illusion: A Study in the Psychology of Pictorial Representation*, Bollingen Series XXXV, 5, 2nd rev. ed., 3rd ptg. (Princeton: Princeton University Press, 1969).

conventionality thesis simply states undisputed facts which in no way imply that expression is intentionally determined.

As I understand Gombrich's thesis as it applies to expression, the expressive import which a design motif or stylistic element possesses is relative to a certain conventionally accepted range of possibilities which comprises a sort of vocabulary of expression. Thus, the particular expressive import of any given motif or element can only be understood when compared and contrasted to the total range of elements of which it is a member. Let us take a simple example which Gombrich uses: the three orders of ancient architecture. Within this simple expressive vocabulary, the Doric order, rather than the Ionic or Corinthian, can express "severity."[3] This is not because there is anything "inherently" severe about the lines of the Doric column, but because the Doric column is seen, if it is seen properly, in its place within a conventional matrix.[4]

But this only means that the severity of the Doric column is relative to its place in a conventionally *used* matrix. There is no doubt that it is an intentional matter whether that matrix, and not some other, was used for expressive purposes in ancient architecture. But it does not follow therefrom that the Doric column was merely *interpreted* according to a convention as being "severe." It does not follow from the fact that an expressive matrix, system, or "vocabulary" is conventionally used, that the expressive import of its elements are conventionally determined. Gombrich's thesis allows us, then, to see expressive import as a function of a conventional "system" without supposing that that import is itself conventional. Thus we are able to reconcile our intui-

[3] Strictly speaking, "severity" cannot be expressed except "objectively" (see Chapter Four). It is more like informality than it is like anger; it is a behavioral characteristic, rather than an inner phenomenon. This fact, however, does not diminish its serviceability in this context.

[4] Gombrich, *Art and Illusion*, pp. 373-374.

273

tions concerning the "conventionality" of expressions of F with the logical impossibility of their being intentionally determined as expressions of F. I should note here, however, that it is not clear from Gombrich's writings that he sees the distinction between a conventionally used matrix and a conventionally assigned expressive import. It is quite possible, therefore, that he would not recognize the point I am drawing from his work.

It is appropriate at this point to say something of how my "realistic" theory of expressibles relates to the recent theory of expression by the archpriest of nominalism Nelson Goodman. Summarizing his position, Goodman says that "if a expresses b then: (1) a possesses or is denoted by b; (2) this possession or denotation is metaphorical; and (3) a refers to b."[5] Part of the trouble with Goodman's thesis is that he does not disambiguate the notion of expression, and consequently it is difficult to know to which sorts of expressive phenomena his theory is intended to apply. I assume, though, that the domain of a is all expressive acts and of b, anything expressible by them.

In condition (1) Goodman recognizes, as I do, the many-one relation involved in expression of this sort. But it is Goodman's use of "denote" in the formula which appears to conflict with the "realistic" analysis of expressibles which I have presented. The term suggests that what is expressed must be a predicate (or at least some sort of symbol) *rather than* a non-symbolic "abstract entity." If that is what Goodman intends, then, our theories are incompatible. But it is not so clear that Goodman so intends his theory of expression. In a footnote to a discussion of nominalism he says

If . . . such abstract entities as qualia are recognized, these—although not labels—may indeed be exemplified by their instances, which are concrete wholes containing

[5] Nelson Goodman, *Languages of Art* (Indianapolis: Bobbs-Merrill, 1968), p. 95.

these qualia. But exemplification of other properties would still have to be explained as above in terms of exemplification of predicates; and simplicity of exposition for our present purposes seems best served by treating all exemplification in this one way.[6]

The last clause appears to allow Goodman the license of speaking as if all expressibles were mere predicates of expressive acts without committing himself on the question of the irreducible reality of what is expressed. And I do not believe, in fact, that Goodman adduces considerations in his arguments for condition (1) which would allow him to conclude one way or the other on the issue.

With respect to Goodman's second condition, though, our theories of expression seem clearly incompatible. Since for Goodman metaphor always involves the "transfer" of a label from one extension to another,[7] his explanation of why what is expressed is obvious in its expressions (and, hence, of why the latter are describable in terms of the former) is an intentional one. For, in his theory, the "principle of unity" among all of the expressions of F resides not in the nature of F, but in the fact that they are all *spoken* of in the same way, i.e., that they have all been subject to the same transfer of labels.

About Goodman's third condition, that an expression "refer" to what is expressed by it, I have little to say. The term "refer," as Goodman uses it, is to my taste intolerably vague and ambiguous. Thus, while it seems to cost me very little to concede that Goodman is probably right on the point (as I do), my impression is that I have bought correspondingly little.

Assuming now the legitimacy of our solution to the problem of the one and the many in the expressions of F, what further conclusions can we draw therefrom? Let us now com-

[6] *Ibid.*, p. 57. [7] *Ibid.*, p. 83.

bine the fact of F's metaphysical "independence" with the fact that F is an overall characteristic of a pattern of acts, each of which in some way partakes of that overall character. The results are interesting and significant. F begins to resemble nothing so much as a Platonic Form or an Idea. F becomes a "general" characteristic of a pattern which is "shared" in by the elements of the pattern. The acts expressive of F "participate in," or "partake of," the overall character of the pattern. The characteristic Platonic vocabulary, usually regarded as so puzzling in the contexts for which Plato's Theory of Forms was designed, seems to find a natural home when we speak of the overall characters of patterns. It even seems right to speak of F "appearing" in its expressions, for it is in them, we have discovered, that F shows, i.e. is *apparent*. Even more strikingly, however, F possesses some measure of the metaphysical status accorded to a Platonic Form: it is independent both of its appearances and of a mind which recognizes it.[8]

[8] Of course, what is expressed *is* mind-dependent in a way that Plato's Forms are not. Indeed they help *constitute* a human mind. So in this respect the parallel fails. Interestingly, though, a Christian transformation of Plato's Theory resulted in Exemplarism, which had the effect of removing some of the substantiality of the Forms by making them out to be ideas in the mind of God. As far as I know, however, this relocation of the Platonic Forms was conceived in such a way that the ideas existed in God's mind as an idea (for a statue, say) might exist in an artist's mind. They were not, I think, ever thought to exist with respect to God's mind as one's anger, love, ampleness of mind, and sensitivity to nature exist with respect to one's own mind. It seems to me, however, that some Christian Platonists, e.g. John Scotus Erigena, should have taken the latter model seriously. It might have given some more precise sense to their theories of creation as they tried to work them out from the inherited Neo-Platonic notion of "emanation."

It is significant in this context that most commentators on Romanticism acknowledge a more or less vague affinity between Romanticism and Neo-Platonism, an affinity which some Romantics themselves felt. See e.g., M. H. Abrams, *The Mirror and the Lamp* (New York: Oxford University Press, 1953), *passim*, and Oskar Walzel, *German Romanticism*, trans. Alma Elise Lussky (New York: Capricorn Books,

Finally, and most interestingly of all, Plato's Forms were also considered *causes* of their appearances. Naturally, it is a much-debated topic what Plato *meant* by saying that a Form is the cause (*aitia*) of its appearances in things. The more or less traditional opinion has it that for Plato "cause" in this connection carried connotations of efficacy. Just what those connotations amount to is not agreed upon. A more contemporary strain of interpretation, represented most recently and radically by Gregory Vlastos, holds that there are no connotations of efficacy in Plato's use of *aitia* in this sort of context.[9] According to Vlastos, Plato simply means by calling a Form, say Beauty, an *aitia* that we can appeal to the Form of Beauty to *explain* how it is that particular things are beautiful. And such an explanation, says Vlastos, says nothing more informative than that beautiful things satisfy the conditions for being beautiful. When Plato says that the Form of Beauty is an *aitia* of beautiful things, he is, according to Vlastos, saying no more than what a thoroughgoing nominalist might admit. For, says Vlastos, the metaphysical status which Plato accords a Form has, for Plato, no bearing on the fact that it is an *aitia* of its particulars.[10]

Vlastos may well be right that, for Plato, there was not a suggestion of efficacy in his use of *aitia*. But Plato's Forms were never the property solely of Plato, and there has been a strong tradition since Plato which has interpreted the Forms as efficacious causes. Aristotle did so, as Vlastos notes, even though he was highly critical of the notion. Certainly the strain of Neo-Platonism, beginning with

1966), *passim*. The connection between expression and a Neo-Platonic interpretation of Platonic Forms which I make in the following argument can be construed as a more precise way of grounding that intuited affinity.

[9] "Reasons and Causes in the *Phaedo*," *The Philosophical Review*, LXXVIII (1969), 291-325.

[10] Vlastos, "Reasons and Causes in the *Phaedo*," 306.

Plotinus, embraced the notion of the Form as (efficaciously) causal. We may say this much then: those things which are expressible have some characteristics which make them akin to the Forms as interpreted by a great part of the Platonistic tradition.

Since we are looking for a way to understand the nature of the causation from expressed to expressions, I am tempted at this point to say that that causation is like the causation alleged to hold between Forms and their particulars. Such a move would not be objectionable on the grounds that we have no adequate idea of Formal causation. For, if the discussion of causality since Hume has shown anything, it has shown that we have no adequate idea of *any* sort of causation. But, of course, even if we have no adequate idea of what it means to say that the movement of one billiard ball causes another to move, we are at least acquainted with actual cases of the latter sort of causation. Since we, or most of us, believe that there are no Forms, we cannot believe that we are acquainted with actual cases of Formal causation. Thus I hesitate to make the move I am tempted to make.

Perhaps, though, I can make the move more indirectly. Let us ask what has tempted, if not Plato himself, then his followers to think of the Forms as causally related to their particulars. What could have made such a notion plausible? In "Platonism and the Spiritual Life" George Santayana has suggested an insightful answer:

This separation of the Platonic Ideas from the things which manifested them has been much blamed, yet it goes with another doctrine which is much prized, often by the same critics. The precious consequence of this abhorred dualism was that the Ideas, if separate, might be powers, creative forces that generated their expres-

278

sions. Separation is a pre-requisite to causal connection: a thing cannot be derived from a part of itself. If ideas were only values, if they were immanent in things, as the form of a poem or its peculiar beauty is immanent in that poem, there would be no sense in saying that the beauty or the form was a power that had produced the poem.[11]

Santayana here explicitly links the independent reality of the Forms to their causal efficacy. He does not claim that the latter is entailed by the former but only suggests that persons committed to the former would find the latter plausible. They might find it all the more plausible, he might have pointed out, if they already believed that the Forms play an explanatory role *vis-à-vis* their particulars. Note now, in virtue of the parallels already pointed out between Forms and overall characteristics of behavior patterns, that it is *as* plausible that the latter are causes as that the former are. For no F is dependent upon properties common to the "acts" which express F. In this sense F enjoys a metaphysical status *vis-à-vis* those acts analogous to that of the Forms *vis-à-vis* their particulars.

Of course, it still remains quite implausible to conceive of the *Forms* as causing their instantiations in particulars. In the article cited earlier Gregory Vlastos gives some arguments to show the absurdity of holding that Platonic Forms are efficacious causes.

For since all Forms are absolutely free of spatiotemporal limitations, then if one of them were supposed to be act-

[11] Santayana, *Winds of Doctrine and Platonism and the Spiritual Life* (New York: Harper Torchbooks, 1957), p. 130.
It is especially interesting in this context to notice that Santayana uses the term "expressions" to denote the particulars participating in a Form. This is a fairly common practice among commentators on Plato's Theory of Forms.

ing on a particular spatio-temporal object, *a*, with a determinate property, P, we would have to suppose (i) that it is also acting on all other objects in the universe, including those which do *not* have the property, P, and further (ii) that all other Forms, including Forms corresponding to properties contrary to P, are simultaneously acting on *a*. How then (i) could the given Form have that specific causal effect on *a* which would account for its being P rather than not-P, without having the same effect on all other objects, including those which are not-P? And how (ii) could it have any determinate effect on *a* at all, if all those other Forms are simultaneously acting on *a* with contrary effect? The only way to avoid the absurd consequences of the supposition would be to credit Forms with the power to act selectively on different objects in the universe, directing their causal influence to some of them, withholding it from others. And how could Plato have so particularized his Forms as causal agents in the world of space and time without fouling up the most fundamental of his metaphysical principles.[12]

I believe these are good arguments for the absurdity of believing in Formal causation, given what Plato included in the category of Forms. Notice, though, that these absurd consequences follow precisely from that feature of Platonic Forms which emotions, moods, attitudes, etc., interpreted as characters of behavior patterns, do *not* share. Whatever of a person is expressed is *not* free of spatiotemporal determination; it "belongs" to the person. It is not an absolutely free-floating metaphysical entity, as is a Form. It is independent only of its own expressions and of any mental intention of which it is the "object." The arguments for the absurdity of Formal causation, thus, do not touch the thesis that the causation in expression is formal causation.

[12] *Ibid.*, p. 304.

Thus far, however, the notion of expression as formal causation gains whatever plausibility it possesses from (1) the "independent" existence of the alleged cause and (2) the fact that it is not an intrinsically absurd notion. But let us consider (3) that we have every reason to suppose that the characteristic of all F's expressions by virtue of which they show F is caused *in some way*. Indeed, it must seem as gratuitous to deny, e.g., that the "angry character" of a person's angry behavior is brought about, or produced by, some causal factor as it would be to deny that the "fatigued character" of your drooping eyelids, waning voice, and dragging footsteps is produced by some cause. Let us further consider (4) that we have no reason to believe, at least at present, that it is caused by anything other than F itself. If we put these four considerations together it becomes highly plausible to conceive of what is expressed as an efficacious cause of its expressions even though it stands in a universal-particular relation to those expressions. But this, in turn, can only mean that the expressed is a formal cause of its expressions in a way analogous to the way that the Forms are considered, in much of the Platonistic tradition, Formal causes of their instantiations.

Let us stop here to review what I am and am not claiming by the preceding argument. I do not suppose (1) that from the four considerations adduced it *follows logically* that the expressed is an efficacious cause of expressions. I claim only that the four considerations render it *plausible* to so conceive of expression. By means of this plausibility, furthermore, I do not intend to *justify* in any ultimate way the notion of formal causation, but merely, first, to *show* that the causation that we *attribute* to expression must be formal causation and, second, to *explain* how in our common and unreflective way of thinking about expression we could have come to such a concept. Our problem all along has been: What do we mean when we think of expression

as causal? The answer is: We think of it as a kind of formal causation. That is the only concept of causation that we can reasonably think of ourselves as having been applying in our ordinary ways of thinking and talking to cases of expression.

In spite of the ingenuity of the above dialectic, some will complain, "formal causation" is too unclear to be accepted as a genuine form of causation. For, after all, we have no grip on the sort of efficacy which F (as general characteristic of a pattern of "acts") is supposed to possess. That is certainly true, if by "having a grip" is meant "having an actual model from outside the realm of expression." But, for better or worse, there are no models of formal causation outside of expression. The causation involved in expression is the only sort of formal causation there is. That is what ultimately substantiates the Romantic intuition of the originality of mind, in both senses of "originality." The formal causation involved in expression is *sui generis*; there is no way of understanding it on the model of other forms of causation. In any case, as I mentioned earlier, we do not even have a firm grip on the concepts of cause applied to causal phenomena with which we are better acquainted. We have indeed many theories about these phenomena, but they are surely only problematically successful. "Getting a grip" on "formal causation" should therefore only amount to this: recognizing it as a genuine and unique sort of causal phenomena.

In fact, it is just because of the uniqueness of formal causation that the controversies about causation which have exercised modern philosophers since Hume do not necessarily even apply to it. For example, because formal causation does not essentially concern *events* at all, the question of the temporal priority of cause to effect is irrelevant. Further, the alleged "independent describability"

condition of causes and effects is blatantly "violated" in formal causation. Finally, the whole issue of the law-like character of causal relations is quite uninteresting with respect to formal causation. For it is either clearly false or trivially true that anything like "constant conjunction" obtains between expressed and expressions. These three issues are indeed legitimate and important with respect to the range of phenomena which modern philosophy has included under the concept of causation. But that range did not originally include, I believe, the expressed-expression relation. And I think I have argued successfully that latter-day attempts, however feeble, so to include it, must fail.

I do not see any of my claims, therefore, as implicitly taking sides in the theoretical controversies which have raged over the concept of causation. I see my results, rather, as arguing for a broadening of the accepted range of causal phenomena. This means, of course, that one cannot validly argue that the formal causation involved in expression is not truly causation on the grounds that it fails to meet conditions specified by theories constructed to accommodate *other* sorts of causal phenomena. The question naturally comes up, by what right I call the relation between expressed and expressions "causal" at all. My answer is that this relation is causal according to our common intuitions embodied in our ordinary and natural ways of speaking. This position presupposes that the lowest common denominator of all the varieties of causation is nothing more precise, clear, or unambiguous than what I have called (perforce misleadingly) "efficacy."

At this point it is worthwhile to take some explicit safeguards against a possible misconstrual of my comparison of what is expressed to "real" universals. I am claiming that any person's expressed *F* can be interpreted as a (real) universal *vis-à-vis* its actual and possible expressions. This

claim does not entail the claim that F *in general* is a "real" universal *vis-à-vis* the person who has F. In other words, my interpretation of x's F is quite compatible with, e.g., a nominalistic theory of terms for feelings, emotions, attitudes, moods, etc. "Anger," for example, does not denote a (real) universal instantiated by the distinct emotions of Tom, Dick, and Harry, who are all angry. Emotions, and indeed any other sort of thing which is expressible, may be radically unique, as some expression theorists have maintained. And if they are, that fact does not conflict with the sort of realism I am arguing for. To put the point in another way: x's anger is a particular with respect to the general term "anger" and a sort universal with respect to the expressions of x's anger. It is x's anger, and not anger in general, which I am comparing to a Platonic Form.

IT IS NOT sufficient, however, simply to interpret any person's (expressible) F as an overall character of a pattern of his actual and possible acts. For we still must understand why such overall characters differ from such characters as are exemplified by case (17) of showing discussed in Chapter Eight. The problem, in other words, is to distinguish "purely behavioral characteristics" from all those sorts of things which can be expressed, given the preceding interpretation of the latter. In particular we must ask why it is that a similar "realism" is not forced upon us with respect to "purely behavioral characteristics." But we must not give as an answer simply that "purely behavioral characteristics" do not "cause" their appearances in behavior, because we also want to know *why* they do not cause that behavior. And it further begs the question to point out that "purely behavioral characteristics" are not expressed. I have been using F as a variable restricted to what can be expressed. In the

following discussion I shall use P as a variable restricted in range to all "purely behavioral characteristics."

Let us now note the differences between the conditions for the correct application, respectively, of F and P to a person x, assuming that both F and P designate overall characters of a pattern of x's actual and possible "acts." It is obvious by now that if x's "acts" show F in virtue of nothing but x's deliberately making them show F, F is not truly applicable to x. Under such conditions x might be feigning F, pretending to have F, acting as if he had F, or imitating someone with F. In such cases, although F might still designate an overall characteristic of a pattern of x's actual and possible acts, F is not x's F and therefore it does not fall in the class of phenomena we have been discussing since Chapter Six. Ascribing F to x, in other words, presupposes that if F shows in x's acts, it is because of x's F and for no other reason which competes with F.[13]

On the other hand, the same is not true of P. I may call x an informal, sophisticated, or severe person and justifiably so call him. It may or may not be the case, however, that x's actions are informal, sophisticated, or severe merely because he deliberately makes them so; x may be informal by virtue of a desire to lead a style of life different from that in which he was born and reared. One may suspect that x's informality is achieved at the expense of considerable effort and dedication and does not come as "second nature" to him. For all that, one does not decide that x is not really informal, after all, if his acts are always or for the most part

[13] This is so, of course, because there can be no actual cases of x's F being commensurate with what shows in his acts and x's *deliberately* doing those acts under the properly expressive description. The "deliberation" would be redundant in such cases, and therefore, any story which included an account of such "deliberation" would simply be incoherent.

truly informal. Similarly, a person naturally inclined to be soft and pliable may undertake to be severe and hard in his relations with people if he thinks, for example, that softness is weakness, or that severity is more effective in getting what he wants. He may succeed in being a severe person by dint of his efforts. It is also quite clear that a person's sophistication can be the result of hard study and be sustained by concerted effort.

Even in the circumstances, however, in which x's P is deeply "internalized," when it is engrained in his very nature, when it has become "second nature" to him, when it is "instinctive," spontaneous or "native" to x, x's P is not, *under such a description* spoken of as "expressed," nor is it the *cause* of the P shown in x's behavior. It is the case under these conditions, however, that P can be *redescribed* and, under the redescription, both be expressed and be the cause of its expressions. Thus, *the severity and hardness of x's whole nature* can be expressed in "acts" which show severity and hardness. The same is true of x's "*instinctive sophistication*," his "*deeply engrained politeness*," his "*thoroughgoing and fundamental flamboyance*."

The case is interestingly similar with respect to certain mental qualities like acuity, precision, clarity. A person may be acute, precise, or clear-headed, and an argument or speech of his may *show* those qualities. They do not *express* his acuity, precision, or clear-headedness. But they might express his *natural acuity of mind*, his *precision of mind*, or his *clarity of mind*. In these instances the phrase "of mind" serves to remove the possibility that the quality of one's "acts" might not be in some sense "spontaneous" or "natural."

In short, the undeniable difference between x's F and x's P does not oblige us to deny that F denotes an overall feature of a pattern of x's "acts." It merely requires us to acknowledge that the conditions of the application of F to x

286

differ from those conditions with respect to *P*. This difference also explains why *x*'s *P* is not regarded as a cause of *x*'s respective "acts," while *x*'s *F* must be regarded as the cause of its expressions.

WE ARE now equipped to discover how it is that interpreting that which is expressed as an overall characteristic of "act" patterns can be reconciled with the "internal" character of what we express. Let us first distinguish three distinct ways of using terms of "innerness" including "in," "within," "internal," and "inner."

(1) These terms can be used in a straightforwardly spatial way. In this sense they are often used interchangeably with "inside" and "interior" in an unproblematic way.

(2) These terms can be used to designate the whole realm or any part of what I'll call our phenomenological awareness. This is the range roughly of what we are wont to call our "private experiences."

(3) Finally, these terms are used so that they are roughly equivalent to "inherent." In this use, they need not retain any suggestion of uses (1) and (2). The following are examples of this use:

(a) Some historians have sought to account for the course which revolutions take by speaking of an internal dynamic in the very nature of revolution.

(b) It is an inner law of bureaucracies that the larger they become the greater becomes their need to expand.

(c) For Hegel, World History takes a course determined by its own inner law.

(d) Some art historians have sought the principle of stylistic change in economic or social conditions, while others have maintained that changes occur

287

on principles internal to the nature of art and its peculiar problems.

(e) Aristotle distinguished art from nature by saying that anything natural has its principle of generation within itself. Thus he was able to say that it is man that begets man, but skill which makes a house. (Cf. *Metaphysics* 1070a 5-10 and *Physics* 192b 10-35.)

There are two important features to notice about the last use of "innerness" terms. First, all its uses occur in the context of giving an explanation of some sort. Second, the principle of explanation is said to be, or implied to be, internal to, i.e. inherent in, some "nature" or "essence." It is the nature of revolutions to develop as they do. For Hegel, there is no way to explain how World History develops except to speak of the very "nature" of the world-historical process. Bureaucracies are, in their very nature, self-inflating. The peculiar nature of artists' special problems give rise to stylistic change. For Aristotle it is with respect to the nature of man *qua* man that he produce more men; but it does not belong to the nature of marble (or to the nature of statues) to generate statues. Thus it is that we use the term "inner nature" or that we can say that it is *"in* the nature" of a thing to do such-and-such. Notice, by the way, that in none of these examples does it matter whether there actually exists an inner principle of the sort alleged. I am interested here solely in the way that terms of "innerness" work.

It is, I suggest, the third case of "inner," which is at the root of our conviction that that which is expressed is "internal." For, as we have seen, it belongs to the "nature" of x's F to produce just the sort of "acts" which show F. x's F is thus an "inner" principle of x's ways of acting; or we might say that x's F works according to an "inner" principle to

produce expressions showing F. Of course, this sense of "inner" has nothing essential to do with either of the other senses. How, then, do we come to suppose that what makes what we express or could express "inner," is, as noted above, the fact that we have "inner" and "private" "access" to them?

Before we answer this question, let us make two points concerning the phenomenological innerness of x's F. First, let us notice that certain inner experiences can accompany x's P as well as x's F and that these experiences do not differ in any qualitative way in each sort of case. Second, the inner experiences of x can sometimes function with respect to x's F in such a way as to provide grounds, though probably never *sufficient* grounds, for x to attribute F to himself even in the absence of any expressions of x's F. On the other hand, x's qualitatively indistinguishable inner experiences can never function in a similar way with respect to x's P. These points are illustrated below in (1a) through (4a) and (1b) through (4b).

(1a) When we are sad, angry, or joyful we usually have kinaesthetic sensations of a variety of sorts. When sad, we can often feel a sort of pressure in our chest and we can feel tears start to come, even if we never get to the point of actually producing noticeable water in the eyes. These experiences are sometimes described in the sentences "My heart is heavy with sadness" or "Sadness welled up inside me." It is thus that we can speak of feeling our sadness within us. Similarly we can feel our own anger. We feel the blood pound angrily in our temples. There may be a churning in our stomachs, a choking sensation in our throats, and we feel our blood racing in our veins. We describe ourselves as "seething inwardly with anger." Analogously, "our heart leaping with joy" describes certain kinaesthetic sensations, as does the phrase "I felt my joy would burst forth" when we have an expanded feeling in the chest and feel our mus-

cles prepare to exert themselves suddenly as in a jump or a thrust of the arms or a shout.

Because of these sorts of experiences, therefore, we do not need to notice our own *behavior* to know that we are sad, angry, or joyful, and we are often in a better position to know whether we are indeed angry, sad, or joyful than anyone else. I am not suggesting here, of course, that these experiences are by themselves and apart from *any* context ever *sufficient* to allow us to know we have such emotions. It is just that these feelings may be part of our grounds for knowing we are, say, angry even if we do not behave angrily.

(1b) On the other hand, we can imagine a person who, for a rather brief moment of his life, becomes outgoing and flamboyant. He is not a flamboyant person but is rather quiet and even mousy. At a party, however, in the company of stimulating persons who do not know him, he suddenly undergoes a change. Without having drunk a drop, he sings lustily and performs card tricks with great gusto and aplomb using elaborate gestures and speech. For this brief moment, then, he is flamboyant even though he never again acts in that way. As he reflects back on his behavior, the man remembers how he felt during the party. His blood was running very fast, he felt "tingly" and "jittery" all over, there was an "expanded" feeling in his chest. He experienced sensations, in other words, of the general sort described in (1a).

Notice, though, that we would not speak of the man's blood racing flamboyantly through his veins. His heart was not bursting with flamboyance. He did not tingle with flamboyance. He did not in any sense *feel* his flamboyance within him. He might say, of course, that he *felt like being* very flamboyant. We might even agree that it was due to these "inner" sensations and feelings that he was able to *act* so flamboyantly. These "interior experiences," however,

do not seem in any way to be a *part* of the man's brief flash of flamboyance, in the way that one's inner sensations are "parts" of one's emotions. Moreover, these sensations could not have functioned to the man as a *ground* for believing he was flamboyant at the party. There are no imaginable circumstances in which he might have felt the way he did, have not acted flamboyantly and have nevertheless said of himself that he was flamboyant at the party that night.

(2a) We can imagine that a person harbors a deep hostility towards his father even though that hostility has never been shown in his behavior. How might that person himself come to realize his own hostility? He might frequently catch himself fantasizing encounters with Father in which he curses and berates him for whatever shortcomings he supposes to be his. Perhaps he remembers a number of dreams which indicate his hostility towards Father, such as the one in which he, as a giant, presses the life out of diminutive Father between his fingers.

(2b) Consider, on the other hand, a very polished and well-mannered person who has fantasies and/or dreams of himself meeting the Queen, dining with her, displaying his impeccable manners, and finally being knighted for the faultless way in which he conducts himself. Clearly, if the fellow never *acted* well-mannered and polite outside his dreams, such fantasies and dreams could not indicate that he was such. Even supposing that he does act in general very politely, however, his fantasies of his own polite behavior do not afford him any grounds for believing he is extremely polite. They are, in other words, in no conceivable sense a "part" of that politeness, in the way that the fantasies in (2a) are a "part" of that person's hostility. For in a case like (2a) we can speak of the persons fantasies *showing* his paternal hostility, but in (2b) the dreams do not *show* the dreamer's politeness.

(3a) It is imaginable that you might come to be aware of your own sensitivity to certain textural effects in nature in the following way. You catch yourself enjoying the way in which the late afternoon sun lights up the rocky hills between the university and home. You realize that this experience is one that is repeated every evening when you drive past the hills: there is a sensation like a pang of excitement as you catch sight of the hills; your forehead gets prickly; and you get "tactile images" on the ends of your fingers, as it were, as if you were running your fingers, God-like, over the rough surface of the mountains.

(3b) It is not possible, on the other hand, to come to a realization of how *frugal* you are in the following way. Your rich aunt invites you to dinner at an incredibly expensive restaurant. Unable to finish your meat course, you watch as the waiter removes the remains of it. But you feel a sudden urge to reach out and wrap the uneaten portion in a napkin to take home with you. As you realize that what you have left will be thrown away, you get a sinking feeling in your stomach and your forehead gets prickly. Even though you retain a grip on your manners, you suddenly realize, from this reaction, how your frugal upbringing has affected you. What you cannot realize on this basis is that *you are frugal*. Such an experience might, of course, lead you to notice your own behavior, and you may notice thereby that you act frugally on many occasions. But your feelings in the restaurant could not on that account be considered evidence to you of your frugality. Thus it is that when one notices the experiences in (3a) one can be said to *notice* one's sensitivity to textures in nature. But when one notices one's feelings at the restaurant, one does not thereby *notice* one's frugality.

(4a) One may also notice the quality of one's imagination by noting what sorts of fantasies one has. Suppose that one

realizes that one has peculiar fantasies of certain real persons which are sparked by seeing those persons. Thus when one sees one's peroxided and pin-curled neighbor, she is transformed, as it were, into Mrs. Southern California; the pin-curls "grow" to outlandish proportions and the hair becomes a ghostly and horrifying white. By your imaginative transformation, your neighbor becomes a caricature of herself. You note the Dickensian cast of these fantasy figures and see your own mind as similar to Dickens' own "abstract" imagination, even though you, unlike Dickens, have never even tried to describe, portray, paint, or draw caricatures.

(4b) One does not, however, *notice* that one is informal on the basis of this sort of a fantasy. One may, of course, have fantasies of, say, the university being operated entirely at the beach with students and faculty and chancellors dressed in swimming suits. This sort of fantasy may actually lead you to realize that you have inclinations or desires to lead a more informal life than you do. But if your actual behavior is in all respects quite formal and "proper," your fantasy cannot be any sort of grounds for believing yourself to be an informal person.

Let us now notice that it is impossible that x's P never be shown in an act of x's. The same is not the case with respect to x's F. In this respect, interestingly, x's F shares an alleged feature of Platonic Forms; x's F exists independently of its instantiations (i.e. expressions) and therefore requires no instantiations in order to exist. Furthermore, there seem to be no *evidence of* x's P which would not also *show* x's P. This is not to say that there might not be *evidence that* x has P. Historical evidence that, for example, Charles was bold might be that he was called "The Bold." But such evidence is not *evidence of* his boldness. Similarly, there are no *signs of* x's P which are not x's acts which exhibit P. But not only is it the case that there may be evidence

of, as well as signs of, x's F which do not show F, there may be such evidence or signs even if nothing x does shows F.

Now it is no more puzzling why we should have "inner experiences" which give us grounds for attributing F to ourselves than that there should be evidence or signs (which are not expressions) of our F which give other people grounds for ascribing F to us. And the reasons, then, why we do not have inner experiences which so function with respect to our own P should be no different from the reasons why there is no *public* evidence, or sign, of our P which exhibits P. I am not suggesting here that the inner experiences discussed in (1a) through (4a) are all properly *called* signs of, or evidence of F. I do believe, however, that they can, and sometimes do, *function* for us with respect to our own F just as signs or evidence of our F function for others with respect to our F. It is no *more* puzzling that there be "inner signs" of our F than that there be public signs thereof, because in both cases we are, on my interpretation, talking about overall characteristics of a person's pattern of "acts," and we would expect such a "thing" to be evident in nothing but the constituents of that pattern.

Our problem, then, comes down to this: why is it that there can be signs or evidence of x's F, which are not expressions of F. For since those signs or evidence apparently are connected with F in a sort of *causal* way, F must be such as to be able to cause them. F must, in other words, be such as to cause our dreams, our kinaesthetic sensations, our "acts" of attention, as well as our skin rashes. Yet if F does so cause such things, the causation involved cannot be analyzed as formal causation, and therefore F must be other than a variety of "universal."

That the latter consequence is not necessarily implied by the fact that there are non-expressive signs of F is easily seen. Although it is no doubt true that many "natural" signs

are in some way causally involved with what they signify, it is by no means the case that they are all effects of what they signify. The case of spring and the croci will make the point. Croci blooming is a sign of spring, but not its effect. It is the effect, rather, of conditons, chiefly warmth, which are characteristic conditions of spring. Likewise, the bright red color of meat is not the effect of its freshness, but rather of a condition—relatively short exposure to the air—which is itself a condition of its freshness. Therefore, all that we need to admit is that F is "conditioned" or even "caused" by some bodily factors or other, however unknown to us, in order to explain how some other physical phenomenon might be a sign of F.

But it is not at all a consequence of the interpretation of F which I have given that it has no bodily causes or conditions. I have already stated that F, although a universal, and even a Platonic Form of sorts, is different in this absolutely crucial way from Platonic Forms: namely, that it enjoys no absolutely disembodied existence. There is every reason to believe, and none not to believe, that everything which is expressed by a person does depend in some way on bodily functions, processes, and elements. That being the case, it is to be expected that there be non-expressive signs and evidence of F and that there be experiences "private" to x which could function for x like signs or evidence of x's F. Indeed, if it were not the case that x's F depended upon something other than its expressions, it would be quite incomprehensible how it, as a sort of universal, could exist independently of its expressions. It would be as incomprehensible as how Platonic Forms can exist independently of their particulars.

On the other hand, there is absolutely no need for us to explain how P can exist independently of its characteristic acts; for it does not. Rather, x's P, as so *described*, depends

upon nothing but the behavior which "instantiates" it. That is the reason that there are and can be no signs, private or public, of P which do not show P. For there would be no way of explaining how there could be such signs of P. The inner experiences of (1b) through (4b) can only function as "private signs" or "evidence" of P insofar as P is redescribed to guarantee its nonintentional existence, as, e.g., from "precision" to "precision of mind."

There are, then, two reasons why x's F should be called "inner" but only one of them is essential to F as an expressible. As far as the expressibility of x's F is concerned, the phenomenologically interior aspect of it is purely accidental. Indeed, it seems to me that the fact that x does have such interior access to his F is due to the contingent fact that people are sensitive in a kinaesthetic way. We might easily imagine people who were not so sensitive. And despite the fact that the lack of such sensitivity might have caused the human race to lose the evolutionary struggle, such a lack would have made us no less human than we are. In particular, it would not have made us less capable of expressing the large variety of things which we do express. And therefore it would not have deprived us of one interesting and very important sort of our much-admired "innerness."

LET us state as clearly as possible now what the preceding arguments have established. We take F as a variable ranging over anything that may properly be spoken of as expressible and x as a variable ranging over persons. Thus, x's F is an overall characteristic of a pattern of x's acts, both actual and possible, such that F shows in those acts; F is applicable to x only if F does not show in x's acts by virtue solely of some intentional act by x or others; and an "act" of x's is understood as anything which is denoted by a verb whose subject is x.

Where now do we stand with respect to some of our earlier questions? Are expressions like natural signs? Do expressions relate to what they express according to any non-mental or non-expressive model? The answer is that expressions are like one sort of natural sign, namely, the "natural" signs of fatigue. Whether this implies, however, that expression is like any non-mental relation is not at all clear. For fatigue, although obviously a condition of the body, can also "affect" the mind. There can also be mental fatigue, and it frequently goes along with or is part of bodily fatigue. Furthermore, bodily fatigue can be phenomenologically *felt*. One can be tired and feel that one is tired, and feel the tiredness of one's muscles. One can, in short, know that one is tired on the basis of what and how one feels, even if it is dubious that one could know that *only* on the basis of what and how one feels.

Not only does *x*'s fatigue *show* in the way that *x*'s F shows, not only does it "cause" the signs which show it, but it also has a phenomenologically "inner" side to it. Despite the fact that fatigue is not properly said to be *expressed* in its signs, therefore, it must be regarded as representing a kind of borderline case of expression. The way it shows in its signs is not a clear case of the non-mental and the non-expressive. In fact, one must understand the sort of showing involved in the signs of fatigue, not by relating it to other "natural" signs, but by relating it to expression.

It is important, however, to see the limitations of these conclusions. In the first place, they apply only to those mental factors which are properly thought of as "expressed." While this includes a great deal, it also excludes quite a bit. The whole realm of mental *activities*, including most of what is considered intellectual activity, is not directly touched by the above conclusion. Such phenomena as sensing and perceiving, believing, and willing, knowing and wanting are

likewise excluded. The whole realm of the intentional, taken by a powerful strain in modern philosophy to be the very mark of mentality, is not included. The area of the phenomenologically "immediate" and what some are wont to speak of as "self-consciousness" is likewise not covered by the above conclusions. To speak of the latter as vindicating a "theory of mind," therefore, is rather misleading.

Nevertheless, the conclusions arrived at do seem to have implications for all the above areas of the mental. We saw in early chapters how expression, in the sense discussed in Chapters Six through Nine, does make important contact with beliefs and ideas, with all sorts of intellectual activity, including science, and with the simplest uses of language. It would be the subject of another, more far-ranging study to discover how the realm of expression relates in general to the whole area of mental activity, intellectual activity, and to intentionality.

In the present chapter, moreover, the realm of expression has been found not to presuppose phenomenological interiority or any sort of self-consciousness based upon the latter. And it has been made abundantly evident that this fact, in turn, does not imply an impoverishment of our notion of "humanness," or human mentality, or of human potential. For even had it happened, however improbable it seems, that man had evolved without his "interior senses," those very features of man which seem most admirable and most precious about him, and which seem to constitute his spirituality and a great deal of his mentality, still could have existed in all their present splendor (and fearfulness). Indeed, the only things we now possess that we would have lacked in such an evolutionary circumstance are those various attitudes, sensitivities, and "disciplines" which feed upon the "objects" of the "interior senses," because the latter are

their proper and only objects.[14] And yet were such attitudes and sensitivities impossible to us we would lack, for the most part, only those opportunities for morbid "self-involvement," misguided "spirituality," and intellectual quackery which we could well afford to lose. I hope it is clear that the theory of expression I am arguing, however, does not deny the *existence* of a realm of phenomenological interiority. It denies only a good share of the significance which has traditionally been accorded it.

I take it to be clear that the conclusions of this chapter should not give any comfort to the obscurantist tendencies of Romanticism. Nor should they, in themselves, encourage a religious veneration for the human soul and its creative powers. Nevertheless, there are many persons who will find these conclusions uncongenial, even if they find them sound. They will only have to point out, then, that however astute the foregoing analysis may be, it leaves an essential question unanswered: Is there *really* an original mental source operating in the "external" world? After all, they might say, I have done nothing but explore the implications of the *concept* "expression." And the results of that exploration rest squarely upon the idea of causation involved in that concept. But the concept of expression is, as was indicated in the Introduction, a historical phenomenon. Could it not be, then, that the above results are nothing but figments of our conceptualization?

I think it could be. The widespread opinion, not always articulated, that there is no sense in asking metaphysical questions which transcend an analysis of concepts is surely

[14] I am thinking here, for example, of some sorts of mysticism which depend upon fantasies, dreams, illusions, and hallucinations of many varieties. I think also of "the interpretation of dreams" and certain varieties of phenomenological analysis or description.

false. One can certainly meaningfully entertain the idea, for example, that some day if the chemical, physical, and/or physiological roots of expressive acts are uncovered, the concepts of expressing, showing, and the "formal causation" they imply will not only become useless but will be shown to be something like mythical fantasies originating simply in ignorance. There might come a day when the concept of expression and its implicit notion of mind is shown to be as metaphysically significant as the belief that Heaven is in the sky. Nothing I have established in this inquiry, at least, precludes that possibility. To answer the question of the metaphysical ultimacy of the notion of expression elaborated here would require, first, a thorough account of the origins, sources, and causes of what we can express in our acts and, second, a sound understanding of what "metaphysical ultimacy" means. Neither is in our possession; nor will it be supplied in this book.

chapter ten

Self-Expression

∾

The so-called "problem of the self" has been closely connected, historically, with questions concerning the nature of mind. We should therefore expect a theory of mind, especially one which concerns itself with feelings, attitudes, emotions, and mental qualities, to have implications for the idea of "self." This is especially true of a theory of mind based upon the concept of expression, for it is the self which is frequently spoken of, in a variety of idioms, as "expressed." These facts alone would be sufficient reasons for discussing the concept of self-expression at this point. There are, however, more interesting reasons.

The "problem of the self" is, in reality, two distinct problems: one, concerning the *nature* of the self, and another, concerning the *unity* of the self. In modern philosophy, however, it is the latter problem, under the rubric "the problem of personal identity," which has received by far the greater attention. In fact, the problem of the self is sometimes simply identified with the problem of personal identity. It should be apparent, however, that a solution to the problem of the *unity* of the self already presupposes a solution (or at least a partial solution) to the problem of the *nature* of the self. In fact, one cannot even properly inquire into the self's unity without a conception of the self's nature. Thus when Hume went searching for the constant impression which, to him, would have guaranteed personal identity, he already had made up his mind that the self must be either an impression, an idea, or some function of these. One must,

in order to look for unity, know where, i.e. among what categories of things, to look for it. But to categorize the self is already to solve much, if not all, of the problems of the nature of the self.

An obvious reason why the problem of the self has, in philosophical practice, collapsed into the problem of the unity, or "identity," of the self is that, in large measure, all philosophers who have sought to solve the problem of the self's unity were in rough agreement concerning the nature of the self, that is, concerning the *category* in which the self is to be located. It was Descartes, after all, who set the problem of the self in its modern, i.e. its only, form. The "I," according to Descartes, is a "thinking thing"—a mental substance. And the mental is for Descartes, and a great part of the modern tradition, that which is introspectively accessible. The common presupposition, therefore, within which the battles over personal identity have been fought, is that the "nature" of the self is definable in terms either of what is phenomenologically "interior" or of what is implied or presupposed by what is phenomenologically "interior."

Now although the problem of personal identity has chiefly been posed as the dry metaphysical problem of accounting for unity amidst obvious diversity, the significance of the problem goes much deeper. For when one understands the principle of the unity of the self, one is in a position to understand the unique principle of one's *own* self. One understands not only what it is to be *a* self, but one is able to go on and discover which self he is. One should, in other words, be in a better position to answer the questions: Who am I? What are my essential characteristics as a particular unified self? How can I be "identified" as a particular self? What, in short, constitutes my particular "personal identity," the "unity" of my self? The problem of personal identity thus takes on a "personal" meaning. It has a "moral" signifi-

cance, in one fundamental sense of "moral." For this reason Hume's critique of personal identity has seemed to some quite devastating indeed. For it contains the suggestion, at least, that we are by our very natures doomed, as it were, to be fragmented and unintegrated. For if Hume is right and it is the nature of any self to be a "bundle of perceptions" then the question "Who am I?" is answerable only by "this particular bundle of perceptions," and nothing else can relevantly "identify" me as a particular self.

Of course, in spite of Hume's critique there is something comforting at least in the presupposition concerning the general nature of the self which Hume shared with other modern philosophers. For if the self is definable in terms of what is introspectively accessible, then if its unity is, in principle, discoverable, every individual will be able to discover the unity of his own self, for every one indisputably has an introspectively accessible "interior." And if Hume is right that there is no "real" unity of the self, this is a misfortune which all human beings share.

Strictly speaking, of course, the moral concern which we have in the problem of personal identity presupposes that *some* persons might fail to have a unity, i.e. a personal integratedness, and hence must fail to discover who they are. Some persons might, after all, simply be "nobody," in these terms; they might, in other words, fail to make a coherent person of themselves and thus have no unity, no "identity." But the Cartesian presupposition concerning the nature of the self in effect guarantees that the sheep and goats will not be thus separated. By hitching our moral concerns for our own self-unity to the modern notions of self, we ultimately preserve ourselves from the embarrassment of moral defect.

Given, therefore, certain of the conclusions of the preceding chapter, any notion of self which depends upon the con-

cept of expression might seem more threatening than even Hume's critique of personal identity. For if it is true, as I argued, that from the point of view of the expressible aspects of mind, the realm of the introspectively accessible is quite inessential, and if it is related to the former only as a sort of convenient "bonus" thrown up by the evolutionary process, than any notion of self which is tied to the concept of expression is likely to be similarly (un)related to the phenomenologically interior. But it might be disconcerting for some to discover that where they have been looking for them*selves* (and where some believe to have *found* themselves) is not even the right direction. It might be disturbing to find that the self, and *a fortiori* its unity, is only evident in what one *does* and how one does it. It may be uncomfortable to realize that the *task* of being a unified self, therefore, still remains. It might be devastating to recognize that the likelihood that one has now, or ever shall have, a "personal identity" is extremely small. It will thus be interesting, at very least, to see what notion of the self an analysis of "self-expression" brings forth.

THE TERM "self-expression" and its cognates in some of their uses do not raise any issues different from the ones already discussed. A man may take a course in public speaking in order to learn to express himself more adequately. He wants to be able to express his opinions and possibly his feelings and attitudes in a more convincing, effective way. If one advises another to express himself one may simply be counseling him not to conceal and repress his feelings. If a psychologist gets a child to express himself by drawing pictures, he may want simply some information about the child's attitudes and feelings towards his siblings or towards school.

On the other hand, the psychologist may be after some more basic information. He may want to get at some "fun-

damental" attitudes of the child, attitudes which color the whole way the child regards and acts towards people and things in general. Similarly, an artist may seek for years to develop a style which truly "expresses himself." And by this he will typically mean that he is looking for a way of painting which allows him to express not simply this or that feeling or attitude to this or that person, place, thing, or event, but some basic attitudes, feelings, sensitivities, or qualities which characterize his whole person and affect his whole outlook. It is this sense of "self-expression," too, which is often operative when we can speak of a person's home or type of work or style of life being an expression of himself. This sense of "self-expression" constitutes the subject matter of the present chapter.

Let us delimit more carefully the conditions of such expression. First, only that can be expressed about a person which has as its object some comparatively general and/or large-scale aspect of a person's world. An ironic attitude towards life, a respect for nature, a sensitivity to the interconnections between man and nature, a feeling for human goodness, a joy in living—all of these sorts of things may be what is expressed when one expresses one's "self." Sometimes an abstract subjective quality, such as "pure assertiveness," "sheer energy of mind," or "utter indomitability of spirit," may be expressed and count as expression of the self. On the other hand, respect for one's mother, sensitivity to the foibles of the department secretary, a special feeling for the needs of one's eldest child, a respectful attitude towards the people who live two doors down could never be a part of an expressed "self" unless they were instances of more general feelings and attitudes.

Interestingly, however, the generality involved in expression of the self must be of rather grand proportions. One might have, as an administrator, social scientist, or historian,

a feeling for the workings of large organizations like General Motors, IBM, or Elizabeth I's bureaucracy. One might have a sensitivity to the needs and problems of middle-class suburbanites. One might have a profound respect for the achievements of modern technology. One might have, as had Howells, a "lively awareness of manners." Yet none of these, however well expressed, count as part of a self which is expressed. They are all too parochial, too historically conditioned, too particularly focussed. (Note, however, that an ironic sense of the historicity of things *may* be a part of an expressed self.) It is not enough simply that what is expressed be fundamental in a person's makeup in order that its expression count as a case of self-expression. If one of a person's *basic* sensitivities were so tied to mere fashions, to mere "historical accidents," to merely "temporary" institutions, he would perforce be "mean-spirited" in the root sense of being concerned with the (however relatively) narrow and particular.

What is required of a self which is expressed, therefore, is that it have a definite nobility. But "nobility" must be glossed here as "magnanimity," and this in turn must be taken in its radical sense of "greatness of soul." According to a notion derivable from, if not actually found in, the writings of Plato and Aristotle, the "soul" can be considered as constituted by the objects of its attentions. It is, therefore, as great as its "objects." And if its "objects" are general, abstract, and of what we may call a "cosmic" nature and import, the soul is correspondingly great, i.e. magnanimous. To be concerned with anything less than objects of cosmic significance is to be correspondingly smaller, i.e. meaner, of soul.

But meanness of soul also suggests other sorts of attitudes and feelings which, however large-scale and however fundamental to a person's constitution, cannot be a part of an

306

expressed "self." Suppose that one had a profound fear or distrust of all that is artificial and man-made. Or imagine a disgust and loathing of what is natural and uncultured. Conceive of a cringing anxiety about the historicity of things. Or imagine a bitter and snarling, or even a cruel and mocking, disrespect for all things religious. If any traits of these sorts were expressed in some work of art, say, such expression would not be a case of self-expression unless it were qualified by some more "enobling" ingredient: some joy in the natural, some love for the products of man's genius, some yearning for the permanent and stable, some respect for a purely human dignity. Fear, disgust, anxiety, and disrespect, even on a "cosmic" scale, are in and by themselves mean emotions and attitudes. Even the cosmic dimensions of their objects cannot make them into noble elements and therefore into elements of a self which is expressed. Lucifer's Satanic rages are not expressions of himself; they do not expand him, they destroy him. Hobbes's fearful vision of man in the *Leviathan*, for all its scale and despite the fact that it expresses the man's own fearfulness, is not Hobbes's expression of him*self*. Such an attitude is of itself cramping rather than enlarging. "Self-expression" is thus an intrinsically normative concept. Specifically, it excludes both the mean and the demeaning.

There is yet another important condition of self-expression which has already been mentioned but not discussed. Not only must what is expressed be of the proper magnitude, it must also be a fundamental aspect of a person in order for its expression to count as self-expression by that person. Love of nature, joy in life, sympathy for man's condition, etc., cannot be simply temporarily or occasionally had feelings or attitudes. They cannot be here today and forgotten tomorrow, revived by this occurrence or stimulated by that, if they are to be characteristics of an ex-

pressed self. Many persons, after all, have moments when they feel the closeness of nature, when they realize the awfulness or the nobility of man's estate, when they thrill to the excitement of just being alive. Yet these moments are generally lost in the great "bundle of perceptions" which comprise most people. Such feelings, attitudes, or moments of awareness are not in most people constitutive of their "selves." For however important and valuable these phenomena are to the person himself, they do not constitute *fundamental characteristics* of the person. What, we must ask, can transform introspectively accessible phenomena of this sort into basic characteristics of the person?

Surely the simple *frequency* of such private experiences "in" a person is not sufficient to elevate them into fundamental characteristics of the person. What could we make of a man who, for example, averred that several times a day he was overtaken by the joy and wonder of just being alive, but who, aside from these avowals, gave no other indication of finding life a joy? Suppose not only that usually he went about his business with a dour countenance but that he engaged in no form of amusement or recreation and spent eighteen hours a day in his counting-house. In the first place, we would probably not credit the descriptions of his own inner life. But even if we did credit them, we would not think of him as a man who could be said to have, more than anything else, a joy in life. A person's attitudes, sensitivities, and/or qualities must, in short, affect what he *does* —if they are to be used to give an overall characterization of the person. And if a man insists, despite the absence of any public evidence to the effect, that he is basically a person who enjoys living for its own sake, he must simply be counted wrong. Of course he is not wrong, necessarily, about everything. He need not be wrong about the description of

308

his own introspective experiences; he would only be wrong in how he construed them.

Yet not everything that one does *because* one takes joy in life for its own sake is enough to give one that sort of fundamental character. The same man above who did nothing besides avidly read Robert Browning and listen frequently to musical comedies would still not be doing enough to show the relevant character. Similarly, a person who avowed frequent experiences of a mystical union with Nature but whose sole contact with Nature was the reading of Wordsworth and donating munificently to the Sierra Club would surely be deceiving himself if he believed that his "love of Nature" was one of his fundamental characteristics. This would be so, moreover, even if there were no *other* attitude or quality or sensitivity which could more plausibly be said to characterize the man. That is, the merely *relative* strength of the man's "love of Nature" would by no means guarantee that the latter was a basic characteristic of the man. It might simply be the case that the man had no fundamental characteristic of the requisite magnitude.

What one does *because* of his joy in life or his love of Nature must at least be such as to *show* the joy or the love if the latter are to characterize him. If one's face is cheerful and one talks and acts with gusto and verve, if one seeks out new experiences to have, persons to know, things to discover and activities to learn—then most probably one not only *has* but *shows* a genuine *joie de vivre*. Likewise, if one seeks to be in the presence of natural things and if one writes magnificent nature poetry like Wordsworth's, one *shows* a genuine love of nature. But to *show* one's joy in life or one's love of nature is precisely to *express* that joy or that love. It appears, thus, that having a "self" to be expressed presupposes that one does express that self. Just

309

as there can be no self-expression without a self of "cosmic magnanimity," there can be no such self without the expression of it.

THE preceding conclusion can be corroborated by seeing what it is to "try" or "seek" to express oneself. We sometimes hear of a person who is looking for some occupation in which he can express himself or of an artist who is searching for a style in which his true self can be expressed. One might expect, knowing a little about expression, that all such a person would have to do in order to express himself would be to produce something, or to engage in some activity, which he knew would *show* what his own fundamental nature was. And since he, of all persons, should know what sort of attitudes, sensitivities, and/or mental qualities fundamentally characterize him, there would seem to be no special difficulty in expressing himself. For he would simply have to "look within" and match what he found with some "way of acting." Yet if that were all one needed to do, the difficulty people find in expressing themselves would be hard to explain.

One might hypothesize, however, that the reason persons do have trouble expressing themselves in some activity is that they are unable to perform the relevant sort of activity or work in the relevant sort of style. The response to this is that if the criterion of relevance is just that the activity or style express their fundamental natures, then it is true, but trivially so, that the unsuccessful seekers after self-expression cannot so perform or so work. On the other hand, what might be meant is that the persons are lacking the technical competence to be, say, a game warden or a landscape designer or a short-story writer in a Hemingwayesque style. However, if this sort of specific incompetence were the obstacle when one tries unsuccessfully to express oneself, one

would hardly say that one is *looking for* some work or for a style in which to express oneself. For in that case one would have *found* the work or style; one simply would not have acquired *competence* in it.

When one is searching for but has not found a way of expressing oneself, therefore, one does *not* know what sort of activity would serve as self-expression. Does this imply, then, that the obstacle to self-expression is that one cannot *recognize* in a sort of activity (or style of activity) those features which would *show* what one antecedently knows one's basic characteristic(s) to be? This cannot be an adequate explanation either. For surely one could know in advance that being a game warden in a National Park would allow expression of one's natural love for natural creatures and concern for their welfare and preservation. Surely one could know that poetry in the Eliot vein will show a dry, intellectualistic attitude towards man and the world. And knowing these things one may, in one's search for self-expression, try to do a game warden's job or try to write poetry like Eliot's. Assuming that one has the requisite competence, one *tries* these things simply because one does not know whether they will serve as expression of one's self, even if one knows well enough what sorts of traits they might express. And one gives up these things because they fail to offer one opportunities for self-expression. But how *could* they fail if the only problem were to match the characteristics of the activity with one's introspectively known feelings, attitudes, and mental qualities, assuming that one were right in the characterization of the activity and could hardly help but be right about what he has introspected in himself?

The only reasonable answer to his question is that when one is seeking to express oneself, one is seeking to *discover* what his own fundamental nature—his "self"—is. One reason that a person may have difficulty in expressing oneself

311

is that he does not yet, and cannot yet, know what his "self" is. Seeking to express oneself is at once trying to "find oneself," to discover what one's fundamental nature is. And succeeding in expressing oneself is discovering what that nature is.

But what is it to "find oneself?" Finding oneself is not the same thing as finding out certain things *about* oneself. One may, after all, discover that one is rude or self-centered or a severe disciplinarian or a model father by having someone else point it out to him. Or you may read of a person, fictitious or real, who is called any of these things, and you may suddenly see that you are yourself very much like that person.

But when one makes discoveries of these sorts one has not thereby succeeded in expressing oneself. And, in any case, one can only express oneself with respect to characteristics of a certain "cosmically magnanimous" sort. But one can discover any number of ignoble characteristics of oneself. If succeeding in expressing oneself is finding oneself, therefore, finding oneself cannot simply be the same as finding out certain things about oneself.

But it is not even the case that finding oneself is doing what exhibits characteristic F, which is of the requisitely noble sort, and possessing F, together with discovering that what you do exhibits F and that therefore you possess F. A poet may have pointed out to him by a perceptive critic that he does inject into his work a profound religious sentiment and a deep natural piety. Yet the poet, recognizing the justice of the critic's perception, may reject his own work as an expression of himself precisely because he is seeking a more authentic, a truer expression of himself. This point brings up one further feature about the self which is involved in self-expression. Not only must it be constituted by traits which are "cosmically magnanimous," not only

must such traits be fundamental and overall traits, not only must these traits necessarily be expressed, but they must be traits acceptable to the person in question. Only then can a person's expression of (his own) trait be a case of his finding himself and be properly described as "self-expression."

We can now see more clearly what it is to find oneself. Finding oneself when one succeeds in expressing oneself is not the same as finding a particular competence, although it presupposes some particular competence. Nor is it merely finding out something about oneself. We might say, rather, that it is like finding something to be. The notion of "finding something to be" does not have many uses. A natural one, however, is in the context of children's play. Frequently in their impromptu games of pretend, e.g. "playing house," "playing army," children will take roles in an imaginary situation. One will be the "father," another the "mother," another the "family doctor," etc. It may happen that some child is excluded in the conventional *dramatis personae* and he runs complaining to his mother. She might assure the child that he can, of course, find something to be, e.g., Uncle Tod or Big Brother. In these cases the notion of finding something to be requires (1) that the "found" role be one for which the child qualifies by virtue of his existing attributes, e.g., size, sex, costume, etc.; (2) that the role be one which is, on some relevant criteria, "important" and not, e.g., the long-dead Aunt Jane or the week-old Baby Sue; and (3) that the role be one which suits the role-taker's expectations of himself, i.e., one which the child, for whatever reasons, "wants" or "would like" to be. The conditions on finding oneself are analogous to these. First, one can only find oneself in an activity to which one "fits" by virtue of one's competence. Second, the self which one finds must be of the requisite nobility. Third, the person must *accept* the relevant traits as part of himself. Thus, just as the ex-

cluded child gets back into the game by making a role for himself, the person who, after a search, succeeds in expressing himself makes, as it were, a self for himself.

An important implication of this notion of self-expression is that expressing oneself does not *mean* exhibiting in one's important and characteristic ways of acting a self which is determinable antecedently to such exhibition. It is not wrong, of course, to think of a person who finally succeeds in expressing himself as exhibiting in an important way what he had been "all along." We must understand, however, that what he had been "all along" must either be what he had only the potentiality to become or what he actually, but only *inessentially*, was. For a person who succeeds in expressing himself is, by that very fact, an importantly different person from what he was before. For now either he has fundamental traits which he previously did not have or he has become reconciled to traits which he previously exhibited unconsciously and/or unwillingly. Once again, what this means is that, according to the notion of self implicated in "self-expression," one is only correctly described as having a self when one has expressed one's self. And since, as is evident from the preceding analysis, if one has (is?) a self of this sort one necessarily has self-unity and a "personal identity,"[1] the latter too depends upon self-expression.

IF THEN there can be no "self" without the expression of it, we will, in uncovering further conditions of the possibility

[1] Of an important sort, though not, of course, of *just* the sort that Locke, Hume, Kant, et al. were looking for. But it is part of the point of this discussion to suggest (not "prove") that they were looking for the *wrong* sort. For let us suppose that they (or their present-day cohorts) found the sort of identity they were seeking. The question would remain: Of what importance would it be? I suggest the importance would be roughly comparable to that of the discovery that each person had a single brain cell that stayed with him unchanged from before his birth to the moment of his death. That is: None.

of self-expression, reveal conditions for the very existence of "selves" who have, as I have put it, a cosmic magnanimity. Although I argued earlier that a "self" must be expressed, some further qualifications must be attached to this conclusion. For if what is expressed in self-expression is something truly fundamental to a person's makeup, its expression has to be of a sufficient "magnitude." Thus the person who takes a thoroughgoing joy in life must show this joy more or less constantly throughout his life, in a large variety of circumstances and with respect to a large variety of things, persons and/or activities. Likewise, a few trips to the woods and a poem or two about the wonders of nature, no matter how well done and "authentic" they might be, are not enough to express a love of nature which is a fundamental attitude of the self. The expression of anything, in order to count as self-expression, must figure largely in the person's life.

How largely is impossible to specify in a general way. This much can be said, however: Since a person's "work" fills up so much of a person's life, it is in the activities involved in that work that one would expect to find that person's "self" expressed. Conversely, if a person's work involves activities which are inherently incapable of expressing the range of traits which, we have found, might constitute a "self," of the relevant sort, that person is less likely to be able to express himself. There might be, in other words, varieties of "work" which tend to prevent, among the persons engaged in them, the development of a self which is cosmically magnanimous. It is important not to construe "work" in this context as merely that by which one earns a living. Rather "work" must be interpreted as "occupation" in a root sense of the latter. Work is what "occupies" a person, i.e. that which "takes up," as it were, all or most of the person in terms of his time, energy, and/or interest. In

315

these terms one's work would not necessarily be how one earns one's living. Nevertheless, for most persons the two are in fact the same.

There is no extensive tradition which hallows work as a subject matter for philosophy, of course. The following analysis may seem, therefore, rather unorthodox. It appears to me, however, that the fact that expression has not been a topic of philosophical inquiry accounts for the fact that work, too, has been neglected philosophically. For the latter topic quite naturally becomes important as soon as expression, and especially self-expression, is taken seriously. Thus it is no accident that Hegel and Marx, who took very seriously subject matters which are intimately involved with, if not identical with, expression and self-expression, should take work seriously. Thus Marx can approvingly remark of Hegel that he saw "labor" as the essence of man and conceives of man as the result of his labor. It is Hegel's deficiency, of course, to have restricted labor only to "abstract mental labor."[2] To undertake an inquiry into work is, therefore, not eccentric, even if it is not common.

Philosophers who have touched on the topic of work, like Plato, Aristotle, Hegel, and Marx, have expressed the idea that the varieties of work are not all equally valuable from an "intrinsic" point of view. In doing so, they have often seemed to embody nothing more than personal and social prejudices for and against certain sorts of work. It is an interesting question therefore whether "intrinsic" value distinctions among occupations have any foundation other than mere bias. In what follows I shall argue that varieties of work do differ in particular with respect to the possibilities they afford for self-expression. I shall also try to show how various sorts of work might be ranked with respect to these

[2] *Karl Marx: Early Writings*, trans. and ed. T. B. Bottomore (New York: McGraw-Hill, 1964), pp. 202-203.

possibilities. In order to carry out this program, we need, of course, a set of categories of work. The following list, although it is devised in the light of points I shall eventually make, accords well enough with our rough common intuitions about how work activities group themselves.

1. Art: This category includes every activity which produces what is now customarily considered a work of "fine art." This category can also include architectural designing. It excludes the writing of literary works customarily called "non-imaginative" or "non-fictional," such as the essay, biography, history, criticism. There are, of course, kinds of writing such as the journalistic novel (e.g. Capote's *In Cold Blood*) which fall neither clearly within nor clearly without this category. Such cases are to be expected throughout these categories. Their existence should be no impediment to my project.

2. Intellectual work: This category includes the doing of philosophy, science, history, criticism, and journalism.

3. Public service: This category does not include everything which commonly goes by the name "public service." It includes preeminently policy making of all sorts. The workers of this category include, besides governmental policy-makers, policy makers of large organizations such as universities, business corporations, unions, etc. The crucial property is that this be work which can affect large numbers of persons and/or society at large. Also included here are various of the so-called professions: teaching, law, medicine.

4. Nature service: This is rather like a sub-category of 3. Included in it are occupations connected with the care, maintenance, and preservation of non-human natural things. Forestry, zoo-keeping, game wardening, veterinary medicine belong here as well as pastoral occupations in general.

5. Craft: This category includes all handiwork activity

which results in a finished and completed artifact. It does not include any activity, which might be performed by craftsmen, which is essentially reparative.

6. Performing art: Here belong dancing as distinguished from choreographing, playing and singing as distinguished from composing.

7. Agriculture: This includes not only farming activities but gardening activities of all sorts.

8. Hunting and gathering: This includes the occupations dominating the cultures "more primitive" than the so-called pastoral and agricultural societies.

9. Playing: This includes all sorts of games, sports, and so-called recreational activities such as mountain-climbing, hiking, surfing, and collecting match-book covers.

10. War-making: This includes actual hand-to-hand, or machine-to-machine, combat as well as strategy design and the policy-making activities of war-making.

11. Mercantile: This includes all the businessman's essential activities: buying and selling, getting and spending.

12. Administration: This includes all activities performed by functionaries in bureaucracies other than policy-making, on the one side, and clerical work, on the other.

13. Subservient activity: This is a very broad category of work which is impossible to capture in a single label. The main feature of this work is that it consists of activities which are themselves simply constituents or stages of a larger activity. Work of this sort is essentially a means or other ingredient of a self-significant activity. It is, therefore, subservient to that activity. Included here is all work which is part of an assembly-line or other step-by-step procedure. Most present-day factory work, therefore, belongs here. The clerical work in the typical office belongs in this category. This category includes also such "purely physical" labor which consists of nothing or little more than such tasks as

lifting, chopping, pulling, carrying, throwing, pounding, digging. It also includes work which accomplishes the latter sorts of tasks by machine operation, such as chauffeuring or operating an elevator.

14. Custodial: Here are all maintenance activity, repair work, and cleaning operations. "Housework" belongs here.

The strategy for determining the expressive possibilities of the work which falls into these categories is rather simple, even if it is difficult to carry out thoroughly. We ask, first, what it is that can be *shown* in the ways these activities can be done and, second, whether what can be shown is sufficiently "magnanimous" to be constitutive of an expressed "self." This strategy will provide as precise a way of ranking varieties of work as "more" or "less" expressive as the subject matter itself will allow.

One immediately sees an obstacle in carrying out this strategy, however. We test whether a sort of work shows some F according to whether the verbs describing the work are modifiable in terms of F. But each of the fifteen categories includes a very large number of different activities, many describable by several different verbs. We seem committed to an "expressive analysis" of the greater proportion of verbs in the English language. But there surely is a point beyond which our taste for tedium must not be indulged. Therefore the following discussion will be rather impressionistic, relying at times on intuitions concerning what are the paradigmatic activities of each category and, at other times, on the results of previous chapters.

VERY little reflection is needed to realize that the whole range of expressible mentality from the most trivial emotion to the sublimest of magnanimous qualities can be shown in some art form or medium. Probably the only sort of thing

which is not artistically expressible is physical pain. The vastness of this range is explainable, of course, by the fact that "art" is itself a vast category which includes extremely heterogeneous kinds of activity. It is important to note, however, that it is not true that every conceivable F, other than physical pain, is expressible in artistic activity. It is only that there is no *sort* of expressible mentality, other than physical pain, which could not be expressed in art. We need not worry about how to identify sorts, however. For this qualification is intended only to allow for the probability that, say, "the passionate intellectuality" of an Aristotle, with all the special qualities of Aristotle's intellectuality, could not be manifested in a work of art. The logical rigor and the dryness of Aristotle's logical works, the tedious and painstaking attention to unattractive detail which shows in Aristotle's biological studies help *constitute* Aristotle's special passionate intellectuality. But these qualities are hardly conceivable in a work of imaginative literature. They certainly do not occur in the only piece of science, or quasi-science, in artistic form, namely, Lucretius' *De Rerum Natura.*

Despite the restriction of the universality of art's expressiveness to virtually all *sorts* of expressible mentality, art is clearly the most expressive of all the categories. To see this, one need only contrast art with the category of intellectual work. This category, of course, includes a great many different sorts of work, which have different expressive potential. Clearly the expressive possibilities of, say, theoretical physics are quite different from those of travel literature or of nature descriptions in the styles of Thoreau or Joseph Wood Krutch. What limits the expressive possibilities of the whole category of intellectual work, however, is the necessity that works of this sort be about something real, or something, e.g. God or Heaven, which is taken to be real. What this

limitation means is that certain attitudes and qualities of mind or spirit, e.g. a magnificent defiance of the limitations of reality, which a Faust figure might express, cannot be exhibited except in art. An expression of sheer individualistic assertiveness, of a raw and elemental drive to achieve, of pure and unfettered imaginative power such as might be seen in the Towers of Simon Rodia[3] are also impossible in any activity which must be "responsible" to a subject matter.

It is impossible to imagine any work of science, philosophy, history, or criticism which could exhibit such purely "subjective" qualities. For the very requirement of achieving truth in the latter sorts of work is incompatible with such expression. A philosophy, a history, a scientific theory, or a body of criticism, however, which is rendered *false* by a drive to assert oneself, or to defy reality, or to exercise the imagination in an unfettered way, would not be *expressions* of the latter sorts of things. Indeed, no matter what qualities they possessed, they could not be accurately described in terms of the latter. Features which in imaginative literature might exhibit noble qualities of the sort listed above, must exhibit only perversity, psychosis, or dementia when present in work which demands truth.

The latter point can be generalized somewhat. We have already at least suggested that all self-expression in artistic and intellectual work presupposes some skill in the execution of the work. Now, it appears, when the criterion of truth is applicable to some work, self-expression presupposes truth as well. It begins to look as though self-expression is incom-

[3] These are located in the Watts section of Los Angeles, whence their alternate name "Watts Towers." Rodia was an uneducated Italian immigrant who built out of scraps of junk and garbage embedded in concrete a delicate and whimsical albeit powerful series of spires and walls in his triangular back yard next to a railroad track. The project took years to complete, and when it was finished Rodia simply moved away. His motive apparently was to do "something great." His towers are now, after a successful attempt to save them from official demolition, under the protection of the City of Los Angeles.

patible with lack of "virtue" of all varieties. This does not mean, of course, that a person could never express himself if he were deficient in some virtue or other. It does mean that any activity, to be genuinely self-expressive, must not be an activity which itself lacks "virtue." This point, we shall presently see, applies to moral virtue as well as to "technical" and "intellectual" virtue.

Most art, and possibly all of the greatest art, is reality-oriented. Most of it, that is, expresses some abstract property of the "objective world" or expresses some moral or spiritual ideal. Most art does not express some *purely* subjective quality of the sort exemplified earlier. Therefore, most art which is, or could be, self-expressive of the artist expresses some "magnanimous" attitude, feeling, emotion, or sensitivity which takes as its object some "cosmic" aspect of the real world. Thus the limitation which I have noted upon the expressive potential of the category of intellectual work may not seem very important, from the point of view merely of the comparative self-expressive potential of the two categories.

Even if that be so, however, this much can be agreed upon: the first two categories of work jointly offer the ultimate degree of expressive potential. The respect and adulation traditionally accorded these sorts of activities—usually by artists and intellectuals, of course—has not been simply self-serving and/or narcissistic. There are more possibilities of being a great person if one's life work is artistic or intellectual.[4] The term "great" must be understood here in terms of the "greatness of soul" discussed earlier. Greatness in a person must not, therefore, be confused with the attractiveness, likeability, happiness, well-adjustedness, general

[4] It by no means follows that one *is* a great person if one is an artist or an intellectual rather than something else. We are concerned here merely with possibilities, not actualities.

ability and efficiency, or morality of a person. It is a further and much larger question how all of these virtues are inter-related and which among them, if any, is the greatest. I do not intend to attempt to answer the question in this book.

A further step down the scale of expressive potentiality are the categories of public service and "nature service." It seems obvious that the "architects" of a world-wide political and/or humanitarian organization or of the constitution of a new country might manifest in their constructions a sense of justice, a concern for humanity, a sensitivity to the social and/or cultural requirements of man. Likewise, we can eas-ily imagine what qualities a man would have were he *effec-tively* to organize a university—"from the ground up"—in accord with, say, Newman's *The Idea of a University*. We know of the great concerns and sensitivities which Louis Brandeis and Albert Schweitzer showed in the way they practiced their professions of law and medicine. One can imagine the concerns and sensitivities, not only with respect to man but with respect to non-human nature as well, which could be exhibited in devising and carrying out policies of nature preservation or restoration. We must remember that these possibilities of expression in these cases pertain to the executing of policies one devises oneself, not merely to the carrying out of policies and the running of organizations devised and set in motion by others. The latter sort of work belongs to the category of administration.

But the third and fourth categories are considerably more limited than the first two. They not only share the limita-tion of the second category but they afford no room—*pace* Plato—for the expression of the purely intellectual qualities exhibited in the work of an Aristotle or a Newton. This is not to imply that such attributes as intelligence, logical rigor, breadth of mind could not be shown in, say, a politi-cal policy. But there is no room here for the speculative

amplitude and penetration of the greatest intellects. By contrast, however, the sublimest of moral, social, and cultural concerns and sensitivities can be expressed in intellectual works which could never be put into effect by their authors simply because of their inexperience and/or incompetence.

Further down the scale belongs the category of craft. Making things, useful things for the most part, can never exhibit some of the sublimer moral and intellectual qualities, attitudes and sensitivities possible in the first three categories. The reasons are (1) that a craft activity is essentially non-verbal and (2) that it is generally not representational in any very important sense. Naturally there are exceptions. The shield crafted by Hephaestus for Achilles is a representation literally of the whole world. What this sort of exception means, however, is that the line between the category of "fine art" and "craft" is not definite. That has been known for some time. Let us, then, include in the category of craft only those activities which do not result in high art.

Even so limited, however, the category of craft does allow for some self-expression. Besides sensitivities to the special beauties of a given material, e.g. the softness and pliability of certain leathers, the sheen of satins, the texture of exposed-aggregate concrete work, more general sensitivities to grace and beauty can be exhibited in the work of a fine cabinetmaker, a ring-maker, a potter, even a cobbler or a carpenter. The builders of the many fine white frame churches—in the so-called "carpenter's gothic" style—which are scattered throughout America often displayed great sensitivity to grace and beauty of design.

Moreover, although crafts are essentially involved in making things for use, the possibility of ornamenting useful items is always present. These possibilities offer opportunities for expressing a striking sense of whimsy or an engaging

playfulness of imagination. The making of clothes, of vehicles, of home furnishings, and of toys is especially rich in such opportunities.

But even apart from beautiful and/or fanciful products of craft, there are opportunities for self-expression in craftsmanship which is no more than simply well done. A well-crafted cabinet with no especially striking proportions and without ornamentation will still be smoothly joined, well-sanded, unmarred, sturdy, and straight. It will, therefore, show the care, attention, diligence which have gone into its making. It will also show, by its very lack of gimmickry or fanciness, even by its faint ungainliness (which is perhaps better described as its "solid plainness") a kind of honesty and straightforwardness. While honesty, straightforwardness, and the sense of responsibility shown by care, attention, and diligence are not the greatest of human qualities, they are not the meanest either. They betoken a degree of "cosmic magnanimity" because they may express a certain "abstract" integrity of spirit.

The category of performing art is, with respect to its expressive potential, slightly higher on the scale than the category of crafts. Here, too, sensitivities to grace, beauty, and the special qualities of one's art are possible. So are responsibility, integrity, and imagination. But in this category, surely more strikingly than in the area of handcraftsmanship, we can see the sort of ultimate and self-consuming devotion in the service of an art exemplified by a Pavlova or a Nijinsky. These qualities can definitely show in the way that an artist performs. For in the very best (and, of course, rarest) performances, a sort of departure from the "real world" can take place so that the performer is, as it were, absorbed totally into his art. We may see, too, in the way a performer, particularly a dancer, "does his job" a sort of palpable spiritual *élan* or energy which is a function not of

325

choreography but of the performance of it. There would seem to be no parallel to this in the way we could work a craft. Furthermore, when we take into consideration such performers as conductors and actors, the range of expressiveness widens well beyond that of mere craftsmanship. There are depths of sympathetic understanding not only of Shakespeare and Beethoven but of humanity at large which can be exhibited in an interpretation of, say, King Lear or the Ninth Symphony, which cannot possibly be shown in the way one pursues a craft.

Agricultural activities are considerably more limited than any of the above categories, even if they are not devoid of possibilities. The more "farming" becomes "gardening" and the more "gardening" becomes "ornamental gardening" the expressive possibilities increase, of course. For an ornamental garden is a product of craft, if not of art. In planning and tending a garden one can display great sensitivities to the textures, colors, and shapes of the garden plants. One may also display considerable qualities of mind and imagination. One may even display sensitivities to the physical and spiritual requirements of human beings who would use the garden. This sort of gardening, of course, really straddles three categories.

But the expressive possibilities of simple farming, i.e. planting, tending, and harvesting edible plants, are rather narrow. One may, nevertheless, imagine a grower of plants who tends them as if he were truly concerned for them and their welfare, who is careful not to use poison sprays which might damage the plants or, ultimately, the soil, a person who "conducts" the growing process as he might a vast orchestra, harmonizing the parts, encouraging a population of toads and lizards and lady bugs to devour the evil insects, paying strict attention to nuances of climate in the various parts of the garden and to shifts and variations in the sea-

sons and the years. Such a respect for and sensitivity to natural rhythms and harmonies might surely be self-expressive, for it could exhibit a respect and appreciation of natural things which approaches the religious.

In a similar way we can imagine a person who, dependent upon what he can hunt and gather in his natural environment for his livelihood, nevertheless exhibits in his predation a degree of respect for, and even awe of, natural harmonies and relationships which constitutes a genuine natural piety. The picture is of a "savage" who is truly "noble." We need not romantically suppose, of course, that any or all of the savages of hunting and gathering tribes were or are noble in this way. We are discussing possibilities here, not actualities.

In order to say anything very meaningful about the self-expressive possibilities of "playing," a fundamental division must be made in the category of play. The division is not absolutely clear-cut, but, in general, forms of play essentially involving competition between two or more persons fall on one side of the division; other forms of play, sport and/or recreation fall on the other side. Although there may be surfing, gymnastic, and diving competitions, such competition is not *essential* to these activities and therefore the activities belong to the second division.

The chief difference between the two sorts of play, as far as self-expression is concerned, can be characterized as follows. In the first division the players must act with respect to other persons and react to the actions of other persons. But in the second division one only acts with respect to other persons and reacts to them in an unessential way. In performing actions which fall under the second sort of play, one does not necessarily do anything with, to, for, or at another person. And one's reactions are all to aspects of the world other than persons. This is surely true of surfing, hik-

ing, mountain climbing, and bullfighting. It is even true of sports which may be done alone, such as track, gymnastics, archery, and swimming. In the latter sorts of activity, one's concern is with the actions of one's own body and with how one is doing the thing.

Now it is clear that one may do activities of either sort in a variety of "expressive" ways: enthusiastically, hostilely, angrily, passionately, brutally, viciously, cleverly, intelligently. None of these ways of engaging in play activities of the first sort will ever have the requisite magnanimity to be self-expressive, however. The reasons are three: First, as far as feelings, attitudes, and qualities which are directed to objects are concerned, they are necessarily of less than "cosmic" import simply because play situations involving the interactions of individuals are always "artificial"; they are always bracketed, as it were, from the real world. One is never "really" reacting to and/or cooperating with other persons in play activity; one is always doing it for the purposes of the game. This is not to deny that one might have, say, some real feeling for one's teammates and some real hostility or respect for one's opponents and that these might show in the way one plays. What the artificiality of these play situations means is that one's feelings for and about one's co-players never takes on an abstract significance. It never can stand, as it were, for a feeling for or about persons or human kind *in general.*

The second reason that such play cannot be self-expressive has to do with possibilities for expressing purely "subjective" feelings and attitudes. In play which essentially involves others one cannot, without damaging one's effectiveness, play with, say, a joy in sheer bodily movement, a pure feeling of graceful motion, a love of violent action in itself, a sheer delight in intellectual complication. So to play would necessarily be to lose sight of one's objectives in play. To

328

play in such ways would demand that what *must* be means, given the point of the play (winning, usually), take on the quality of ends in themselves. So to play would hinder effectiveness, and therefore such playing would presuppose a lack of virtue (i.e. an ineffectiveness) in performing the play activity.

There is, however, one sort of "abstract" attitude which is compatible with playing of this sort. That is the sheer joy in, or love of, competition or battle. Such an attitude need not, obviously, result in ineffectiveness. This possibility constitutes the third reason that play of this sort cannot be self-expressive. But I shall postpone discussion of it until I deal with the category of war-making.

The second division of play activities are not subject to the same qualifications as the first. For concerning those activities, such as mountain climbing, hiking, or bullfighting, which essentially involve some non-human element, there is nothing about the context in which these activities are performed which could "bracket off" that non-human element from reality. The mountains one climbs, the landscape one hikes in, the bulls one fights are not merely playing games, in other words. One's engagement with these elements is therefore genuine and not artificial. One's profound respect for nature's power, or one's Titanic contempt for her dangers can, therefore, show in the way one engages in mountain climbing or fights bulls. Likewise, one's feeling for natural beauty, or one's joy in the harmonies of nature can be manifested in the way one pursues the simple recreation of hiking.

Moreover, concerning play activites of the second division which are not essentially concerned with non-human elements, limitations imposed by the requirement of being "effective" do not exist. One's concern in diving, for example, need be nothing more than to make a perfectly formed dive.

329

Beautiful timing, articulation, and coordination can be the only aim in a gymnastic exercise. One may surf, too, with a transcendent sense of joy in the body's graceful conquest of a dangerous natural element. These possibilities place the second division of play activities at least on a par with the categories of "agriculture" and "hunting and gathering." Perhaps it even ranks slightly higher, but such fine discriminations are hardly important to make.[5]

There are many "expressive" ways in which one might make war and fight battles: lustily, angrily, passionately, enthusiastically, joyfully, with a sense of tragic doom, with a sense of dignity, with a sense of respect for the worth and humanity of his opponent. Yet although these ways of fighting might express this or that feeling, emotion, attitude, or sensitivity, none of these can ever amount to self-expression. What we must discover is some "cosmically magnanimous" attitude with which to fight. Perhaps one might, like Satan, fight with a consuming hatred for all mankind. While such an attitude might be "cosmic" enough, it is insufficiently magnanimous. Hatred is essentially ignoble, even when justified. And, in any case, who could *justify* a hatred of mankind?

A likely candidate for self-expression is the characteristically "heroic" attitude towards war: a transcendent, burning joy in battle and its exhilaration, excitement, and glory for their own sakes. Such an attitude was recently vividly portrayed by George C. Scott in the film "Patton." If there were

[5] Of course, not every activity which belongs in the second division of play is as potentially self-expressive as every other. But the same is true for the category of art. Assessing in greater detail than is possible here the comparative expressive potential of the various arts is an appealing project which has not been carried out systematically, as far as I know. A like assessment of the varieties of play would also demand an equally subtle and interesting inquiry, even if the results might not be as rich. Such a project might constitute a *legitimate* "philosophy of sport," if there is any such thing at all.

ever a possibility for the self-expressiveness of war-making, it is presented in the character of General Patton.[6] Patton's attitude certainly has the requisite largeness of scale; it even approaches, at least, the requisite magnanimity.

Approaches, I think, but does not—indeed, cannot—reach it. For the very attitude which Patton exhibits so strikingly *essentially* depends upon wreaking harm on other human beings. It makes no difference to this point whether the war-making is morally justified, in some sense or another, just as the morality of the war makes essentially no difference to Patton's attitude towards it. The bare fact is that such an attitude as Patton's *could* not exist without the existence of killing, maiming, pillage, and destruction. Indeed, it is precisely this largeness of attitude combined with its gruesome basis that accounts for a big part of the effect of the film "Patton." One is compelled to watch Patton with admiring horror. Patton's attitude is not Satanic, for it is not perverse. But its dependence upon evil is enough to deny its self-expressive possibilities. Thus, one could not (logically) hope that another might succeed in *expressing himself* in a Patton-like devotion to war, simply because it is indecent to hope that a person will find such an attitude to be his most characteristic and personally rewarding one.

This point can be used to reflect upon the pure joy of competition said earlier to be possible with respect to the playing of games and other competitive sports. It will be objected, of course, that there is no true parallel between warring and competing in games or sports. The latter competition does not necessarily bring harm of any material, physical, or psychological sort with it. Even the most brutal of these sports, e.g. boxing, is relatively gentle compared with war. While this is all true, however, to insist too

[6] I am referring here *only* to the fictionalized character as presented in the film; it is immaterial for present purposes whether the real Patton was as the film portrays him.

strongly upon the "bracketing" of the real world in the play-
ing of competitive games and sports is to eliminate the
requisite largeness from the pure joy in competition. If the
competition is restricted simply to artificial situations, it is
to that extent less "cosmic" in scale. Can the joy in "battle,"
however intense, that one injects into the *games* one plays,
ever by itself be enough to express one's *self?* Even if the
pure joy in competition were an unambiguously "noble"
attitude, which is itself dubious, such an attitude would not
be grand enough in scale to constitute a self of the requisite
sort.

All of the remaining categories of work together take an
equal rank at the bottom of the scale of self-expression. All
of the work in categories 11 through 14 is inherently mean
work. It is mean because its focus is too narrow. One's atten-
tion in these sorts of work is always away from the cosmi-
cally universal and on the very particular. If one doubts it,
he may try to imagine how to engage in business or admin-
istrative activity in such a way as to show some abstract
quality of mind or imagination, some sensitivity to and/or
attitude towards man, God, or nature. One may, of course,
perform any of these sorts of jobs intelligently, cleverly,
shrewdly, with relish, gusto, delight, enthusiasm, even pos-
sibly with passion. It is even possible to carry out adminis-
trative duties with feeling for, or sensitivity to, the concerns,
troubles, weaknesses, and strengths of the persons affected
by the policy you are administering. But I do not know
anyone, unless it is the Pope, who runs the Heavenly City
on earth, who can carry out a policy in such a way that
exhibits any variety of sensitivity to mankind at large. And,
of course, that the Pope is an administrator, and not a pol-
icy-maker, depends upon the assumption that there is a God
whose vicar he is. That is at least an open question. How-
ever, there are no other deeper and grander sensitivities and

qualities of mind which can be exhibited in these activities. Moreover, it has been admitted for centuries, even by its foremost apologists, that commercial and financial activity is work in which one's central concern must be one's self. But this sort of selfishness, even if rendered harmless to others by an "invisible hand," is incompatible with the magnanimity required for self-expression.

The meanness of what I call subservient and custodial work is even more obvious. Even the sorts of relatively abstract sensitivities to material qualities, to grace and beauty of form and design, even the whimsy and playfulness of imagination, the honesty and responsibility which a craftsman may inject into his work are denied workers in these occupations. The custodial worker, of course, makes nothing at all. At best his work may express a concern for order, but only a janitor or repairman of literally Herculean stature can turn this concern into a cosmically significant attribute.

Although work of the subservient type frequently *aids* in the making of some object, such work does not in and by itself eventuate in a finished product. All work of this sort, therefore, fits into the total process of producing a product as the making of a few brush strokes fits into the making of a fresco. It might be true of the fresco that it was painted with great passion, sensitivity, and imaginative power, but it hardly ever is true that this or that of its brush strokes was made with such a sensitivity, or that this or that of its pigments was applied with great imaginative power. Thus it is that despite the fact that, for example, Peter Paul Rubens did not actually execute much of his large paintings, the expressive attributes of his paintings are attributed to *Rubens'* artistic acts and not to subservient acts of his apprentices.

Subservient work, in its nature, is work which is only a "fragmented" part of some greater work. But working on a

333

fragment of a product almost never allows the opportunities for the larger-scale significance requisite to self-expression. An assembly line procedure may produce a cabinet which looks just like an honest, straightforward piece done with care, diligence, and conscience by a single craftsman. Nevertheless, however carefully, diligently, and conscientiously each worker on the line has, respectively, sawn, hammered, joined, sanded, stained, and rubbed the piece, the honesty and simple straightforwardness of the piece is not theirs because they did not *design* it. None of them was responsible for the whole form.

There is only one way in which all of the last four categories can be self-expressive. There is no activity, no matter how mean or how sublime, which cannot be done with enthusiasm, gusto, and delight. And such activities so described may express the attitude of a man who takes unadulterated and uninhibited joy in living. In fact, it might be a test of the genuineness and profundity of such an attitude in a person that he be able to show it in even the most insignificant and spiritually destitute of activities. It is important to notice, however, that the more that one's life is "occupied" by activities of the latter sort, the more is the possibility of showing one's joy in living in these activities threatened. For a very wide variety of activities is essential to that particular attribute of a "self."

What are the results of all this? The preceding discussion allows us to believe now, with some foundation, that, generally speaking, persons whose opportunities for employment are restricted, for whatever reasons, to the sorts of work in categories 11 through 14 have virtually no opportunities of self-expression. If such opportunities are to be found they must be found, as were Simon Rodia's, outside one's nominal occupation. It also follows that a society in which "subservient" work, business activity, and bureaucratic

functions are the dominant forms of work and in which involvement, either as a participant or a spectator, in competitive sports is seen as a desirable way to spend one's "leisure" time and/or energy is a society in which the possibilities of self-expression are exceedingly small. But this means that the possibilities of human greatness are virtually nonexistent. Although this is not part of what Marx had in mind in his critique of capitalist society, it ought to have been.[7]

THUS FAR we have located merely the greater or lesser possibilities of self-expression in the varieties of work. Engaging in work which offers *more* such possibilities—what I shall refer to henceforth as more "articulate" work—does not *guarantee* self-expression. As a matter of fact, most artists, intellectuals, public servants, and craftsmen, to say nothing

[7] As I understand Marx, his critique of capitalist society is contained essentially in the notion of "alienated labor." For Marx, labor which is alienated does not, and I presume cannot, express anything of the worker. Alienated labor is so inexpressive because it has come under the control of powers "alien" and "hostile" to the worker. (I rely here upon Richard Schacht's helpful book *Alienation*, Garden City, New York, Doubleday, 1970, pp. 65-114.) The precise logic of Marx's idea is unclear. But he is clearly wrong if he believes that just because some "power" other than the worker controls the work, the work must be inexpressive. It all depends upon what aspects of the work are outside the worker's own control. The gardener slave may make gardens which are for him quite self-expressive if his master allows him sufficient latitude in his work, even if the master has the power to dispose of the garden or even of the gardener. However, the intuition behind Marx's critique is correct: the more limitations are placed upon the ways a kind of work can be done, the more will the self-expressive possibilities of that kind of work diminish.

My point above, though, is quite a different one. I have argued that certain sorts of work are either *inherently* incapable of expressing a worker's "self" or must, by their very natures, allow fewer possibilities of self-expression than other sorts. I find my own explanation of the human repressiveness of capitalist society more persuasive than Marx's simply because alienated control of the "means of production" in a given kind of work seems neither necessary nor sufficient to preclude self-expression in that kind of work.

of farmers and "savages," never express themselves in their "work." Greatness of soul is rare in any occupation in any age. But why should this be? Is there anything we can say about the conditions under which inherently more articulate work is done which facilitate or prevent self-expression?

I trust it is clear that merely engaging in articulate work, even if the way that work is done shows some mental attribute of the proper nobility and magnitude, is not sufficient for self-expression. The entire foregoing analysis presupposes that any such work truly occupy a substantial part of one's life. Thus an artist's entire *oeuvre*, or a large or late part thereof, might express the artist's self, whereas one or two small works would not. What counts as being "large" enough is relative to many conditions, of course. Simon Rodia's towers are the man's only work, yet their very monumentality allows them to be expressive of the man himself.

It is also important to note of Rodia's towers that their value as self-expression might be entirely destroyed were they simply one example in a substantial tradition of making fanciful towers of concrete and junk. The towers are unique, and that allows them to be expressive of a self. This fact suggests that whether a given work, or body of work, is its author's self-expression depends not only upon what mental attributes it shows but also upon its historical position *vis-à-vis* a tradition or an established pattern of that sort of work. This point is best illustrated in the arts. The builder-designer of the Parthenon cannot be regarded as expressing himself in that building simply because the Parthenon is too much like other temples of the times. It is simply a particularly excellent example of a type. The building exhibits certain attitudes characteristic of its type— a cool passion for "abstract" clarity, order, and simplicity— but these features do not express a self.

Similarly, for all the excellence of Cimabue's *Crucifix* in

Arezzo, for all the fact that it shows a certain aloof and somber religiosity, the work is too bound to Byzantine formulas to be the artist's self-expression. By contrast, the mature work of Giotto stands out as so stunningly original in comparison to what went before that the tremendous "sense for the significant in the visible world" (Berenson's phrase) evident in that work may well be Giotto's expression of himself.[8] To take yet another example, Michelangelo's *David* embodies a characteristic High Renaissance devotion to Ideal Beauty. On that account alone, Michelangelo cannot be thought to have expressed *himself* in that early statue. It is only in his later works like *The Last Judgement* and *The Crucifixion of St. Peter*, which exhibit intense, agonized religious feelings, could the artist plausibly be said to have expressed himself. For in these works Michelangelo's feelings and attitudes were like nothing which the earlier classical style had exhibited or allowed to be exhibited. I do not mean to deny, however, that even in the *David* Michelangelo's special imprint cannot be seen. For all its classical beauty, the *David* shows the artist's special power and intensity. In the work as a whole, however, such qualities do not overpower the more harmonious attributes common at the time. It is only in the later works that the uniquely Michelangelesque attributes completely take over and form something totally new and different.

More generally, then, the followers of any highly original person in whatever work, whose work is guided and informed by that person's work, are prevented from expressing them-

[8] Of course, whether Giotto did actually express himself in his work is a question which must be established by art historical techniques. To establish it in this case one would have to show that Giotto's own "sense for the significant" did "cause" him to paint in that particular way. The only point I am making above is that merely from the standpoint of Giotto's relationship to his forbears his work is capable of being an expression of himself.

selves precisely to the degree that the "cosmic" attitudes which inform their work are derivative. And this is true, I repeat, regardless of the "quality," i.e. the competence, the usefulness, or the truth, of the work which is so derived. The great majority of artists, scientists, philosophers, historians, and critics, being followers working within a style, a method, or a framework of ideas which they did not develop, therefore do not express themselves. Similarly, a member of a primitive tribe who lives close to nature does not express himself when he operates sensitively and "piously" with respect to his own natural environment; he is simply doing as he has been taught. It takes an original kind of perception and an original kind of act of, e.g., a Thoreau, to effect self-expression of this sort.

Likewise, the countless number of noble Romans who, we may surmise, lived the life of Stoicism expressed so eloquently in Aurelius's *Meditations*, did not express *themselves* in living those lives. They were mere disciples. The man who merely expands his mind on the mountaintop, becoming one with the universe by means of special training of the body and mind, does not thereby express himself. He is a mere follower; and whatever his soul may be like, it does not qualify as the magnanimous self of "self-expression." It should be quite obvious, therefore, that those persons of "cultivated" intellect and sensibility produced by what we call "liberal education" do not, for the most part, possess the sorts of "selves" which are expressed. Merely being able to "appreciate" the reaches of Beethoven or Dante or, for that matter, to "dig" the sublimer heights of Jimi Hendrix does not make a soul "great." Of course, in cases of mere "appreciation" there is no expression, so there cannot be any self-expression. But, more significantly, where there is no self-expression there can be no self either. The

338

mere "appreciator" of culture, or of nature, cannot, any more than can a mere "disciple," possess greatness of soul.

It does not at all follow that the "cosmically magnanimous" attitudes, sensitivities, and/or mental qualities which are expressed when a truly original person expresses himself are unavailable to the mere disciples or the mere appreciators. All that follows is that the originators alone are properly described as having a self-identity, as being "unified" selves. In lesser people, the attitudes, feelings, and sensitivities remain merely more or less frequent "perceptions"; the mental qualities remain only occasionally attributable to them. In original persons, however, such things are elevated to the status of characteristic and constitutive overall personal attributes. Such attributes in turn make a unity of the person and "save" him from being merely a "bundle" of activities and experiences. Self-unity of this sort is naturally quite uncommon. Almost every individual, whatever his work, lacks not only greatness of soul, but personal identity as well.

Selected Bibliography

I. Books

Abrams, Meyer H. *The Mirror and the Lamp.* New York: Oxford University Press, 1953.

Beardsley, Monroe. *Aesthetics: Problems in the Philosophy of Criticism.* New York: Harcourt, Brace, 1958.

Cassirer, Ernst. *The Philosophy of Symbolic Forms.* Vols. 1 and 2. Translated by Ralph Manheim. New Haven: Yale University Press, 1953, 1955.

———. *Wesen und Wirkung des Symbolbegriffs.* Oxford: Bruno Cassirer, 1956.

Collingwood, R. G. *The Principles of Art.* Oxford: Clarendon Press, 1938.

Croce, Benedetto. *Aesthetic.* Translated by Douglas Ainslie. Revised edition. New York: Harper and Row, 1968.

Dewey, John. *Art as Experience.* New York: Minton, Balch, 1934.

Goodman, Nelson. *Languages of Art: An Approach to a Theory of Symbols.* Indianapolis: Bobbs-Merrill, 1968.

Gombrich, E. H. *Art and Illusion: A Study in the Psychology of Pictorial Representation.* Bollingen Series XXXV, 5. Second edition, revised, third printing. Princeton: Princeton University Press, 1969.

———. *Meditations on a Hobby-horse and Other Essays on the Theory of Art.* London: Phaidon, 1963.

Hanslick, Eduard. *The Beautiful in Music.* Translated by Gustav Cohen. Indianapolis: Bobbs-Merrill, 1957. The Library of Liberal Arts edition.

Hofstadter, Albert. *Truth and Art.* New York: Columbia University Press, 1965.

340

Hospers, John. *Meaning and Truth in the Arts.* Chapel Hill: University of North Carolina Press, 1946.

Langer, Susanne K. *Feeling and Form.* New York: Scribner's, 1953.

——. *Philosophy in a New Key.* Cambridge, Mass.: Harvard University Press, 1942.

——. *Problems of Art.* New York: Scribner's, 1957.

Reid, Louis Arnaud. *A Study in Aesthetics.* New York: Macmillan, 1931.

Santayana, George. *The Sense of Beauty.* New York: Scribner's, 1896.

Tolstoy, Leo N. *What Is Art?* Translated by Aylmer Maude. Indianapolis: Bobbs-Merrill, 1960. The Library of Liberal Arts edition.

Tormey, Alan. *The Concept of Expression: A Study in Philosophical Psychology and Aesthetics.* Princeton: Princeton University Press, 1971.

II. Articles

Alston, William P. "Expressing." In *Philosophy in America,* edited by Max Black. Ithaca, N.Y.: Cornell University Press, 1965.

Benson, John. "Emotion and Expression." *The Philosophical Review,* LXXVI (1967), 335-357.

Bouwsma, O. K. "The Expression Theory of Art." In *Philosophical Analysis,* edited by Max Black. Ithaca, N.Y.: Cornell University Press, 1950.

Hospers, John. "The Concept of Artistic Expression." *Proceedings of the Aristotelian Society,* LV (1954-55), 313-344.

——. "The Croce-Collingwood Theory of Art." *Philosophy,* XXXI (1956), 3-20.

Sircello, Guy. "Expressive Qualities of Ordinary Language." *Mind,* LXXVI (1967), 548-555.

BIBLIOGRAPHY

Sircello, Guy. "Perceptual Acts and Pictorial Art: A Defense of Expression Theory." *Journal of Philosophy*, LXII (1965), 669-677.

Tomas, Vincent A. "The Concept of Expression in Art." In *Science, Language, and Human Rights*, 1952 Proceedings of the Eastern Division of the American Philosophical Association, pp. 127-144. Philadelphia: University of Pennsylvania Press, 1952.

Wollheim, Richard. "Expression." In *Royal Institute of Philosophy Lectures*, Vol. I, 1966-67: *The Human Agent*, pp. 227-244. New York: St. Martin's Press, 1968.

———. "On Expression and Expressionism." *Revue Internationale de Philosophie*, XVIII (1964), nos. 68-69, fascs. 2-3.

Index

Abrams, M. H., 3, 276n
abstract properties, 133, 136, 142, 149, 173, 183, 195, 274
achievement verbs, 144-45
Achilles' shield, 324
"acting as if," 172, 180
administration, 318, 332, 334
Aeschylus, 133, 137, 147, 151
aesthetics, ix, 158
agriculture, 318, 326, 330
Alpern, Herbert P., 121
Alston, William, 100
ambiguity of "expression," 9, 14, 217, 274
anthropomorphic properties, 18-19, 22-26, 30-32, 35-36, 38-42, 50, 52, 58-60, 62, 64, 74, 77-78, 85, 89-90, 121, 130, 146, 242, 250; of artistic acts, 45-47; compared to color predicates, 36-39; and expression of ideas, 173-75; as expressive properties, 7, 16; of linguistic expressions, 104-14, 117; as metaphorical, 37-38; and objective expression, 151-55; as relational, 39
Aquinas, St. Thomas, 178
architecture, orders of, 273; Roman, 75; "carpenter's gothic," 324
Aristotle, 3-4, 9, 124-25, 260, 277, 287-88, 306, 316, 320, 323
art, creation of, 63, 65; as expression, 26, 46, 63, 85; as reality-oriented, 322; representational, 24-25; verbal works of, 89, 135, 157; as work, 317, 320-21, 326
artistic acts, 30-31, 33, 35, 47, 65, 73-74, 77, 81, 114, 131, 146, 151, 153-55, 174, 213, 217, 333; anthropomorphic descriptions of, 45-46; attack on, 40;

metaphysical import of, 26-29; not anthropomorphically described, 78-79; translatability of, 40-46; as virtual acts, 29n
Ashton, Sir Frederick, 135
Attila, 258
attitudes, 82, 83, 105
Aurelius, Marcus, 338
Austin, J. L., 124

Bartok, Bela, 60-61, 65-68, 84-85
Baudelaire, Charles, 61-62, 68, 74
Beardsley, Monroe, 16-17, 32, 40, 63-65, 130, 158-59, 163, 188-89
Beethoven, Ludwig van, 22-24, 38, 64, 326, 338
Berenson, Bernard, 337
bodily factors, 233-37, 272, 295
Bosch, Hieronymus, 140
Bouwsma-Beardsley position, 17, 32, 63. *See also* canonical position
Bouwsma, O. K., 16-17, 32, 63, 130
Brandeis, Louis, 323
Breughel, Pieter, 20, 24-25, 42-43
Browning, Robert, 309
Bruno, Giordano, 125-26

Cage, John, 23, 25, 28, 31, 42, 44-45
Cannon, Walter F., 128-29
canonical position, 26-27, 36, 38, 46, 64-65, 67; as Bouwsma-Beardsley position, 17, 32, 63; defense of, 39-42; as interpretation of expression theory, 18, 32, 47, 62, 85
Capote, Truman, 317
"capturing," 135-36, 138, 144, 153-55, 195
Cassirer, Ernst, 16

343

INDEX

illocutionary acts, 99-103, 112, 117, 131
Ingres, 190, 192, 196-97, 202-03, 213, 216, 231
inner experience, 266-67, 273n, 289-91, 298; as signs, 294. *See also* introspectively accessible phenomena; private experiences
innerness, terms of, 287-88
intellectual work, 317, 320-22
intensity of the expressed, 193
intentional act, expression as, 229-31, 296
introspectively accessible phenomena, 302-04, 308-09, 311. *See also* inner experience

James, Henry, 50, 66, 81, 83

Kant, Immanuel, 248, 314
Koyré, Alexander, 125-26
Krutch, Joseph Wood, 320

Langer, Susanne, ix, 16, 184, 187-88, 253-55
language as expression, 85, chapter 3 *passim*
Lever House, 248
Limburger, Annie, 223
linguistic acts, 115, 298. *See also* illocutionary acts
linguistic expressions, 12, 88, 95-96, 125, 183; anthropomorphically describable, 106-14, 117; classification of, 103-05; conditions of use, 97-98, 100, 107-12; localizability of, 107-12
literature, New Critical theories of, 63
localizability of expressions, 107-12
Logical Positivists, 90
Lucifer, 307
Lucretius, 320

magnanimity, 306, 309-10, 312, 314, 319, 325, 328, 330-31, 333, 338-39

Mann, Thomas, 133, 157, 159-60, 162-63, 168-69, 172n, 173
Mannerism, 54, 82-83
Marcuse, Herbert, 117, 123-24
Marx, Karl, 316, 335
McGaugh, James L., 121n
mercantile work, 318, 333-34
metaphor, 37, 274-75. *See also* anthropomorphic properties
metaphysical status of the expressed, 271, 276, 279-80, 300
Method of Expansion and Contrast, 107-12, 152
Michelangelo, 11, 13, 133, 143-44, 157, 159, 160, 162-63, 165, 169, 173, 337
Milton, John, 20, 24
Mind, as creative, 14, 299; as derivative, 3-4, 12-13; as internal, 8-9, 12, 14-15, 267; natural model of, 9, 12-14; as original source, 4, 7-9, 12-15, 282, 299; Pre-Romantic model of, 3-4; Romantic model of, 3-4, 7-9, 12, 14-16, 265, 282; as unique, 7-8
Mondrian, Piet, 248
Mozart, W. A., 22, 24-25
Murgatroyd, Sadie, 219-20
Mutz, Zelda, 224-26, 261

natural expressions (facial, vocal, gestural), 29, 32-33, 35, 46, 63-64, 73, 77-78, 88, 90, 112-13, 181-84, 188, 205, 212, 242, 247-49; distinguished from cultural expressions, 184-85
natural lay of the face, 31
natural signs, *see* expressions, as natural signs
nature of the expressed, 270-72, 275, 288
nature service, 317, 323
necessary connection, between expressed and expression, 215
Negro sculpture, 54-55, 75, 77, 79

INDEX

Ryle, Gilbert, 3, 8-9, 117, 145, 267

Saarinen, Eero, 134, 137-40, 144, 152
Santayana, George, 278-79
Schacht, Richard, 335
Schevill, Ferdinand, 116, 122-23
Schubert, Franz, 134, 139
Schwayder, D. S., 95
Schweitzer, Albert, 323
Scott, Sir Walter, 75
Scott, George C., 330
self, chapter 10 *passim*; finding oneself, 312; nature of, 301-02; nobility of, 306; as phenomenologically interior, 302-04; presupposes expression of self, 309, 314-15; seeking to discover, 311; unity of, 301-04, 314, 339. *See also* personal identity
self-consciousness, 298
self-expression, xi, chapter 10 *passim*; must be of acceptable traits, 313; requires competence, 310-11, 313, 321; requires cosmic magnanimity, 306, 309-10, 312, 314, 319, 328, 330-31, 333, 338-39; difficulty of, 310-11; and finding oneself, 312; must be of fundamental characteristics, 307-08; generality of, 305, 312; intrinsically normative concept, 307; requires large-scale significance, 333-34; magnitude of, 305, 315, 331-32, 336; requires nobility, 306, 313; must be original, 337-39; may presuppose truth, 321-22; requires virtue, 322, 329; in work, 315-39
sensitivity, forms of, 54, 57-58, 67. *See also* subjective factors
Shakespeare, William, 162, 326
showing, chapter 8 *passim*, 265, 268-69, 281, 284, 291, 296, 300, 309-10, 319, 336; in

avowal expressions, 204-06; distinguished from "showing that," 202-03; of fatigue, 232, 236-37, 297; meaning of, 238-42; and pain, 203n; of purely behavioral characteristics, 262-64, 285; in signs, 202, 206, 208
Sidney, Sir Philip, 171-72
signs, 268-69, 293; and causation, 294; as "showing that," 202, 206, 208; inner experiences as, 294
Sircello, Guy, 29n, 44n
skill, 259-61, 321
Skinner, B. S., 220-23
Sophocles, 90n
speaking, ways of, 99-104, 106, 112, 114, 121
sport, philosophy of, 330n. *See also* playing
"standing out," *see* objective expression
Stoicism, 328
Strachey, Lytton, 115-17
style, 115-17, 123, 126, 129, 247, 305; to express oneself, 310-11
subjective factors, 47-85, 91, 122, 213-15, 321; eliminability of, 73-85; as forms of sensitivity, 54; not translatable as anthropomorphic predicates, 47
sub-personal intentions, 320n
subservient activity, 318, 333-34
sympathy, 178-81

technical languages, 183
Thomson, Virgil, 60-61, 65-67, 73, 84-85
Thoreau, Henry David, 320, 338
Thucydides, 195
Titian, 241
Tolstoi, Leo, 51-52, 68, 81, 157
Towers of Simon Rodia, 321, 336
Trilling, Lionel, 50-51, 52, 57n, 58-59, 65-66, 72-74, 76, 81, 83-84
truth, 321-22

348

349